£41-

[signature]
-1989-

THE HISTORY OF MINOAN POTTERY

THE HISTORY OF

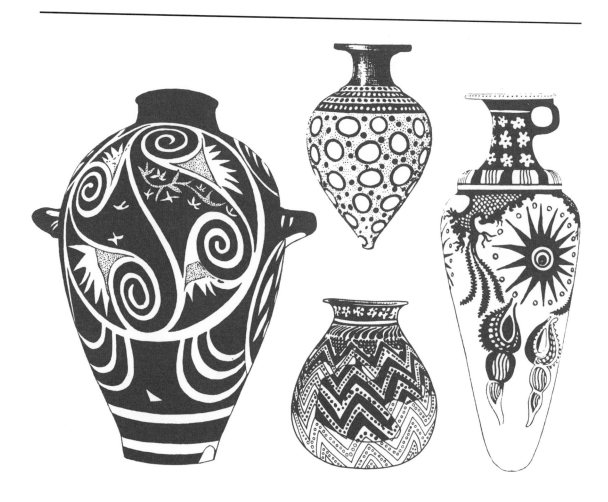

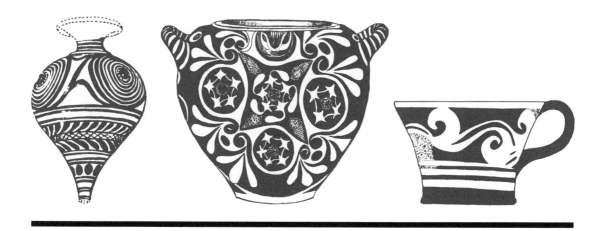

MINOAN POTTERY

By Philip P. Betancourt

Princeton University Press

Princeton, New Jersey

Published by Princeton University Press, 41
William Street, Princeton, New Jersey 08540
In the United Kingdom: Princeton University
Press, Guildford, Surrey

Library of Congress Cataloging in Publication
Data will be found on the last printed page of
this book

ISBN 0-691-03572-2
ISBN 0-691-10168-x (pbk)

This book has been composed in Linotron
Baskerville and Gill Sans

Clothbound editions of Princeton University
Press books are printed on acid-free paper,
and binding materials are chosen for strength
and durability. Paperbacks, although
satisfactory for personal collections, are not
usually suitable for library rebinding.

Printed in the United States of America
by Princeton University Press
Princeton, New Jersey

DESIGNED BY LAURY A. EGAN

TO JOHN AND MICHAEL

CONTENTS

LIST OF ABBREVIATIONS

Abbreviations of Museums

AM	Ashmolean Museum, Oxford	MHC	Mount Holyoke College, South Hadley, Massachusetts
AN	Museum, Aghios Nikolaos, Crete	NMA	National Museum, Athens
BM	British Museum, London	NMC	National Museum, Copenhagen
HM	Archaeological Museum, Herakleion, Crete	Penn	University Museum, University of Pennsylvania, Philadelphia
Kh	Museum, Khania, Crete	SMM	Stratigraphical Museum, Malia
KSM	Stratigraphical Museum, Knossos		
Louvre	Musée du Louvre, Paris		
MMA	Metropolitan Museum of Art, New York		
MFA	Museum of Fine Arts, Boston		

Abbreviations of journals follow the conventions used by the *American Journal of Archaeology*, vol. 82, no. 1, 1978.

LIST OF ILLUSTRATIONS

PLATES

TABLES

PHOTOGRAPH AND DRAWING CREDITS

Figures and Plates are included by courtesy of the following persons and organizations:

American Journal of Archaeology: Figure 90

Kristin Anderson, by courtesy of the Museum of Fine Arts, Boston, C. C. Vermeule, Curator of Greek and Roman Art: Plates 4I, 5B, 22G

The Art Museum, Princeton University: Plate 7E

Ashmolean Museum, Oxford: Plates 2H, 5I-K, 6D, 6F, 8H, 9G, 12I, 13F, 13J, 14B, 18E, 21B, 30E

Paul Åströms Forlag and P. Betancourt: Figure 101

Philip P. Betancourt: Figures 1-11, 12A-D, 13-16, 17, 20-23, 25, 27, 29, 31-33, 35, 38, 39C-D and F-G, 41, 45-60, 62, 63A-H and J, 64-65, 67-69, 76-77, 79-80, 84-85, 86A, 87-89, 92-94, 97-99, 103-104, 106, 110-112, 114-118, 120A, 121-123, 126, 128-130, 132, 134

Plates 2A-B, 3C, 6B, 7A, 7H, 8A, 8C-D, 9A, 12D, 13A-E, 13H-I, 13K, 14D-E, 15A-B, 15F, 16D-F, 17A, 20D, 24A, 30N, 31G, 32C-G

H.-G. Buckholz: Plate 21A

M. Chuzeville, by courtesy of the Louvre Museum, Paris: Plates 29J-K, 30A-B, 30P, 31C-D

Danae Cotsis: Figures 81, 86B

Danae Cotsis, by courtesy of L. Vance Watrous: Figure 113

Costis Davaras, Aghios Nikolaos Museum: Figure 89, Plate 3A

Robert T. Fagan and P. Betancourt: Figure 98

Harrison Eiteljorg II, by courtesy of the University Museum, University of Pennsylvania: Plates 4D, 6A, 7G, 14C, 18G, 20G, 30I-J, 30L

Alison Frantz: Plates 22C, 25B

Lori Grove: Figure 12E, 39E, 63I, 120C

D. K. Harlan: Figure 71C and Maps

Nicholas Hartmann, by courtesy of the University Museum, University of Pennsylvania: Plates 4F-G, 5A, 5G, 5H

Barbara Hayden: Figure 39A-B

Francis Heacox and P. Betancourt: Figure 105

Hirmer Fotoarchiv: Plates 4A-B, 6C, 21E, 22F, 25C

Robert Koehl: Plates 7D, 8E, 12A, 12F, 15E, 17H, 22D, 23D, 30-O, 31B

Lennart Larsen, by courtesy of the National Museum, Copenhagen, Department of Near Eastern and Classical Art: Plate 5F

Doro Levi: Plates 26A-D

David Neal Lewis: Figures 51, 66, 71A-B, 78

Jodi Magness: Figure 133

The Metropolitan Museum of Art: Plates 4E, 5D-E

W. D. Niemeier: Plate 4J

Jackie Phillips, Figures 73, 82-83, 86

Nicolas Platon: Plates 20H, 21C, 22A-B, 22E

Mervyn Popham: Figure 119

Elizabeth Schofield and the late John Caskey: Plate 18A-D

Laurinda Stockwell, by courtesy of the University Museum, University of Pennsylvania: Plate 15C

Temple University Aegean Symposium: Figure 102. Plate 17E-F

I. Tzedakis: Plates 2J, 3B, 3H-I, 26G, 27A-B, 29E

University Museum, University of Pennsylvania: Figures 24, 28, 36, 38, 40, 42-44, 72, 74-75, 91, 95-96, 100, 107-109, 120B, 124-125. Plates 18F, 18I, 20A

R. K. Vincent, Jr., by courtesy of the Herakleion Museum, John Sakellarakis, Director: Plates 1A-F, 2C-G, 2I, 3D-G, 3J-M, 4C, 4H, 5C, 6E, 7B-C, 7F, 8B, 8F-G, 9B-F, 9H-J, 10A-E, 11A-G, 12B-C, 12E, 12G-H, 13G, 14A, 15D, 16A-C, 17B-D, 17G, 18H, 19A-E, 20B-C, 20E-F, 21D, 21F-H, 22H, 23A-C, 23E-H, 24B-D, 25A, 26E-F, 28A-I, 29A-D, 29F-I, 30C-D, 30F-H, 30K, 30M, 31A, 31E-F, 31H, 32A-B

Gisela Walberg: Figure 70

Peter Warren: Figures 19, 26, 30, 35

Peter Warren and *Antiquity*: Figure 18

L. Vance Watrous: Figure 113, Plate 31I-J

PREFACE

In ancient times, as today, ceramic vases are both utilitarian objects and works of art. Ancient vases also offer a key to knowledge of many types, from chronology to the history of culture to the development of technology. The present study examines one tradition in the history of ceramic vessels, the Minoan pottery of ancient Crete. Other works of clay, such as sculpture, drains, loom weights, and other specialized topics, do not form a part of the investigation. Since the subject is an active area of research, it is still filled with unresolved problems. An attempt has been made to present opposing viewpoints on many issues while pointing out the mainstream of scholarly opinion on particular points. The work is intended for the reader who is already somewhat familiar with Minoan history and archaeology but wishes to know more about the pottery. References to archaeological reports and specialized studies are incorporated for those who wish to pursue the subject further; only a basic outline can be presented in a general survey of this type.

Special thanks are extended to the following museum curators for permitting me to study the vases under their jurisdiction and for help of many types: Stylianos Alexiou, Archaeological Museum, Herakleion; Dietrich von Bothmer, Metropolitan Museum of Art, New York; B. F. Cook, British Museum, London; Costis Davaras, Museum, Aghios Nikolaos; G. Roger Edwards, University Museum, University of Pennsylvania; Spyros Iakovidis, University Museum, University of Pennsylvania; Iannis Sakellarakis, Archaeological Museum, Herakleion; Yannis Tzedakis, Museums, Khania and Rethymnon; Cornelius C. Vermeule, Museum of Fine Arts, Boston; Michael Vickers, Ashmolean Museum, Oxford.

The text has been read by my colleagues Sinclair Hood, Wolf Niemeier, and Peter Warren, and I am most thankful for their comments. Helpful comments on Late Minoan II were made by L. Vance Watrous. I am also very grateful to the many other colleagues and friends who have helped shape this study with discussions, information, photographs, and help of many types. Among those who have lent special assistance are: Hans-Günter Buchholz, Gerald Cadogan, Hector Catling, the late John Caskey, Jack Davis, Christos Doumas, Elizabeth French, Vronwy Hankey, Robert Koehl, Frederick Matson, Jennifer Moody, George Myer, Nicolas Platon, Mervyn Popham, David Reese, Elizabeth Schofield, Joseph W. Shaw, and Gisela Walberg. I am grateful to the American School of Classical Studies in Athens, the Greek Archaeological Society, the Greek Archaeological Service, and the British School of Archaeology at Athens for assistance with work in Greece.

Portions of the writer's study were paid for by a grant from Temple University.

THE HISTORY OF MINOAN POTTERY

I · THE BEGINNINGS OF POTTERY PRODUCTION IN CRETE

Crete is a rugged, beautiful island, the southernmost of the Aegean group. It stretches about 260 kilometers from east to west, varying from only twelve and a half to nearly sixty kilometers from north to south. Most of this area is mountainous, with some peaks rising high enough to keep their snow for most of the year. The hills often come right down to the sea, creating natural inlets and harbors.

Like most islanders, the ancient Cretans were sailors as well as farmers and craftsmen. Their land had several geographic regions, offering advantages not shared by the rest of the Aegean isles. It had abundant timber, stone, and clays, enough fertile valleys and plains to support a sizeable population, and room for large-scale grazing and herding. During the long centuries of the Neolithic and Early Bronze Age, its isolation allowed it to escape at least a few of the troubles that beset the northern Aegean, while its size permitted it to develop its own independent traditions. On the other hand, it was not too far away for contact and cross-fertilization, and it was close enough to the East to receive new ideas from the older civilizations. When the entire island was consolidated under the leadership of a series of major palaces at the end of the Early Bronze Age, the sleeping giant came into its own.

The first known pottery makers arrived during the Early Neolithic. A radiocarbon sample from the Early Neolithic I level at Knossos has yielded a date of 6000 ± 180 B.C. (J. D. Evans 1964: 140), which is several centuries earlier after calibration (Klein et al. 1982). It suggests a seventh millennium B.C. settlement.

Neolithic architecture varied somewhat through time, but most Neolithic Cretans lived in houses of mudbrick or more perishable materials set on stone foundations to raise the walls above the dampness of the ground. Several rectangular or irregular rooms were put together to form each house. Families lived near one another in villages, traveling out to the surrounding land to tend their crops and animals. Caves were also sometimes used as homes, and they were symbolic to the religion; offerings of pottery and other goods were placed within them. Agriculture was the mainstay of the economy.

This was a time of relatively slow progression, a decided contrast with the dynamic development of later times. The farmers and herdsmen who made up the majority of the population seem to have been very conservative, and tradition probably played a large role in many aspects of their lives. Pottery would have been an important household item; in a culture with few watertight and non-

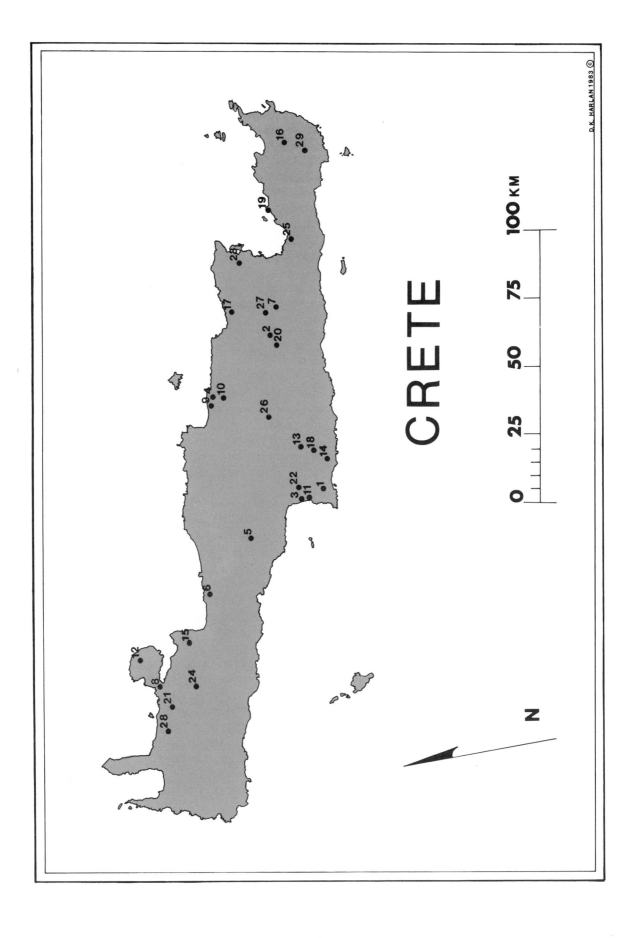

CRETE

N

0 25 50 75 100 KM

D.K. HARLAN 1983 ©

flammable containers, it filled a major need. Most Neolithic Cretan vessels were utilitarian, serviceable, and fairly well made. If they lacked the artistic excellence of some contemporary work from the Greek mainland, at least the best pieces were well potted and durably fired, and some pots were carefully decorated as well.

Like many of their contemporaries in the eastern Mediterranean, the earliest Cretan potters made coarse-textured dark wares with thick, heavily burnished walls. Such pottery occurs in a broad horizon across the Near East, Anatolia, and Europe. Like farming and herding, it is a common Early Neolithic feature in this part of the world, and its technology cuts across many geographic boundaries.

Neolithic pots, like most Stone Age crafts, are made from naturally occurring materials. The principal ingredient is clay, a fine-grained mixture of hydrated aluminosilicates and other minerals, rock particles, and even organic substances. Although suitable deposits are found in most parts of the eastern Mediterranean, compositions and properties vary so widely that no two clays behave in exactly the same way. In most cases, a clay becomes more plastic when it is mixed with water; it can then be shaped by hand to form containers, figurines, and other useful articles. The resulting object is harder when it dries, and a really permanent substance can be made by heating, or in ceramic terms firing, it to a few hundred degrees Celsius. A sufficiently high temperature can be achieved fairly easily, even in a banked hearth.

All Early Neolithic pots are made by hand and fired to relatively low temperatures. They normally have coarse textures, and often some additional gritty fragments, called temper, are mixed with the raw clays to make them even coarser—gritty clay shrinks less during drying and will not crack so readily, and rough inclusions permit water vapor to escape during the firing, with the same result. Several hand methods can be used for shaping: coils pressed together with a little liquid clay, or slurry; patted out slabs joined in the same way; lumps or balls of clay pinched out by hand (the "pinch pot" method); or balls or slabs of clay pounded over a form like an inverted bowl or jar (the "paddle and anvil" method). Vessels are almost always wiped with water to improve the surface, and they are sometimes rubbed with a smooth implement, a process called burnishing. After drying, the vessels are ready to be fired. Most early cultures used a banked fire, a system still in use in the twentieth century. The resulting vases are not very hard, but they are adequate for most functions. Surfaces are usually dark, with glossy marks from the burnishing.

On Crete, the earliest pottery of Knossos has become the cornerstone of the

Map I · Neolithic and Final Neolithic sites in Crete. (1) Aghia Kyriaki; (2) Arkalokhori; (3) Arolithia; (4) Eileithyia Cave; (5) Ellenes; (6) Gerani Cave; (7) Grimane Cave; (8) Kastelli, Khania; (9) Katsampas; (10) Knossos; (11) Kommos; (12) Koumaro Cave; (13) Koutsokera; (14) Lebena; (15) Lentaka Cave; (16) Magasa; (17) Malia; (18) Miamou Cave; (19) Mokhlos; (20) Partira; (21) Perivolia Cave; (22) Phaistos; (23) Phournoi; (24) Platyvola Cave; (25) Sphoungaras; (26) Stravomyte Cave; (27) Trapeza Cave; (28) Vryses Kydonias Cave; (29) Ziros.

New Stone Age sequence (for general discussions of all Crete see Zois 1972; 1973; for good brief summaries see Hutchinson 1962: 46-53; Sakellarakis 1973). Sir Arthur Evans excavated the original material in the first decade of the twentieth century and divided it into three stages. The definitive study, by Furness (1953), has kept Evans' division into Early, Middle, and Late periods but has subdivided the first stage into two phases. For the earliest styles, Knossos still provides our best evidence.

No pottery at all comes from the lowest Knossian level, but it appears in a fully developed form in the next period, Early Neolithic I (Furness 1953: 103-117; J. D. Evans 1964: 196-212). Since none of the hesitant first steps in pottery making are found, it seems likely the craft was imported from elsewhere, though no totally convincing foreign parallels have yet been found. The best candidate for the origin of the technology is the Alaca region of Chalcolithic Anatolia. The suggestion, advanced by Furness, is based on several points of similarity, especially the clay knobs and pellets that are added to some of the Early Neolithic pieces from Knossos.

From the beginning, the pottery is well made. Furness has distinguished two wares: Coarse Burnished Ware and Fine Burnished Ware. They are similar except that the fine ware is better levigated and is used for thinner-walled vessels with a better finish. Both clay bodies are tempered with powdered gypsum and are softer than most later Neolithic pottery, indicating a low firing temperature. Their surfaces are usually dark, but there is a variation from red to buff to black.

As with most unglazed pottery, Cretan Neolithic wares owe their colors to iron oxides. Iron may be in the original clay in many forms (especially lepidocrocite,

goethite, and hematite). The intense heat of the firing alters some of these compounds, and conditions during the firing have much to do with the resulting products (a good brief discussion is in Noble 1965: 31ff.). If oxygen is present, a condition called an oxidizing atmosphere, much of the iron will unite with it to form ferric oxide (Fe_2O_3). This compound, hematite, is red. If insufficient oxygen is present for the combustion of organic matter to form carbon dioxide (CO_2), a reducing atmosphere, incomplete combustion forms carbon monoxide (CO) that joins with the ferric oxide. The result is ferrous oxide (FeO), which is black. The chemical process is:

$$Fe_2O_3 + CO = 2FeO + CO_2$$

With water vapor present, magnetite may be formed (Fe_3O_4). It, too, is black. Here the process is:

$$3Fe_2O_3 + CO = 2Fe_3O_4 + CO_2$$

Various intermediate shades, as well as paler tones, can result from mixtures of the processes or from variations in the temperature or the amount of iron. The colors are permanent, and they are fixed as soon as the temperature is lowered.

Since the Cretan Early Neolithic pottery is mostly black, it must have been baked in a covered fire. Red or pale pieces are less common. Sometimes several hues occur on one vase, indicating that fuel was in contact with the pots during the heating process, a natural circumstance if the potters used a banked hearth or campfire. Where the fuel or another vase blocked the draft or consumed the oxygen, black iron oxides would have formed, while red areas indicate drafts of air.

The range of vases seems surprising for such an early period (Fig. 1). Open-mouthed bowls, some small and others

1 · Early Neolithic shapes from Knossos, Scale 1:9.

large enough for storage, are the most common shapes. Others include narrow-necked jars, small-mouthed bowls, pedestalled bowls, dishes, and a few rarer shapes. Handles are of various types, including a design that looks like a wishbone. No slip or paint is used, and many pieces are left plain. Usually the moist clay was well burnished before firing to compress the surface and make it harder and more impervious to moisture, a helpful trait for soft, low-fired vases.

A few pieces are decorated (Fig. 2).

Applied pellets, knobs, or strips of clay might be added to the walls, and incised decoration, which would be very popular later, also begins in this first phase. Punctations are sometimes used, and one variation, called *pointillé*, is particularly interesting (Fig. 2B-E). Used exclusively on fine ware, it consists of areas filled with small pricked dots, edged with incisions. Sometimes the depressions contain white or more rarely red slip, making a more striking surface. The designs are all angular, composed of lines, pricks, and

2 · Early Neolithic I designs incised on pottery from Knossos.

3 · Early Neolithic II designs incised on pottery from Knossos.

filled areas. Zigzags, which are particularly popular, occur in many variations. Like the other motifs—step patterns, branches, groups of short horizontal lines, stripes, triangles, and the rest—they are normally placed in horizontal bands.

Early Neolithic II is also known only from Knossos. Its pottery continues EN I traditions but is slightly better made (Furness 1953: 117-120; J. D. Evans 1964: 212-219). Again, one can distinguish Coarse and Fine Burnished Wares. The most common shapes are similar to those of the earlier phases; they include open-mouthed bowls with rounded or sharp profiles and low jars with narrow necks. The pots are still handmade, but they are more even in color, suggesting a

better firing. Plastic decoration and the *pointillé* style decline in popularity, while incising continues, with many new motifs (Fig. 3). All the ornaments are still abstract, based mostly on simple rectilinear design. The organization is usually careful, and repeat motifs are common. A few vases are burnished with rippled lines (Rippled Ware).

Beginning in the Middle Neolithic, evidence comes from other centers besides Knossos (for Knossos see Furness 1953: 120-126; J. D. Evans 1964: 219-225; for Katsampas see Alexiou 1953: 308 fig. 7; 1954A: 373 fig. 4; for the possibility of Middle Neolithic at the Lentaka Cave see Hood 1965: 112). Most shapes are similar to the Early Neolithic ones (Fig. 4), but

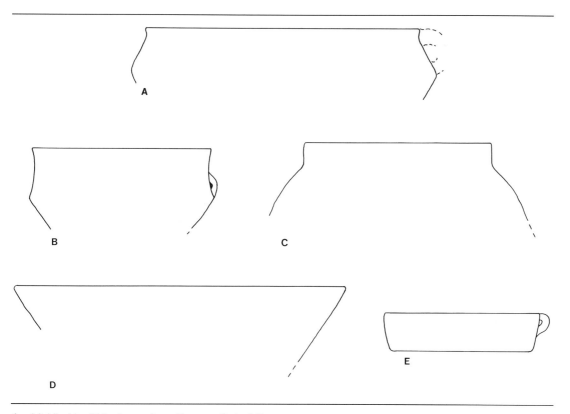

4 · Middle Neolithic shapes from Knossos, Scale 1:9.

the coarse wares are less often burnished. New introductions include a cylindrical vessel with an opening in the side (Pl. 1A) and a ladle, a specialized dipper with a long pointed handle (Pl. 1F). A few rare pieces are covered with a paint made of liquid clay (called slip). Fine Burnished Ware continues to be made (Pl. 1C), and the surface is more often rippled. The incised decorations, applied more carefully than in previous periods, are often very attractive (Figs. 5 and 6).

This incising is the most striking feature of the period. Its range is considerable, much greater than in Early Neolithic. Diamond chains, hatched triangles, branches, bands of vertical lines, and many other decorations are used. As in earlier times, they are strictly linear, with continuous horizontal friezes as the most common arrangement. Usually only a few bands (or a single one) decorate a vessel.

5 · A cup or bowl from Knossos with incised bands, Middle Neolithic, Dia. ca. 19-20 cm.

The population of Crete seems larger by the Late Neolithic, and several new foundations may be recognized. Excavated settlements include Magasa (Dawkins 1904-1905: 264-265, fig. 3 and pl. 8 nos. 24-31 and fig. 3) and Sphoungaras (Foster 1978: nos. 2-3). Caves are more important than previously (Jantzen 1951:

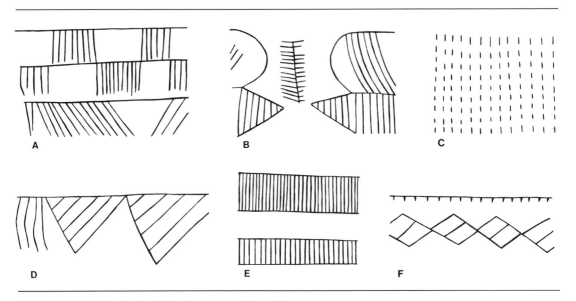

6 · Middle Neolithic designs incised on pottery from Knossos.

6-11 and pls. 8-15; Faure 1964), and many other sites are known, especially from surface surveys (Hood, Warren, and Cadogan 1964; Hood 1965). They cover the entire island.

The finds from Knossos are the most important because they demonstrate continuity from the Middle Neolithic (Furness 1953: 126-132; J. D. Evans 1964: 225-229). Late Neolithic surfaces are still mostly dark and burnished, a feature that continues to distinguish Cretan pottery from the rest of the Aegean. Many Neolithic painted wares flourish on the mainland, and deep-seated changes occur there far more frequently than on the south Aegean island. Stability and slow progression are prime Cretan characteristics, probably because of the island's isolation. During almost its whole history, Neolithic Crete remained essentially outside the mainstream of the Aegean development.

Vase shapes from the Cretan Late Neolithic are shown in Figures 7 and 8. They are more varied than before, with shallow and deep bowls, cups, jars of several types, pyxides, and some unusual forms of uncertain purpose like the pointed cups in Figure 8. There are still no shapes with raised spouts, and in fact no vessel with a closed or narrow neck is common at all. Although most of the shapes have Middle Neolithic predecessors, they are now more varied and specialized.

Firing is better than in the Middle Neolithic. A dark or red fabric is the

7 · Late Neolithic shapes from Knossos, Scale 1:9.

most common clay body. A coarse, red, wiped ware, usually unburnished, seems to have developed from the earlier coarse wares. Fine wares include Fine Burnished Ware and Rippled Ware, with the Rippled Ware being less common than in Middle Neolithic. Experiments with different decorative techniques indicate an increasing concern for the surface (Fig. 9). The many systems include: *pointillé*

decoration; incised lines; lines scratched after firing; grooves; ridges with incisions; and possibly pattern burnishing. Vases from the end of the phase anticipate the next period.

Several sites suggest the presence of a ceramic style between Knossian Late Neolithic and Early Minoan I. The phase is now usually called the Final Neolithic, though it has sometimes been referred to as the Cretan Chalcolithic or the Sub-Neolithic. Stratigraphic confirmation, which is scanty, includes the Trapeza Cave where two Neolithic levels were recognized (Late Neolithic and Final Neolithic, Pendlebury, Pendlebury, and Money-Coutts 1935-1936). Equally important, the Final Neolithic material at Phaistos is completely different both from the Late Neolithic at Knossos and from Early Minoan I at the same sites. The best study for the period and its pottery is by Lucia Vagnetti and Paolo Belli (1978).

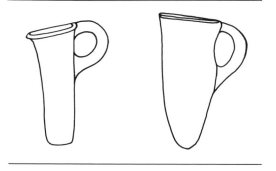

8 · Two miniature cups from Knossos, Late Neolithic. (Left) Ht. 9.6 cm.; (Right) 10.7 cm.

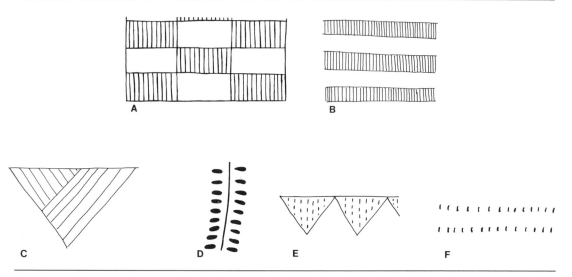

9 · Late Neolithic designs incised on pottery from Knossos.

Although their conclusions are still tentative, Vagnetti and Belli build on the studies of Renfrew (1964: 112-114) and Levi (1965) and join together a number of deposits covering all of Crete. The most important sites include:

Eileithyia Cave (Marinatos 1929A: 95-104; 1930: 91-99; Zois 1973: 125-128; Gerard 1967; Faure 1964: 55f.)

Knossos (disturbed parts of Stratum I, J. D. Evans 1971: 113f. and pls. 3 right, 4, and 5, regarded as Late Neolithic at the time of excavation)

Lebena (Tomb II, earliest pottery, Alexiou 1960)

Miamou Cave (Taramelli 1897)

Mokhlos (pottery beneath Tomb V, Seager 1912: 93)

Palaikastro (Dawkins 1902-1903: 341 figs. 1-2)

Partira (Mortzos 1972)

Phaistos (Neolithic levels, Mosso 1908; Pernier 1935: 85-112; Levi 1965; 1976: pls. 5-10; Vagnetti 1972-1973)

Phournoi Meramvellou (Platon 1959B: 388)

Platyvola Cave (earliest pottery, Tzedakis 1965: 569f.; 1966: 428-429; 1967: 504-506)

Trapeza Cave (Sub-Neolithic pottery, Pendlebury, Pendlebury, and Money-Coutts 1935-1936)

These finds are united by a number of characteristics. They show continuity from the Late Neolithic as defined from Knossos, along with several new features. Closed shapes, especially jugs without spouts and two-handled jars (Pls. 1B and 1D), are much more frequent. New shapes include bottles, suspension pots with tall horned lids, tankards, horned cups and small jars. Among the fabrics associated with the phase are the heavy, unburnished Trapeza Ware of the Lasithi Plain (Pendlebury, Pendlebury, and Money-Coutts 1935-1936), Scored Ware (see discussion below, under EM I), and several Phaistian wares (Vagnetti 1972-1973). Incising continues (Fig. 10), but it is not very common. Some pieces are decorated with "scribble burnishing," and others have burnished patterns (Pyrgos Ware). One ware, decorated with red ochre, is found at both Knossos and Phaistos (Pl. 1E and J. D. Evans 1971: 113-114 and pl. 3).

The Phaistian vessels in Figure 11 furnish a nice selection from a settlement. They include both open and closed shapes, in fine and coarse-textured fabrics. The unusual jar with the strainer in the mouth, painted with red ochre, is also from Phaistos (Pl. 1E).

An assortment of complete pots, shown in Figure 12, offers examples of additional shapes. Four of the vessels are from Partira: a cup or bowl with horns flanking the handle; a plain bowl; a tankard with handles on the upper shoulder; and a small pyxis with a horned lid. All are decorated with burnished patterns and so may be classed with Pyrgos Ware, a type of pottery that continues into EM I. The other horned cup, from the Eileithyia Cave, is decorated in the same way.

The Final Neolithic seems to be the earliest period with much evidence for foreign contacts (on the whole question of Minoan foreign relations see Branigan 1981). Comparisons may be made with several regions, but they are closest with the northeast Aegean. Footed bowls (see Fig. 11D) come from Poliokhni on Lemnos (Bernabò-Brea 1964-1976: I pls. 9-22 and 106-113), Kum Tepe in the Troad (Sperling 1976: 320), Alishar (von der Osten 1937: 67-71, figs. 75-77), and elsewhere. Cylindrical lids for pyxides (Fig. 12D) are known from Troy I-II (Blegen

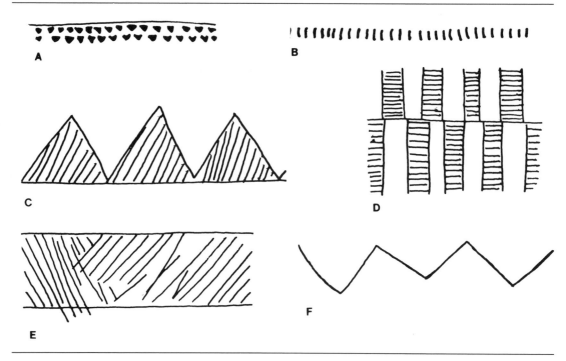

10 · Incised Final Neolithic designs from Phaistos.

1950: I, ii, fig. 223b nos. D 1, fig. 404 nos. 36.1149 and 35.437). Horned handles (Fig. 11B) are common at several Cycladic and Anatolian sites during this general period (for a list see Mellaart 1966: 114-115 and 117). Carinated bowls and bowls with everted rims like those from Phaistos (Vagnetti 1972-1973: 65) may be compared with similar bowls from Tigani on Samos (Furness 1956: fig. 8 nos. 2 and 13). Red ochre is used to decorate Neolithic pottery at quite a few places in the Aegean (Vagnetti 1972-1973: 80-83), and pattern burnishing has an especially wide distribution in the Aegean, Greece, Anatolia, and elsewhere (discussion in Chapter 3, under Pyrgos Ware). Additional parallels are discussed by Vagnetti (1972-1973: 126-128). The synchronisms are very general, and no really close comparison can be made between the pottery from a specific site in Crete and a specific foreign site, but the general increase in the number of Cretan sites and the preference for new situations (like open settlements on hilltops) suggest the likelihood of a few new residents.

By the close of the Stone Age, Cretan pottery has developed from a humble household craft to a more varied and interesting production. Grave goods and cave offerings like the vases from Partira and the Eileithyia Cave indicate a new desire for novel shapes designed for special purposes. The stylistic changes are accompanied by advances in both potting and pyrotechnology, opening up new possibilities for the age to come. Perhaps most important of all, Crete has broken its isolation. The long, stable Neolithic period is now past, and foreign interaction will provide both increased motivation and fresh ideas.

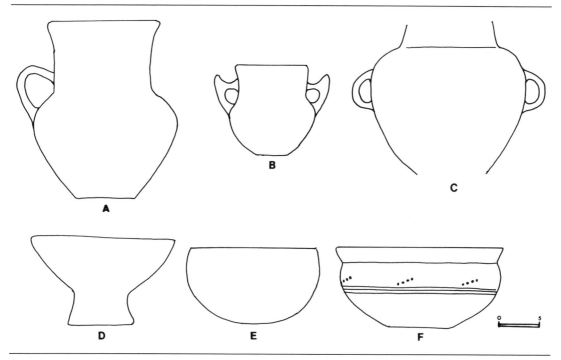

11 · Final Neolithic vases from Phaistos, Scale 2:5.

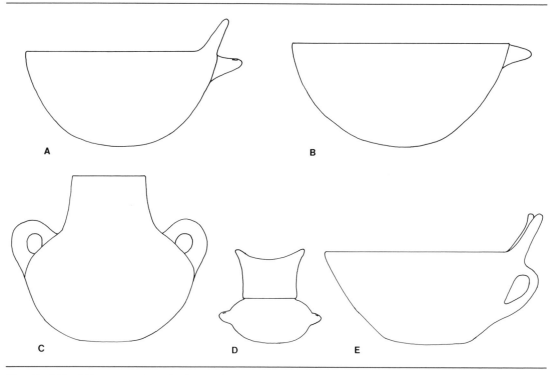

12 · Final Neolithic pattern-burnished vases from Partira (A-D) and the Eileithyia Cave (E), Scale 1:9.

2 · THE EARLY BRONZE AGE DEVELOPMENT

THE AMBIENCE of Early Minoan pottery is very different from that of the Cretan Neolithic. Most Stone Age Cretan vessels are simple cups, bowls, and jars. Special shapes are rare, and most vases are designed in such a way that they could have served for many purposes. Beginning already in the Final Neolithic, a change is visible, and by EM I specialization is much more widespread. Although generalized bowls and jars are still present, they now exist alongside animal and bird effigies, jugs with open or closed spouts, bowls on high stems, vessels with particular kinds of handles or lugs, and many unusual shapes that betray a new type of response to specific community needs. The ceramicist is now a special craftworker, not just a casual laborer making a container. Although the distinction may seem subtle, the new role is very different, and the higher status is necessary for the development of fine art. Progressively more aesthetic products can only be made if the artist is appreciated as someone whose efforts fulfill a need in the best way possible. Improvement is thus encouraged, and development is inevitable.

At the beginning of the period, the culture is not readily distinguishable from the Final Neolithic except in a few details. Villages are still mainly agricultural, with most households depending on crops and flocks for their food supply. Changes are slow and not always clearly

datable. If the few excavated remains are typical, these villages are small, with clusters of houses built of mudbrick on stone foundations, techniques already familiar from the Neolithic period. Burials with up to several hundred individuals suggest strong family or clan ties that continue for many generations. Burial customs are generally similar in different parts of Crete, but details and tomb types differ widely. Caves are popular in the north and west and are used sporadically elsewhere; constructed rectangular chambers are sometimes used in the east; round buildings called *tholoi*, or beehive tombs, are common in the south. In all cases, however, the customs are similar: burial is communal with weapons, tools, pottery, and other goods accompanying the deceased into the next life, and with nearby areas set aside for offerings.

Trade increases greatly by the middle phases of the age. Metallurgy advances especially, and copper or bronze daggers are common enough to suggest every adult male may have had one. Jewelry and seals, carved trinkets and stone bowls all begin or appear in larger numbers, suggesting a new affluence based on foreign exchange or on a better administration of the existing resources. Wealth and social differences in the burials show that stratification is in progress; a few individuals can afford the luxury of objects made by those with too much skill to spend

all their time cooking or tending crops and animals. The age of the artists has arrived.

In this world beginning to reach out to nearby areas for new ideas, ceramics quickly became an important commodity. The age had few outlets for artistic expression, and those that did exist were quick to develop. Ceramics attracted some of the best talents of the time. Styles developed in relatively quick succession, with several individual masterpieces. In many ways, Early Minoan pottery is a high point in our artistic heritage.

As in the Neolithic, much of the pottery is stone tempered. Local materials— sand or crushed stones—are added to the clays for large- and medium-sized vessels, and occasionally for small ones as well. If a particular clay body is wanted, the potters mix their natural materials to achieve the proper workability. Only hand methods are used, but by EM II small turntables aid in the smoothing process.

Although most Early Minoan styles have local versions, their principles are island wide. Crete has a larger population than in the Neolithic (Map 2), and some of the pottery wares are well distributed from east to west. Local advancements and stylistic changes are often paralleled at other sites fairly quickly. Communication must have been routine, and we may already speak of a general Minoan milieu (on the relation of these advancements to foreign contacts see Warren 1981B).

Most of the surviving pottery comes from either houses or tombs. Conscious specialization operates, with some (though not all) of the grave goods differing from those intended for the home. One finds vessels in tombs that were probably buried for their contents, others that seem important cult objects in their own right, and an extraordinarily large number of drinking cups and jugs. The

last group suggests some drinking ceremony, perhaps toasting ended with the breaking of the vessels. Pottery from the settlements is more varied. A few pieces may have been used in ceremonies, but in most cases it is functions like cooking, storage, serving, and food processing that must be envisioned. Even here, however, the number of drinking and pouring vessels is remarkably high. Evidently the pottery industry needed to supply a continuous cultural need for large numbers of fine drinking sets, suggesting a constant impetus for the production of fine pottery.

Several chronological frameworks have been suggested for dealing with the Minoan culture. Only two are widely used today, with each one having its own advantages. Based on his excavations at Knossos, Sir Arthur Evans proposed Early, Middle, and Late phases, each divided into three subperiods. He based his ideas on successive pottery styles, making the system roughly equivalent to the Old, Middle, and New Kingdoms of Egypt. An alternate plan, derived from architecture, is preferred by Nicolas Platon, Doro Levi, and others. It divides Minoan history into Pre-Palatial, Old Palatial, New Palatial, and Post-Palatial periods. In addition, Levi has argued that Early Minoan is a short, transitional phase that cannot have lasted more than a few years (Levi 1951: 340ff.; 1957-1958: 136ff.; 1960; 1964: 4-5). Recent stratigraphic excavations have reconfirmed the long length of the Early Bronze Age, contradicting this part of the alternative system, but the Palatial nomenclature has been accepted by many writers as a useful alternative to the ceramic periods of Evans. This system, however, has some drawbacks. It works well for the settlements, but its broad phases are much too impre-

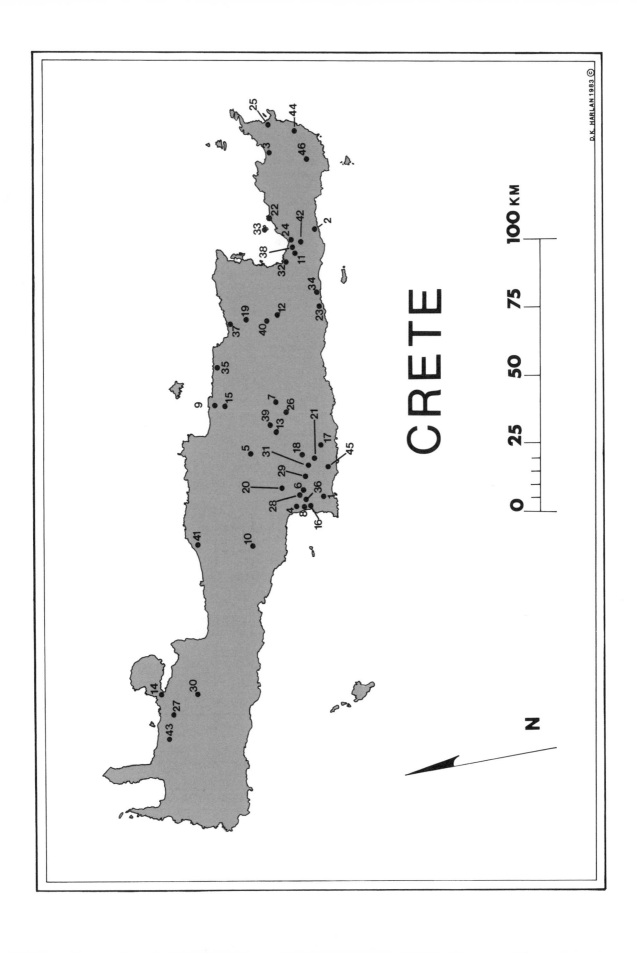

CRETE

N

0 25 50 75 100 KM

Table 1 · Synchronization between Minoan and Helladic periods.

	CRETE	MAINLAND GREECE
ca. 3200-2800 B.C.		
	EM I	EH I
	EM IIA	EH II
	EM IIB	
ca. 2100-1950 B.C.	EM III	EH III
first potter's wheel	MM IA	
	MM IB	
	MM IIA	MH
	MM IIB	
ca. 1650-1550 B.C.	MM III	
	LM IA	LH I
	LM IB	LH IIA
	LM II	LH IIB
	LM IIIA	LH IIIA
	LM IIIB	LH IIIB
ca. 1150-1050 B.C.	LM IIIC	LH IIIC
	SM	SM

cise for pottery; the terminology of Evans is preferred here.

An adaptation of Evans' system is shown in Table 1, with the Early Bronze Age periods on the Greek mainland and in the Cyclades illustrated in Table 2 for comparison. For the Greek peninsula, Early Helladic I, II, and III have long been accepted as standard nomenclature (a good discussion is Caskey 1960). Among the chronological frames proposed for the Cyclades in recent years, the cultural divisions of Renfrew (1972) and Doumas (1977) are the best alternatives to the system used here. In the present treatment, it has seemed best to use a framework that parallels EM I-III, especially since the tripartite division of the Cyclades is mainly defined from pot-

Table 2 · Chronology for the Aegean in the Early Bronze Age.

CRETE	MAINLAND GREECE	CYCLADES
EM I	EH I	EC I
EM IIA	EH II	EC II
EM IIB		
EM III	EH III	EC IIIA
MM IA	MH	EC IIIB

Map 2 · Early Minoan sites in Crete. (1) Aghia Kyriaki; (2) Aghia Photia Ierapetras; (3) Aghia Photia Seteias; (4) Aghia Triada; (5) Aghios Myron; (6) Aghios Onouphrios; (7) Arkalokhori; (8) Arolithia; (9) Eileithyia Cave; (10) Ellenes; (11) Gournia; (12) Grimane Cave; (13) Kanli Kastelli; (14) Khania; (15) Knossos; (16) Kommos; (17) Koumasa; (18) Koutsokera; (19) Krasi; (20) Marathokephalo; (21) Miamou Cave; (22) Mokhlos; (23) Myrtos; (24) Pakheia Ammos; (25) Palaikastro; (26) Partira; (27) Perivolia Cave; (28) Phaistos; (29) Platanos; (30) Platyvola Cave; (31) Porti; (32) Priniatikos Pyrgos; (33) Pseira; (34) Pyrgos; (35) Pyrgos Cave; (36) Siva; (37) Malia; (38) Sphoungaras; (39) Stravomyte Cave; (40) Trapeza Cave; (41) Tsikouriana; (42) Vasilike; (43) Vryses Kydonias Cave; (44) Zakros, Upper; (45) Lebena

tery (see the discussion of Barber and MacGillivray 1980).

Many synchronisms exist for the Aegean as a whole. For EM I the most important Cycladic material is the Kampos Group, a pottery assemblage with the collared jar, the bottle, the small bowl, an early type of "frying pan," and a few other shapes (Bossert 1960; Doumas 1977: 18-20; Coleman 1977: 110-112). The phase lies late in Early Cycladic I (Barber and MacGillivray 1980), and its shapes appear in Crete during EM I (at the Pyrgos Cave, the Aghia Photia cemetery, and elsewhere, discussed below). Both Early Helladic II and Early Cycladic II can be related to EM IIA by finds of sauceboats from Knossos (Warren 1972A); the shape is particularly typical of the middle phases of the Early Bronze Age in Greece and the islands. Early Minoan IIB and EM III cannot be related to the rest of the Aegean so directly, but they must span the time at the end of the Early Bronze Age. Early Cycladic IIIB, the later stages of the first city of Phylakopi, can be related to Middle Helladic Matte Painted Ware (Buck 1964) and to other MH wares (Barber and MacGillivray 1980: 152-153), which should make it correspond to the early part of Middle Minoan. Synchronisms with Anatolia, which are filled with problems, do not affect the Cretan sequence (for discussion and bibliography see Easton 1976).

Little evidence survives for the absolute chronology. Although the synchronizations between Middle Minoan and the Middle Kingdom of Egypt push the period well back into the third millennium B.C., only a few Near Eastern correlations exist from before 2000 B.C. None of them are without controversy, but many writers accept the occurrence of local and imported Egyptian stone vases in EM IIB

and later contexts as evidence for placing EM IIB a century or two after 2500 B.C. (the best discussion is Warren 1976). A silver cylinder seal from Tomb I at Mokhlos (with EM II pottery), if Akkadian, as suggested by Kenna (1968: 322-324), implies the same conclusion.

Few radiocarbon dates are useful enough to contribute information. If one excludes single dates (regardless of whether they seem to "fit" or not) and groups of dates that do not exhibit internal consistency, the only good series from Early Minoan Crete is a group from Myrtos (Switsur 1972). All of the dates come from a destruction at the end of EM IIB. Since they come from carbon collected from burned architecture, they should provide dates for lumber used in the settlement's construction. The dates, clustering within the range of 2650-2400 B.C. after calibration, complement the evidence from the Near Eastern synchronisms.

For the beginning of the phase, one must look elsewhere. The EM IIA sauceboats equate this period with EH II, and C-14 dates from Eutresis and Lerna suggest that EH I begins near or even before the beginning of the third millennium B.C. (Ralph and Stuckenrath 1962: 149-150). Radiocarbon dates from Sitagroi in Macedonia (Renfrew 1971) suggest the same conclusion. Although EM I need not begin at exactly the same time as EH I, the C-14 dates clearly suggest a long chronology. If Early Minoan begins before or shortly after 3000 B.C., EM I and EM IIA are both long, stable periods. Together, they must last for several centuries, so that Early Minoan must span most or all of the third millennium B.C.

During this entire period, before the standardization of styles by the palatial workshops, Cretan ceramics may be visu-

alized as a series of specific wares. The concept is illustrated in Table 3. A ware is a type of pottery that can be defined in terms of surface and decoration (Rice 1976). It is normally used for a specific group of vase shapes. Many wares consist of several subvarieties, made from different local clay bodies. As used here, the term is broad enough to be recognized under field conditions from sherds as well as from whole vases.

The wares in Table 3 are the most useful ones for defining the various periods in Crete. Most of them are fairly widely spread, and they are distinctive and easily recognizable. Since they are seldom precisely successive, one need not be bothered by the discovery of a few sherds of Vasilike Ware, the hallmark of EM IIB,

in an EM IIA stratum. A specific period is defined not only by the exclusive presence of certain features but by the fact that some wares are common while others are just beginning or ending their periods of greatest popularity.

Early Minoan decoration is very different from its predecessors. Most Final Neolithic pottery, like Scored Ware and Pyrgos Ware, is an extension of Neolithic aesthetics; surfaces are decorated with tools that alter the clay rather than with brushes that add painted patterns (for Scored Ware at Knossos in the Late Neolithic see J. D. Evans 1964: 225). The earliest painted ornament, as on Aghios Onouphrios Ware, is still closely tied to the shape of the vessel, with long sweeping lines that move across the body of the

Table 3 · Characteristic fine wares of the Early Minoan periods.

	FINAL NEOLITHIC	EM I	EM IIA	EM IIB	EM III	MM IA
Pyrgos Ware	xx	xx	?			
Aghios Onouphrios Ware		xx	xx			
Lebena Ware		xx	?			
Scored Ware	xx	xx				
Fine Gray Ware		x	xx			
Koumasa Ware			xx	x		
Vasilike Ware			x	xx	x	
White-on-dark Ware				x	xx	xx

xx Common at some sites x Occurs ? Questionable occurrence

shape. As time goes on, the systems that alter the clay become more rare, and painting loses its ties to the ceramic form. By the close of the third millennium B.C., the painting is much more artificial; motifs are conceived independently of the vessel and applied as an added aspect. Painted ornament enters the second millennium as the decorative technique *par excellence*. The Middle Bronze Age pot-

ters will emphasize brushwork from the beginning, and experiments with tactile ornaments like Barbotine Ware and the Middle Minoan Incised Style will gradually die out, replaced by the more dynamic painting system; it is the tradition of painted pottery that will reign supreme in the Late Bronze Age, ultimately to be transmitted to later Greek art.

3 · EARLY MINOAN I

THE BEGINNING of EM I is defined entirely on the basis of pottery. Many of the other cultural traits—like tholos tombs and house tombs—are also present in the Final Neolithic, suggesting that the two phases may overlap a little in date. Early Minoan I is found at a few new settlements as well as at old ones like Knossos and Phaistos, so that many archaeologists believe a few foreign settlers moved in at this time. Continuity with the Neolithic is indicated by the general level of culture; communities are still based primarily on farming and herds. More sites are now on or near the coast, suggesting a new penchant for seafaring, and overseas contacts must have brought in foreign ideas to add to the progress of local traditions. By the start of EM II, bronze tools and weapons, sealstones, stone vases, terracotta figurines, and other aspects of Minoan culture are firmly established.

Early Minoan I ceramics marks a real advance over the Neolithic traditions. Completely burnished pottery continues, but it is now less common; most sites prefer pattern-burnished Pyrgos Ware or vessels with an overall slip or with linear decoration in red, white, or dark paint. Typical shapes (Fig. 13) include the jug with a raised, cut-away spout and a rounded bottom, the chalice, the globular pyxis with vertically pierced lugs and a high or low neck, the tankard, the askos, and several types of cups and bowls. Jugs are extremely varied, though most have a raised spout and a rounded bottom (Fig. 14). The new traditions do not begin

everywhere at once. At Knossos, for example, pattern-burnished vessels already appear in the Final Neolithic (Evans 1921-1935: I 59; II 10-12 and figs. 3m and 4; J. D. Evans 1964: 229), whereas jugs with raised spouts are not made until the beginning of EM I.

Most new shapes, like the Neolithic ones, seem to be based on pre-existing pottery types or on forms found in nature. Gourds are probably responsible for several of the new clay experiments. The Cretan gourds are either small and squat or larger with a long neck; today they still make serviceable containers. Modifications like those in Plate 2A and B result in shapes with a wide distribution among clay vases, suggesting an easy origin for many of the EM I shapes. Baskets and leather bags may also have played a role, and even sea urchins have been suggested as the prototypes for some Early Bronze Age shapes (Doumas 1977: 16). Probably many potters copied shapes their customers already knew.

The Early Minoan wares are carefully made, and they are usually better fired than the Neolithic ones, with clays that are more completely refined. Oxidized pottery (like Aghios Onouphrios Ware) and completely reduced pottery (like Pyrgos Ware) attest to an improved control over firing atmospheres. Potters are more expert than before, and they turn out better products.

The situation in Crete is not just a local development. In Greece, the Aegean islands, western Anatolia, and many nearby

regions new wares and traditions provide evidence for a quickening of the pulse as better made and more durably fired clay vessels take over functions once served by more perishable materials. Many of these Early Bronze Age shapes betray the same origins as the vases from Crete; note the gourd-shaped jugs from northwest Anatolia in Figure 15. The new vessels are an integral part of a complex pattern of technological and cultural changes that cut across geographic boundaries and characterize the Final Neolithic to Early Bronze I strata of this part of the Mediterranean; many peoples raised the same crops, tended the same herd animals, and used generally similar stone tools. It is not surprising that they also made

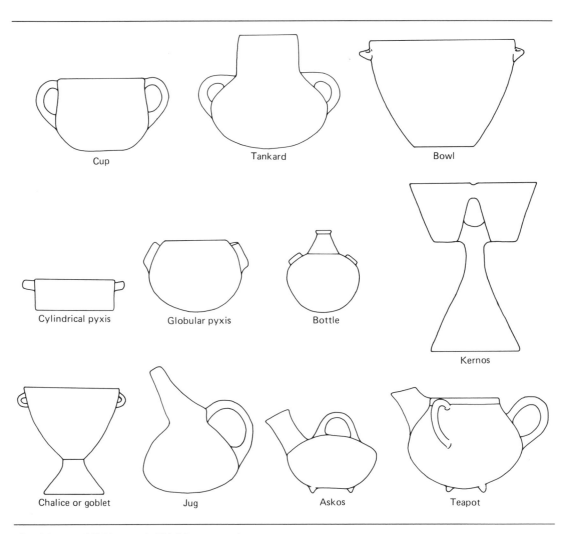

Cup

Tankard

Bowl

Cylindrical pyxis

Globular pyxis

Bottle

Kernos

Chalice or goblet

Jug

Askos

Teapot

13 · Names of EM I to early EM II fine ware shapes.

somewhat similar pottery.

Several good deposits establish the Cretan chronology. Stratified EM I material has been found in an Early Minoan well at Knossos (Hood 1961-1962: 92-93; 1966); since EM I was clearly beneath EM IIA here, it furnishes a solid basis for the style. Lebena, in southern Crete, is also useful. Two tholos tomb sites have been investigated near this ancient city, the modern Lenta (Alexiou 1958A; 1960; 1961-1962). Tomb II, with a Final Neolithic to EM I deposit stratified below an EM IIB level, is especially helpful. At Phaistos, EM I deposits come from several contexts (see especially the *Casa sotto il Peristilio*, Pernier 1935: fig. 50, mixed EM I-IIA). A level with Pyrgos Ware and

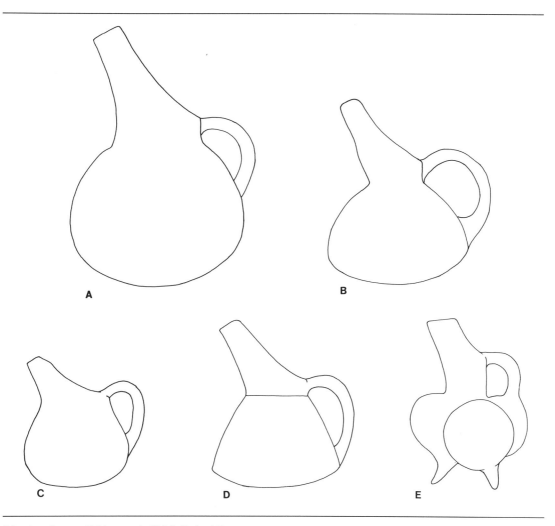

14 · Jug shapes, EM I to early EM II, Scale 1:9.

15 · Jugs with rounded bottoms from Kum Tepe in the Troad, Period Ic. (Left) Ht. 9.3 cm; (Right) Ht. 10 cm.

Aghios Onouphrios Ware below the central court was clearly stratified above Final Neolithic material (Pernier 1935: 76-81; Vagnetti 1972-1973: 6; for the EM I-IIA sherds see Mosso 1908: color pl. 1 nos. 6-9 and 11-13). In western Crete a settlement with an EM I phase has been excavated at Debla (Warren and Tzedakis 1972; 1974). In eastern Crete there is less material. The excavations at Myrtos have demonstrated that Fine Gray Ware and Koumasa Ware, once placed in EM I, should actually be dated to the beginning of EM II (Warren 1972A: Phase I). It is possible that the eastern part of Crete was only sparsely inhabited at the beginning of the Early Bronze Age, but a few deposits do exist, including some mixed burials at Sphoungaras (Boyd 1904-1905: 181; Hawes et al. 1908: 56) and a group of tombs with Cycladic connections at Aghia Photia (Davaras 1971: 648-650; N.D.: figs. 2-6). From these deposits in various parts of the island and from mixed contexts at Arkalokhori (Hazzidakis 1912-1913), the Pyrgos Cave at Nirou Khani (Xanthoudides 1918A), Kyparissi Cave west of Kanli Kastelli (Alexiou 1951), and other sites, a general picture of EM I pottery may be reconstructed.

Pyrgos Ware, Aghios Onouphrios Ware, and Scored Ware are the most characteristic of the fine wares. Their floruit, which is not limited to EM I, is shown in Table 3. A subdivision into two phases, A and B, has been proposed for Knossos where the EM I well deposit does not have the cylindrical pyxides found in the more developed phase at the Pyrgos Cave (Hood 1966: 110; 1971A: 10 and 36-37), but more evidence is needed from other sites before one can apply the system to Crete as a whole. The end of the period is not at all secure ceramically. Early Minoan IIA is defined more by the presence of new wares than by the disappearance of the EM I fabrics, some of which seem to have continued in use for a time.

PYRGOS WARE

Cretan pottery with burnished patterns is called Pyrgos Ware. It is usually dark from complete or nearly complete reduction, with the surface varying from gray to black (Pl. 2E and H). The name comes from the type site, a burial cave in north central Crete where many examples were found, but additional finds come from other parts of the island as well. The scattered distribution, ranging from single sherds to deposits with many complete vases, illustrates the crossregional contact of the period. In many ways, the Minoan island was already developing into a single unit.

Sites with pattern-burnished pottery include:

EASTERN CRETE

Aghia Photia Seteias (Davaras 1971: pl. 603 no. 2; 1976: fig. 149)

Grimane Cave (Pendlebury, Pendlebury, and Money-Coutts 1937-1938A: pl. 5,1 no. 21)

Pakheia Ammos Cave (Betancourt
1983: nos 13-14)
Ziros Seteias (Alexiou 1965: 552)

CENTRAL CRETE

Aghia Kyriaki (Blackman and Brani-
gan 1972: 631; 1982: 27)
Arkalokhori (Hazzidakis 1912-1913:
fig. 3)
Eileithyia Cave (Marinatos 1929A: 96
fig. 1 center row no. 2; 1930: 95
fig. 6)
Gortyn (Levi 1965: 226)
Kanli Kastelli (Alexiou 1951: pl. 14
fig. 1 nos. 2 and 4-5 and fig. 2 no.
7)
Knossos (Evans 1921-1935: II figs.
3m and 4; J. D. Evans 1964: 227;
Hood 1961-1962: 93; 1966: 110)
Kommos (unpublished)
Koutsokera (Xanthoudides 1924: 75)
Krasi (Marinatos 1929B: fig. 17 up-
per row no. 2)
Lebena (Alexiou 1959: 371)
Partira (Zervos 1956: figs. 119 and
13 center; Mortzos 1972)
Patrikies (Bonacasa 1967-1968: 47)
Phaistos (Pernier 1935: pl. 12 nos. 1
and 6; Levi 1961-1962B: figs. 132-
133; 1964: 4-5; 1965; 1976: I 281
and 536, pl. 6e-g; Vagnetti 1972-
1973: type G)
Pyrgos Cave (Xanthoudides 1918A)
Stravomyte Cave (Platon 1950: 532)

WESTERN CRETE

Khania (Styrenius and Tzedakis
1970: 102)
Korphi tou Koukkoghianne, at El-
lenes (Marinatos 1932B: col. 177)
Platyvola Cave (Tzedakis 1967: pl.
378 no. 5; 1968: pl. 376 nos. 4-5)
Vryses Kydonias Cave (Kera Speli-
otissa) (Tzedakis 1967: 506)

In contrast with the overall burnishing
of some Late Neolithic to Early Minoan
pottery, Pyrgos Ware is treated only on
selected parts, leaving other areas plain
for the sake of contrast. The qualities can
be appreciated from Plate 2H, a frag-
ment of a chalice from Knossos. Its de-
signs are made with a smooth rubbing
tool, setting dark glossy patterns on the
unburnished background. The contrast
between burnished and unburnished
areas is striking and attractive. As with
most pieces, it was finished in a reducing
atmosphere to create a uniform, dark
clay body.

Several local types can be recognized
within a chronological development that
seems to span both the Final Neolithic
and the Early Minoan I periods. A Final
Neolithic variety from Partira, sometimes
called Partira Ware, has a pink to gray
fabric and patterns of scribbles or lines.
The ware at the Pyrgos Cave is darker
with more carefully made patterns. The
chronology is not yet precisely arranged,
and complex vessels like the footed bowl
have been dated to the Neolithic (Evans
1921-1935: II figs. 3m and 4) as well as
to EM I.

The most artistic pieces use several dif-
ferent designs on the same vase. Al-
though some even use zigzags (Fig. 16),
spirals (Hazzidakis 1912-1913: fig. 3), or
circles (Mortzos 1972: pl. 30), in most
cases the lines are simply diagonal, hori-
zontal, vertical, or crosshatched. By one
suggestion, the decoration imitates the
grain of wood, a theory that fails to ex-
plain the vases with several patterns on
one vessel but still merits consideration.

Plain or footed bowls are the most
common EM I vases. They are sometimes
burnished on both the interior and the
exterior, with straight or diagonal lines.
Jars and pyxides are also made, as are
cups of several types, jugs of typical EM I

design, and a few other shapes. The most distinctive vessel is the chalice, a cup or bowl supported on a tall foot (Pl. 2E and H). Figure 16 illustrates a typical example from the Pyrgos Cave. It has vertical, horizontal, and diagonal burnished lines with the diagonals set in alternating groups to form a zigzag just below the rim. The syntax is of a type called tectonic decoration, meaning that it varies on different parts of the vase so that the structure is emphasized by the ornament.

Other chalices have a higher or lower bowl, with a concave, straight, or convex profile. One example has a crinkled rim (Pl. 2E). The pedestal varies in size, and a small knob or stem sometimes separates it from the bowl. Similar chalices occur from elsewhere in the Aegean and nearby regions (for a list of sites with bowls on pedestals see Mellaart 1966: 114). Footed goblets from Poliokhni on Lemnos make an especially good comparison (Bernabò-Brea 1964-1976: I pls. 9-22 and 106-113).

Two different suggestions have been made for the ware's origins. The Final Neolithic examples from Knossos and Phaistos have convinced the excavators of these sites that pattern burnishing developed in Crete itself (Levi 1964: 4-5; Evans 1921-1935: I 59; II figs. 3m and 4; see also Hutchinson 1962: 138). A foreign source, on the other hand, has been preferred by several other writers (see in particular Frankfort 1927: 86-88; Deshayes 1962: 548-550; Warren 1965: 37-38; 1969A; 1974: 41-42). Since pottery with burnished lines begins in Crete at the same time as several other new features (that is, the new vessel shapes discussed above in connection with the Final Neolithic), one is tempted to see it as one facet of a new foreign stimulus to Cretan ceramics.

Pattern-burnished pottery is found

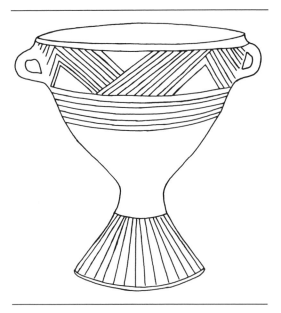

16 · Pyrgos Ware chalice from the Pyrgos Cave with burnished horizontal, vertical, and diagonal lines, EM I, Scale 1:4.

throughout the eastern Mediterranean. The definitive study, an article by Fischer (1967), records its presence at dozens of sites in Anatolia, Greece, Crete, the Cyclades, Europe, and the Near East (for Palestine and North Syria add Hennessy 1967: 40). Except for Crete, the Aegean finds are scattered, ranging from northern Greece (Wace and Thompson 1912: pottery type Gamma 1 alpha 2; French 1964: fig. 7 no. 20) to Prosymna (Blegen 1937: II fig. 635), Eutresis (Goldman 1931: 76-77), Athens (Immerwahr 1971: 27 and pls. 1 and 9 no. 35), and several other places in the south. Examples have also been found in the islands (for Chios see French 1961: 112; Hood 1981: Emporio Phase VIII; for Paros see Schachermeyr 1955: 140 fig. 35 no. 4). A concentration of sites in the northeast Aegean includes Beşika Tepe (Lamb

1932: 127 and figs. 13-14), Kum Tepe (Sperling 1976: 316), and several other places in Anatolia (see the lists given by Fischer 1967: fig. 1, French 1961: 114 n. 38, and Sperling 1976: 316 n. 7) plus the large island of Samos just off the Anatolian coast (Heidenreich 1935-1936: 128-129 and 156-159; Furness 1956: 187 and 209 and pl. 17; Milojčić 1961: 61-62). Some of the burnished bowls from this region are very much like the Cretan ones, with groups of vertical lines and crosshatching just below the rims (discussion in Warren 1974: 46 n. 4). The comparisons have sometimes been used to suggest migrations from Anatolia to Crete (Warren 1974), but other possibilities (like the dissemination of technology) also exist. So far there is little evidence for northwest Anatolian inspirations for Minoan architecture or tombs, evidence one would expect if there were migrations from this area. The parallels in the pottery are so close, however, that some connection seems likely.

AGHIOS ONOUPHRIOS WARE

A pottery with red linear decoration on a buff ground, named after a tomb site at Aghios Onouphrios near Phaistos, is one of the most attractive of the prehistoric styles (Evans 1895: 105ff.). In the most typical examples several groups of vertical diagonal lines create areas of formal design that must have appealed as much to ancient eyes as they do to ours. Horizontal lines are less common, though they do occur. The patterns are crisp and finely executed; since they often cover the entire body of the vessel, they can complement its form very nicely.

A jug from the type site (Pl. 2F) illustrates the style at its best. The principal motif, two groups of converging diagonal lines with their ends crossed, is repeated three times, once opposite the handle and twice evenly spaced around the vase. Accessory lines are on the spout and between the main designs. Because the syntax is thought out in three dimensions, the viewer is encouraged to see the vase as a solid object. The rounded shape transforms the straight lines into gentle curves, creating an effect of pleasing, balanced movement.

Variations in the ware come from both clays and techniques. Schachermeyr recognized two types (1962: 118, including Koumasa Ware), but this is a simplification because there are actually many local varieties. The fabric, usually rather coarse or sandy, is occasionally better levigated. The red paint may shade toward brown, especially in the later pieces, and it can be applied thickly or in a thin and streaky way.

Some stylistic variation may also be recognized. In the earliest stage of the style, round-bottomed shapes predominate, and the lines sweep around the vases, enhancing their shapes (Pl. 2F). The syntax is not as tectonic as with Pyrgos Ware. On other vessels, many of them undoubtedly later, the lines are shorter and may be confined to the upper shoulder (Pl. 2I). Crosshatching is now common, and the designs are tighter and more controlled. Small feet or flat bottoms are sometimes used for vases with this class of decoration, which seems to be typical of EM IIA. Since the same red paint is used for both classes, the two divisions are not always distinguishable in sherds. The name Aghios Onouphrios Ware is in common usage for the entire tradition, and it may be divided to form Aghios Onouphrios I and II.

Finds from Knossos (Hood 1966) and Lebena (Alexiou 1960; 1961-1962: 89) establish the general chronology. Prob-

lems still remain with the precise dividing line between EM I and EM IIA, especially because of the lack of good stratigraphy for this period. The division between rounded and flat or footed bases has often been supposed (as suggested, for example, by Pendlebury 1939: 50), but this may be illusory because we do not know how much the types overlapped.

The red-painted ware is most common in the Mesara and in neighboring parts of southern Crete. It occurs at every south Cretan site with an EM I-IIA level but is less common elsewhere:

EASTERN CRETE

Aghia Photia (Davaras 1971: pl. 603 no. 4 right; 1976: fig. 80)

CENTRAL CRETE

Aghia Kyriaki (Blackman and Branigan 1982: 29-32)
Aghia Triada (Laviosa 1972-1973)
Eileithyia Cave (Marinatos 1929A: fig. 1 lower row nos. 1-2)
Knossos (Hood 1966: 93)
Kommos (unpublished)
Krasi (Marinatos 1929B: figs. 9 no. 9 and 10 no. 2)
Kyparissi Cave (Alexiou 1951: pls. 13-14)
Lebena (Alexiou 1960: fig. 20)
Malia (Effenterre and Effenterre 1969: pl. 2)
Phaistos (Pernier 1935: 130ff.; Levi 1965; 1976: I pl. 13)
Pyrgos Cave (Xanthoudides 1918A: 144 fig. 5 nos. 5-6 and pl.1 upper left)

WESTERN CRETE

Platyvola Cave (Tzedakis 1966: pl. 466 no. 3)

A favorite shape is the jug with a high spout (Fig. 14). It has no antecedents in the island's Neolithic pottery, and the shape looks like it might have been copied from gourd vases. Sinclair Hood has suggested that even the decoration may be related to these theoretical prototypes (1971: 30); since the lines seem to enclose the vases, they could have been inspired by strings or nets used for suspension. Although most jugs have round bodies, a type with a rather angular body and a low maximum diameter (Fig. 14D) is also common. Many other types exist, and one unique piece from the Pyrgos Cave has a tripartite body with tiny feet (Fig. 14E).

Other shapes use gentle curves, with few if any angles. One of the most interesting of these is the tankard, a cup or small jar with a cylindrical neck set on a rounded body with two opposed handles (Fig. 13). Many examples are known (Alexiou 1951: pls. 13 fig. 2 no. 4 and 15 fig. 2 no. 2; 1960: 227 fig. 20 upper row no. 2; Daux 1960: 842 fig. 3 upper row no. 2; Davaras 1976: fig. 80). Like the jug, it may be derived from containers made of gourds with the necks cut off and handles added at the sides, as shown in Plate 2B. Other shapes include the bowl (Fig. 13), the cup (Alexiou 1951: pl. 14 fig. 2 nos. 3 and 10), the teapot (Fig. 13 and Pl. 2I), the askos (Fig. 13), the cup or bowl with two opposed vertical handles (Fig. 13 and Alexiou 1960: 227 fig. 20 lower row no. 1; Daux 1960: 842 fig. 3 lower row no. 3), the pyxis (Daux 1960: 842 fig. 3 upper row nos. 1 and 3; Alexiou 1960: 227 fig. 20 lower row no. 2), and various animal-shaped vases (Alexiou 1960: 227 fig. 14 lower left and fig. 15).

Although it was once thought that the high-spouted jug pointed toward an Anatolian origin for this ware (Frankfort

1927: 86), most recent research has looked elsewhere because painted linear decoration is foreign to Anatolian Early Bronze I and earlier strata. Evans thought of Egypt where painted pottery was made before and during the First Dynasty (1921-1935: I 48; more recently see Weinberg 1965: 307). Levi suggested a derivation from Neolithic fabrics in Crete (1964: 5). Other writers have considered the Syro-Palestinian area where styles from the end of the Chalcolithic period show some general similarities (Weinberg 1965: 307; Branigan 1970: 199). The Syro-Palestinian comparisons are enticing because some of the Proto-Urban pottery from this region uses groups of lines to form areas of decoration, as in Crete (Kenyon 1970: fig. 12 nos. 5 and 7). As a whole, however, the ceramic assemblage is not the same as in the Aegean, and the most the present evidence would allow would be a small amount of stylistic influence. Accidental similarity is also possible.

SCORED WARE

A monochrome pottery with a scored surface is most common from western Crete. It is decorated with a series of rough lines, vertical, horizontal, or diagonal, made by wiping the moist clay with the ends of a bunch of stiff straws, a rough comb-like instrument, or some other tool (Pl. 2J). Besides making a design of sorts, the working of the surface must have helped pare and shape the vessel.

The ware is rather interesting, but it is not as attractive as the splendid Aghios Onouphrios style. Jugs and bowls are the most common shapes. The jugs have raised spouts and rounded bodies like those used for Aghios Onouphrios Ware,

linking them clearly to the period. Plate 2J illustrates a good example, found in the Platyvola Cave in western Crete (Alexiou 1964A: pl. 523 no. 1). The bowls are usually open, with convex profiles.

The chronology is established from the stratigraphic excavations at Knossos where Scored Ware begins in the Late Neolithic or Final Neolithic levels (J. D. Evans 1964: 225). It is still in use at the time of the EM I well deposit (Hood 1961-1962: 93; 1966: 110), and it may continue even longer; finds from elsewhere do not contradict this picture. Some related sherds come from a Final Neolithic or EM I deposit below Tomb V at Mokhlos (Seager 1912: 92), but the ware seems to have been rather rare in this part of the island. In western Crete, however, it is particularly common, occurring both in caves (Faure 1965: 57; 1969A: 216; 1969B: 201 note 2; Alexiou 1964A: pl. 523 no. 1) and at open sites like Debla (Warren and Tzedakis 1974: 321-323 pls. 52d and 53). A single carbon sample from a Final Neolithic site with this pottery, the Lentaka Cave at Medoni Apokoronou (Faure 1965: 57; Warren 1976: 212), has given a radiocarbon date in the late fourth millennium B.C. after calibration (Klein et al. 1982). Although this is an isolated date, it agrees well with the chronological picture suggested above.

LEBENA WARE

An EM I pottery with white-on-red decoration has been christened Lebena Ware (Branigan 1970: 27). At the type site the clay is buff with a red slip over the entire surface. An off-white slip (actually a very pale yellowish white) is laid on top of the red, producing linear designs that look very much like their

Aghios Onouphrios counterparts. Although the shapes used for Lebena Ware often have rounded resting surfaces, the round-bottomed jugs that are so common in Aghios Onouphrios Ware are not usual.

Lebena Ware is most common in southern Crete. At the type site it was found with Aghios Onouphrios Ware stratified below an EM IIB level in Tholos Tomb II (Alexiou 1960: 227). Since EM IIA was not present here, the end of the phase is not certain. A find at Marathokephalo along with Koumasa Ware (Xanthoudides 1918B: 18) has suggested a survival into early EM II to Keith Branigan (1970: 28), unless this context was mixed. Other sites include Siva (Paribeni 1913: 22 no. 35), Aghios Onouphrios (Pl. 2G), Koumasa (Xanthoudides 1924: pl. 28 no. 4295), Phaistos (Pernier 1935: 130), Aghia Kyriaki (Blackman and Branigan 1982: 29) and Knossos (Evans 1903-1904: 22).

The shapes are incredibly varied and creative. Like Aghios Onouphrios Ware, Lebena Ware inspired a burst of individual artistry that seems especially vivid when set against the rather repetitive forms of some of its contemporaries. The potters had a good sense of fun, and they probably enjoyed making and using these strange little pots. One vase is ship-shaped, with two high ends, small feet, and lugs on the shoulder (Alexiou 1960: 226 fig. 9 right). Another is shaped like a gourd (Alexiou 1960: fig. 9 left). Among the many vases from Lebena is a horizontal cylinder with closed ends and a central neck (Alexiou 1960: 227 fig. 14 upper right). More conventional shapes, like cups and tankards, are also found.

Closed boxes with lids are as popular in this ware as in other EM I and II fabrics. The example in Plate 2G, from Aghios Onouphrios, has an elliptical shape with a pronounced shoulder and a raised neck to accommodate the lid. The two horned lugs are doubly pierced; they must have been used for suspension or to tie on the lid. Both the fabric and the creamy off-white slip are like those used at the type site. The horizontal bands and zigzags on the body are typical of the ware.

OTHER WARES

A Cycladic incised pottery, called Pelos Ware after a site on Melos where it was discovered in the last century (Edgar 1896-1897), is rather rare in Crete but is important for its foreign connections. The fabric is brown or dark and coarse-textured, with incised lines made while the clay was still wet. The incisions have been compared with the *Bandkeramik* of eastern Europe (Schachermeyr 1955: 138-140). In Crete, Pelos Ware is most common on the north coast. The main shape is the bottle, a specialized type of suspension pot (Fig. 13). It consists of a globular body with a tall, conical neck and a small mouth. Pierced lugs on the shoulders would be used for a string or cord. Incisions are limited to straight or curved lines, sometimes arranged in designs like chevrons or herringbones. Examples have been found in the Pyrgos Cave (Xanthoudides 1918A: fig. 8 nos. 49-50 and fig. 9 nos. 67-69) and at several other Minoan sites (a list is in Doumas 1976A: 70). Most writers have attributed the group to the Cyclades, since good parallels come from that area (references in Renfrew 1972: 201), but the origin of the Cretan examples is still an open question (against their Cycladic origin see Doumas 1976A: 70).

Wherever individual pieces were actually potted, Pelos Ware is essentially a

product of what Colin Renfrew has termed the late Grotta-Pelos or early Keros-Syros cultures of the Cyclades (for a discussion of those cultures see Renfrew 1972: chaps. 9-10). Earlier doubts about a validity as distinct chronological phases (Weinberg 1965: 301-302) may now be laid to rest because the affinities with neighboring regions show that the Keros-Syros assemblage must generally follow the Grotta-Pelos one, even if the two overlap slightly. The position of the bottle in the island sequence has been given variously: Renfrew has placed it in the Grotta-Pelos culture (1972: 165), while Doumas has preferred a slightly later period (1976A: 70). This difficulty is largely a question of semantics. The division of the Cycladic material into a larger number of groups (Doumas 1977) has demonstrated that the shape fits best with a Kampos Group that lies stylistically between the earlier Pelos Group (when pyxides and collared jars are common) and the Syros Group (when sauceboats are used). Since sauceboats are not known in Crete before EM IIA (see the discussion below), the bottles may belong to EM I; those who use a tripartite division for the Cyclades place Pelos Ware either at the end of EC I (Barber and MacGillivray 1980) or at the beginning of EC II.

The frying pan in Plate 3A comes from the same period. Found in a tomb at Aghia Photia in eastern Crete, it also belongs to the Kampos Group of the Cyclades (Davaras 1971: 648-650). The shape's purpose is not known. It consists of a shallow dish with low sides and a small handle, with incised decoration on the "underside." In this example a small hole in the handle could be used for suspension. Lid or dish, offering bowl or mirror, the shape is interesting and enigmatic. There is no reason to assume this

example was not made in Crete.

Much of the EM I pottery has never been classified under specific wares. It is often undecorated or simply painted with an overall slip, though a few pieces are patterned with punctations or incisions or simple painted lines. As with the more precisely defined wares, the most common shapes are bowls, cups, jugs, and jars, but some unusual pieces are also known. A red-slipped, burnished ware from EM I-IIA has been called Salame Ware (Blackman and Branigan 1982: 29). The strange vessel in Plate 2C points up the problems that arise in nondiagnostic styles. The shape, four cups set together around a high fifth container, appears to be unique. It comes from the Pyrgos Cave and is made from a coarse, dark clay, with crudely incised decoration. Since the context is chronologically mixed with larnakes perhaps dating from as late as EM III-MM I, the piece cannot really be dated; it may be as early as EM I or considerably later (for the view that almost all of the pottery from the cave is EM I see Branigan 1973: 365).

Two other vessels from the Pyrgos Cave are illustrated in Plates 2D and 3D. Each has its own problems. The chalice (Pl. 2D) may be dated to EM I by comparison with the other goblets, but the reasoning in this case is circular because we cannot guarantee the date of the group as a whole. The surface of this piece is not very distinctive, and it cannot be classified with any specific ware. The flat pyxis with fitting lid is more elaborately decorated (Pl. 3D). It is made of coarse, red clay and has incised ornament applied before the clay dried. Since a similar box comes from the early level at Lebena (Schachermeyr 1962: fig. 12 lower row no. 2), this example is probably also from EM I.

In many ways, these vases are transi-

tional between the Neolithic wares and the more controlled pottery of later periods. Even though the shapes are based on traditional forms, one can detect the inventive spirit that will be so much a part of the Minoan ceramic tradition. Both painting and incising are well established, and the groundwork for the later pottery is firmly laid.

4 · EARLY MINOAN II

EVERYONE who has studied the Aegean Early Bronze Age has come away with a keen appreciation of the advances made in the era's middle phases. Settlements are expanded, new sites are founded, and trade flourishes as never before. Technological improvements, especially in metallurgy, usher in a whole new range of products. Since Cretan pottery shares in the general progress, EM II wares are especially well made. The best pieces are firm and durable, with excellent potting and beautifully decorated surfaces. Shapes continue the EM I types, but they gradually become more refined (Fig. 17).

It is possible that pottery production was already a specialized industry. Although we cannot be sure when the first formal workshops were organized, one is tempted to associate them with the improved technology and greater care that mark the beginning of EM II. Certainly the best candidate for an Early Bronze Age potter's work area dates to this period (Warren 1969A; 1972: 18). The room, at Myrtos, is a simple rectangular workspace opening off of a larger area to the west (Fig. 18). A nearby room held pithoi, perhaps for the storage of clay or water (Warren 1972A: 20).

Several discs of a simple design were near the workshop's eastern wall (Fig. 19). They were all made with one flat and one convex surface, with the latter often worn at the center from turning. The excavator has suggested they were used for pottery. Apparently they were unpivoted turntables, intended to be spun while a vase sitting on them was worked. Painted crosses may have helped in aligning spouts and handles. The discs would have been a distinct aid in making handmade pottery, and the potters at Myrtos may have used them on a regular basis. Two of the discs were grooved on the sides, perhaps for some simple turning device, though it is difficult to see how it would have functioned without an axle to help keep the spin true.

The possibility of a single work area for several houses in the village at Myrtos implies an increased systematization in Early Minoan craftwork. One possibility is that the families shared the workshop, using it as needed to make their own pottery. On the other hand, it is possible we are already past the period of the simple domestic chore when a wife or daughter would make the pots for her household and perhaps a neighbor or two, and we have entered the era of craft specialization. Although too little is known of Early Bronze Age social organization to even suggest a socioeconomic model, it is clear that the potters—men or women; family members or trained craftsmen; local residents or foreigners—were well organized. They made vases in many fabrics and shapes, from coarse cooking pots and storage jars to fine table wares.

The chronology of EM II has been clarified in the last few years, and earlier finds can more clearly be put into focus. For Knossos, evidence comes from excavations beside the West Court (J. D. Ev-

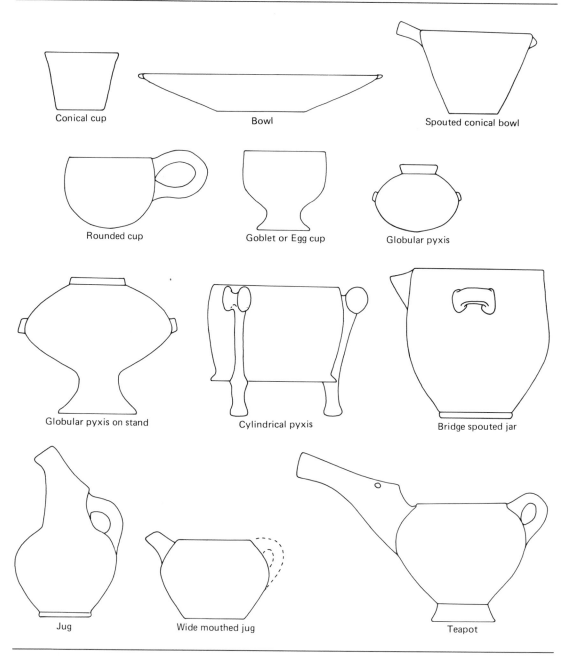

Conical cup

Bowl

Spouted conical bowl

Rounded cup

Goblet or Egg cup

Globular pyxis

Globular pyxis on stand

Cylindrical pyxis

Bridge spouted jar

Jug

Wide mouthed jug

Teapot

17 · Names of EM II fine ware shapes.

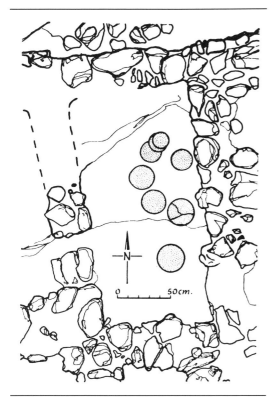

18 · Plan of the room at Myrtos containing potter's discs, EM IIA.

ans 1972), at the south side of the Royal Road (Warren 1972B), and north of the Royal Road and on the south front of the Palace (Hood 1961-1962: 93; 1962B: 27; 1966). Two distinct strata may be recognized: the first is characterized by Fine Gray Ware, other incised wares, and pottery decorated in a linear style with dark slip (Koumasa Ware); the second is defined by the appearance of Vasilike Ware. In southern Crete, the tholoi at Lebena also suggest a division of EM II into two phases (Alexiou 1958A; 1960; 1961-1962; Daux 1959; 1960). Well-preserved EM IIA houses have been found at Aghia Triada (Laviosa 1972-1973). In the eastern part of the island, Myrtos is

the definitive site because of the modern excavation techniques and clear publication (Warren 1972A). It, too, has two strata. Early EM II levels occur at Vasilike (Seager 1904-1905: 211-215; 1906-1907: 115, Periods I-II) and Palaikastro (Dawkins 1903-1904: 200-201; Bosanquet and Dawkins 1923: 4-5), and a later phase may be recognized at Vasilike (Seager 1904-1905: 211ff.; 1906-1907: 113-114), Palaikastro (Dawkins 1903-1904: 199-200; 1904-1905: 272-274; Bosanquet and Dawkins 1923: 3ff.), and Mokhlos (Seager 1909: 278-279). From western Crete the best stratigraphy comes from Debla (Warren and Tzedakis 1974). The evidence thus emerges from many parts of the island, and it presents a fairly uniform picture.

The two subdivisions may be termed A and B. In EM IIA the pottery is appreciably better in quality than in EM I. Tripod vessels become popular. Jugs and other shapes supported on tiny feet, firmly dated to this period (J. D. Evans 1972), represent an advance over the earlier round-bottomed shapes. Flat bases soon appear as well. Bowls, cups, goblets, jars, teapots, animals, and other shapes are also made. Some of the designs, like the teapot, present a new challenge to the potters because they must be constructed from several separate parts, all molded together to make an aesthetically pleasing unit. Pithoi with trickle decoration occur at Knossos and elsewhere. The most easily recognized fabrics are Fine Gray Ware, Koumasa Ware, and the late version of Aghios Onouphrios Ware. Pyrgos Ware has died out at many sites (but perhaps not at all), and Scored Ware has also been replaced. Only a sherd or two of Vasilike Ware occurs in this stratum. In the next phase, EM IIB, Vasilike Ware becomes common, supplanting Fine Gray Ware and Koumasa Ware and

their variations. Its mottled decoration is typical of the period. Most of the EM IIA shapes continue, but they are more refined. Jugs are taller and more graceful. Goblets, conical bowls with spouts and opposed lugs, teapots, cups, bridge-spouted jars, and open bowls are the most typical pieces. Ring bases and pedestal bases are common. Painting and incising are rarer than before, and many vases are completely burnished and fired solid red, brown, or black. Early Minoan III, with pottery that has a new linear light-on-dark ornament, overlies EM IIB.

Overseas connections show that Crete is less isolated than before. Foreign pottery shapes may be recognized in many of the local styles, suggesting that some of the new technology may have come from abroad. The sauceboat (Pl. 3B) is the most striking new introduction. Whereas the shape is rare in Crete, it is well known as the hallmark of Early Helladic II on the Greek mainland (where it had appeared at Eutresis in EH I, for which see Goldman 1931: 94 and fig. 118). Its widespread presence in the Keros-Syros Culture of the Cyclades (Early Cycladic II) demonstrates the coincidence of this society as well. On Crete, sauceboat sherds from Knossos date to EM IIA (Warren 1972B). There is still

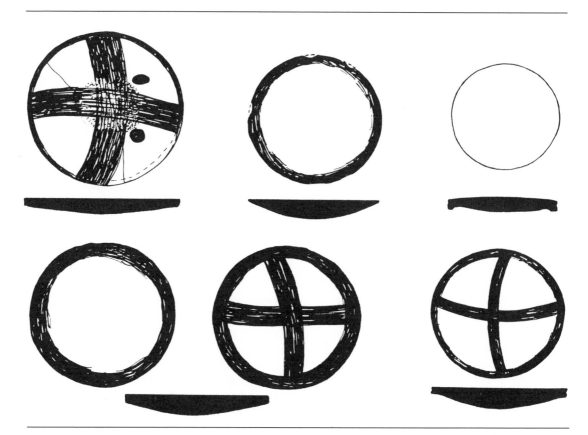

19 · Fine clay potter's discs from Myrtos, EM II, Scale 1:6.

too little evidence to know whether EM IIB is also contemporary with the "sauceboat phase."

The Cretan sauceboat is typical of the type (Pl. 3B). It has an elegant shape, a rounded form with a graceful raised spout that flows smoothly out of the body. A pedestal base and a small handle complete the design. Its use has never been convincingly demonstrated; suggestions range from a drinking cup to a container for some kind of runny cheese (Vermeule 1964: 40). Metallic prototypes have often been proposed, especially since there are two examples in gold (Strong 1966: 27-28; Branigan 1974: nos. 3203-3204; both are suspected of being fakes by some archaeologists). A good alternative, considering the rarity of metal

at this time in comparison with the widespread appearance of the sauceboat, is vessels cut from gourds by using the design shown in Plate 3C (Hood 1978B: 33 and 244 n. 18).

Among the other Minoan shapes with good foreign parallels, the pyxides hold a special position. These lidded boxes occur in several varieties. They are common in the Cyclades where some versions are only a little different from the Cretan ones (Fig. 20); a similarity in the incised decoration reinforces the possibility of a common ancestry. Although the shape is particularly popular in Fine Gray Ware, it occurs in other traditions as well.

Several wares are associated primarily with EM II. Only the most characteristic are described here.

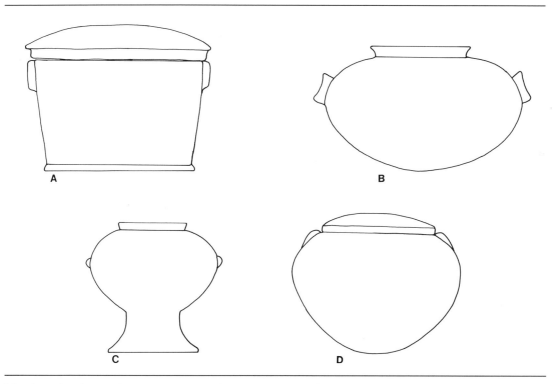

20 · Incised and painted pyxides, from the Cycladic islands, EC II, Scale 1:9. (A) Naxos; (B-C) Syros; (D) Paros.

FINE GRAY WARE

Fine Gray Ware differs from earlier gray pottery in several ways. Besides having a finer fabric, it is wiped with water or painted with a smooth slip to make a better surface. The clay is a uniform gray tint. Decoration, when present, is incised into the clay before firing.

The firing is very different from that of Aghios Onouphrios Ware or Lebena Ware. Clay bodies are gray from the surface to the core, indicating a completely reducing condition during the entire cycle. Most likely the pots were stacked with fuel piled over and among them, and the fire was banked to prevent the entrance of excess oxygen. A long, smoldering heat would yield proper results.

The distribution covers all of Crete. At Knossos the ware seems to have begun during EM I, and it continues as a fine table pottery in early EM II (Hood 1971A: 36-37; J. D. Evans 1972: 126 fig. 15). Elsewhere it is associated with Koumasa Ware rather than with Aghios Onouphrios or Pyrgos Ware; contrary to the early suspicion that it dates mostly to EM I, its main period is certainly EM IIA (for a discussion of the chronology see Zois 1968A: 73-80).

Fine Gray pyxides are very numerous. Several variations are known with the most common types being a spherical box with a short neck and vertically pierced lugs (Pl. 3G and H) and a cylindrical type with a flat bottom (Pl. 3I). Both footed and plain pieces exist, and a few examples have three small feet. Sometimes they have small clay lids (Warren 1972A: P 61). Since related vases come from the Aegean islands (Fig. 20), a foreign inspiration seems likely. Other Fine Gray Ware shapes include the kernos (Pl. 3K), various kinds of bowls (Warren 1972A: P 4-5, 20-21, 23, and 25-27; Hood 1971A:

37), the stemmed goblet (Warren 1972A: P 40-41 and 43-45), and the strainer (Warren 1972A: P 72).

Although incising is not always present, it is common enough to be a regular feature of the style. The artists seem to have favored continuous patterns or repeat-designs in which two motifs are alternated (Fig. 21). They are nearly always arranged in horizontal bands or friezes. Semicircles, straight lines, diagonal lines, herringbone, and punctations are especially popular. An unusual incised variation, an overall pricked pattern, is shown in Plate 3J. The design is made by rolling a pricking instrument across the surface while the clay is still wet enough to create a texture of tiny dots. In all these cases the ornament is geometric and artificial. Unlike that of Aghios Onouphrios Ware, it owes little or nothing to the shapes on which it is placed.

Fine Gray Ware seems to have been especially popular for miniature containers; a great number of small jars and pyxides survive, especially from tombs. Since similar vases are found in different parts of the island, one may probably imagine a brisk trade in some desirable commodity. The contents must have been precious enough to be stored in small quantities, and unguents or perfumed oils are the most likely candidates. The vase mouths are always large enough to insert a finger or two, which would be helpful for ointments intended to be applied by hand, and the tradition of anointing the body, so strong in later times in this part of the world, may very well go back this early.

KOUMASA WARE AND RELATED STYLES

Painted pottery using red or black linear ornament on a light-colored clay is

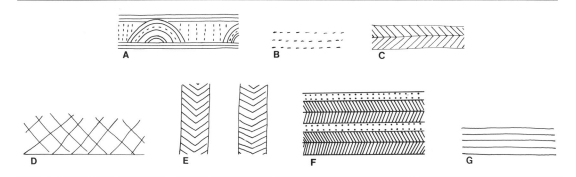

21 · Incised designs used on EM IIA Fine Gray Ware.

common to many parts of Crete during EM IIA. One of the variations of this style is Koumasa Ware, named after a tholos tomb site in the Mesara where the pottery was found in some quantity (Xanthoudides 1924: chap. II). It may be used to define the main tradition. At Koumasa the decoration is always in reddish brown to black paint. It is usually linear, with simple geometric configurations. Hatching and crosshatching are common. Shapes rest on flat bases or tiny feet, a distinct advance over the rounded bottoms of earlier times. After a floruit in EM IIA, the style rapidly declines in favor of Vasilike Ware and other EM IIB wares. It has been discussed in detail in a study by Antonios Zois (1968C).

The angular quality and the predilection for linear designs leave little doubt about the style's origins. It must be a development from Aghios Onouphrios I Ware, with the ornament systematized and made more precise. Most of the simple designs can be easily traced to the EM I versions of the red-painted style, and the shapes are often similar as well.

The teapots and jugs in Figure 22 and Plate 3E-F and L-M, all from Koumasa, are typical of the style at its best. Several points set them off from their EM I Aghios Onouphrios I antecedents (Pl. 2F). The shapes are more squat, with a lower center of gravity and a firmer base.

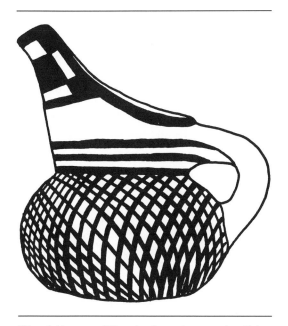

22 · A Koumasa Ware jug from the type site, EM IIA, Scale 1:1.

They usually sit nicely on a flat surface. Equally important, the ornament is more tightly controlled. It is organized into clear groups of lines or shapes, precisely painted and carefully set onto each vase. In comparison with the more free flowing lines of the EM I stages of Aghios Onouphrios Ware, Koumasa Ware seems very systematized.

As in the EM IIA type of Aghios Onouphrios Ware (Aghios Onouphrios II), the syntax is quite simple: usually one or two linear figures on each side of the vase form a clear, bilateral arrangement. Handles, spouts, and other structural features are a part of the symmetry, and lines are usually painted on them to complement the main motifs. With spouted vases, a small design is usually put underneath the spout.

Koumasa Ware must have been popular for serving liquids because cups and bowls, like jugs and teapots, are particularly common. The bowls usually have convex profiles, and they sometimes have handles (Warren 1972A: P 6-11). Among the many minor shapes are two-handled cups (Xanthoudides 1924: pl. 27 no. 4132), askoi (Zois 1968C: pl. 23 no. 4), goblets (Zois 1968C: pl. 23 nos. 1-2; pl.

24 nos. 1-2), and jars (Zois 1968A: pl. 25 nos. 1-3).

The most remarkable example of Koumasa Ware is a vase in the shape of a woman with a striped snake across her shoulders (Fig. 23). One of two such ladies found at Koumasa, she gives us a rare glimpse of Early Minoan religious beliefs. She was found just outside the tombs, perhaps left as a cult object or an offering. It is tempting to see her as the ancestor of the "Snake Goddesses" of the second millennium B.C. Maybe, as Branigan suggests, she was designed to pour libations (1969: 34-35).

Stylistically, the lady is abstracted and greatly simplified. Many anatomical details are barely suggested or are omitted entirely, characteristics that also appear in other art forms of this period. The head is reminiscent of the Cycladic marble figurines and their Minoan counterparts, several of which were found at Koumasa itself (Renfrew 1969: 18-20; Branigan 1971: 61-63). A spout, perhaps meant to be a jug cradled in the left arm, allowed the liquid in the hollow body to be poured out. The vase is finished with reddish brown geometric designs in the Koumasa Ware tradition, either simple ceramic decoration or an imitation of woven or stitched patterns on clothing.

For a repertoire of straight lines and simple rectilinear patterns, the ornament of Koumasa Ware and its cousins is extraordinarily rich. Quite a range of attractive, if formal, motifs are used in the broad tradition, which extends to many parts of the island. A design formed by joining two triangles at their points, sometimes called a butterfly motif or even a double axe, is the main motif on a well-known bowl from Tomb II at Mokhlos (Fig. 24). The paint is different from that used at Koumasa, but the style is surely related. Solid pendant areas and

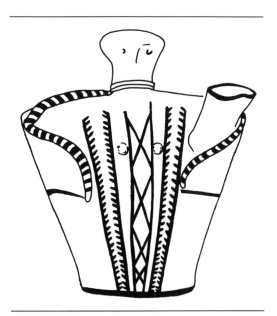

23 · A vessel in the form of a woman with a snake draped around her shoulders, found outside the tholos tombs at Koumasa, EM IIA, Scale 1:4.

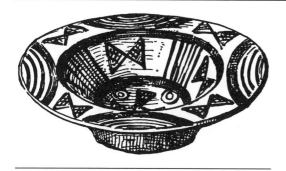

24 · Bowl from Tomb II at Mokhlos, EM II, Ht. 3.7 cm.

hatched triangles decorate a pyxis from Aghia Photia Ierapetras (Fig. 25), a contemporary piece. The vases from Myrtos in Figure 26 span both phases of EM II; the bowl, the wide-mouthed jug, and the rounded jug are from EM IIA, and the two slimmer jugs are from EM IIB. They add additional motifs to the decorating corpus, all related to Koumasa Ware through their linear style and controlled syntax. Usually the decoration is circum-

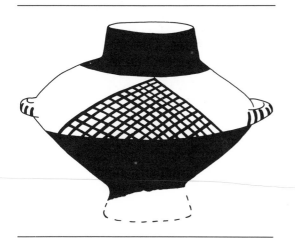

25 · Pyxis from a tomb at Aghia Photia, EM II, Pres. ht. 13 cm.

current, with triangles or other designs repeated around the vase. Jugs with five groups of vertical fans like in Figure 26D are particularly aristocratic; they are called Myrtos Ware by their excavators.

As these vases show, contacts within Crete must have been fairly close. The characteristics visible at Koumasa are similar to those seen elsewhere, and several Minoan traits—a well-developed syntax, clear organization, and precise geometric ornament—were well established throughout the island. They would continue to play an influential role in later Minoan art. Vases like the jugs with fans from Myrtos kept the tradition of pottery painting alive during the second half of EM II when many potters seem to have preferred solid burnished red or brown surfaces or mottled Vasilike Ware. Although linear designs were then a minority style, they persisted on these vases (and probably also on perishable objects like gourds and wooden boxes) to transmit their notions of style and syntax to EM III; the White-on-dark Ware of the end of the Early Bronze Age owes an enormous debt to Koumasa Ware and the other dark painted wares of early EM II.

VASILIKE WARE

A mottled black, red, and brown pottery, named after Vasilike in eastern Crete, may be regarded as the definitive ware for EM IIB (Pl. 4A-E). It is thick walled, sturdy, extremely well made, and beautifully finished. The shapes range from conservative to highly exotic (Fig. 27). Most typical are the teapot with an exaggerated spout (F), the jug with a really high spout (J), the small goblet (H), the spouted, conical bowl (C), the bridge-spouted jar with convex profile (D), the open bowl (A), and several types of cups

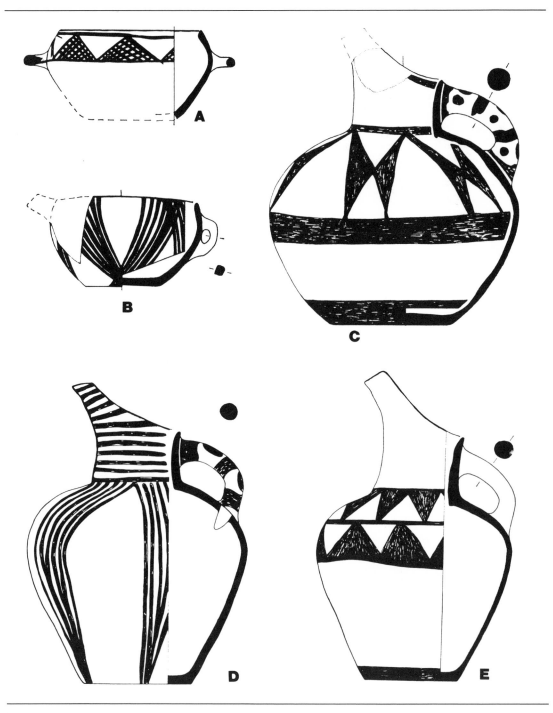

26 · A bowl and four jugs from Myrtos, Scale 1:3. (A-C) EM IIA; (D-E) EM IIB.

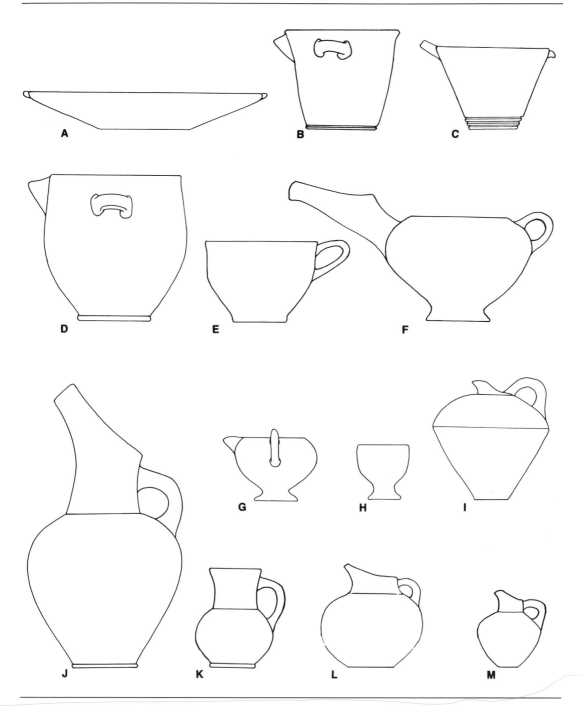

27 · Vases in Vasilike Ware, EM IIB, Scale 1:4. (A) Open bowl, Sphoungaras; (B) Bridge spouted jar, Myrtos; (C) Spouted, conical bowl, Vasilike; (D) Bridge-spouted jar, Vasilike; (E) Cup, Myrtos; (F) Teapot, Malia; (G) Bridge-spouted goblet, Sphoungaras; (H) Goblet, Vasilike; (I) Carinated jug, Sphoungaras; (J) Jug, Vasilike; (K) Jug, Gournia; (L) Jug, Trapeza Cave; (M) Jug, Vasilike.

(E), jugs (I and K-M) and jars (B).

Mottled decoration is the most distinctive and easily recognizable feature. The surface is always covered with slip, burnished, and fired so that it varies from red to brown to black. Many vases have pale areas with several black patches. On some pieces the mottling is obviously deliberate, with lines or groups of black dots, while in other cases it looks accidental. The most complete study, by a team of researchers in several fields, is presented in the monograph *Vasilike Ware* (Betancourt et al. 1979).

Although mottled pottery is most common in eastern Crete, it also occurs in the central and western parts of the island. Find spots are listed by Betancourt et al. (1979); the most important ones include:

EASTERN CRETE

Aghia Photia Ierapetras (Boyd 1904-1905: 184 fig. 4a)
Gournia (Hawes et al. 1908: pl. 6 no. 1)
Mokhlos (Fairbanks 1928: pl. 2 nos. 13-19)
Myrtos (Warren 1972A: Period II)
Palaikastro (Dawkins 1903-1904: 197 fig. 1; Forsdyke 1925: 72-73)
Priniatikos Pyrgos (Betancourt et al. 1979: catalogue)
Pyrgos near Myrtos (Hood, Warren, and Cadogan 1964: pl. 16a)
Sphoungaras (Hall 1912: figs. 20-21)
Trapeza Cave (Pendlebury, Pendlebury, and Money-Coutts 1935-1936)
Vasilike (Seager 1904-1905: fig. 6 and pls. 34-35; 1908: pl. 12 nos. 5-11 and 14-15; Blinkenberg and Johansen N.D.: 24; Richter 1953: pl. 2a; Betancourt et al. 1979: catalogue)

CENTRAL CRETE

Aghia Triada (Banti 1930-1931: 164, 168, and 179)
Aghios Myron (Alexiou 1969: 239 and pl. 272 no. 2)
Knossos (Betancourt et al. 1979: catalogue)
Koumasa (Blinkenberg and Johansen N.D.: pl. 30 no. 10)
Lebena (Daux 1959: fig. 13; 1960: fig. 7)
Malia (Chapouthier and Charbonneaux 1928: pl. 25 no. 4; Demargne 1945: 6-7 and pls. 27-29; Effenterre and Effenterre 1969: 9-10 and pls. 1 and 28; Amouretti 1970: pl. 24; Effenterre 1980: I figs. 43, 113-118 and VI-VII; II figs. 734-735)
Platanos (Xanthoudides 1924: pl. 51a)
Porti (Xanthoudides 1924: 61 and pls. 6 and 35)

WESTERN CRETE

Kastelli, Khania (Tzedakis 1965: pl. 712 nos. 1-2)
Perivolia Cave (Tzedakis 1969B: pl. 442 no. 1)
Platyvola Cave (Tzedakis 1967: pl. 378 no. 4)

AEGEAN ISLANDS

Kastri, Kythera (Coldstream and Huxley 1973: deposit beta nos. 15-18, 31, and 38)

At most sites, Vasilike Ware comes only from the mature phase of EM II. At Vasilike, however, it seems to have begun a little earlier and to have lasted a little longer (Seager 1904-1905: 211ff.; 1906-1907: 113-114). A similar situation exists

at Knossos where it occurs in a clearly stratified EM IIB level with a handful of sherds in EM IIA and EM III (Hood 1961-1962: 93; 1962B: 27; 1966; Betancourt et al. 1979: 21). Elsewhere—at Myrtos, Mokhlos, Palaiskastro, Lebena, and other sites—the ware seems to be restricted to EM IIB.

The mottling has always commanded interest, and many suggestions have been made for the techniques of manufacture. The surface was first covered with a slip that would vitrify during the firing to produce a hard, glossy surface, an effect achieved by the fineness of the particles and by the fact that the slip includes a high percentage of potassium, a fluxing agent that lowers its melting temperature (Hofmann 1962; Noll 1982). It is this slip that is mottled. Since different variegated effects are visible on different vases, it has been suggested that more than one method was developed to make them (Betancourt et al. 1979: chap. II). In some cases the effects were evidently applied in slip, most likely dabbed on with a sponge, while on other vessels an oxidizing/reducing inversion seems indicated. In the latter cases the mottling probably resulted from firing the vases in contact with a moist, combustible substance, at least in the last stages of the firing. The result is a broad range of mottled effects, often with many intermediate gradations.

The jug in Plate 4A, from Vasilike, is an excellent example of the class with deliberately and carefully applied ornament. The upper and lower parts of the vase are solid and dark. Tongues of color extend up onto the shoulder, and vertical rows of dots are between them. Either the design was sponged on before the vase was fired, or something that would burn and create the darker areas was dabbed on at the end of the firing cycle. Some sherds, like the example in Plate

4D, have been examined microscopically and clearly have only a single, even coat of slip that varies from pale brown to red to black because of selective oxidation and reduction. The exact material whose burning created the effects is not known.

Plate 4B shows a teapot, a *tour de force* of the mottled style. It illustrates the extraordinary features the ware can encompass. The designs are again applied deliberately, with a dark color on the rim, handle, base, and under the spout and handle. An irregular cross is on each side of the body, with opposed crescents flanking each cross. The finished product gives the effect of a light-colored mottled line meandering on each side of the body, but the designs are all within the slip. The spout, left unslipped, is painted with a ladder motif in some other paint. In the photograph the edge of the slip can be seen most easily at the base of the spout. Like so many of the best examples of the ware, the vase comes from Vasilike.

A different type of teapot comes from Mokhlos (Pl. 4C). Unlike its cousin from Vasilike, here the mottling is surely accidental. The slip is on the lower body only, with a zigzag pattern at the upper edge of the paint. Several other EM II vases from eastern Crete use a similar effect. In this case three sets of double vertical rows of punctations are incorporated into the design. The only mottled spot on the body is made by touching something during the firing, perhaps another vase, a piece of wood, or the side of the kiln wall. Wood, which would burn and create the licking action of flames, is the most likely candidate.

Besides the better mottled specimens, many EM IIB vases have variegated colors from the firing, splashes of red and black made by irregular oxidizing and reducing conditions. Coarse-textured

open bowls like those in Figure 28, which have this type of surface, have usually been grouped with Vasilike Ware, and it is possible that they bear some relation to the more carefully mottled pieces. They may imitate the finer techniques, or they may only be similar through chance or coincidence.

28 · Bowls from Sphoungaras decorated with irregular black to red areas (imitation of Vasilike Ware ?), EM IIB, Scale 1:6.

OTHER WARES

Some of the most interesting vases of the Early Bronze Age come from EM II. As in EM I, the potters seem to have delighted in strange and unusual shapes, especially for funeral purposes. The rich communal tholos tombs of the Mesara have yielded an especially diverse array of animals, birds, and other shapes. Speculation on the cult practices of the Early Bronze Age must be based on too little evidence for a solid footing, but the predominance of vessels with spouts suggests the pouring of libations, probably in some ritual associated with the dead. Whatever their function, the vases are common at tombs; they are found inside the burial chambers, in small rooms near the entrances, and outdoors in the vicinity of the burial structures.

The vessels in Figure 29 illustrate the variety that can come from one tomb group. They are all from Koumasa, the same site where the snake handler in Figure 23 and the jugs and teapots in Figure 22 and Plate 3E, F, L and M were found, but even with these additions, the group is by no means indicative of the full range of vases at the site. Many of the pieces, like the spouted tripod (Fig. 29E) and the ring vase (Fig. 29B), seem designed as novelties. The birds are especially successful as miniature sculptures (Fig. 29C and F-G). They are rendered with real wit and humor, making a nice play on the shape of jug or askos. More staid is Figure 29D, a small pyxis of a type sometimes called a bean pot. Made of brick red clay, it has vertically pierced lugs set low on the shoulder. Figure 29A is very problematical. One of a class found at several places in Crete, it has been called both a stand and a lid—one cannot be sure which way is up or if different pieces were used in different ways. The strange looking bull with dark lines and spots (Fig. 29H) is shaped very much like the Koumasa Ware lady with the snake (Fig. 23). They probably come from the same workshop, thus dating the bull to EM IIA. The other pots in Figure 29 are more difficult to date, as they come from mixed strata, but most of them are probably from about the same time.

Many other wares come from EM II. Coarse pithoi, sometimes with trickle decoration, are used at several sites. The examples in Figure 30 are from Myrtos; they are typical of the type. Tripod pots, present in EM I Debla (Warren and Tzedakis 1974: 329), continue their long tra-

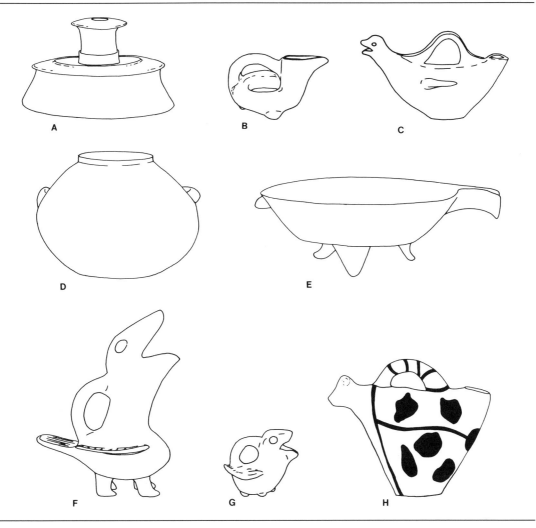

29 · Unusual vases from Koumasa, EM II, Scale 2:7. (A) Cover or stand; (B) Ring vase; (C) Bird-shaped askos; (D) Jar or pyxis; (E) Spouted bowl; (F) Bird-shaped jug; (G) Bird-shaped jug or askos; (H) Zoomorphic vessel.

dition in Minoan pottery. Figure 31 was deposited with a burial in a rock shelter at Aghios Antonios near Kavousi in eastern Crete. Since it was found with an EM II bronze knife, the date should be about this time. Early Minoan tripod legs are both circular and flat in section at this period (S. Hood, personal communication), but by MM I they are almost always flat. The tripod system—with stable legs to hold a bowl above the embers of a

fire—is so successful that once adopted it quickly became standard for cooking and other purposes. Shallow cooking dishes, basins, trays, and many types of bowls and jars round out the coarse-ware class, filling the needs of cooking, storage, and other domestic tasks.

Among the undecorated fine wares, Red-Burnished Ware, Brown-Burnished Ware, and Black-Burnished Ware are all typical of EM II, especially at east Cretan

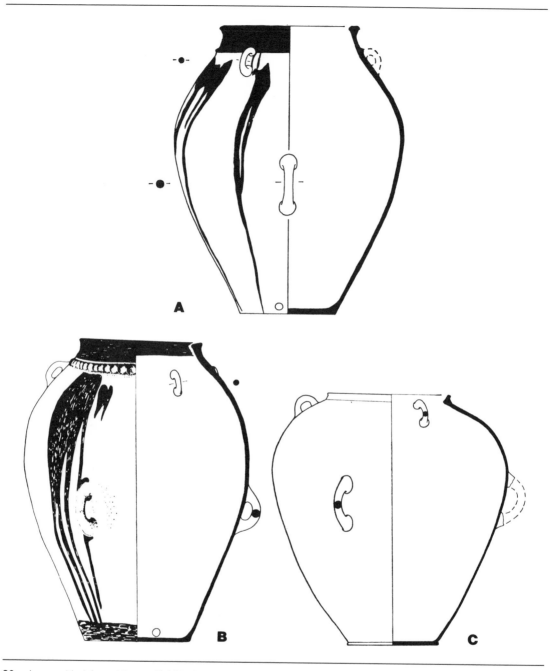

30 · Large pithoi from Myrtos, EM IIB, Scale 1:9.

31 · Tripod vessel from a burial at Aghios Antonios, Found with EM II material but of uncertain date, Ht. 9.5 cm.

sites. The red and brown pieces are especially common in east Cretan EM IIB, contemporary with Vasilike Ware. They occur in the same contexts as their mottled counterparts, in the same shapes. Probably they were all made by the same potters, and some vases were just not mottled. By contrast, at Knossos the burnished wares are only prominent at the beginning of EM II and then give way in favor of painted pieces, so that the eastern sites preserve the burnished fabrics for a much longer period. Perhaps this is a sign of eastern conservatism, visible in other periods as well.

A few clay vases are shaped like boats or ships. Besides their interest as ceramics, they are important documents in the early history of seafaring, providing evidence for several details of shipbuilding. The small model shown in Figure 32 comes from Mokhlos. It has a flat bottom, a high prow and stern, and small projections at or below the waterline. If the two pairs of knobs inside the hull are intended as thole pins, they provide evidence that some Early Minoan craft were rowed (discussion in Bass 1972: 28-29). The sailing vessel on the sealstone in Figure 32B also has a high prow and stern and may show the same type of ship. A different type of craft is illustrated in Figure 32C. The high prow and the projection at the stern compare closely with designs incised on contemporary pottery from the Cyclades (Fig. 32D), with ships

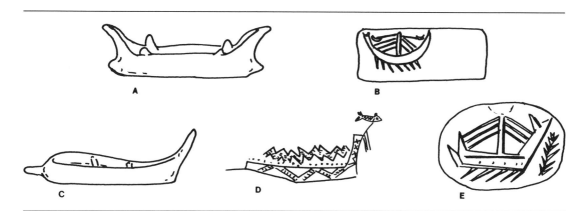

32 · Aegean ship representations, not to scale. (A) Clay model from Mokhlos, EM II; (B) Design on a Minoan seal, EM III-MM; (C) Clay model from Palaikastro, EM II; (D) Design incised on pottery from Syros, in the Cyclades, EC II; (E) Design on a Minoan seal EM III-MM.

on Minoan seals (Fig. 32E), and with the later and much more naturalistic craft on murals from the West House at Akrotiri on Thera (Marinatos 1968-1976: VI color pl. 9). These parallels suggest the model is copied from a ship manned by a large crew of oarsmen or paddlers, and it probably represents a seagoing vessel.

Some additional vases are shown in Figure 33. The cups are heavy and rather clumsy, but they are the ancestors of the graceful shapes of the Middle Bronze Age. These two examples come from Sphoungaras (A) and Vasilike (B). As always, bowls are common. Figure 33C shows another of the many variations made in this period. The vases from Malia (D) and Priniatikos Pyrgos (E) illustrate two additional subvarieties of the jug. Although the piece from Malia

uses an EM I shape, it could just as easily date from EM II.

As a whole, the vases of EM II are more carefully planned than in EM I, and the lines are crisper. Parts—bases, spouts, and handles—are set off clearly where in earlier times they might flow out of the body. In the exuberance of lively creativity, a taste for the bizarre manifests itself in certain shapes that would not last at all. Teapots and jugs with exaggerated spouts, jugs with carinated bodies and rows of punctations, and tiny goblets with handles and spouts (even bridged spouts) are unique to EM II. They indicate an age of experiment, a time when the techniques of potting and firing had already been mastered, and the potters were willing to turn their creative urge toward the product itself.

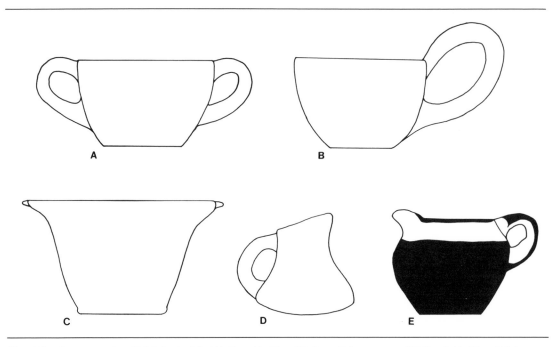

33 · Miscellaneous vases, EM II, Scale 1:3. (A) Cup, Vasilike; (B) Cup, Sphoungaras; (C) Bowl, Vasilike; (D) Jug, Malia; (E) Jug, Priniatikos Pyrgos.

5 · EARLY MINOAN III

Evans defined Early Minoan III more from finds in eastern Crete than from his stratigraphy at Knossos, and consequently his definition has not worked well for the central and western sites. The period is now characterized a little differently, as a time when pottery with white patterns on a dark background becomes popular but before the appearance of red paint. This definition fits well with the stratigraphy at Knossos (Hood 1961-1962: 93-94), and it may be extended to the remainder of Crete if one allows the last part of the very long east Cretan EM III to overlap with the first part of Knossian MM IA (see Table 4).

Table 4 · Chronology for Knossos and eastern Crete from EM IIB to MM IA.

EAST CRETE	KNOSSOS
EM IIB	EM IIB
EM III	EM III
	MM IA
MM IA	

Early Minoan III strata at Knossos have been found at several points on the site. North of the Royal Road and at the south front of the palace they are interlayered between EM IIB and MM IA (Hood 1961-1962: 93-94; 1962B: 27; 1966). Similar finds come from the Upper East Well (for the context see An-

dreou 1978: 12-25) and from House B beneath the Kouloures in the West Court (Andreou 1978: 15).

Larger deposits come from eastern Crete. At Vasilike, EM III is stratified above EM IIB (Seager 1904-1905: 218-220; 1906-1907: 118-123). A similar situation may be recognized at Palaikastro (Dawkins 1903-1904: 198-199; 1904-1905: 272-274; Bosanquet and Dawkins 1923: 3ff.; Sackett, Popham, and Warren 1965: 250, 269-272, and 277-278) and Mokhlos (Seager 1909: 278 and 283-284). Many examples, both sherds and complete vases, come from Gournia (Hall 1904-1905; 1908), Palaikastro (Dawkins 1904-1905: 269-272), and Vasilike (Seager 1906-1907: 118-123).

In the Mesara, the latest Early Minoan styles shade directly into MM I. A similar situation may exist in the west, where little stratigraphy has been recognized, but the stray finds suggest that EM III is probably island wide.

The vase shapes are slightly different from those of EM II (Fig. 34). The goblet (or egg cup) develops from a type with a high foot (EM IIB) to a shape with a low foot (EM III-MM I). The rounded cup and the conical cup also appear in large numbers, often unpainted or decorated with a single horizontal band of white paint. Sometimes the conical cup is tall enough to be called a tumbler. Handles occur, but they are never thin ribbons, and many cups are plain. Bowls are of several types. Flaring rims are usual, and the thickened, inturned rim used in

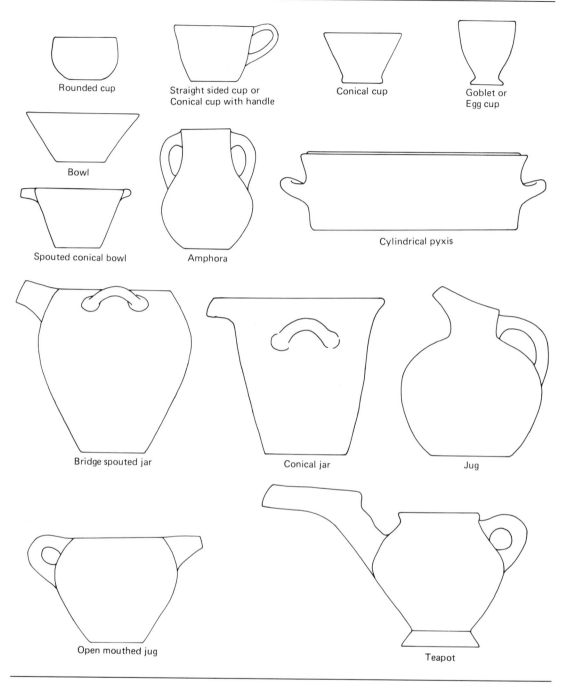

Rounded cup

Straight sided cup or
Conical cup with handle

Conical cup

Goblet or
Egg cup

Bowl

Spouted conical bowl

Amphora

Cylindrical pyxis

Bridge spouted jar

Conical jar

Jug

Open mouthed jug

Teapot

34 · Names of EM III fine ware shapes.

EM II is no longer made. Jugs have smaller spouts than in earlier times, often cut out at the front. Teapots, jars, and bridge-spouted jars are also known. Lids, tripod vessels and other cooking shapes, pyxides, jars, and a few other shapes round out the picture.

Several wares may be recognized. Dark-on-light pots with linear designs on the pale-colored clay are found alongside vases with an overall dark slip and the ornament in creamy white (White-on-dark Ware). Coarse storage vessels are present, and there are also gritty-textured red to brown tripod cooking pots and other cooking shapes. Only a few sherds of Vasilike Ware and other EM IIB wares survive into this period, and it is likely they were no longer being manufactured.

WHITE-ON-DARK WARE

A pottery with white designs on a dark background is the definitive ware for EM III. It is most common in eastern Crete where it begins in late EM II and persists into MM I. The main studies are by Zois (1968B), Andreou (1978: 57-65), and Betancourt (1982B; 1984A).

Like most Cretan pottery, White-on-dark Ware is made from a clay that fires to a very pale brown to red color. It has an overall slip, darker and more even in color than in EM II, with white linear decoration painted on top. It is attractive and easily recognizable, making a dramatic contrast with the plainer wares of EM IIB.

The earliest pieces seem to be somewhat experimental (Fig. 35). They come from EM IIB strata, contemporary with Vasilike Ware (for Myrtos see Warren 1972A: Period II; for Aghia Photia Ierapetras see Boyd 1904-1905: pl. 25 no. 3). Since their technique varies, with both

burnished and unburnished surfaces, they seem to represent a style whose tenets have not yet been worked out. The white ornament is very simple; straight lines predominate, with basic and uncomplicated arrangements.

By EM III the style is more mature. Spirals, quirks, dot bands, and many other elements are added to the repertoire, and the tradition is more confident and standardized. The surface is no longer burnished, and it has a dark and even color. At some sites the ware is so dominant it represents more than 90 percent of the fine decorated pottery.

Several differences may be detected between the eastern style and that of central or western Crete. In the east, the decoration is more varied, with a diverse array of individual motifs, often combined in interesting and creative ways. Spirals, semicircles, zigzags, quirks, circle motifs, and complex triglyph and metope motifs are used. In the other parts of the island, simple lines are more common, and many vessels have only horizontal bands. Even with the finest vases, the western decoration never has the range it does in the east. East Cretan White-on-dark Ware may thus be distinguished as a separate and distinct tradition.

In the east, the ware has been excavated from every EM III site. Gournia, near the coast on the Gulf of Mirabello, may be regarded as the type site because of an especially large deposit from the northern edge of the settlement (the North Trench, Hall 1904-1905; 1908). Typical sherds are illustrated in Figure 36. Other good EM III groups from eastern Crete include:

Malia (Demargne 1945: 1-12; Chapouthier, Demargne, and Dessene 1962: 13ff.)
Mokhlos
 settlement (Seager 1909: 278 and fig.

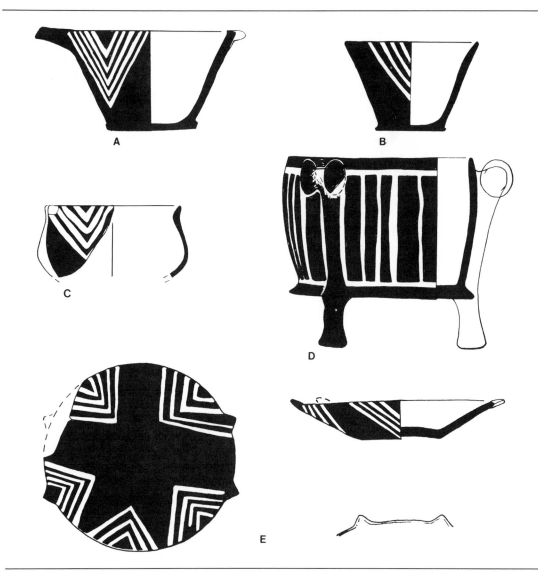

35 · Early White-on-dark Ware from Myrtos, EM IIB, Scale 1:3. (A) Spouted, conical bowl; (B) Bowl; (C) Cup with S-shaped profile; (D) Pyxis with legs; (E) Shallow conical bowl.

6, 283-284 and figs. 7, 8, and 13 center row nos. 2-4 and bottom row)

cemetery (Seager 1912: Tombs IV and V)

Pakheia Ammos (Seager 1916: nos. Ib and XIc)

Palaikastro

settlement (Dawkins 1903-1904: 198-199; 1904-1905: 269, 273, and fig. 5c)

Kastri (Sackett, Popham, and Warren 1965: 250, 269-272, 277-278, and pl. 726-c)

cemetery, Ossuary III (Dawkins 1904-1905: 269-272 and fig. 5a-b)

Sphoungaras (Hall 1912: 50-51 and fig. 23)

Vasilike (Seager 1904-1905: 211 and 218-220; 1906-1907: 118-123)

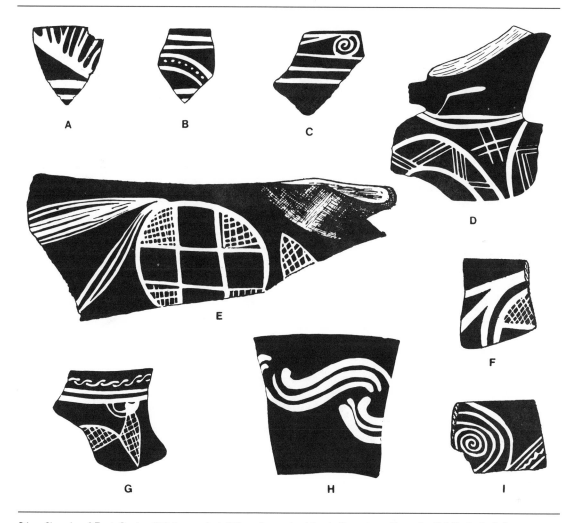

36 · Sherds of East Cretan White-on-dark Ware from the North Trench at Gournia, EM III, Scale 2:5.

The most characteristic feature of the ware is its decoration. Some of the motifs are shown in Figure 37. Mostly linear, they consist of both straight and curved lines. Spirals, unknown in EM IIB, now appear in large numbers, recalling the occasional rare example from EM I (Hazzidakis 1912-1913: fig. 3b). Circle motifs are of many types; they are either painted singly or with connecting lines borrowed from the running spirals (Fig. 38). Quirks, semicircles, and wavy lines are also curvilinear. Rectilinear designs include the chevron, the triangle, parallel vertical lines, and zigzags. Dot bands are used singly or with other motifs. An alternation of vertical or diagonal lines and some other element, called a triglyph and metope motif, is also common. Many other designs occur, including a few clever representations of the agrimi (Figs. 36G and 37N).

Figure 39 and Plates 4F-I and 5A-B illustrate some complete vases from eastern sites. The rounded cups (Pl. 4I) have circumcurrent designs, repetitions of ele-

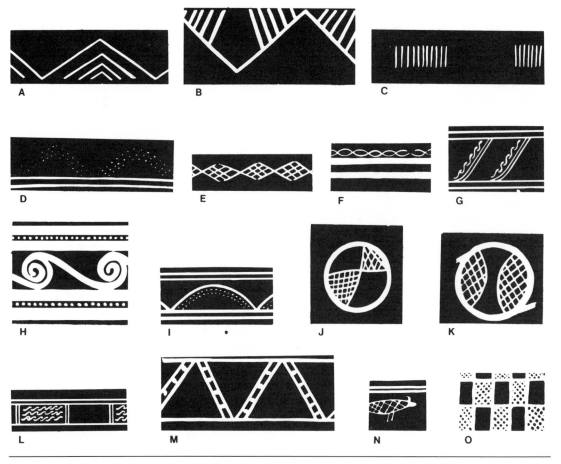

37 · East Cretan White-on-dark Ware motifs.

38 · Circles joined by connecting lines, from a vase from Gournia, EM III.

ments around their rims or bodies. Small horizontal handles are sometimes added. A jug from Mokhlos in Figure 39G has a rounded, dumpy shape; only the elegant spiral rescues it from mediocrity. Its decoration sweeps diagonally around the body, an early example of the torsional movement that would soon transform the Middle Minoan style with its dynamic visual impact. By contrast, a teapot from the same site is more static (Pl. 4H). This time the ornament is the zigzag, a motif that creates a sharp up and down alternating movement. The bowls in Figure 39A and Plate 4F and G from Vasilike are decorated with facial designs, triangles that spread upward from the base

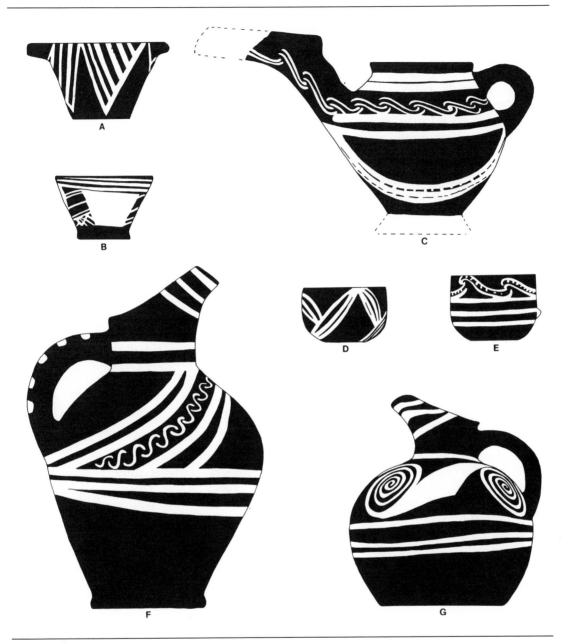

39 · Vases from eastern Crete, EM III, Scale 1:3. (A) Spouted, conical bowl, Vasilike; (B) Cup, Vasilike; (C) Teapot, Vasilike; (D) Rounded cup, Mokhlos; (E) Rounded cup, Vasilike; (F) Jug, Mokhlos; (G) Jug, Mokhlos.

and emphasize particular sides of the shape. Like the circumcurrent compositions, this type of syntax would have many heirs in Middle Minoan pottery.

Early Minoan III may have been short lived in central and western Crete. The strata are slim at Knossos, suggesting that the red paint that defines the end of the period may have appeared earlier here. Finds of White-on-dark Ware in MM IA contexts (and *vice versa*) confirm an overlapping chronology like that shown in Table 4 (for discussion see Warren 1965: 25-27). The attractive and energetic character of the local style may explain why the east Cretan potters were slow to take on new ideas; they continued making traditional ceramics even after new concepts were abroad elsewhere.

The White-on-dark Ware of central and western Crete is not a complicated style, and spirals and other eastern motifs do not appear until later. Plate 4J shows a selection of sherds from Tsikouriana, a settlement site in the region of Khamalevri (Hood, Warren, and Cadogan 1964: 65 no. 6; Schiering 1982). Their date is EM III-MM IA. A majority of the ornament consists of dot bands and straight lines, crossed or arranged in other simple ways. The shapes—bridge-spouted jars, cups, and bowls—are like those found everywhere at this time, and the dot bands and simple decorations also join the style with the eastern pottery. The simplicity of the ornament, however, contrasts sharply with the east Cretan style.

White-on-dark Ware seems to have been primarily a fine table ware, intended for serving and drinking. In the North Trench at Gournia, where almost 900 sherds were recognizable as to shape, conical and rounded cups constituted 60 percent and containers for pouring—bridge-spouted jars and jugs with small spouts—accounted for 35 percent of the total (Hall 1904-1905). Since the pottery in this dump was very fragmentary, suggesting it came from more than one context in the settlement and was mixed when it was finally deposited, the figures are probably typical for the site. A funerary deposit, Ossuary III in the Ellenika Cemetery at Palaikastro, shows the range for a tomb (Dawkins 1904-1905: 269-272). Of the 41 vases found, 75 percent were cups and 10 percent were jugs and bridge-spouted jars. The numbers are not very different from those at Gournia. It is likely the majority of the vases were made for liquids, with cups naturally being required in greater numbers than vessels for pouring.

At the end of the period, White-on-dark Ware gradually develops into the Middle Minoan style. A late phase, dating from MM IA and IB, may be recognized from several eastern sites:

Malia (Chapouthier, Demargne, and Dessene 1962: 13ff.)
Mokhlos (Seager 1909: 290-293 and fig. 13 upper row)
Palaikastro (Sackett, Popham, and Warren 1965: 251)
Pyrgos, Myrtou (Cadogan 1978: 71-73)
Vasilike (Seager 1906-1907: 126ff.; Betancourt 1977A: 345-346 and illustr. 1)

New shapes are invented: the cylindrical cup; the rounded cup with a thin strap handle; and the carinated cup. The designs include unusual combinations of old motifs as well as new ones (Fig. 41). A few vases, like the jug in Figure 40, are extremely conservative; they preserve the earlier style into a period usually characterized by polychrome vases of a completely different type.

40 · Jug from House B at Vasilike, MM IB, a late example of East Cretan White-on-dark Ware, Ht. ca. 20 cm.

OTHER WARES

As with other periods, most EM III wares have not been carefully defined. They include pithoi, coarse jars, tripod cooking pots and other cooking shapes, and many other vessels. The larnax also begins to be popular at about this time.

The undecorated pyxis in Figure 42 is from the North Trench at Gournia. It provides an example of a much earlier shape, the cylindrical pyxis, and it thus

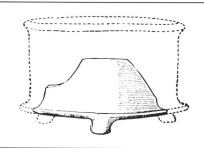

42 · Pyxis from the North Trench at Gournia, EM III, Scale 2:5.

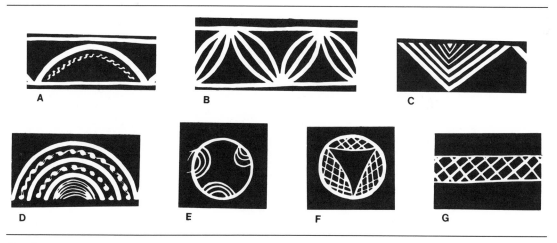

41 · Late variations of White-on-dark Ware motifs, MMI.

helps to bridge the gap between the many examples of EM II (Pl. 3I) and the pyxides of the Middle Bronze Age.

Although modeled vases continue to be made, few examples from this period are really well dated. Such a piece is the EM/MM I juglet in Plate 5C, from the tholos site of Koumasa. The small figure clinging to the neck is extremely simplified. It has few lifelike details; naturalism will not enter the Minoan sculpture style until well into the Middle Minoan period.

The dark-on-light vases of eastern Crete are important as the ancestors of the Middle Minoan Dark-on-light Style (discussed below). Their decoration is always simple and applied directly onto the clay (Fig. 43). By continuing a fashion that goes back to the Aghios Onouphrios Ware of EM I, they keep a long tradition alive and transmit it to their second millennium successors. The style is not very popular in EM III, but it picks up ground in the next few centuries.

An important new custom, burial in jars and larnakes, begins in the Early Bronze Age. The earliest examples of larnakes are some long, low boxes with rounded corners from the Pyrgos Cave (Xanthoudides 1904: fig. 4). Their date is not known, but most of the material from here is EM I. More secure are small jars and boxes from the cemetery at Pakheia Ammos, dated to EM III by their use of creamy off-white slip. An example of a small larnax from this period is shown in Figure 44, at the center of the front row. It is one of the earliest pieces from the cemetery.

Most of the late Early Minoan pottery is transitional in scope and execution. It is less exotic than the wares of EM II, with a practical and utilitarian feeling. So many of the traditions of MM I have al-

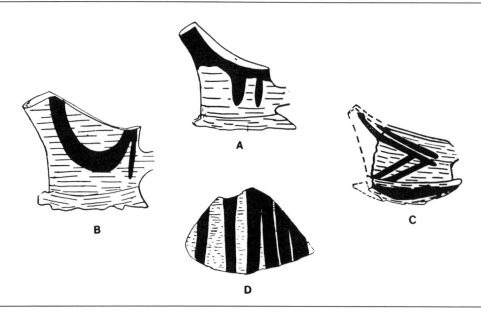

43 · Early examples of the Dark-on-light Style from the North Trench at Gournia, Scale 2:5.

ready begun that it is usually difficult to decide the date of individual pieces. Many undiagnostic wares are plain, covered with slip, or given a few lines or bands in white or dark paint. Their conservatism belies the burst of creativity that was waiting to spring forth.

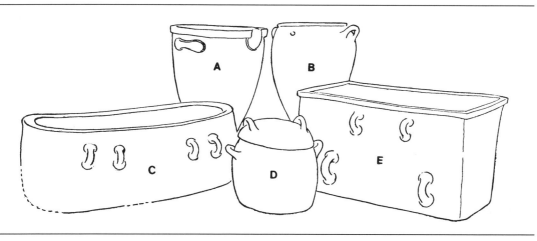

44 · A selection of larnakes and burial jars from the Pakheia Ammos cemetery. (A) LM I; (B, C, and E) MM; (D) EM III.

6 · THE MIDDLE BRONZE AGE DEVELOPMENT

THE MONUMENTAL PALACES are the most visible new factors in Middle Minoan Crete. As architectural focal points for a new type of centralized society, it was inevitable that they would create changes in many areas. Among other things, they acted as redistribution centers, collecting agricultural produce and other commodities and disbursing them as required. Since many of these products were stored in clay containers, vases were needed in large quantities. In addition, an associated urbanization movement brought people together in larger numbers which also increased the need for ceramic vases. The potter's wheel, introduced in MM IB, helped fill this need by speeding the manufacturing process, but some more deeply seated changes in the production may have occurred as well. Standardization, visible in shapes like the carinated cup and the bridge-spouted jar, suggests a more closely supervised craft, and the purer clay used for the fine wares may

indicate changes at other steps as well.

Although there may have been large buildings at Knossos and the other palatial seats by the Early Bronze Age, little has been found of these structures because of the leveling and rebuilding that took place during Middle Minoan times; only indirect evidence like the scope of the MM I projects suggests a palatial civilization probably began much earlier. Many sites are known (Map 3). Knossos, Malia, and Phaistos were already important by MM I. Less is known about this period at Khania and Zakros, which boasted palaces in later times, but it is likely there were already a number of regional centers.

The palaces are especially important to the development of Minoan art. Their rulers were interested in attractive display, and they paid special attention to the visual arts. Murals, plaster reliefs, miniature sculptures, metalwork of several types, sealstones, ivory carvings, and

Map 3 · Middle Minoan sites in Crete. (1) Aghia Photia; (2) Aghia Triada; (3) Aghios Onouphrios; (4) Amnissos; (5) Arkalokhori; (6) Arkhanes; (7) Drakones; (8) Gournes; (9) Gournia; (10) Kamares Cave; (11) Kamilari; (12) Khalara; (13) Khania; (14) Knossos; (15) Kommos; (16) Koumaro Cave; (17) Koumasa; (18) Lebena; (19) Malia; (20) Mokhlos; (21) Monasti-raki; (22) Pakheia Ammos; (23) Palaikastro; (24) Patrikies; (25) Perivolia Cave; (26) Phaistos; (27) Platanos; (28) Platyvola Cave; (29) Priniatikos Pyrgos; (30) Pseira; (31) Pyrgos; (32) Sphoungaras; (33) Trapeza Cave; (34) Tsikouriana; (35) Tylissos; (36) Vasilike; (37) Zakros.

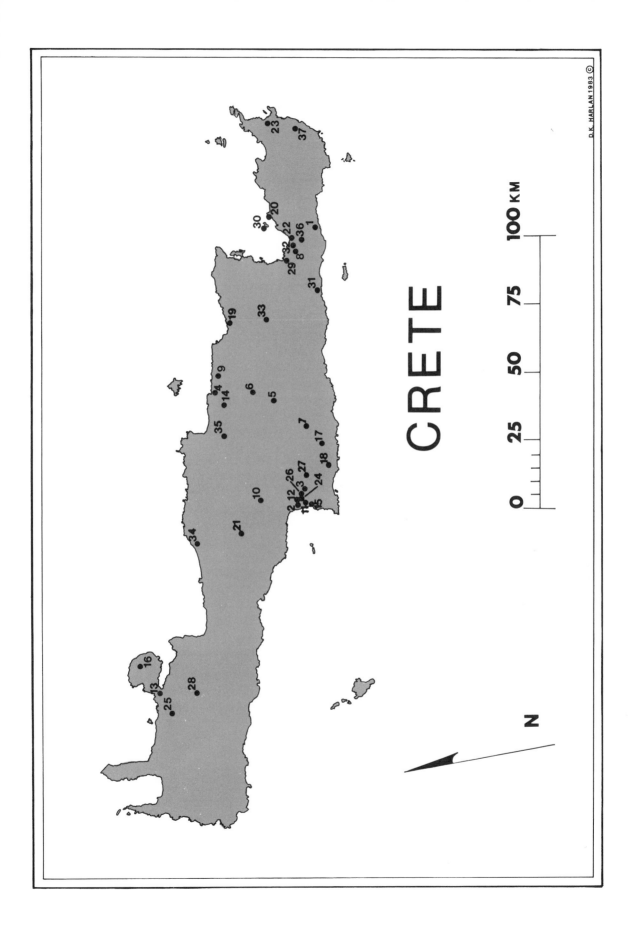

CRETE

N

0 25 50 75 100 KM

stone vases were produced in quantity. Because the workshops had to be near the central authorities that supervised them, the artists and craftsmen were well aware of what was being made by others, and the exchange of ideas could stimulate all. Palatial styles were often cultured, sophisticated, and incredibly beautiful. Especially with painted pottery, they reached a height of visual expression beyond anything that came before; craftsmen at outlying villages were left well behind.

Phaistos and Knossos had the most dynamic of the Middle Bronze Age styles. Their workshops produced a steady stream of fine products, with many influential aspects. The correlation between the two sites, however, has been difficult and controversial, and several schemes for dealing with them have been proposed. Evans suggested a tripartite division with each phase containing two subperiods. His plan may be contrasted with the system of Walberg (1976: 125):

WALBERG	EVANS
Pre-Kamares	MM IA/early IB
Early Kamares	MM IB/IIA
Classical Kamares	MM IIA/IIB/IIIA
Post-Kamares	MM IIIA/IIIB

Doro Levi used a different organization for his excavations in the Mesara, dividing his Middle Bronze Age material into three phases, the first with two subdivisions. Platon (1961) and Zois (1965) have criticized this division severely, suggesting that Levi misunderstood his stratigraphy and that his "phases" were actually three stories of a single building. These criticisms should now be set aside because of the additional evidence furnished by the fuller publication of the material from Phaistos (Levi 1976) and because of the independent stratigraphic information from Kommos (Shaw 1978:

126-127 and 147; 1979: 159 and 169; Betancourt 1978). One can be sure that Phaistian Phases IA, IB, and III exist in the main as separate ceramic periods; the pottery of Phase II is still difficult to distinguish stylistically.

The following correlations are used in this work:

KNOSSOS	PHAISTOS
MM IB-IIA	Phase IA
MM IIB	Phase IB-II
MM III	Phase III

Some of these equations are more certain than others. A correlation between Knossian MM IIA and the end of Levi's Phase IA seems undeniable. The ceramic assemblages are united by distinctive wheelmade shapes as well as by stylistic considerations. Since many early Kamares Ware motifs—rosettes, petals, and other designs—are already developed in this lowest palatial level at Phaistos, it would seem that the architectural phase did not end until after MM IIA had already begun (for MM IIA vases found below the lowest calcestruzzo at Phaistos see Pl. 8E to G). No one denies that the brilliant polychrome style of Phase IB at Phaistos is contemporary with its Knossian counterpart, MM IIB. Almost all of the complete vases from this period of Phaistos come from the mature phase of the style, when the palace was destroyed. Although Phase II at Phaistos may be an architectural period, its ceramics does not seem to differ materially from the style of Phase IB. Like Phase IB, it is probably contemporary with MM IIB at Knossos. Phase III in the Mesara is best known from near the palace at Phaistos and from Kamilari and Kommos because extensive remodeling at Phaistos (when the LM I palace was built) destroyed much of the relevant Phase III material on the site of the palace itself (exceptions in-

clude Pernier and Banti 1951: houses 101-102 and 104). Most of the vases from Phase III are decorated more simply than in earlier times, and correlations with MM IIIB at Knossos suggest this is the last pottery before the beginning of LM IA.

It is still difficult to distinguish MM IIIA as a separate period. As Walberg has shown (1976: 108), Evans himself was unable to pin down the style, and on some occasions he placed the same "MM IIIA" vases in different periods. The stratum does exist at Knossos as a post-MM IIB phase that still uses thin, fine Kamares Ware, but not enough good deposits are known to establish a general MM IIIA style for all of Crete, and for the present it seems best not to subdivide MM III when discussing the entire island.

The absolute chronology of the Middle Bronze Age is chiefly derived from correlations with Egypt (for Minoan exports see Kemp and Merrillees 1980). Radiocarbon dates from this period are without real value as no good series of dates exists, and isolated dates should not be used because of the problems of statistical interpretation (for discussion see Betancourt and Weinstein 1976). Conclusions cannot really be precise, but there is more information for Middle Minoan than for the Early Bronze Age.

The date of MM I is best established by imports into Crete. Two Egyptian scarabs come from MM I-II burials at Gournes (Pendlebury 1930: nos. 17-18; Platon 1969: nos. 402 and 405). One has been dated to the XIth Dynasty, and the other is contemporary or a little later (Ward 1971: 93-94). Three scarabs from Lebena, found with MM IA vases, come from surer contexts (Alexiou 1958A: 7 fig. 5; Platon 1969: nos. 180, 201, and 204). Two of them are dated by Ward to

the First Intermediate period, and he places the third (Platon 1969: no. 180) a little later, in the Twelfth Dynasty (1971: 76-77). Warren has argued, however, that this scarab is probably contemporary with the other two (1980: 495). A scarab from the EM III-MM IA ossuary at Arkhanes may be a trifle earlier (Platon 1969: no. 395: for discussion see Warren 1980: 494-495). These finds show that Eleventh Dynasty scarabs were being buried in Cretan tombs by the beginning of the Middle Bronze Age. Thus the First Intermediate period can be regarded as a *terminus post quem* for MM IA. Hood suggests that it begins a little before 2000 B.C. (1971A: 10), as does Warren (1980: 495), but a slightly later date is not impossible—the *terminus* only proves that the period cannot be earlier.

For the middle phases of Middle Minoan, the correlations are far more general. The Tôd treasure, a cache of metal vessels found in Egypt with material from the time of Amenemhat II (dated to ca. 1929-1895 B.C. in the *Cambridge Ancient History*), has several Minoan affinities from MM IB-II (Bisson de la Roque 1950; Bisson de la Roque, Contenau, and Chapouthier 1953). Middle Minoan IB-II sherds were found at Harageh in mixed rubbish dumps of Twelfth Dynasty and possibly later date (Engelbach 1923: 10 and pl. 10 no. 15; Evans 1921-1935: II fig. 119a-g). Other MM IB-II sherds come from Twelfth- and Thirteenth-Dynasty contexts at Kahun (Evans 1921-1935: I fig. 198; II fig. 119h; Forsdyke 1925: 91-94 and fig. 113; for the date see Hood 1966). A complete MM II bridge-spouted jar from Abydos is more useful for chronological purposes (Garstang 1913). It was found in a multi-shaft tomb that is probably from the time of Senusert III and Amenemhat III (ca. 1878-1797 B.C. in the *Cambridge Ancient His-*

tory), suggesting that the MM II style was already in existence by this time. Middle Minoan II pottery also comes from Twelfth- and Thirteenth-Dynasty contexts at Ugarit (Schaeffer 1934: 144 and fig. 16; 1938: 201ff.; 1939: 54ff.; 1948: 16 and pl. 5J no. 24). Although none of these finds is definitive in itself, they all present a uniform picture, and their sum has been convincing to most Minoan scholars. They suggest that MM IB-II pottery was already in the Near East and Egypt in the Twelfth to early Thirteenth Dynasties, and that MM II was already in progress by the nineteenth century B.C. (for an alternate view, with MM I beginning somewhat later, see Åström 1957; 1961-1962; 1968).

Little is added by the foreign objects found in Crete. Tholos B at Platanos where three Egyptian scarabs and a cylinder seal often ascribed to the time of Hammurabi were found must have been used for several centuries, at least from the end of the Early Bronze Age until MM IB or II (Branigan 1968). The scarabs, some of which date from as late as the Thirteenth Dynasty, have been used to suggest a late chronology for MM IB (Åström 1957: 258-259; 1963: 139-142), but the evidence loses its validity for all chronology if the tomb was still being used in MM II-III, as suggested by a study of the Minoan seals (Yule 1977-1978). Knossian finds include a Twelfth- to Thirteenth-Dynasty scarab found in an early MM II context south of the Royal Road (Hood 1961-1962: 96 and pl. 1; Ward 1971: 81 n. 334) as well as some other Egyptian objects with a less secure context (for discussion see Betancourt and Weinstein 1976). The finds in Crete thus do not contradict the general picture, but they add nothing significant to the chronology.

For the end of the Middle Bronze Age,

the evidence is even sparser. Neither the foreign objects in Crete nor the Cretan objects abroad offer any help whatsoever (Betancourt and Weinstein 1976: 336-337). Since the beginning of LM I is equally problematical (see below), one can only suggest that MM III probably spans part of the Second Intermediate period, with no real precision for its start or end. Its chronology must be placed by the brackets of earlier and later stages.

The development of Middle Minoan pottery proceeds from a rustic beginning in MM IA through several successive stages until it stands at the doorstep of the Late Bronze Age. Many different styles exist in MM IA. They look in various directions: Barbotine Ware adjusts the clay surface; the conservative Incised Style combines painted ornament with lines cut into the soft clay; the Dark-on-light Style is sketchy and plain; White-on-dark Ware is stylized and controlled, with a wide range of interesting motifs. Among all of these styles, it is White-on-dark Ware that stands in the mainstream of the future development. Red color is added to the painting in MM IA, and orange, crimson, and yellow are used by MM IB. Under the leadership of the palaces, a transformation occurs.

Middle Minoan IB is a major watershed in both technology and style. The potter's wheel is used for the first time in Crete, and thin, well-made pottery begins to replace the handmade varieties. Stone temper is now restricted to the larger shapes that are still made by hand. Stylistic changes affect the whole craft. Motifs became dynamic and complex, while the syntax grows more sophisticated. Middle Minoan IIB is the high point; its painting is brilliant, and its wheelmade shapes are sleek and refined.

Minoan artistic principles reach full maturity during this period. They have

been analyzed in detail by several scholars, especially Matz (1928), Furumark (1939; 1941), Groenewegen-Frankfort (1951: 185-216), and Walberg (1976; 1978; 1983). Although they may be examined in many of the arts, nowhere are they better visible than in Kamares Ware, the elegant polychrome pottery of the middle phases of the Middle Bronze Age. Kamares Ware uses abstract and natural forms set in attractive patterns on a dark-faced background. Compositions employ a whole range of syntactical systems from simple bands to twisting torsion and whirling compositions that emphasize both center and circumference. In many cases the curvilinear contours and moving patterns create a vibrant sense of the living world, as if lines are sprouting and growing from other forms. The shapes keep pace with the development; they are taut and crisp, with a contained energy of their own.

Middle Minoan III is a time of consolidation. Less energy is poured into advancement, giving opportunity for past gains to become more widely known. Polychromy declines, and new naturalistic motifs are added to the inventory, foreshadowing the naturalism of LM I. The ornament experiences a recession as it waits for renewed influences from other quarters like wall painting and metalwork. Another technological revolution occurs at this point. A lustrous reddish-brown firing slip, perhaps made by grinding the raw materials more finely than before, is used on a dense, smooth, burnished clay body. Tortoise-Shell Ripple Ware and related late Middle Minoan styles are first to use the innovations for fine ware: they appear extremely advanced alongside the softer and grittier standard products. The new technology is really the beginning of the next phase; when it becomes popular, LM I has begun.

Middle Minoan ceramics differs from earlier pottery in much more than its artistic style. Crete's population must have increased greatly, and the larger number of people stimulated the needs for vases in unexpected areas. Pottery assumes many new functions—cooking and serving are joined by needs for large-scale storage, transport, commerce, food processing, burial, and many miscellaneous tasks. As a result, clay containers become an indispensible part of daily activities. An example of the new awareness of ceramics is the seal in Figure 45, illustrating a sight that must have impressed even the most casual visitor to a Minoan household. Large pithoi and jugs stand in rows, as the sealcutter has used the vases to suggest a well-stocked storeroom.

45 · Seal from Malia showing a human figure holding a jug and three other jugs above pithoi with several handles, MM I-III.

Excavations prove the image is very typical; both palaces and houses had rooms filled with dozens and dozens of jars and other vessels. Other seals (Fig. 46) suggest the same conclusions. Although one cannot be sure if Evans was correct in assuming these particular examples illustrate potters at work (1921-1935: I 123-124), there is no denying that the popu-

46 · Seals from Kasteli Pediada near Knossos either showing potters at work or various persons using pottery, MM I-III.

lation as a whole was completely aware of ceramics: clay pots would be seen and used throughout a person's life, and one might even rest in one in death.

Burial in jars and larnakes cannot be dated with as much precision as one would like, but the practice becomes much more widespread during the Middle Bronze Age. The selection of shapes in Figure 44, from a large cemetery at Pakheia Ammos, shows the range of types. Larnakes with rounded corners begin earlier than the more box-like design, but the types overlap and exact dates are not really known. The tall jar with the rounded shoulders is from early in this period, while the more open-mouthed lipped jar is from MM III-LM I. The custom is sporadic during the entire Middle Bronze Age; it becomes more popular after LM I-II, culminating in the elaborately painted larnakes of LM III.

7 · MIDDLE MINOAN I

Unlike the ceramics of the Early Bronze Age, Middle Minoan pottery cannot be studied as a sequential series of individual wares. Except for Barbotine Ware and Kamares Ware, two large and ill-defined traditions that could be divided into many smaller components, the clay vases of the second millennium B.C. are better classified in chronological styles. Good reasons exist for this change. Influences from the palaces become completely dominant during Middle Minoan times, leveling and consolidating the island's craftwork to an extent that never occurred in the Early Bronze Age. Many individual practices are now submerged within a series of stylistic stages that become a part of the general Cretan development. The leveling of the industry proceeds steadily after about 2000 B.C. until by the Late Bronze Age it is nearly complete; LM IIIB is a standardized *koine*.

This is not to say that regional styles do not exist. On the contrary, they are very much a part of the Middle Minoan picture (Walberg 1983). In the east, the vases from Palaikastro to the area of the Gulf of Mirabello have many points in common. At Malia, the style shows affinities with vases from the Lasithi Plain and south to Pyrgos Myrtou on the south coast. Knossos and other north central sites have a related tradition, while the Mesara and its neighboring regions goes its own way. In the west, the styles are different as well. These regions, centering around the efforts of a palace, may

be of profound importance for the economic and perhaps political history of the period. They suggest a balance between regionalism in detail and a general progression that was common to the island as a whole.

MIDDLE MINOAN IA

Middle Minoan IA is the last period in Crete to use only handmade pottery. Its decorations are conservative, with linear motifs and many survivals from the Early Bronze Age. The shapes, made on turntables with extensive wet working, are traditional as well. New ideas include the cylindrical cup, the rounded cup with thin strap handle, the handmade carinated cup, and new types of jugs and goblets. A varied and creative ornamental repertoire uses polychromy, barbotine, modeling in three dimensions, dark painting on an unslipped surface, simple white lines, and even incising.

One of the most easily seen indications of the new period is the introduction of red paint for decoration (Hood 1971A: 39). The new practice distinguishes most large deposits from the EM III contexts, but individual pieces occasionally pose problems; not all vases use red, and the light-on-dark style of EM III continues to be used alongside the newer polychrome technique. In eastern Crete, where the EM III White-on-dark Ware is particularly creative, the early style seems to have persisted well into the Middle

Bronze Age (for lists of EM III vases in MM I contexts and *vice versa* see Warren 1965: 25-26; see also Betancourt 1977A: chart on p. 351). The situation implies a central Cretan origin for MM I, presumably at the palaces, but this cannot be the entire picture. Early Minoan III from Knossos is staid and conservative in comparison with the dynamic innovations of the eastern sites, and although the mechanisms of transmission are still unclear, there can be no doubt that east Crete exerted a major force in the formation of the new tradition.

Deposits from Patrikies (Bonacasa 1967-1968; Levi 1976: I 747-756) and Drakones (Xanthoudides 1924: 76-79) help define the MM IA style for the Mesara sites (Fig. 47). Patrikies, a small hamlet between Phaistos and Aghia Triada, seems to have been destroyed just before the introduction of wheelmade pottery. The complex of two tholoi and some smaller accessory buildings at Drakones is from about the same time.

At Knossos, the area in and around the palace is the most important locale. The MM IA style has usually been defined by the pottery found in three houses beneath the Kouloures, some pits of unknown purpose found in the West Court (Pendlebury and Pendlebury 1928-1930; Evans 1921-1935: I 172-175, figs. 122 and 123a; IV 82-87 and figs. 45 and 50-53; Andreou 1978: 26-54). Most of the ceramics is in a uniform MM IA style, but the inclusion of complete vases from EM II and the presence of a few sherds from wheelmade carinated cups (Andreou 1978: 26 and 29, where they are regarded as "intrusive") cast doubts on the integrity of the contexts. Similar pot-

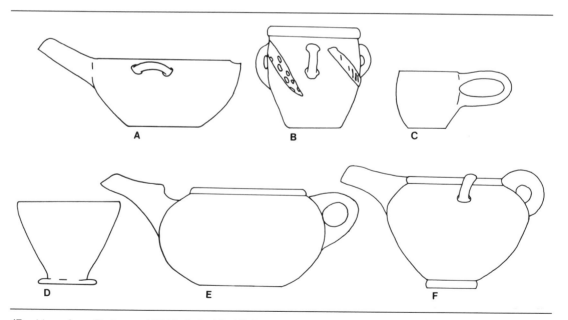

47 · Vases from Drakones, MM IA, Scale 1:3. (A) Spouted bowl; (B) Jar; (C) Cup; (D) Conical cup; (E) Teapot; (F) Bridge-spouted jar.

tery comes from a deposit in the Basement of the Monolithic Pillars, also called the Dove Vase Deposit (Mackenzie 1906: 244-248 and pls. 7 and 9; Evans 1921-1935: I fig. 107). This material, however, was not stratigraphically sealed (Andreou 1978: 30). One can place more confidence in deposits found south of the Royal Road where the presence of a phase with polychrome decoration but with no wheelmade pieces is undeniable (Hood 1965).

Confirmation of the Knossian style comes from the cemetery at Arkhanes where Building 19, a rectangular house tomb, has yielded several handmade vases like those found at Knossos (Sakellarakis and Sakellarakis 1976: 371-385). The tomb had two stratified Middle Minoan levels, the lower one dating to MM IA-B.

In eastern Crete, good MM IA deposits come from Pyrgos, Myrtou (Cadogan 1978: 71 and figs. 6-7, Phase IIa-b) and from Roussolakkos Block Khi at Palaikastro (Sackett, Popham, and Warren 1965: 251). Red bands and accessory details associate the style with the other MM IA groups, and new shapes and decorations separate the pottery from EM III. No other pure MM IA deposits are published from the eastern part of the island.

Even less is known of western Crete. Middle Minoan IA, while present, cannot be defined from large ceramic assemblages. The isolated vases that are known suggest it is similar in style to the rest of Crete.

Middle Minoan I is mainly characterized by conservative but diverse pottery; it is an age of experiment and variation. White-on-dark Ware continues, especially in the east. A Dark-on-light Style, with designs painted directly on the buff surface of the clay, is popular everywhere.

In central Crete, vases are incised with simple decoration (the Incised Style), while others have raised ridges and other early Barbotine Ware ornament. Modeling in three dimensions also continues. The most distinctive of the new styles, however, is the earliest stage of Kamares Ware, a tradition using red and orange paint along with white. Most of the decoration is still linear, but it is more complex than in EM III, with new patterns of several types. Early Minoan motifs continue, with throwbacks to Early Minoan II and earlier, suggesting inspirations from woodworking, textiles, or other perishable objects that could have preserved traditional decorations. Sometimes the paint is chalky white, somewhat different from that used in EM III.

Most MM I shapes are efficient and functional (Fig. 48). A majority are inherited from the Early Bronze Age, but a noticeable change can be seen in the Middle Bronze Age versions. Their shapes are quieter and more practical, and exaggerated details like long spouts and high bases have disappeared (compare the MM I teapot in Pl 5J with the EM IIB and III examples). Creativity and experiment exist in the decorative systems, but when a shape is found to work well it tends to be repeated so that subtypes are abandoned.

As in EM III, drinking cups outnumber all other shapes. The most common type is the conical cup, a small handleless shape made in several varieties (Fig. 49). It is one of the standard shapes of Cretan ceramics, and hundreds or even thousands have been found in some houses, suggesting a consumable use like toasting followed by the smashing of the containers. The earliest Middle Minoan examples are irregular and rather uninspiring, with diagonal ridges from a hasty manufacture. By MM IB they are joined

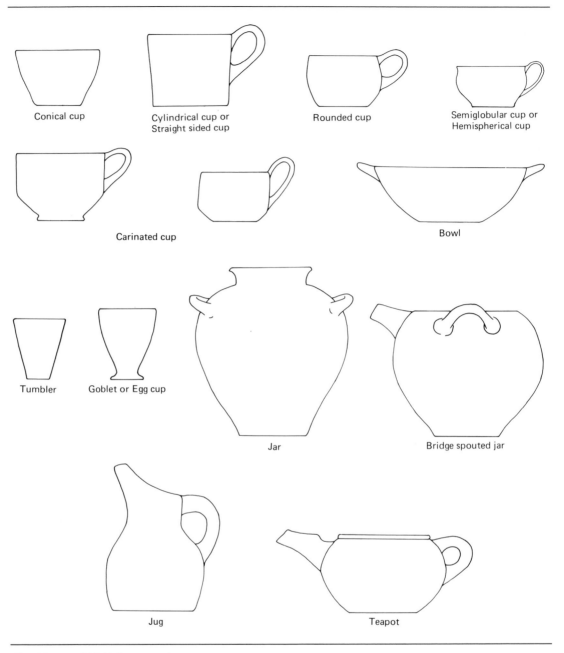

Conical cup

Cylindrical cup or
Straight sided cup

Rounded cup

Semiglobular cup or
Hemispherical cup

Carinated cup

Bowl

Tumbler

Goblet or Egg cup

Jar

Bridge spouted jar

Jug

Teapot

48 · Names of MM I fine ware shapes.

by a few wheelmade cups, and the MM II shape is thin and finely made (Fiandra 1975).

Tall conical cups are called tumblers. Usually without handles, they are often decorated with a single band of dark or white paint (Pl. 5D). More attractive designs also occur occasionally, and one class is mottled from the firing, recalling some of the more informal mottled effects from EM IIB (for a good color photo see Zois 1969: pl. B lower right).

Closed shapes are less extravagant than in earlier ages. Jugs usually have small and narrow spouts, with the neck set off from the shoulder by a sharp juncture. A common type at Knossos, typical of both MM IA and IB, has a dark "butterfly motif" on the front (Pl. 5I). Rarely, the mouth has a trefoil shape (Evans 1921-1935: IV fig. 53 no. 4). A squat shape, as in Figure 51, also appears sometimes. Jars are varied. The bridge-spouted types continue without a break, and plain or

49 · Conical cups, MM I, Scale 1:3. (A) Kommos; (B) Malia; (C) Knossos; (D) Aghia Triada; (E) Knossos.

Goblets are popular, especially at Knossos and other sites in north central Crete (Pl. 5E and F). They also occur in the west (for Galatas see Hood 1965: 108), but they are rare from east of Malia. The shape has developed a little; it is usually angular and less rounded than in EM II and III. Few examples persist into MM IB.

Cups with handles continue, often with the appendage simply added onto the usual rounded or conical form (Pl. 5G). In contrast with the heavy coils of the Early Bronze Age, the Middle Bronze Age handles can be thin and delicate. New shapes include the cylindrical cup (Fig. 50 left) and the handmade carinated cup (Pl. 5H).

50 · Two vessels with simple white decorations, from MM IA, Scale 1:16. (Left) Cylindrical cup from Mokhlos, from a deposit beneath House D; (Right) a jug from Palaikastro.

51 · Squat MM I jug painted with linear designs in red paint, from Priniatikos Pyrgos, Ht. 9 cm.

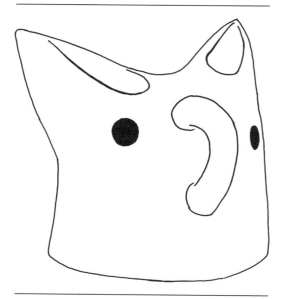

52 · Double-spouted jug from Koumasa, Date uncertain, EM to MM II, Ht. 11 cm.

side-spouted jars are also made. Teapots have spouts of the short variety, and bases are uncommon (Pl. 5J and Fig. 47E). Other closed shapes include the amphora and the jar with horizontal handles (Evans 1921-1935: IV fig. 52).

Perhaps because they respond to the same concerns, cooking and storage vessels continue earlier traditions. Deep bowls, usually with three legs with flat oval cross sections, are still used for cooking, along with shallower trays and dishes (Betancourt 1980). Their clay is always tempered to make it coarse and gritty, probably to minimize the thermal shock caused by uneven heating during use. Jars, pithoi, coarse jugs, and other domestic shapes are used for storage.

As in earlier times, tomb offerings require special products. The double vase from Koumasa in Figure 52 is usually dated earlier, but examples from Phaistos suggest the type is more likely from the Middle Bronze Age. It resembles a curious head with hollow ears for pouring, a resemblance that is probably accidental because the shape is more like two jugs joined together; it is made as a single body with two spouts.

Perhaps the strangest shape of the era is the "sheep bell" (Fig. 53 and Pl. 5K). This curious object has caused a considerable amount of speculation. It is somewhat bell shaped, with a hollow interior, two tiny horns at the upper corners, and a small handle. The top has two perforations. Some pieces are single while others are joined as pairs. Evans believed the objects really were bells (1921-1935: I 175), with the small holes suggesting a string for a clapper. Pendlebury, on the other hand, thought they were lids for vessels (1939: 107). Hazzidakis regarded them as votive costumes (1921: 73; 1934: 104-105), while Franchet suggested idols

(in Hazzidakis 1921: 73 n. 1). No real evidence for an identification exists, and they remain a mystery.

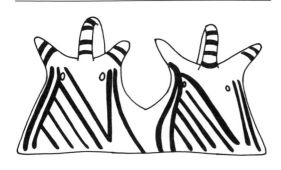

53 · A double "sheep bell" from Knossos, probably MM I, Ht. 6.5 cm.

Only a few imports and exports are known (Rutter and Zerner 1984). A handmade Early Helladic III/Middle Helladic I bowl, made of Gray Minyan Ware, has been found in a MM IA level at Knossos (Hood 1971B). It seems to come from some site in southern Greece. On the other side of the coin, MM IA sherds are found in the earliest Middle Helladic levels at Lerna, the earliest in a long series of Minoan finds from the Middle Bronze Age strata at this site (Caskey 1960: 299; Zerner 1978: 163-178). Sherds that may be this early come from Asine (Frödin and Persson 1938: 277-278), Aghios Stephanos (Rutter and Rutter 1976: 31 no. 140), and a few other sites. Except for a bridge-spouted jar from Lapithos, in Cyprus, which is either from MM IA or IB (Grace 1940), none of the eastern finds of Middle Minoan pottery seem to be this early.

MIDDLE MINOAN IB

The potter's wheel becomes widespread in Crete at the beginning of MM IB. It makes a good chronological peg because wheelmade products are easily recognizable, even in small sherds; their thin walls and horizontal finger marks are usually unmistakable (for the suggestion that the wheel is the best indication for MM IB see Warren 1980: 492). The new style's possibilities may be quickly appreciated if a handmade carinated cup is compared with its wheelmade counterpart (Fig. 54). The handmade effort,

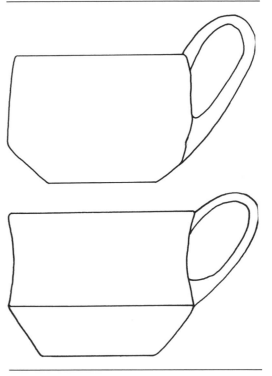

54 · A handmade and a wheelmade carinated cup, both from Vasilike, MM I-II, Scale 3:10.

with thick walls, a rounded carination, and a heavy handle, seems clumsy beside the more graceful shape of MM IB-II. The wheelmade version is slightly concave above the carination and convex below it, creating a taut, crisp form. It is easy to see why the new cup became popular as soon as it was invented.

Curiously, the potter's wheel was known in other parts of the Aegean for many years before it reached Crete. It was used on the Greek mainland by the time of Lerna IV (Caskey 1960: 295), in northwest Anatolia by the time of Troy II, and in Cilicia by Early Bronze III (Mellink 1965: 115, with references). Even after the Minoans learned of the wheel, they did not accept it overnight. The earliest examples seem to be a few miniature handleless cups from the MM IA strata at Knossos. By MM IB many other shapes—especially the carinated cup—join the repertoire, but the MM IB and IIA deposits indicate that most households of this time used handmade and wheelmade pottery side by side.

The Minoan wheels must have been chiefly of perishable materials because the only surviving parts are heavy discs of coarse clay (Pl. 6A). First discussed in detail by Xanthoudides (1927), the discs, called bats, survive from a large number of Minoan sites. They are always hollowed out and roughened on the bottom to make a better bond with a head on top of an axle. Their weight is considerable, a helpful trait in building up kinetic energy when the machine was in use. The upper surface where the lump of clay would be centered is always smooth, and it often shows signs of wear, indicating the potter worked directly on top of the bat.

The discs were probably used as the upper parts of fairly simple machines

(Fig. 55). If they were stuck to the head of the axle with clay, the whole unit would spin together. A pivot for the bottom of the spindle and some means to keep it steady would be essential, but a separate flywheel to maintain the spin would not be absolutely necessary with a heavy clay slab like those used by the Minoans.

55 · Theoretical reconstruction of a Minoan potter's wheel. The bat, of fired clay, is attached to the head of the axle with moist clay. The remainder of the machine, including the strut to steady the axle, would be of wood.

Homer knew of a wheel set close to the ground, so that the potter had to sit or crouch:

> . . . they would run very lightly, as when a
> potter crouching makes trial of his wheel,
> holding it close in his hands to see if it will
> run smooth.
> (Iliad XVIII, 598-600, trans. by Richmond Lattimore, by courtesy of the University of Chicago Press)

Similar low wheels are known from Egyptian models (Johnston 1974: cover and fig. 6) and wall paintings (Lucas 1962: 318), and from Classical Greek

vases (Noble 1965: fig. 78). Sometimes a young apprentice turns the wheel, or it may be rotated by the potter himself. A similar machine, still used as a turntable by the folk potters at Thrapsano in central Crete, is shown in Plate 6B. The Thrapsaniote wheel is used as a turntable (not as a potter's wheel), but the general construction may be similar to the ancient wheels.

A kickwheel, as is usually used today, has been proposed for Bronze Age Palestine (Johnston 1974: 99-100). In the Old Testament the wheel is referred to in the dual (Jeremiah 18:3), possibly suggesting a double arrangement with a separate flywheel or kickwheel, and a wheel spun by the feet is mentioned in Ecclesiasticus (Ben Sirach) 38:29 (for discussion of the subject see also Kelso 1948). Although a kickwheel cannot be rejected out of hand for Minoan Crete, there is no evidence at all for its use in the prehistoric Aegean or Classical Greece, and it is more likely the machines were simpler and turned by hand.

The major difference between turntable and potter's wheel does not lie in the method of turning but in the way the wheel is used. If a heavy wheel is placed on a stable pivot, it can be used to build up centrifugal force to a point where the potter simply manipulates the clay while the force of the spin does much of the work. Both the speed of manufacture and the symmetry of the finished product are increased immensely.

If one begins MM IB with the first wheelmade shapes, several of the deposits usually termed MM IA must be moved to this later period. In this category are the Vat Room deposit at Knossos (Evans 1902–1903: 94-98 and figs. 65-66; 1921-1935: I 165-170), some of the pottery from the tomb groups at

Gournes (Zois 1969), the South Houses at Malia (Chapouthier, Demargne, and Dessene 1962: 13ff.), and probably the latest pieces in the rooms beneath the Kouloures in the West Court at Knossos (see above). Several deposits from east Crete are approximately contemporary: House B at Vasilike (Seager 1906-1907: 126ff.; Betancourt 1977A: 345-346); a deposit below House D at Mokhlos (Seager 1909: 290-293 and fig. 13 upper row); Period IIc-d at Pyrgos, Myrtou (Cadogan 1978: 71); and Seager's Period IV at Vasilike (1904-1905: 211, 218-220; 1906-1907: 118-123). The presence of a few MM IB sherds in these groups means they were buried after the introduction of the potter's wheel, but often the majority of the pottery is handmade; the styles obviously overlapped, and it is also likely that many of the contexts span both periods.

Decoration is now becoming more varied. While the Incised Style declines, the Dark-on-light Style continues to be popular. White-painted linear decoration continues in vogue, with several new variations. Some of the designs are very simple, but others are much more complex than in EM III (Fig. 56). Among the new motifs are some strikingly innovative plays on the traditional spirals, quirks, and arcs, designs that mark the first efforts of the complex Kamares Ware repertoire.

Polychromy is just coming into its own. The earliest Kamares Ware uses motifs with a larger range than in MM IA. Spirals, whorls, and petals are common; a few motifs suggest the floral kingdom, and some of the Kamares Ware pots experiment with torsion. Barbotine Ware is becoming more popular. It occurs in many varieties, especially on jugs, usually in combination with white or polychrome painting.

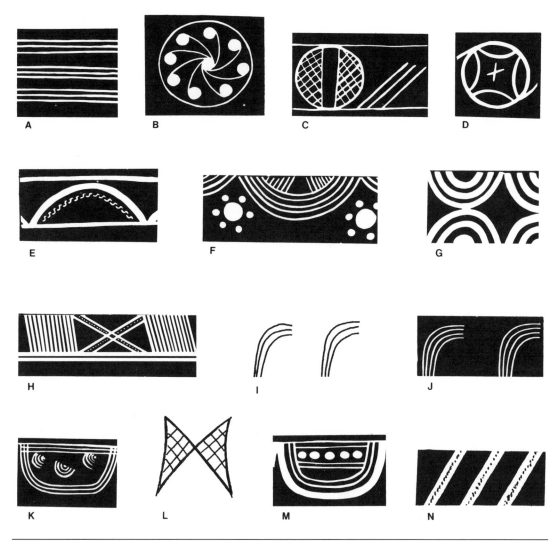

56 · Middle Minoan I motifs.

Many of the shapes look like they were inspired by metalwork. Almost from the beginning, some of the wheelmade pieces are thin enough to be called "eggshell ware." Sharp metallic carinations are used on cups and other small shapes, handles are thin, and undulating rims and small rivet-like pellets also occur. All of these traits are characteristics of metal vases. Certainly the ceramicists were aware of the attractive characteristics of the contemporary shapes in bronze and precious metals, and a relation is highly likely.

New patterns are visible in the overseas connections. In the Cyclades, the second stage of the second city at Phylakopi on Melos may be correlated with the period

both from finds on Melos and at Knossos (Hood 1961-1962: 94; Renfrew 1972: pl. 13 no. 2). Contacts with the Greek mainland continue as well, and several Minoan imports come from the middle phases of Middle Helladic at Lerna (Caskey 1957: pl. 43c). One can also trace contacts with the East. In Cyprus, a bridge-spouted jar (MM I) has been found in an Early Cypriot III tomb at Lapithos (Grace 1940). The evidence from the pottery is nicely complemented by eastern imports and exports in other materials, especially seals (discussed, with bibliography, by Ward 1971: chap. IV; 1981). It is tempting to see this exchange as the first efforts by the new Minoan palaces, a reaching out for the raw materials and overseas markets that would soon put Crete in the forefront of Aegean commerce.

Naturalistic modeling either uses small figures added in three dimensions or shapes the whole vase as a miniature sculpture. The style is too varied to be regarded as a unified ware, but it is a persistent tradition throughout the island.

An important group consists of bowls with small figurines in the interiors like the bowl in Plate 6C. Since it comes from a badly disturbed tomb near Palaikastro, the piece cannot be dated by the context, but the decoration on the exterior suggests MM IB-IIA. Nearly 160 tiny animals are neatly arranged inside. They look like sheep, and the shepherd, who comes behind them, must be proud of his well-ordered flock. Several other bowls from Palaikastro have birds or other figures inside them (Evans 1921-1935: I 180-181; Bosanquet and Dawkins 1923: 12), and a related piece comes from Sphoungaras (Hall 1912: fig. 29).

A different type of modeling is illustrated in Plate 6E. Here the entire vase is shaped like an animal, a bull with three tiny "bull leapers" on the head and horns. The body is hollow, with a hole in the muzzle for pouring out the liquid. It is one of a long series of bulls and other animals in the form of vessels. The shape is often called a rhyton, though the term "askos" fits better because the word "rhyton" (from the Greek "to flow") implies a container with a hole in the bottom so that liquid can flow out continually.

The bull with the small acrobats comes from Koumasa. Its dark bands, schematized animal body with only three legs, and minimal detail suggest an early date. It can be no later than MM IB, and it may even date from the closing years of the Early Bronze Age. The vase is important as one of the earliest bits of evidence for the Minoan sport or ritual of "bull leaping," well known from later gems, paintings, and other representations. Its sprightly and witty spirit—note the postures of the frightened little humans clinging on for dear life—is vivid testimony to the charm of some of this early Minoan art.

Several decorative styles are particularly associated with MM I. Among the most important are the Incised Style, the Middle Minoan Dark-on-light Style, and Barbotine Ware, discussed in this chapter. In addition, the last stages of the White-on-dark Ware (discussed in Chapter 6) and the initial period for Kamares Ware (discussed in Chapter 8) are used to advantage.

THE INCISED STYLE

One of the most interesting developments of MM I is the revival of the ancient practice of incising. One of the

mainstays of the Cretan Neolithic, the technique continues to be popular in EM I and EM IIA, but except for an occasional exception, it is eclipsed by other styles in the final years of the Early Bronze Age. It now emerges as a new style, particularly in contrast with other types of decoration.

The chronology is established by finds at Patrikies (Bonacasa 1967-1968: fig. 33) and the Kouloures at Knossos (Evans 1921-1935: IV fig. 53 nos. 1-2). Several examples come from north central Crete, from Knossos and nearby sites like Arkhanes (Sakellarakis 1972A: fig. 108). Although the style is most common in MM IA-B, an occasional version persists into later times.

The shapes are often thick walled and somewhat squat. Jugs conform to the usual MM I type, with a small upturned spout and the neck set off from the shoulder (Pl. 6D). Cups can be heavy and rather clumsy looking (Evans 1921-1935: IV fig. 53 no. 1; Sakellarakis 1972A: fig. 108; Sakellarakis and Sakellarakis 1976: pl. 219 no. 2). Other shapes include the goblet (Pl. 6F), the jar (Marinatos 1929B: fig. 9 no. 24 and fig. 10 no. 5), the spouted jar (Demargne and Gallet de Santerre 1953: pl. 50 no. 9233), and the teapot with a long spout but no base (Zois 1969: pl. 46).

The incisions are nearly always used as area-filling patterns. Straight lines seem to be preferred, and in most cases the designs are built up from just a few strokes (Fig. 57). Zigzags, diagonals, hatched or crosshatched areas, short dashes, and punctations are the most common motifs. The usual system employs them as bands, contrasting the incising with plain spaces or zones of white patterns or some other decoration.

The well-preserved jug from Knossos

in Plate 6D shows the style at its best. The incising is confined to a single zone at the widest part of the body. This effectively breaks the shape up into a series of horizontal friezes in which negative space, like the undecorated upper shoulder and lower body, plays an important role. The white designs are typical of MM IA-B.

57 · Motifs of the Incised Style, EM III-MM IA.

The goblet in Plate 6F is more experimental. A descendant of the EM III egg cups, it has two small wishbone handles at the sides. Although it also comes from Knossos, its ornament is less successful than the jug in Plate 6D. The body is broken up into two panels, one with diagonal painted zigzags flanked by triple bands and the other with incised crosshatching above and below two white butterfly motifs. The whole effect is busy and a little disjointed, fitting poorly with the shape of the goblet.

Incising enjoys only a brief revival. By the end of MM IB it is out of fashion, re-

placed by the more striking polychrome effects. It will never again be popular in the Cretan Bronze Age.

BARBOTINE WARE

Barbotine, a French word, is used in ceramics to signify rough plastic relief on the surface of a clay vessel. It is often used as ornament in the Middle Minoan period, especially for jugs with round bodies and small raised spouts. It is most popular in the south. The style has been examined briefly as a part of excavation reports and other studies, and it is the subject of a monograph by Karen Foster (1982).

Vases with rough prickly surfaces are already present at Phaistos by the Final Neolithic period (Vagnetti 1972-1973: fig. 121). Raised clay ornaments appear intermittently during the Early Bronze Age, but the style is not really popular until around 2000 B.C. Its height of popularity comes in MM IB to IIA.

Most Barbotine Ware is found in central Crete. Phaistos seems to be a center of production, and many examples come from the palace and its vicinity (Levi 1976: I). A substantial number have been excavated from Knossos and elsewhere in the north, but the ware is rare in east and west (for eastern Crete see Hawes et al. 1908: pl. 6 no. 23; Bosanquet and Dawkins 1923: pl. 14f.; Zois 1965: pl. 13 no. 4715; for western Crete see Tzedakis 1967: pl. 375 no. 5).

Several types of barbotine decoration exist. Wave Barbotine consists of long ridges, either applied or worked up from the surface of the vase (Fig. 58A). Dabs of slurry, called Barnacle Work, are usually applied to broader areas (Fig. 58B). Small points of clay are known as prickles (Fig. 58C). Other classes, like strips (Fig. 58D) or simple knobs of clay (Fig. 58E) are less common. Representational relief work, a persistent tradition in Minoan ceramics, is not part of the ware as defined here.

58 · Types of barbotine decoration. (A) Waves; (B) Barnacle Work; (C) Prickles; (D) Strips; (E) Bosses.

Wave Barbotine can be applied horizontally, vertically, or diagonally. Sometimes the ridges are straight and rather stiff, but they can also be more organic. Among the earliest examples are some goblet fragments from Kythera (Coldstream and Huxley et al. 1973: 84-85). They have horizontal ridging and are probably from about EM II-III. More typical are a group of later vases from Drakones with slightly sinuous waves that curve from neck to base (Fig. 59). Some of the waves are plain while others have serrated edges. Their curves suggest the

circular motion of the turntables on which the jugs were made, and the torsional movements complement the shape of the rounded bodies.

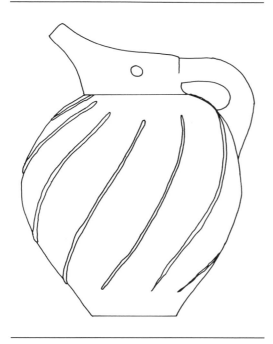

59 · Wave Barbotine jug from Drakones, MM I, Ht. ca. 20 cm.

The best known type of barbotine decoration is the texture Evans christened Barnacle Work because he supposed an origin in rough marine growths (1921-1935: IV 100-102). It is made by dabbing a thick slurry onto the vessel and lifting the fingertips repeatedly to make small round dabs (Pl. 7A). The surface varies from high and rough to low and patterned, and a tool may have helped to push the slurry around on the vessel (Foster 1982: 3).

Barnacle Work is already present at Patrikies (Bonacasa 1967-1968: fig. 35 nos. 3-4; Levi 1976: I fig. 1207) and the houses beneath the Kouloures at Knossos (Evans 1921-1935: IV fig. 54c). In these early examples the texture is often rough and irregular, filling selected areas that contrast with smooth surfaces on the same vessels. The decoration is often combined with painted ornament, a system reaching its height in MM IB and continuing into MM IIA. By the second half of MM II, Barnacle Work has been almost abandoned.

Prickles are longer lived. Used as area textures or as rows of points, they begin in the Early Bronze Age and persist throughout Middle Minoan. Examples are shown in Plate 7B-E. Usually, as here, they form patterns on the shoulder as well as on the rim and handles. Painting in red and white is placed both on the dark ground and across the rough designs. The rhyton from Zakros (Pl. 7D) is a very unusual piece. One of the few Barbotine Ware pieces found in eastern Crete, it combines prickles on the upper shoulder and body with dark chevrons on the lower body. Its date is uncertain but may be as late as MM III.

Foreign sources for some of the Barbotine Ware types have occasionally been proposed. Both prickles and scale-like patterns are used in Anatolia in Early Bronze I-II (Lloyd and Mellaart 1962: 127, 131, and pls. 17b and 18a-b), leading some scholars to suggest an eastern origin (Coldstream and Huxley et al. 1973: 84). Designs that look like Wave Barbotine come from areas north of Greece (see Matz 1928: fig. 86 and Schachermeyr 1964: fig. 18, with discussion). Waves, however, could easily be suggested by the turning motions of turntables or potter's wheels, and, like

the Anatolian parallels, the comparisons might be accidental.

Evans supposed the ware was inspired by barnacles, coarse marine growths, or rough sea animals like the thornback crab or the spiny oyster (Pl. 7H). Certainly the Minoans were well familiar with surfaces left to the talents of Mediterranean sea creatures. Sea urchins without spines are also a possible source, but whatever inspired the first example was soon left far behind. The MM IB syntax is regular and carefully controlled, conforming to the accepted laws of Minoan design. This is an important feature, suggesting the essentially Minoan character of the ornamental system.

A selection of Barbotine Ware motifs is shown in Figure 60. The designs are seldom simple areas; more common are typical Minoan motifs like chevrons, spirals, lines, or bands. Since the roughly modeled surfaces use the same designs as the painted vases, in the same syntactical arrangements, they must all be regarded as part of the same tradition. In fact, most of the barbotine vases also use painted designs to complement the textures. Paint is also applied on top of the barbotine, especially the Barnacle Work. White or black dots laid over the textures are especially typical of the floruit of the style.

In spite of its interesting designs, Barbotine Ware does not conform much to modern ideas of aesthetics. Its irregular surface would be difficult to clean, and most examples are not very pleasant to the touch. The ornament seems harsh and unpleasant. A long list of archaeologists have regarded the ware with disfavor, but surely the makers and users felt differently; the barbotine vases were popular for several generations.

THE MIDDLE MINOAN DARK-ON-LIGHT STYLE

Many Middle Minoan vases are decorated with simple motifs in dark paint. The style, too varied to be termed a ware, employs the same dark slip used as the background for White-on-dark Ware and Kamares Ware. It is found throughout the island. Designs are painted directly onto the pale or reddish Cretan clay, and burnishing is not common. As a result the dark ornament is matte and dull, typical of the dark reduced slip with its red to black iron oxides trapped beneath an incipient vitrified layer.

The style is used mostly for domestic vessels. Dark-on-light storage jars and bowls are common, even at the palaces,

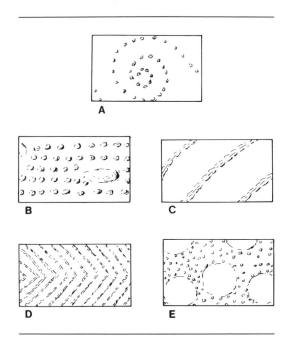

60 · Barbotine Ware motifs from Aghia Triada.

61 · Bowls and other vases in the Middle Minoan Dark-on-light Style from Kommos, Scale 1:3. (A) MM IB; (B-E) MM II; (F-H) MM III.

and in most areas the style is popular for table ware also. The tradition has been examined by several writers, especially Zois (1969A) and Betancourt (1977A).

Aesthetically, the style is only a step above the coarse, undecorated domestic pottery. Designs are often cursory, with many random drips and accidental effects. Even the occasional carefully applied designs use only the simplest of lines. The style, however, illustrates a typical characteristic of Minoan life, a preference for decoration that pervades even the commonest household objects. The Dark-on-light Style lacks the artistic excellence of some of its contemporaries, but it is still interesting craftwork, a quiet backwater from the same time as the more exuberant Kamares Ware tradition.

The origins of the style may be traced to the Early Bronze Age. Dark designs are common in Koumasa Ware and its stylistic cousins, and a few examples are found in the EM III deposits (for the North Trench at Gournia see Fig. 43). The fashion is never completely supplanted by the more elegant light-on-dark technique, and it persists for the entire Middle Bronze Age. It is most popu-lar in deposits dating from MM I. Some motifs, like concentric arcs and parallel chevrons, are particularly associated with this period, while others (triple plumes, trickle ornament, connected discs, and vertical lines) are used for a longer time (for discussion see Betancourt 1977A). The style finally merges with the general tradition of dark-on-light pottery at the beginning of the Late Bronze Age.

Several regional variations may be recognized. They differ both in their vase shapes and in their choice of decoration, suggesting a series of village workshops. The pottery was probably made in quite a few provincial centers, providing for local needs and catering to local tastes.

The vases in Figure 61, from Kommos, sum up the character of the simple style used in the Mesara. Their date is MM IB-III. Dipping is common in this part of Crete, and many of the pieces have their paint applied in this way. Blots or areas of paint, lines, trickle ornaments, and other designs are common.

A selection of miniature jugs from Gournes, in northern Crete, has a totally different style (Fig. 62). Dots, vertical or diagonal lines, and solid upper parts are

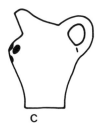
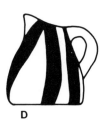

A B C D

62 · Jugs from Gournes, MM I-II, Scale 1:3.

63 · East Cretan vases, Scale 1:3. (A) Jar, Vasilike; (B) Jug, Pseira; (C) Lid, Gulf of Mirabello area; (D) Lid, Pseira; (E) Conical cup, Vasilike; (F) Conical cup, Vasilike, (G) Jug, Sphoungaras; (H) Cup, Sphoungaras; (I) Cup, Vasilike; (J) Jug, Sphoungaras.

common, the latter often made by holding the vase upside down and dipping it into the slip. The tower of plume-like designs in Figure 62A is unique.

In eastern Crete, the embellishment is more varied (Pl. 7F and G and Fig. 63). The style is interesting and diverse, providing a richer range of ornament than in other parts of Crete. Triple plumes, a design composed of hook-shaped lines, is common on jugs (Fig. 63B). Connected discs, a continuous arrangement of joined solid circles, looks like it is derived from the motif of the running spiral. It is common on jars, sometimes disintegrated to the point where the design is no longer continuous (as in an example from Mokhlos, Pl. 7G). Cups and tumblers may have concentric chevrons or arcs (Pl. 7F and Fig. 63I), diagonal lines (Fig. 63E), or simple drips (Fig. 63F), especially in the earlier part of the style. Trickle designs, large ovals, and many other designs occur as well.

The most interesting set of motifs from east Crete, however, is a zoomorphic and anthropomorphic group (Fig. 64). Although the figures are very schematized, they are easily recognizable. They represent some of the first Cretan experiments with painted figures, a tradition that will become more widespread in years to come.

64 · Bird design on a jug from Gournia, MM I-III.

8 · MIDDLE MINOAN II

THE SECOND MIDDLE MINOAN period is the mature phase for the art of the "Old Palaces" at Knossos and Phaistos. Kamares Ware, with white, red, crimson, and orange decorations on a dark ground, reaches new heights of artistic expression. Provincial ceramics either imitates the palaces or goes its own way, following the quieter traditions of MM IB. The Middle Minoan Dark-on-light Style continues, especially for rustic domestic pottery and storage vessels, while Barbotine Ware and the Incised Style decline dramatically. As always, plain wares are used as well.

The MM II contexts indicate a considerable dichotomy between the palatial styles and the craft of the villages. Most of the sophisticated and ornate decorations used at Knossos, Malia, and Phaistos never reach the provinces. Only a few palatial details—polychromy and a handful of fine motifs—interest the outlying potters.

The better pottery of MM II was attractive enough to find its way into an occasional foreign house or tomb. A MM IIA cup was found in a Middle Cypriot I tomb at Karmi (Stewart 1963: fig. 8 and pl. 7). Among pieces from the Nile valley (Kemp and Merrillees 1980), mention has already been made of sherds from Harageh (Engelbach 1923: 10 and pl. 10 no. 15) and Kahun (Evans 1921-1935: I fig. 198; II fig. 119h; Forsdyke 1925: 91-94 and fig. 113; Kantor 1965: fig. 3 nos. 12-13). A bridge-spouted jar with a rosette motif from a tomb at Abydos is probably

to be associated with the time of Senusert III and his successor Amenemhat III (Garstang 1913). A vase with plastic decoration from Qubbet el-Hawa is also of MM II inspiration (Edel 1972; Walberg 1983: pl. 1). Scattered MM IB to II finds come from several other sites in the Near East, including Ugarit (Schaeffer 1937: 144 and fig. 16; 1938: 201ff.; 1939: 54ff.; 1948: 16 and pl. 5J no. 24) and Hazor (Yadin et al. 1960: 91 and pl. 115).

Minoan products also reach the Cycladic and Helladic regions to the north. Local products from as far away as Rhodes imitate Minoan styles, and both Cretan exports and local copies have been found at Asine (Frödin and Persson 1938: 278 fig. 192 no. 1), Lerna (Caskey 1954: pl. 8c-e; 1956: pl. 43a; 1957: pl. 43c), Aghios Stephanos (Rutter and Rutter 1976: 23-26 nos. 19-36 and 28-31 nos. 93-139 and 141-150), and several other sites (Rutter and Zerner 1984). Obviously Minoan pottery was becoming known abroad in increasing quantities, an indication of a trading pattern that may have reached as far as Mesopotamia (Strøm 1981).

But even though the pattern suggests a new market for Aegean products, the quantity of the exports is actually quite small. Minoan craftsmen were somewhat slow in responding to the northern and eastern markets, perhaps because their luxury goods were individual creations that were only produced slowly; they did not lend themselves to mass production.

It would still be some time before Minoan pottery was exported in quantity.

Surprisingly, the two most distinctive fine ware styles of MM II stand at opposite poles. Kamares Ware is elegant and ornate with complex laws of syntax. Its successful capture of torsion and vital movement is still a model of two-dimensional design. The most popular contemporary rival is the Dark-on-light Style (discussed in Chapter 7). Direct and simple, it is the antithesis of the polychrome pottery. Pure chance plays a major role in the decoration, and vases may include drips, splatters, or casual dabs. The painting is often hasty, and compositions are never as carefully planned or as meticulously executed as the work of the fine Kamares Ware artists. Between these two extremes lie the many average pieces, products of the workaday craftsmen who furnish a high percentage of the ceramics of any pottery-using society. Many vases are decorated only in white on a dark background, with relatively simple motifs. Unpainted vases, both for storage and serving, are also found in large numbers.

Typical shapes are shown in Figure 65. The most common vessel of all is the small conical cup without handles. It is rare to find a decorated piece. Usually the walls are thin and even, and the shape is well thrown. Typical variations are illustrated in Figure 66.

Plain and coarse vases outnumber the fine wares, with the larger shapes still made by hand. Decoration, when present, is usually in dark paint. It is sometimes limited to just a few strokes (as in Pl. 8B), or it may be a cursory version of some more elegant design (see the grass clumps on the hydria in Pl. 8c).

Lamps are of several types. The simplest design continues an Early Minoan tradition, with a small bowl and a pulled-out spout for a wick (Fig. 67). Handles are loops, straight rods, or simple knobs. Other lamps are larger, with one or two wick cuttings, and sometimes with a base.

Cooking vessels are a regular feature of Minoan life. Sherds from Kommos, shown in Figure 68, illustrate two common shapes, shallow vessels (called cooking trays) and deep bowls (called Type B tripod cooking pots). Both are supported by clay legs. The class often has burn marks—carbon and dark discolorations—on the underside and the exterior from being set over fires. Deep pots like the one at the right in Figure 68 would be restored with two opposed handles and an open spout at the rim; the shape is used without a break until LM IB. The only other Kommian shape with regular evidence for use over fires is an open dish with a rounded bottom; it is not normally supported by legs and may have been set over coals or embers. The cooking vessels from this site have been studied in detail in a short monograph (Betancourt 1980).

Pithoi continue to fill the need for storage in large quantities. The example from Phaistos in Plate 8A is distinctive because of its broad shape and knobbed decoration. It has raised bands called ropework, a trickle decoration in dark paint, and an unnecessarily large number of handles; it is certainly an unusual piece.

MIDDLE MINOAN IIA

The most useful context for the chronology of MM II is a series of superimposed floors from the Middle Minoan levels at Kommos. The clear stratigraphy at this site permits a division between MM IIA and IIB, putting the finds from nearby Phaistos into better perspective

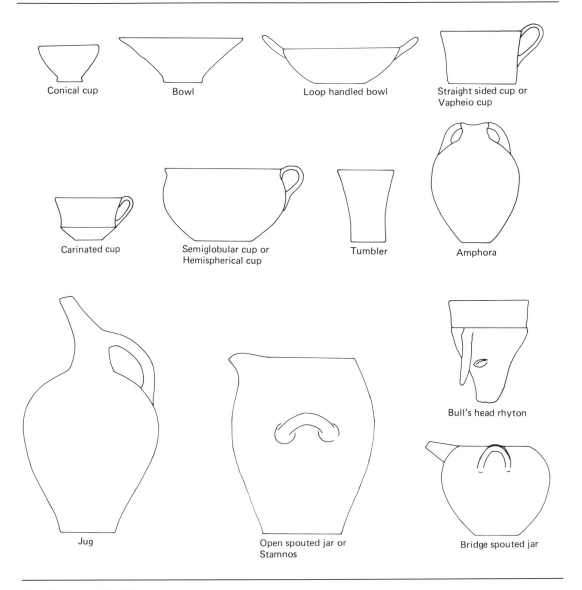

65 · Names of MM II fine ware shapes.

(Betancourt 1984B). The Kommian stratigraphy shows that the earliest stratum in south Crete with carinated cups and other wheelmade shapes—which must date it to MM IB—has only a tiny percent of wheelmade pottery alongside a style otherwise indistinguishable from MM IA. The next phase, with more wheelmade pieces and with the beginnings of the Kamares Ware style, can be termed MM IIA. It has many points of comparison with Phase IA at Phaistos (Levi 1976), but Phase IA at the palace also seems to be mixed with MM IB material as defined from the stratigraphy at Kommos. At Knossos, it is possible that the MM IB and MM IIA periods as defined by A. J. Evans are also part of the

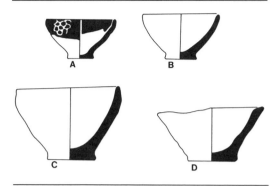

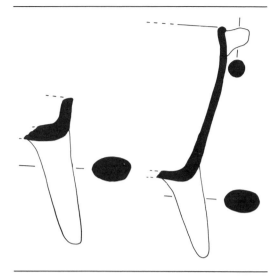

66 · Conical cups from Kommos, MM II, Scale 1:10. The most common type is B.

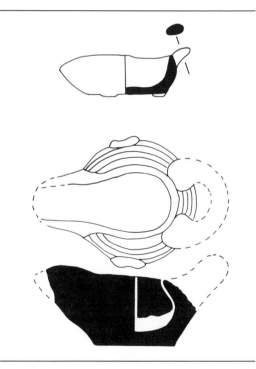

68 · A cooking tray (left) and a cooking pot (right) from Kommos, MM II, Scale 1:4.

67 · Hand lamps of Middle Minoan type, Scale 1:3. (Above) Sphoungaras, date uncertain; (Below) Kommos, MM III.

same period (S. Hood, personal communication). A good Knossian deposit for the MM IB/MM IIA stratum came from beneath the West Court (Evans 1921-1935: I 186-189 and figs. 135-136, then called MM IB). Most pieces are wheelmade cups and bowls. Both straight-sided and semiglobular cups are present. The carinated cup is found, but it is not as popular as the other two types. Many plain conical cups (without handles) are also in the assemblage. Conservative features include parallel striations from cutting the vases off the wheel, semicircles and other simple decorations in white paint, and shapes like the "sheep bell," a continuation from MM I. From the quantity of the wheelmade pottery, however, it is clear that the deposit comes from well after the machine was introduced, and the style agrees exactly with MM IIA at Kommos.

Examples of the MM IIA style are shown in Figure 69 and Plate 8. Plain and scantily decorated wares are common

in this period, even for table wares. The fine painted pieces have already begun to use some of the elegant Kamares Ware motifs, but they are not as elaborate as they will be in the next period. Holdovers from MM IB include circles, dot bands, chevrons, and other simple designs. The style has already begun to develop, and only a small step is necessary

MIDDLE MINOAN IIB

The second part of MM II is the main period for Kamares Ware, one of the most beautiful wares of the ancient world. The chronology can only be distinguished at central Cretan sites that are associated directly with the palace workshops; provincial MM II is a cursory ver-

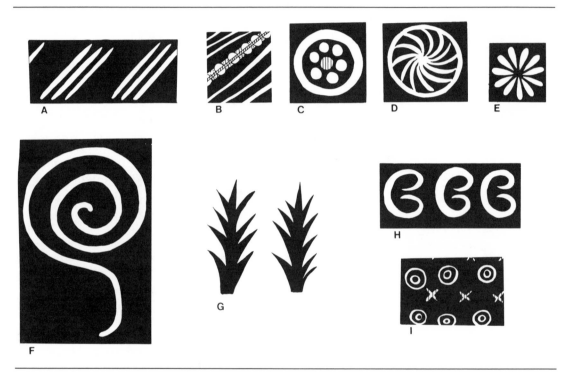

69 · Middle Minoan IIA motifs.

to reach the elaborate phase of MM IIB. Walls are sometimes turned to surprising thinness, so that Evans christened one group "eggshell ware." An example is Plate 9G, a carinated bowl with an undulating rim, thinner and more delicate than any previous pottery.

sion of the fine palatial styles (Walberg 1983). At Phaistos the palace experienced a major destruction, and many whole vases have been published from the MM IIB style (Levi 1976: I, most of Phase IB and Phase II). Knossian MM IIB-IIIA comes from the room of the Olive Press

(Mackenzie 1903: 179-181); the Royal Pottery Stores (Evans 1921-1935: I 240-247 and pl. II), and a few other places. At Malia, fine Kamares Ware and other MM IIB pottery has been found in Quartier Mu (Poursat 1972; 1973; 1975; 1980A; 1980B). These contexts are augmented by finds from a few smaller sites like Kommos (Shaw 1979: 159). The provincial contexts, however, are difficult to date; House A at Vasilike can be anywhere from MM IIA to early MM III (Seager 1906-1907: 123-126; Betancourt 1977A: 346), and a similar situation exists elsewhere.

The pottery of MM IIB is illustrated in Plates 9A, C-F, and H-J, 10, 11, and 12A-F and H. Much of the fine ware can be classified as Kamares Ware by its fine polychrome decoration. Other styles, especially the Middle Minoan Dark-on-light Style, are popular as well. The pottery has matured considerably in both its potting and its decoration, assuming an artistic role seldom encountered in prehistoric cultures; many vases are not craft items so much as high art.

Kamares Ware

Kamares Ware is a wheelmade pottery decorated with elaborate floral, figural, and geometric designs painted on a dark-firing slip that covers all or part of the surface. It uses several colors, chiefly white, red, orange, and crimson, but other decorate techniques, like barbotine and relief work, are added occasionally. The finest pieces come from the palaces of Phaistos and Knossos and from nearby sites that used the same style (like Kommos near Phaistos). They are major monuments in the history of ceramic art, vessels with eggshell thin walls and brilliant-ly designed patterning, triumphs of potter and painter alike.

The style begins in MM I, reaches its height in MM IIB, and declines in MM III. It has been studied most thoroughly by Gisela Walberg (1976) who divides the polychrome tradition into four phases:

Pre-Kamares

The initial phase in the Minoan polychrome style antedates the introduction of the potter's wheel. Although it begins very early, with the first use of red paint alongside white (MM IA), it already shows some of the characteristics that would be elaborated in later times. The phase persists into the beginning of MM IB (an example is the Vat Room deposit at Knossos where both handmade and wheelmade pots were used side by side, unless the deposit is mixed). Many of the motifs are simple, and most are linear, but torsion is already present, and a use of curvilinear and spiraliform motifs looks forward to the next phase (for the mixed nature see Evans 1902-1903: 94). Many of the pre-Kamares designs seem to derive from disintegrated running spirals. Closed vessels often have a high maximum diameter, and many depressed globular-conical vessels occur. The most typical Kamares Ware shapes—wheelmade carinated cups, straight-sided cups with concave sides, semiglobular cups, and squat, rounded bridge-spouted jars with thin walls—appear only at the end of the phase.

Early Kamares

As has been noted, the introduction of the potter's wheel in MM IB has a major impact on the Cretan shapes. Walls become thinner, lines crisper, and curves

more sweeping. New details (like the thin ribbon handles) and new shapes (like the mature carinated cup) now make their appearance. Closed vessels continue the tradition of the Pre-Kamares style, but they are more taut and a little less angular. Running spirals have a resurgence after the disintegration of the Pre-Kamares style. Many new motifs are used, and the foundations for the next phase are firmly laid.

Classical Kamares

The mature phase of the polychrome tradition may be dated to MM IIA and IIB. It is essentially a palace style. Although polychrome vases exist from outlying areas, they are mostly pale reflections of the dynamic developments at Phaistos, Malia, and Knossos, and it is clear the palatial workshops were the most important influence. Shapes of closed vessels are often more ovoid or more globular than in earlier times, with a lower maximum diameter. Many new shapes appear. Whirling and radiating motifs are common, as are spiral motifs, often elaborated by additional coils or petals. Floral inspiration is much in evidence. The decorative vocabulary is immense, and the elements are often combined in unusual and unique ways. Circumcurrent repeat designs that flow around the vase and facial motifs that decorate one side are both used.

Post-Kamares

Although polychromy continues into MM III, the Kamares Ware style is now obviously in decline. A tendency to attenuation in closed shapes, already evident in some vases from the Classical Kamares phase, continues in this period; a few pieces have an especially exaggerated, tall form. The average maximum diameter is often raised somewhat, and some closed shapes have a constricted lower body. The use of colors other than white declines dramatically. Red is usually restricted to bands or an occasional dot or accent. Rosettes, elaborate spiraliform motifs, and other complex designs are rare. They are usually replaced by large retorted spirals, grass clumps, foliate bands, and other simple white ornament. A new pictorial style with palms, flowers, and other naturalistic effects enters the tradition as well, perhaps as a complement or a reflection of the palatial murals.

Walberg's four phases, of course, are not intended as precise divisions that begin or end abruptly. The styles all merge gradually from one stage to the next, with the line between Early Kamares and Classical Kamares being especially indistinct. If one subtracts the Pre-Kamares and Post-Kamares styles, the term Kamares Ware may be reserved for the more elaborate traditions of Minoan polychrome pottery. This narrow definition is more useful than applying the term to all vases with white and red on a dark background (as has occasionally been done), and it makes the style easier to analyze.

A selection of vases from the early stages of Classical Kamares may be seen in Plate 8 D-H. They all date to MM IIA. The ornament uses a wider variety of motifs than in earlier times, with more floral inspiration. Bulls, as in Plate 8E, are sometimes decorated with white designs. Rosettes normally have rounded petals (Pl. 8F). Although some of the designs are more complex than in MM IB, they seem staid indeed when they are compared with the height of the style in MM IIB.

The elegance of the mature phase may be well appreciated from Plates 9 to 12G. The shapes are now more creative, and the sides are given a greater curvature—either in or out—to achieve a finer effect. The decoration bursts forth with thousands of new motifs and elaborations. Their richness, especially among the curvilinear and floral embellishments, makes the style unique.

The ornament is the most striking feature of the tradition. Since it offers several contrasts with the pool of earlier patterns from which it drew its nourishment, its ambience is quite new. The main characteristics include:

(1) *Polychromy.* The addition of red, crimson, orange, yellow and off-white to the triad of white slip, dark slip, and pale clay opens up a new world of coloristic effects.

(2) *Floral and faunal motifs.* For the first time, plant life and animal life are important in the inspiration of the decoration, resulting in an immediate enrichment of the ornamental vocabulary.

(3) *Complex ornament.* Whereas most earlier Minoan motifs are linear, Kamares Ware regularly covers broad areas with paint, building up complex images from elements that are sometimes linear and sometimes two dimensional. Curvilinear contour and flowing lines are emphasized.

(4) *Complex syntax.* The vessels are planned in ways that had already been developing in Minoan pottery for centuries, but they carry the compositional rules to new heights, often emphasizing specific effects such as torsion, flowing or directed movement, alternating directionals, or whirling imagery.

(5) *Inventiveness.* No complete catalogue for the Kamares Ware ornament can be visualized. Each large excavation adds hundreds of previously unrecorded examples, many of them apparently unique. Creativity and the excitement of the unexpected are regular traits of the style.

Typical Kamares Ware motifs may be seen in Figure 70. They range from simple designs like interlocked crescents (M) to gorgeous spiraliform motifs embellished by petals (A-C, F-J, and AN-AP). Rosettes and other circular motifs may be descended from the EM III circles (O-T). Foliate bands (AG) and several other florals (AH, AL, and AM) are directly inspired from the plant kingdom, while many of the petals and tendrils are indebted to similar sources in a more subtle way. There are imitations of polished stone (AK) and several examples from the animal world (AQ-AU). All in all, the scope is very large.

In all cases, the artists begin by creating a flat composition. This is true even with motifs borrowed from the natural world. Overlapping to create a sense of the third dimension is not permitted, so that trees and plants (like the palms in Fig. 70AL and AM) are shown as two vertical strips of leaves or fronds flanking a central stem. Flowers are often painted from the top (O-Z), and animals are rigorously simplified (AG-AU). The result is a very decorative scheme whose visual impact is carried by the many attractive shapes set on a contrasting background. Painters concentrate on the nature of the shapes and their arrangement rather than on symbolism or an imitation of the real world.

Kamares Ware shapes are particularly creative. Although they almost always have handmade prototypes, the wheelmade pieces stress new aspects, especially those that capitalize on the turning technique. Besides the standard jugs, jars,

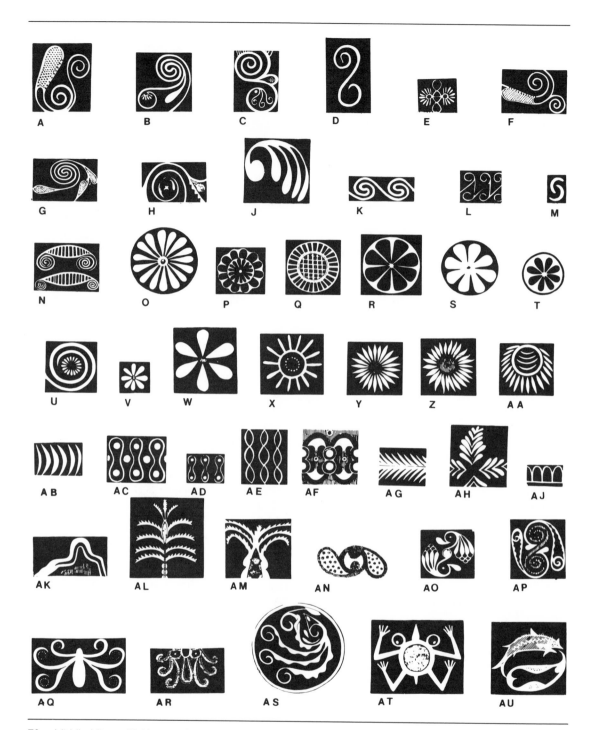

70 · Middle Minoan IIB Kamares Ware motifs.

cups, and bowls, there are many specialized forms. A surprising number are very rare, with only one or two known pieces (examples which are difficult to date are depicted in Plate 9B and G).

As always, cups are extremely popular: Plates 9C-F and H-I and 10A-C and Figure 71 illustrate the major types. Many are elegant and attractive. The straight-sided ones always have vertical handles, but the shapes—deep or shallow—and the profiles—straight or concave—vary considerably. A subvariety with a concave profile is restricted to MM IB-II (Pl. 10B and C). Carinated cups also allow much

neither cohesion nor central theme; the piece may have some symbolic meaning, but as an art object it is not very successful.

Closed shapes offer a larger field for painting than the cups and bowls, and they consequently include some of the best of the Kamares Ware vases. Jugs have a wide distribution. Many varieties exist, though most have a raised spout (Pls. 10E and 11D). Among bridge-spouted jars, a group with several subclasses, a favorite is the globular jar (Fig. 72). Since few globular examples survive into MM III, it is especially valuable for

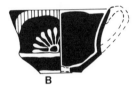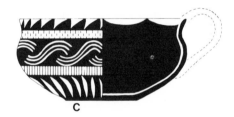

71 · Carinated and semiglobular cups from Kommos, Kamares Ware, MM IIB, Scale 1:3.

variation (Pl. 9C-F and H and Fig. 71A and B). They are particularly characteristic of the ware, and many examples are known. A few have undulating or scalloped rims. Semiglobular cups (Fig. 71C) are probably descended from the rounded cups of EM III-MM IA. Shapes without handles, both conical cups and tumblers, are also decorated occasionally. Other open vases include bowls, shallow plates, and a few special shapes. The fruitstand in Plate 10D is unique. Its unusual decoration of large clay flowers on the bowl and stem complements several painted designs—spirals, an imitation of stonework, a checkerboard, and other elements. The effect is disjointed with

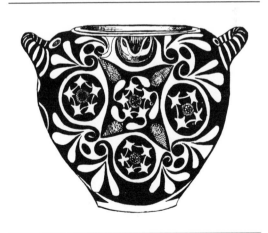

72 · A bridge-spouted jar from Knossos, MM IIB, Ht. 23.5 cm.

dating. The MM II potters sometimes added a third handle vertically at the back as a complement to the other two. Fine decoration is now extended to large shapes used for storage. The lipped jars in Plate 11C and E-G are good examples of the class. The thickened rim creates a feature that will last for a long time: the visual emphasis keeps a large shape from appearing weak at this point while the extra thickness prevents warping during the drying process and makes the rim easier to grasp for handling. Other closed shapes include the rhyton (Pl. 12A), the amphora (Pl. 12B and C), the teapot (Pl. 12E), the askos (Pl. 12H), the animal-shaped vase, and many others.

The bull's heads illustrated in Plate 12D and F and Figure 73 begin a long tradition in Minoan art. True rhyta, they

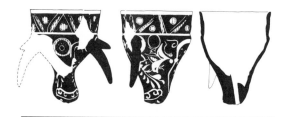

73 · Three views of a bull's head rhyton found in a Middle Minoan house at Kommos, Kamares Ware, MM IIB, Scale 2:9. See also pl. 12D.

have openings at both the top and the base so that the contents will flow out steadily. A use in rituals has often been supposed, especially since bulls played an important role in Minoan sacrifices. Other functions, however, cannot be discounted; the design would make an admirable funnel or filter (on the functions of rhyta see Lacy 1967: 287; Koehl

1981). The example in Plate 12D was found at Kommos and dates to MM IIB or early MM III. The decoration, now mostly gone, is restored in Figure 73. Made on the potter's wheel and modeled to add the features, it has long horns and a somewhat porcine face. The short-horned head in Plate 12F, from Phaistos, is perhaps intended as a calf. Its style dates it to the same period as its counterpart from nearby Kommos, near the end of MM II.

Although the identification of specific artists has been challenged (Walberg 1981), the limited provenience and the complexity of the motifs have made it possible to isolate several hands in such a way as to convince most viewers. The best work in this direction is a study by Pelagatti (1961–1962). As an example, the jug in Plate 10E and the monumental goblet in Plate 10D are united by their meandering rockwork design as well as the carefully painted checkerboards, leaving little doubt they were made by the same artist (they were, of course, found in the same building in the same destruction level). One may also compare the similar designs on the rims of the two cups in Plates 9I and 10A.

Kamares Ware syntax makes a major contribution to the history of Minoan ceramics. Pioneering studies on this subject have been written by Friedrich Matz (1928) and Arne Furumark (1939; 1941); the best recent treatment is by Gisela Walberg (1978). All these authors divide Minoan syntax into two classes. Tectonic or structural syntax organizes a vessel in accordance with its structural parts and uses a series of friezes and decorative zones to emphasize those parts. In the case of the carinated cup in Plate 9D, for example, the upper part (above the carination) is given a horizontal band that

goes all around the vase, while the lower part, which contracts, is minimized. It may be contrasted with the cup in Plate 9E which has the other type of syntax, called unity decoration. Here the ornament takes no cognizance of the carination but spreads across it, emphasizing the form of the vase as a whole. Whereas tectonic syntax is used by many different Aegean cultures, unity decoration is peculiarly Minoan, reaching its greatest development in the period from MM II to LM IB.

The unity compositions of MM IIB are particularly dynamic. They occur in many other media, with especially attractive variations on seals (Schiering 1981). The designs always make good use of movement, directing the eye across and around the ornament to emphasize its form and volume. Among the most successful are compositions based on the circle, as in Figures 72 and 74. They use a technique called restrained expansion, with a whirling and radiating movement that leads the eye out from the center and around the ornament, eventually coming back toward the center again. More diagonal schemes, as in the jug in Plate 11D, create movements that twist around and up the vessel, an effect called torsion. Other syntactical movements expand upward (Pl. 9C), contract inward (Pl. 10B and C), radiate (Pl. 9J), or combine several systems on the same vase. The final effect is often achieved by balancing one movement with a countercurrent that gives a balanced center, so that figures seem to float rather than stand.

Although Kamares Ware is mostly a product of the palaces, provincial workshops sometimes imitated its simpler aspects. The jug in Plate 12G, one of more than a dozen such vases found in House A at Vasilike, is a good example of the provincial style. It has a bridged spout and an uninspired, dumpy shape, but the decoration of swimming fishes adds an interesting note. Both red and white are used for the ornament, on the usual dark field.

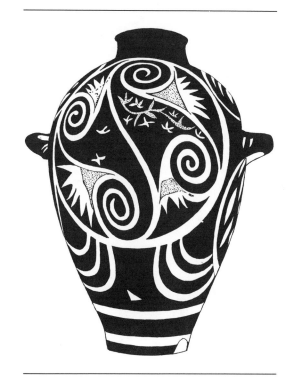

74 · Narrow-necked jar decorated with a quadruple spiral motif from Phaistos, MM IIB, Ht. 46 cm.

One of the few provincial groups with a real flair is a kantharos class made in eastern Crete. Two examples from a tomb at Gournia are illustrated in Figure 75. They have undulating rims, polychrome decoration, and a tall, aristocratic shape. The group has been studied by Ellen Davis who plausibly suggests an origin in Anatolian metalwork (1979).

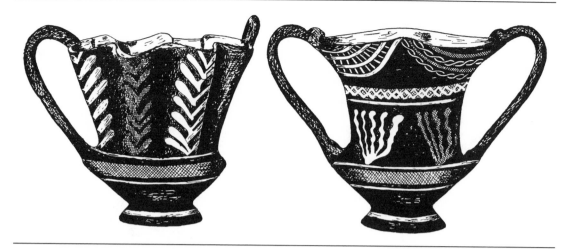

75 · Fluted kantharoi from a house tomb at Gournia, MM II, (Left) Ht. 11 cm; (Right) Ht. 10.6 cm.

Less flamboyant but more typical are the vases in Figure 76. All come from east Cretan sites, from Sphoungaras, Vasilike, and Priniatikos Pyrgos. They have typical Kamares Ware shapes even though the decoration is plain or very simple; palatial potting was easier to imitate than the complicated designs of Kamares Ware, and most villages had to be content with relatively simple products.

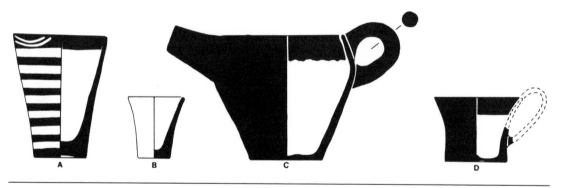

76 · Provincial Kamares Ware shapes from eastern Crete, MM IB-II, Scale 1:3. (A) Tumbler, Priniatikos Pyrgos; (B) Tumbler, Sphoungaras; (C) Bridge-spouted jug, Vasilike; (D) Straight-sided cup, Vasilike.

9 · MIDDLE MINOAN III

EXCEPT for a fine pottery called Ripple Ware and a few other exceptions, much of the ceramics of MM III represents a surprising and still unexplained recession in both style and technology. In comparison with the best work of MM II, the later pottery is poorly made, hastily decorated, and not very well fired. Painting in white on a dark ground continues—it would still be important in LM I—but red is now used chiefly for bands and small details, and other colors, like orange and crimson, are seldom used at all. The period is most clearly defined from the regions around Knossos and Phaistos; the western styles are little known, and in the east many of the old provincial traditions seem to have continued without a break, so that the middle phases of Middle Minoan simply shade into LM I.

At Phaistos the end of MM II is accompanied by a major architectural change, interpreted by the excavators as a destruction and rebuilding. Two wings of the late Middle Minoan palace have been investigated, one by Minto and Pernier (Pernier and Banti 1951: especially the pottery from Casa 104) and one by Levi (1976: I, the deposits of Phase III). The relative dating of these two structures is still disputed, and they may or may not be strictly contemporary architecturally. Very little late Middle Bronze Age pottery has been published from either context: evidently many of the relevant deposits were disturbed when the Late Bronze Age palace was constructed, and the MM III phase was also probably fair-ly short (for its length see Banti 1939-1940: 39). Enough pottery was found by Levi, however, to show that this period (his Phase III) is ceramically identical with several smaller sites in the region:

Aghia Triada (La Rosa 1977: figs. 10-12 and 19-21)
Kamilari (late MM level, Levi 1961-1962A)
Khalara (Levi 1967-1968: figs. 102-107)
Kommos (Betancourt 1978; 1984B; Shaw 1980: pl. 56a-d; 1981: pl. 51e)

Among these sites Kommos has the largest deposits. It supported a sizeable community at the end of the Middle Bronze Age, and when it was destroyed, probably by a severe earthquake, many of the ruins were abandoned or covered with debris to create a better space for building. The resulting deposits are extensive, with whole and restorable vases as well as many sherds. Since the next level uses LM I pottery, they must represent the latest Middle Minoan style in southern Crete. It seems best to call this style simply MM III, with no subdivision for A or B (see the problems with MM IIIA, discussed in Chapter 6).

At Knossos, the Temple Repository deposits nicely define the final stage of MM III (Evans 1902-1903: 38-94; 1921-1935: I 463-523). Although the presence of faience with dark painted flowers (Evans 1921-1935: I figs. 357 and 364; Foster 1979: figs. 5-6 and 17-19) and clay jars with dark-on-light spirals (Evans 1921-

1935: I figs. 333 left above center and 404g) raise the possibility they are at the edge of the next phase, most of the published pottery is well within the MM III style. Other deposits at Knossos come from the House of the Sacrificed Oxen (stylistically a little earlier than the Temple Repositories), the House of the Fallen Blocks, beneath the floor of the Kasella in the Fourth Magazine and the South West Basement (Evans 1921-1935: II 301-311, figs. 176-180; I figs. 328 and 403). The Lily Vase deposit, however, is perhaps later; besides the jars with the lilies (Fig. 92), which have parallels from LM IA, it contains some late cups (deposit dated to MM III by Evans 1921-1935: I 578-579 and 604-605 but see fig. 421 no. 11 and probably also no. 3). Also useful because of their clear publication are some small deposits from Area KSP near the Knossian acropolis (with a sequence from MM III to LM I, Catling et al. 1979). A deposit in the Loom-weight Area (Evans 1921-1935: I 248-256 and fig. 187b) has usually been called MM II, but Hood has pointed out that the latest pottery is more likely to be from MM III (for the jar with the palms, Pl. 12 I, see Hood 1971: 217). Good parallels connect the Knossian industry with the pottery from the Mesara. In both regions the light-on-dark style is well past the elaborate polychrome phase, and many distinctive shapes, like tall slim jars and amphoras, connect the two styles (Evans 1921-1935: I fig. 176d; compare Levi 1976: I pls. 188a-d and i and 190b).

Another good deposit from northern Crete is the temple at Arkhanes (Sakellarakis and Sapouna-Sakellaraki 1981), a building with a number of important objects including some very fine pottery. Since its destruction by earthquake buried many whole vases, the style may be studied in some detail. It compares well with the MM III pottery from elsewhere in central Crete but seems a little earlier than the Temple Repositories.

In western Crete, the latest Middle Minoan style is not very well known. Indications from Khania suggest that it follows the same development as in the central part of the island (Georgiou and Tzedakis 1976: 6).

A somewhat different situation exists in the east. The Middle Minoan Dark-on-light Style (discussed above) continues without interruption, while spirals and simple floral motifs increase in popularity in imitation of the palatial fashions. At Pyrgos, the phase with carinated cups and other typical MM II features (Pyrgos III) also includes Tortoise-Shell Ripple Ware and other pottery associated with central Cretan MM III (Cadogan 1978: 74-76, fig. 16). It is followed by a Late Minoan I phase. Evidently the styles here are not divided as precisely as at Phaistos and Knossos and their environs. A similar situation exists elsewhere, for example at the cemeteries at Pakheia Ammos (Seager 1916) and Sphoungaras (Hall 1912: figs. 33-36) where many of the burial jars dating from MM II-LM IA cannot be assigned with certainty to their exact point in the sequence. No MM III destruction was found at Palaikastro (Bosanquet and Dawkins 1923: 18-21), and the late Middle Minoan pottery here is as difficult to define as elsewhere in eastern Crete.

Only in central Crete, where the pottery has enough new components to build up a style with an entirely different orientation from Kamares Ware, can MM III be well defined. Motifs are simpler, with less use of color, and multiple friezes are more common. Old pot shapes are abandoned. Especially in the south, the MM III clay is grittier and more porous than in MM IIB, suggesting either a

new clay source or poorer refining techniques. Even though a few fine cups are still thin walled, most vases are thicker, with surfaces so soft they flake badly. The potting is often hasty, and finger grooves from the throwing may be visible, as if the potters were not interested enough to completely finish their smoothing operations.

Evans suggested that most persons might be using metal in preference to clay (1921-1935: I 553), which is not impossible. An alternate explanation is that the violent destructions at the end of MM IIB may have severely curtailed the workshops responsible for the best ware, at the same time that they created an unprecedented need for a large quantity of new vases. A simple sobering of tastes that rejected the more flamboyant forms may also have played a role. Certainly the many points of continuity between MM IIB and MM III—in shapes as well as ornament—indicate an uninterrupted sequence between the two styles. One cannot postulate an entirely new source for the pottery.

Whatever the reason, there are fundamental changes in the popularity of certain vases. A few types are shown in Figure 77. Among the open shapes, small, fine conical cups, carinated cups, and straight-sided cups with concave profiles are no longer made. They are replaced by an increased percentage of large, coarse conical cups with straight or inturned rims or with outurned rims (Pl. 13A and B and Fig. 78) and straight-sided cups with vertical walls (Pl. 13C). The straight-sided cups are sometimes beveled at the bottom of the wall, a trait that ends during LM I. Semiglobular cups, either large and coarse (Pl. 13D) or smaller with thin and nicely set off rims (Pl. 13E) continue to be made. Bowls and basins, as always, are common.

Closed shapes also show some changes. Round-bodied bridge-spouted jars and the most striking of the Kamares Ware products drop out of the picture. The usual bridge-spouted jar is now taller and heavier, with a pronounced base (Pl. 13I) or a constriction that creates a piriform shape and a sort of stemmed base (Fig. 77, second row center). Amphoras and jars are sometimes stout (Pl. 13F) and sometimes very attenuated (Pl. 13G and K). Other typical shapes include the pitharaki or piriform jar, the lipped jar, and many kinds of jugs (Pls. 13H and J, 14B, and Fig. 79). The first stirrup jars are also made now (Pl. 14D and E).

Rhyta appear in a wide variety of designs (Fig. 80). The ancestors of the Late Bronze Age conical and ostrich-egg shapes may be recognized, and there are also other kinds: globular with no neck; ovoid with a pointed base; and alabastron shaped: They are found in settlements (Shaw 1978: pl. 37a-c; 1980: pl. 55c) as well as tombs (Levi 1961-1962A: fig. 161), often stored in groups of two or more. Some of the finds from Kommos come from ordinary domestic contexts, but a few may have been used in rituals as well.

Three opposed tendencies may be recognized in the MM III ornament. They have little to do with one another, pointing up the complexity of the situation at this time. It would seem that the nascent Late Palatial society was already stimulating many new fashions, and the direction of the development was not yet settled. As Emily Vermeule has put it, "art in Crete is swinging back and forth from formality to pictorial freedom and back again, at different speeds in different crafts" (1975: 34). Out of these experiments would come the successes of the Late Bronze Age.

First, many vases show a penchant for simplification. Very few of the complex

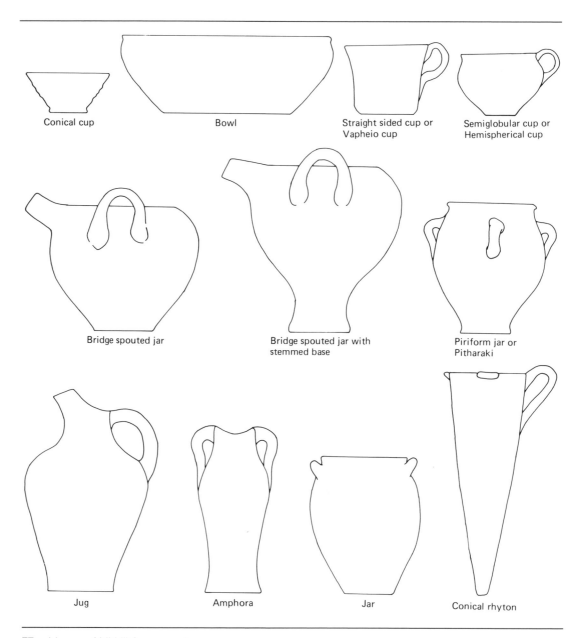

Conical cup

Bowl

Straight sided cup or
Vapheio cup

Semiglobular cup or
Hemispherical cup

Bridge spouted jar

Bridge spouted jar with
stemmed base

Piriform jar or
Pitharaki

Jug

Amphora

Jar

Conical rhyton

77 · Names of MM III fine ware shapes.

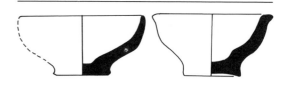

78 · Profile drawings of MM III conical cups from Kommos illustrate the thickness of the walls, much greater than in MM IIB, Scale 1:9.

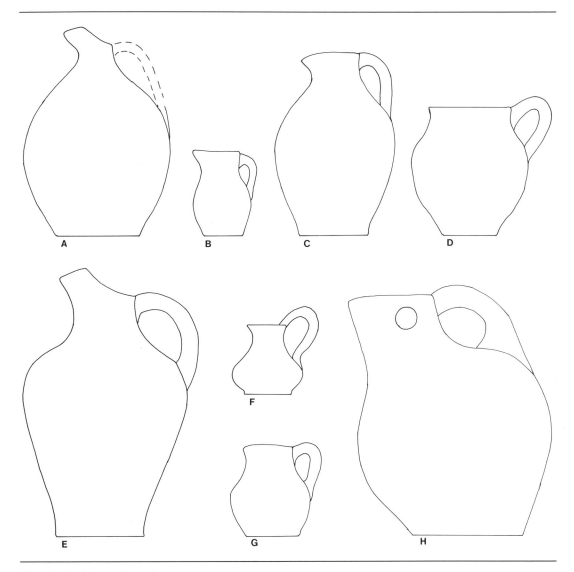

79 · Middle Minoan III jug shapes.

Kamares Ware motifs survive, and a complicated composition like the one in Plate 13F is a rare exception. A surprising percentage of the fine ware is decorated like the vases in Plates 13J and 14B and Figure 81, with only horizontal bands and large white spirals. The style is widespread enough to give the pottery as a whole a rather sober, simple aspect.

A second tendency is pictorialization.

With extensive use of naturalistic motifs, it seems to be the antithesis of the simplifying style. The movement is surely related to the taste for nature seen in the MM III/LM IA murals, faience, seals, and other arts; it shows up on clay vases painted with crocuses, lilies, palms, and even animals. A good example of the style is the hydria from Kommos in Figures 82 and 83. Its white crocuses, lilies,

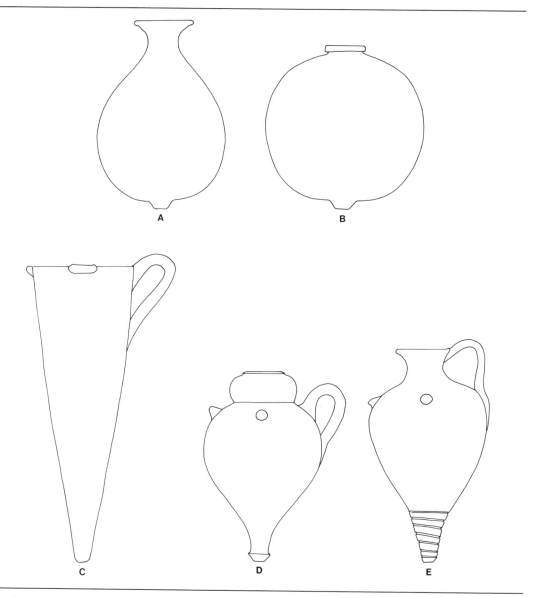

80 · The range of shapes in MM III rhyta from Kommos, Scale 1:9.

and spirals are nicely set off on the black field, and the vase has a new lyrical spirit completely foreign to MM II.

Finally, MM III sees the widespread dissemination of Tortoise-Shell Ripple Ware and other dark-on-light wares that are the ancestors of the LM I pottery. Their designs are painted in a reddish brown, lustrous paint that has little in common with the other MM III slips. The technology (discussed below) anticipates the hard, burnished pottery of LM IA; the addition of spirals and floral motifs to the style begins the initial phase of the next stylistic period.

Some typical MM III motifs are illus-

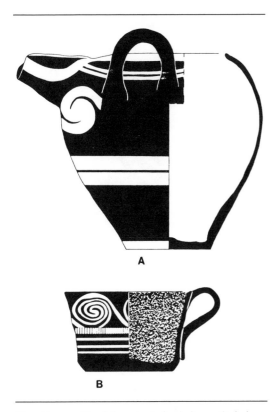

81 · Vases with white retorted spirals, particularly common in MM III, from Kommos, Scale 1:3. (A) Bridge-spouted jug; (B) Straight-sided cup.

ed through the white paint before firing to show the black underneath. Examples of the style, with an effect like that of Athenian black figure, come from several sites and provide an excellent link for central Cretan MM III: Kommos (Fig. 84G); Knossos (Evans 1921-1935: I fig. 436); and the Arkhanes temple (Sakellarakis and Sapouna-Sakellaraki 1981). The fine jar in Plate 12I is probably also from MM III, although Evans and others have considered it a little earlier. Its naturalistic palms are much less stylized than the palms of MM IIB, giving the vase a very attractive presence.

Motifs like those in Figure 85 are typical of late Middle Minoan in eastern Crete. They all come from the cemetery at Pakheia Ammos on the Isthmus of Ierapetra (Seager 1916). As elsewhere, white is used to advantage, with spirals and florals forming the main part of the repertoire. The designs are provincial,

trated in Figure 84. Spirals, retorted or running, are among the most popular elements. The speckles, especially common on straight-sided cups in the south, might be related to the taste for vases of speckled stone (discussion in Schiering 1960). One may note the large number of rather simple patterns like diagonal lines and crosshatching, and the preference for circumcurrent designs. Flowers, like the lily and the crocus, are typical of the pictorial class: they are among the more attractive of the MM III motifs. The palm design (Fig. 84G) is within the same class but uses a novel technique; it has incised fronds, with the lines scratch-

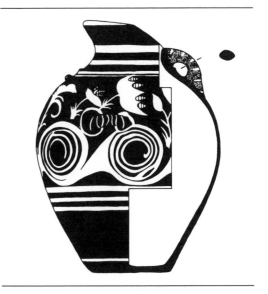

82 · Hydria decorated with flowers and spirals from Kommos, MM III, Scale 1:6.

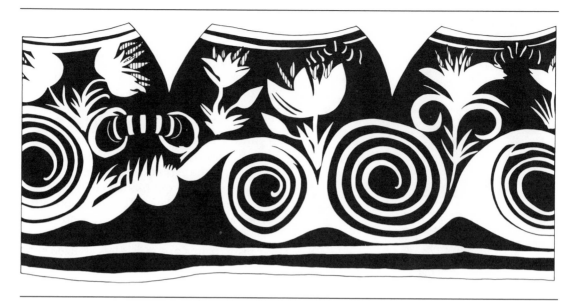

83 · The rolled out decoration from the hydria in Figure 82.

but they illustrate the debt these eastern vases owe to the palatial designs.

Modeling in three dimensions becomes much more sophisticated toward the close of the Middle Bronze Age (for the class in general see Kaiser 1976). Plate 14A shows one of the best pieces from the period. A stand or large lamp, it commands immediate attention even though only the lower part survives. It is a masterpiece of its genre, found in the MM III level in the palace at Phaistos. The main motif, the dolphin, is set in a rocky seascape filled with shells and other marine life, all shaped in a crowded and exuberant format that anticipates the Marine Style of LM IB.

As usual, the domestic pottery is difficult to date. An example, the lipped jar in Plate 14C, belongs to a group that had already made its appearance by the end of the Middle Bronze Age. Particular examples like this one from Sphoungaras could come anywhere from MM III to LM IB.

Other coarse vessels include vats, basins, braziers, lamps, and other specialized shapes. Sometimes, as with the cup and the small amphora in Plate 13D and K, they mirror the fine ware shapes; at other times they go their own way. For cooking purposes, the traditional shapes are still used, with each site having its own individual mannerisms. Figure 86 illustrates some examples from Kommos. As one can see by comparing them with the earlier Middle Minoan tripod vases and cooking dishes, the shapes are extremely conservative. Small-and medium-sized jars are common everywhere. The tall side-spouted example in Plate 13G, with trickle ornament, and the undecorated lipped jar in Plate 14C are typical of the class.

Only one coarse shape may be singled out as a new height of production. The pithos industry, perhaps stimulated by new needs for storage that accompanied the expanding palatial economy, began turning out larger and better jars. Among the most notable ones are tall, slender "medallion pithoi" from Knossos, with three or four horizontal bands set with circular emblems (Evans 1921-1935:

84 · Middle Minoan III motifs from central Crete.

85 · Middle Minoan III-LM IA motifs from Pakheia Ammos in eastern Crete.

II 632-637). Plainer examples have rope decoration, trickle ornament, or incised or relief patterns. Plate 15A is a "medallion pithos." Found at Knossos, it is one of the finest examples of the group. It has four stories of decoration, each with handles and circular medallions, with the stories separated by horizontal bands.

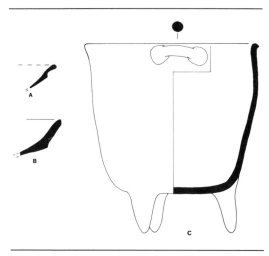

86 · Cooking dishes (A-B) and a tripod cooking pot (C) from MM III Kommos, Scale 1:4 (A-B) and 1:9 (C).

The jar was made in MM III but was still in active use during LM I, a good testimonial to its durability and usefulness. Another example, this one from Malia, is in Plate 15B. Standing almost one and three-quarters meters tall, it has an interesting ornament made from incised clay bands that look like ropes tied around the body. The decoration may suggest how the jars were moved or how they were kept from warping while they dried. Pithoi were used in series or by themselves, as storage for the increas-

ingly large surplus Crete was now able to produce.

Because of this surplus, the Minoans were able to think more seriously about overseas trade. The pottery testifies to a great expansion by MM III. Aghios Stephanos in Lakonia, Mycenae in the Argolid, Kastri on Kythera, Akrotiri on Thera, Phylakopi on Melos, Aghia Eirene on Keos, and several sites on Karpathos were already importing Cretan pottery by this time, and from now on the Minoan exports increase by arithmetic progression. By LM IA the Minoan workshops would influence the entire Aegean.

In the Near East, however, MM III pottery seems to be extremely rare. A few sherds that have been called MM III are of doubtful date, more likely to be earlier (for a MM II-III sherd from Hazor see Cadogan, in Ward 1971: 78) or later (for a sherd from Alalakh, probably LM I rather than MM III, see Woolley 1955: 370 and pl. 129, no. 1.AT/48/16). A Minoan stirrup jar from Minet-el-Beida, decorated with white retorted spirals, might well date from this period (Schaeffer 1932: pl. 7 no. 1; Evans 1921-1935: IV 777 fig. 756c). Middle Minoan III is not known from the western Mediterranean.

A handful of pieces move the other way. Imports into Crete come from Greece (Evans 1921-1935: II 309), the Cyclades (Evans 1921-1935: I figs. 404h and 405; Betancourt 1978: fig. 3 and pl. 43d no. 1; on the Cycladic provenance see Jones 1978; MacGillivray 1984), and Cyprus (Shaw 1984: pl. 49b-c). No Italic or Near Eastern pottery has been recognized from the island. The imports and exports thus suggest the same picture: Crete was extending its influence, in an ever widening circle that was yet to reach the East or West. The table was now set for the main course, to be served in LM I.

TORTOISE-SHELL RIPPLE WARE

The earliest examples of fine-burnished pottery with lustrous red to brown ornament appear during the Middle Bronze Age. Although a relation may exist with some MM II or earlier brown-burnished lamps and offering tables, the style did not become popular until it was applied to fine wares, a situation that began about the end of MM IIB. The fabric of this fine pottery is always hard and well fired, and sherds "clink" when dropped on a hard surface. Because of the burnishing, the entire surface is compact, slightly glossy, and attractive; even small fragments are clearly recognizable when compared with the duller surfaces of most contemporary pots.

Decorations include waves, zigags, horizontal bands, and groups of irregular parallel lines called tortoise-shell ripple (Pl. 15C-E and Fig. 87). The wares evidently represent the first examples of what would become the typical Late Minoan pottery; when spirals and a few floral motifs are added to the existing repertoire, we are in LM IA.

Tortoise-Shell Ripple Ware is the most common lustrous dark-on-light pottery of MM III. It begins in Knossos by MM II-IIIA (Evans 1921-1935: I 592), and it is still very important in LM IA. Although it occurs in small quantities throughout Crete, and many pieces have been found in the Aegean islands as well, its place of origin (somewhere in Crete, perhaps in the east) has never been determined. At some sites it declines in popularity in LM IB.

The ornament of Tortoise-Shell Ripple Ware and the other related traditions is usually a rich reddish brown, contrasting nicely with the pale Cretan clay. Tests have shown that its color is due entirely to iron oxides (Stos-Fertner, Hedges, and Evely 1979; Noll 1977; 1982). Since Middle Minoan sherds are also colored by iron, and since they refire to a brown color if heated in the presence of oxygen (Farnsworth and Simmons 1963: 393), the basic materials were already available for the new technology. The techniques can be reconstructed fairly accurately because of analyses that show the LM I paint is finer and the firing temperature is a little higher than was usual in Middle

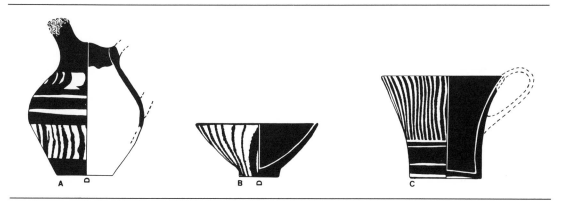

87 · Tortoise-Shell Ripple Ware, MM III-LM IA, Scale 1:3. (A) Jug, Pseira; (B) Conical cup, Priniatikos Pyrgos; (C) Straight-sided cup, Priniatikos Pyrgos.

Minoan times (Noll 1977; 1982; Stos-Fertner, Hedges, and Evely 1979: 193).

The technology is particularly important in the history of Aegean ceramics. It gradually replaced the light-on-dark pottery at the beginning of the Late Bronze Age, eventually becoming the mainstay of Late Minoan potters. Since it was also exported to Mycenaean Greece, it must be regarded as one of the main ancestors of the ceramic technology of the Greeks and Romans.

The new appearance of the surface seems to be caused by a combination of the kiln conditions and the carefully prepared slip (Noll 1977: 32-33; 1982). Only the very finest particles will produce a lustrous-firing paint, and perhaps the clay for the slip was ground in a mortar as an adjunct to the levigation process. It must also include a flux (in this case a potassium mineral), so the materials must be carefully selected. After the pot was painted, it was thoroughly burnished while it was still wet. The burnishing and the size and composition of the slip particles would create the luster through partial vitrification, while the more porous body was less vitrified. For the desired effects, enough oxygen needed to be present during the firing for the iron in the slip to turn a rich red or brown.

Tortoise-Shell Ripple Ware occurs as a minority fabric at most MM III sites, becoming more common in LM IA. The many shapes include cups, jars, am-phoras, bridge-spouted jars, bowls, and jugs. Even large storage vessels are sometimes decorated with zones of the ornament. Shapes used for serving are probably the most common. On small shapes the ripple takes up most of the wall, while on larger shapes it forms horizontal friezes.

The rhyton from Zakros in Plate 15E has white ornament applied on a solid dark ground above two friezes of tortoise-shell ripple. Its designs—floral and abstract motifs of the type used in both MM III and east Cretan LM IA—spread over the entire shoulder and upper body. They make an interesting contrast with the ripple on the lower body.

The vases in Plate 15C and D and Figure 87 illustrate other typical examples. The ostrich-egg-shaped rhyton from Gournia (Pl. 15C) is probably from LM IA. As the illustration shows, its paint was applied as parallel vertical lines, and the rippling effect is caused by the burnishing. The jug and the conical cup (Fig. 87A-B) might be a little earlier, but there is no way to date these simple shapes with any degree of accuracy. The straight-sided cup (Fig. 87C) may be placed in LM IA because of its concave walls. Like all examples of this ware, these pieces are attractive and pleasant to handle. It is easy to see why they were liked; their hard and smooth "feel" is a decided improvement over the run-of-the-mill pottery of MM III.

10 · THE LATE BRONZE AGE DEVELOPMENT

Economically and artistically, the Late Bronze Age is the culmination of Minoan civilization. Widespread sites suggest a large population (Map 4). The clay tablets—both Linear B and the still undeciphered Linear A—demonstrate the existence of a well-organized bureaucracy administered from central seats of power. It is possible that all of Crete was under a single government by LM I, and if the pottery is a reliable indicator, the main ruler was probably at Knossos. Certainly the Knossian pottery was widely exported, and it exerted enough influence to submerge the provincial Middle Minoan styles.

Regardless of whether or not the island was ruled by a single power, the society was palatial in concept. The central seats that had developed during the Middle Bronze Age now exerted a dominating influence; large establishments have been noted at Knossos, Phaistos, Malia, Khania, and Zakros. Other powers, like Arkhanes and Vathypetro, may have been more localized in strength or may have exerted far-reaching influences—the situation is only imperfectly understood. Towns like Gournia on the Gulf of Mirabello seem to have been centers of craftwork for the surrounding areas, providing goods and services for its own residents and for nearby farmsteads (Hawes et al. 1908), but rich country houses like the one at Pyrgos on the southeastern coast (Cadogan 1978) were probably self-sufficient. Evidence for fortifications is scarce, and many of the settlements are large, rambling complexes that spread out in several directions. All of this evidence suggests a time of peace when the Minoan civilization could develop and expand. Cretan settlements or influences in the Cyclades and elsewhere, discussed more fully below, helped spread Minoan ideas throughout the Aegean (discussions include Davis 1979; Barber 1981; Stucynski 1982; Doumas 1982; Schofield 1982A; 1982B).

The period of peace ended with widespread destructions at the end of LM IB. Mycenaean contacts are closer after this time, and Crete gradually becomes more dependent on Mycenaean ideas. Economic prosperity increases, and the number of tombs and settlements suggests a large population during LM IIIA and IIIB. Trade and manufacturing flourish, but occasional setbacks like the destruction of the Knossian palace at the beginning of LM IIIA:2 interrupt the development. By LM IIIB the Knossian region is ruled by the speakers of Mycenaean Linear B. After this period a new wave of disruptions and destructions interrupt life again, and the Iron Age develops gradually.

The pottery of the beginning of the period is somewhat different from its predecessors. The technical expertise visible in Tortoise-Shell Ripple Ware and the related dark-on-light pottery of MM

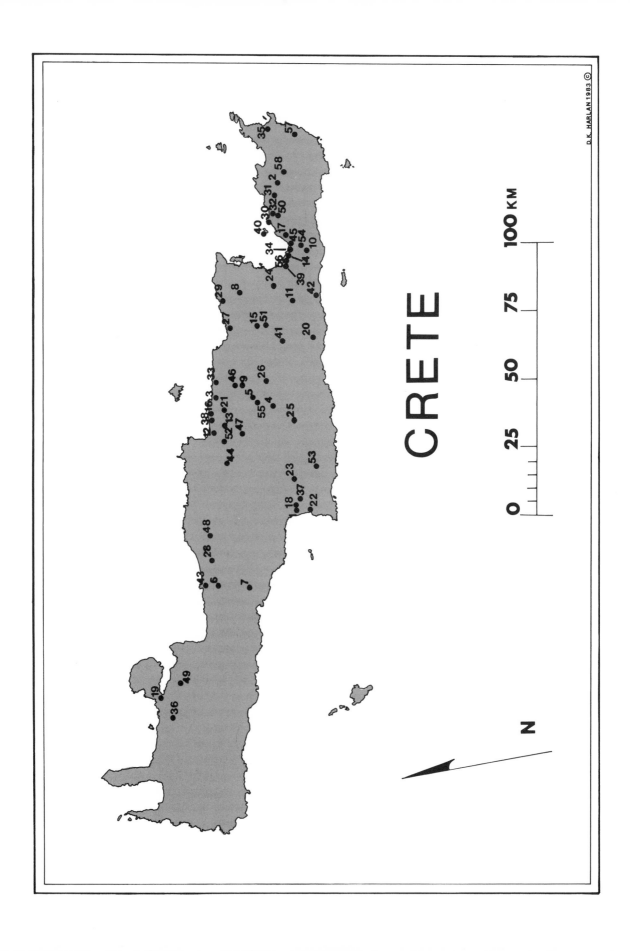

CRETE

D.K. HARLAN 1983 ©

N

0 25 50 75 100 KM

III becomes widespread by LM IA. As has been shown above, the new style is more than a simple reversal of the painting from light-on-dark to dark-on-light. The new lustrous-firing slip requires a more careful preparation and a different set of kiln conditions, and its adoption is accompanied by better refined fabrics and a renewed taste for burnished surfaces. Perhaps because the innovations reflect a whole new way of making pottery, they do not supplant the traditional methods overnight.

The reversal of the painting from light-on-dark to dark-on-light, however, should not obscure the basic unity of the style as a whole. The style of MM III continued into LM IA. Nearly all of the LM I motifs have white-painted predecessors, and the vase shapes of MM III continue as well. The new technique, however, was eventually embraced by palace and village alike. It led to a new flourishing of design and form, a new flowering after the recession of MM III.

More is known of the kilns used for these Late Bronze Age products than for earlier periods. Most of the excavated kilns date from LM I-IIIB, though since the dating is often uncertain, some examples may come from late in the Middle Bronze Age.

Several types of pyrotechnic constructions are known from Late Minoan Crete. Small built hearths for cooking are a regular feature of LM III (an example with a cooking pot in place is shown in Shaw 1979: pl. 54c). A stone chamber of uncertain form (perhaps apsidal?) stands in the court at the north of the palace at Phaistos (Pernier 1904: col. 366 and fig. 21; Pernier and Banti 1951: 215). Channel kilns, with several long passages using the crossdraft principle, occur at Vathypetro (Marinatos 1955: 310 and pl. 115 no. 3), Aghia Triada (Davaras 1980: 120 n. 15), Kato Zakros (Platon 1979), and Knossos (for kilns SE of the palace see Hood 1958: 24 and fig. 6B; Daux 1958: 783-785 and fig. 12; for those behind the Stratigraphical Museum see Warren 1979: 37; 1981A: 76-79). Smaller constructions, usually rounded or horseshoe-shaped, are found at several sites:

Akhladia Seteias (Platon 1952B: 646 and fig. 25)

Khalara (Levi 1976: 318, 327-328, 509, and figs. 494 and 510-511, and 784)

Khania, Kastelli (Tzedakis 1977: fig. 140)

Palaikastro (Davaras 1980)

Phaistos (Levi 1965-1966: 351-354 figs. 43-44, pl. 4)

Stylos (Davaras 1973)

Zou Seteias (Platon 1956: 233, 238, fig. 1 and pl. 113 no. 2)

Map 4 · Late Minoan sites in Crete. (1) Aghia Triada; (2) Akhladia; (3) Amnissos; (4) Arkalokhori; (5) Arkhanes; (6) Armenoi; (7) Atsipades; (8) Dreros; (9) Episkopi; (10) Episkopi Ierapetras; (11) Erganos; (12) Gazi; (13) Gournes; (14) Gournia; (15) Karphi; (16) Katsampas; (17) Kavousi; (18) Khalara; (19) Khania; (20) Khondros Viannou; (21) Knossos; (22) Kommos; (23) Kourtes; (24) Kritsa; (25) Ligortynos; (26) Liliano Cave; (27) Malia; (28) Maroulas; (29) Milatos; (30) Mokhlos; (31) Mouliana; (32) Myrsine; (33) Nirou Khani; (34) Pakheia Ammos; (35) Palaikastro; (36) Perivolia Cave; (37) Phaistos; (38) Poros; (39) Priniatikos Pyrgos; (40) Pseira; (41) Psykhro Cave; (42) Pyrgos; (43) Rethymnon; (44) Sklavokampos; (45) Sphoungaras; (46) Stamnioi; (47) Stavrakia; (48) Stavromenos; (49) Stylos; (50) Tourloti; (51) Trapeza Cave; (52) Tylissos; (53) Vasilika Anoghia; (54) Vasilike; (55) Vathypetro; (56) Vrokastro; (57) Zakros; (58) Zou.

Only this last group may have functioned as pottery kilns. The LM III hearths only had small, open fires, unsuitable for making the type of pottery used then. Sometimes the channel kilns, as with the construction in the north court at Phaistos, have glassy deposits on the interior walls. Unless these coatings were deposited from the heat of the fuel, the kilns were probably used for other purposes.

The best studies of Minoan kilns are by Costis Davaras (1973; 1980). Constructions are always small, made of stones and clay, with the chamber sometimes backed against a natural outcrop. The lower part of the late Middle Minoan to Late Minoan kiln at Palaikastro is carved into the bedrock. Shapes vary considerably, but most examples are roughly circular or horseshoe-shaped, with an opening at the front. Roofs are either of corbelled stone or of perishable materials; presumably there was a hole in the center to enhance the draft.

Except in rare instances, the kilns had some means to raise the pots within the chamber. This was accomplished in various ways. The kilns at Palaikastro and Akhladia had a shelf around the sides. In other cases, for example at Phaistos and Stylos, a series of walls were built inside the chamber. The two kilns at Knossos, from LM I-II, had traces of a pierced floor (but it is doubtful they were used for making pottery). In all these instances, the technological advantage is the same. Raising the load to be fired makes the construction into an updraft kiln, taking advantage of the rising air currents. The principle is illustrated in Figure 88. Since the space for the vases (either a shelf, the floor of a support, or an actual stacking chamber) is higher than the firebox, the heat rises among the pots and passes out the roof or a

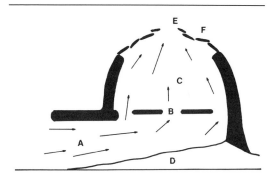

88 · The principles of the updraft kiln. (A) Firebox for adding the fuel; (B) Floor or support that raises the vases above the level of the firebox; (C) Stacking chamber where the vases are placed; (D) Kiln floor (a slanting floor aids the draft); (E) Exit flues for the draft (the temperature can be controlled by adjusting the size of the apertures); (F) Roof (this feature can be temporary, added after the load is stacked in the chamber).

built flue. The temperature in such a kiln can be controlled by the amount of fuel or by increasing or diminishing the draft through opening or closing the door or the exit flues, so that the potter has better control over the results.

The well-preserved stone and clay kiln from Stylos is a good example of the type. Set within a settlement that dates to LM IIIB, it is a carefully built structure (Pl. 15F and Fig. 89). Dimensions are 2.3 m. wide by about 1.35 m. deep. The original height is not known because the walls only survive up to the top of the fuel chamber. Interior surfaces are nicely plastered with clay, baked solid by the heat of the firings. The shape is roughly circular. The fuel chamber is divided into three compartments by two walls that form a support at the center of the kiln; several stone slabs lie across these two walls to make a floor for the vases. Since the mud plaster once covered this central

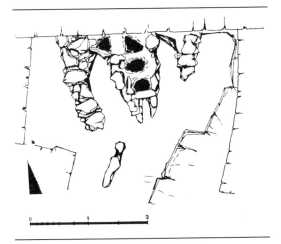

89 · Plan of the kiln at Stylos, LM III.

support evenly, it must have been a free standing construction rather than an underpinning for a floor across the entire kiln. Evidently the vases were stacked upon the central platform, and the heat would have risen both through and beside them, producing a very hot firing rather easily. The kiln was built on the slope of a hill to take advantage of the rising bedrock; the floor of the fuel chamber slopes upward naturally at the left, and only the right part of the floor needed to be built up at the back with clay to create the desired updraft. Unfortunately, the front part of the firebox does not survive.

Updraft kilns of this type are very efficient (for discussion of the principles of their design see Rhodes 1964; Olsen 1973). The enclosed chambers produce a hot, even firing, and the temperature can be raised as quickly or as slowly as desired. Atmospheres can be varied from oxidizing to reducing by a combination of fuel and draft. Probably the Stylos kiln was loaded from the top, and a temporary roof was built for each firing (as folk potters do in modern Greece), but no real evidence for the loading system survives.

The Late Minoan kilns produced a good product. Most of the LM I and II vases are finer than those of MM III, and by LM III they are better yet. The LM III fabrics are denser than in earlier times. They have a finer and more even texture, and they are harder than in LM I, a sign of expert pyrotechnology.

Accompanying the new technology are several basic changes in style. Late Minoan art is especially concerned with design and natural forms. It often glorifies nature, using the contours of plant or animal to suggest abstract motifs or slightly simplified organic elements. These preoccupations have often been used to distinguish it from its contemporaries, both in the Near East and in Greece and Europe: the former is sometimes thought of as concerned mainly with human and divine achievement, the latter with human achievement or with formal nonobjective design. The apparent uniqueness of Minoan aesthetics has occasionally puzzled classical scholars who want to see it as the ancestor of Greek art in spite of the fact that it seems "the absolute antithesis of what is most deeply valued in classical art" (Groenewegen-Frankfort 1951: 188). As more is learned of Minoan art, however, the lines that separate it from its neighbors become increasingly obscured. The Minoans do not, in fact, leave out geometric design or human achievement, they simply do many other things in addition. The richness of the Minoan contribution can include a frieze of quirks on a vase or a long row of figures bringing gifts in the Procession Corridor at Knossos as well as a lovingly painted clump of lilies. The wonder of Minoan art is its dazzling creativity, its variety of form and expression.

The pottery is particularly successful during LM I. Especially in the second half of the period, it is able to adapt the movement and syntax of the essentially abstract Kamares Ware to a new naturalism borrowed from the real world. In the best products the result is organic and vibrant with a sense of form that brings a vessel to life. The products were appreciated abroad as well as at home, and Minoan ideas became the most influential force in all Aegean pottery; the Special Palatial Tradition of LM IB is often regarded today as the high point of all Cretan ceramics.

New influences begin in LM II. Late Minoan IB ends violently, and many new features are introduced in the next period. Mycenaean contacts are now closer. Influences move both ways, and mainland features can be recognized in Minoan shapes, decorations, and syntax, even though the pottery's character remains essentially Minoan. Stylistically, the pottery of LM II-III proceeds in a generally linear fashion. Naturalism and variety are gradually abandoned in favor of standardized shapes and motifs that culminate in the crisp and schematic repertoire of the latter part of LM III. The relationship with Mycenaean Greek styles grows closer as time goes on, and LM IIIA-B is part of the Late Helladic circle.

Political disturbances at the end of LM IIIB disrupt the ceramic production and lead to new styles. Cretan IIIC is more independent. Although it still owes debts to the mainland, it develops a Plain Style and a Close Style with many individual mannerisms. Some pottery is now extremely ornate, and other styles are simplified; the simpler ornaments finally reach the cursory style of Sub-Minoan, the final note in the Late Bronze Age development.

Chronological synchronisms between Crete and Mycenaean Greece are as follows.

CRETE	MYCENAEAN GREECE
	(Late Helladic)
LM IA	LH I
LM IB	LH IIA
LM II	LH IIB
LM IIIA:1	LH IIIA:1
LM IIIA:2	LH IIIA:2
LM IIIB	LH IIIB
LM IIIC	LH IIIC

Fortunately, there is general agreement on the main lines of these correlations; they have been confirmed by finds at many sites, especially in the islands. Only the slight overlap at the beginning and end of the period needs to be refined (for example, LM IB and LH IIB pottery occur together at Aghia Eirene on Keos, suggesting an overlapping sequence, discussed more fully below, in Chapter 11).

The foundations for both the relative and the exact chronology of the Aegean Late Bronze Age were laid down some years ago by Arne Furumark (1941). His analysis, based on the Mycenaean pottery sequence, was tied to fixed points derived from finds of Aegean pottery in datable contexts in the East, especially in Egypt. Furumark's conclusions have been refined in more recent discussions, but their main parameters still stand. Among recent work, the best discussion of the chronology is by Hankey and Warren (1974). Their study takes into consideration the work of Kantor (1947), Desborough (1964), Hornung (1964), Hayes (1970), Popham (1970B), Stubbings (1970), and many other scholars. Its main conclusions on the relative chronology are shown in Table 5. Two choices are shown, a high and a low chronology. The differences are based on a contended point in Egyptian dating, whether the New Kingdom astronomical observations

Table 5 · Absolute chronology for Late Minoan as suggested by Hankey and Warren (1974).

	HIGH CHRONOLOGY	LOW CHRONOLOGY
MM III	17th century B.C.	17th to early 16th century B.C.
LM IA	ca. 1570 ± 10 to 1515/05 B.C.	ca. 1550 ± 10 to 1490/80 B.C.
LM IB	ca. 1515/05 to 1460 B.C.	ca. 1490/80 B.C. to 1440 B.C.
LM II	ca. 1460 to 1420 ± 10 B.C.	ca. 1440 to 1405 B.C.
LM IIIA:1	ca. 1420 ± 10 to 1385 B.C.	ca. 1405 to 1375/70 B.C.
LM IIIA:2	ca. 1385 to 1350/40 B.C.	ca. 1375/70 to 1335/25 B.C.
LM IIIB	ca. 1350/40 to 1190 B.C.	ca. 1335/25 to 1190 B.C.
LM IIIC	ca. 1190 B.C.	ca. 1190 B.C.

were made in Memphis or Thebes. One must choose one or the other alternative, not a point midway between them.

The chart is based on many finds, mostly Minoan and Mycenaean vases found in Egypt itself. Among these, by far the most important are the many Mycenaean sherds found at Amarna, the city of Akhnaton (Hankey 1973A). Most of them are from Late Helladic IIIA:2, but a few early LH IIIB pieces survive as well, suggesting LH IIIB and LM IIIB had already begun by the time Amarna was destroyed early in the reign of Tutankhamen. One assumes the small number of poor later visitors would not be importing Aegean commodities.

The beginning of the Late Bronze Age, however, cannot be tied to calendrical dates so easily. Radiocarbon dates are no help; many of the analyses from this period are so obviously problematical that the series as a whole is suspect, and some individual groups that seem internally consistent suggest a date in the seventeenth century B.C., generally regarded as incompatible with the Egyptian synchronisms (Betancourt and Weinstein 1976). Correlations with Egypt, however, are only good for the end of LM IB and later. The most helpful find is a squat jar of LH IIB date (contemporary with LM

II) from the tomb of Maket, at Kahun, dated to late within the reign of Thutmose III (Hankey and Tufnell 1973). Thus the beginning of LM II/LH IIB should occur no later than the second half of the fifteenth century B.C. (for discussion see Hankey and Warren 1974: 147). Late Minoan IB is also probably at least partly within the reign of Thutmose III because a number of LM IB or LH IIA vases come from Egyptian graves from about this time. A good example is the tall alabastron in Figure 90, found in Tomb 137 at Sedment. The shape is Minoan, while the decoration is canonical

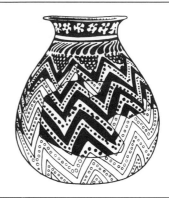

90 · Tall alabastron from Grave 137 at Sedment, Egypt, LM IB or LH IIA, Rest. ht. ca. 20 cm.

for LM IB and LH IIA (compare the ornament of the vessel from Sklavokampos in Pl. 22H). Other early Eighteenth Dynasty finds have been discussed by a succession of writers (see, among others, Furumark 1950: 210-215; Kantor 1947: 33-36; Betancourt and Weinstein 1976: 337-338). A LM IB sherd from Tell Ta'annek in Palestine is also from the time of Thutmose III (Lapp 1967: 33-34 and fig. 23), and a LH IIA cup from Lachish is probably from about the same time (Tufnell, Inge, and Harding 1940: pl. 58B no. 5; Stubbings 1951: pl. 14 no. 1). The regnal dates for Thutmose III are hotly disputed (see the bibliography in Betancourt and Weinstein 1976: 338-339), but it is likely that the transition between LM IB and LM II, which surely occurred during his reign, should be dated to about 1490-1460 B.C. Probably a maximum of 20-50 years should be allowed for LM IB and somewhat longer for LM IA. The Late Minoan period should thus begin between about 1650 and 1550 B.C.; there is no evidence for the more precise "traditional" view that it begins ca. 1580 B.C.

After LM IB the chronology becomes increasingly more precise. A scarab of Amenophis III comes from Sellopoulo Tomb 4 at Knossos, a tomb that also had an imported Mycenaean vase from LH IIIA:1 (Popham 1969B: 33). Two LH IIIA:2 vases come from Qatna, from a destruction that seems to have occurred during the reign of Akhnaten (Hankey and Warren 1974: 147). Several imports including some LH IIIA:1-2 pottery were found in an undisturbed tomb at Acre along with a silver ring and a clay plaque bearing the name of Amenophis III (discussion in Hankey and Warren 1974). The finds from Amarna, which have already been mentioned, suggest that LH/LM IIIB began in the fourteenth century, before the reign of Ramses II.

The dating of LM IIIC is more problematical. The exact correspondence between the Cretan and Mycenaean sequences is not firmly fixed, so that even if one accepts Hankey and Warren's date of ca. 1200 B.C. for the transition to IIIC in mainland Greece (1974: 148-149), the Cretan sequence may not correspond exactly.

For the later part of the Bronze Age, the radiocarbon dates agree exactly with the picture suggested by the Near Eastern synchronisms. Good groups of radiocarbon dates like those from the Citadel House at Mycenae (Betancourt and Weinstein 1976: 334) are fully compatible with placing LM IIIB in the late fourteenth and thirteenth centuries B.C. Thus all the evidence converges to present a unified picture. Late Minoan IIIC spans most of the twelfth century B.C., and Sub-Minoan follows immediately. Iron is already present in LM IIIC. It becomes more widespread in Sub-Minoan, and it is accompanied by many new cultural traits; the Bronze Age is now at an end, replaced by new styles and new ideals.

11 · LATE MINOAN I

THE BEGINNING of LM I may be defined as the point at which spirals and floral designs in dark, lustrous paint become popular. The older styles continue alongside them, so that LM IA is really a transitional period. Eventually, the old style gives way completely, and the new fashion is free to develop; perhaps, as Mervyn Popham has suggested (1967: 338), the new medium itself was the stimulus to greater creativity.

The LM I vases have a new feeling. Especially among the floral elements, one can detect an exuberant joy in nature, capturing what Groenewegen-Frankfort has called "the passionate beauty of plants in bloom" (1951: 185). The motifs are not only more naturalistic, they also have a greater sense of movement, as if leaves and flowers are growing or rippling in a gentle wind. Part of this feeling must come from outside the ceramic tradition, and many scholars believe it originated in wall paintings. The relationship between murals and vase painting can be seen by comparing the pea plants in Figure 91 with their slightly simplified counterparts on the spouted jar in Plate 16C. The pot painter has copied more than the essential iconography; he has managed to capture the lyrical motion created by the pattern of gently curving, opposed lines.

In some cases, the muralists' designs are as suited to pottery as to large walls. The group of lilies on the jar in Figure 92 is surely derived from some monumental source, probably one that looked

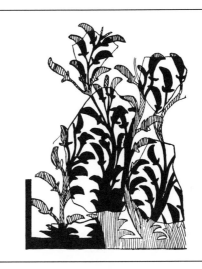

91 · Painting on plaster from Knossos showing pea plants, LM I.

very much like a painting discovered at Amnissos (Pl. 16B). The decoration fits very well on the jar's surface. Its composition begins quietly at the base with a small clump of leaves placed where the vase is narrow, and it expands toward the top, reaching its greatest width at the jar's maximum diameter. All the blossoms are flattened and arranged with a minimum of overlapping, making an attractive arrangement against the reddish ground.

Some of the shapes used in LM I are shown in Figure 93. Conical cups remain the most common shape (Wiener 1984). Both the straight-sided and semiglobular types develop slightly, with more taut contours. As always, jugs occur in many

guises; the selection in Figure 94 gives some idea of the range but is not the complete typology. The other shapes betray their debt to MM III; the development from the Middle Bronze Age is smooth and uninterrupted.

Since many deposits have been discovered from LM I, even the coarse wares are well known (Figs. 95 and 96). They present, however, problems not shared by the finer vases, and because of their conservative nature, a distinction between LM IA and IB cannot yet be made without knowing the other finds in the same context. Sometimes they are specialized and unique (Pl. 16A), but usually they conform to accepted types.

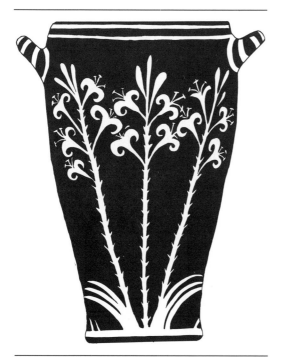

92 · Jar from Knossos, Lily Vase Deposit, MM III-LM IA, Ht. 26.5 cm.

Although usually unpainted, the domestic vases have the power to stimulate an interest of their own. They are "warm in colour, rustic in texture, shapely in form," contributing their own flavor to any setting (Pirie and Edwards 1983: 143). The economy of ornament makes them seem extremely functional even when their original use is not completely known. The vat with the large drain in Figure 95, for example, is a vase which has aroused a considerable amount of speculation. Found at Gournia, it is made of gritty red clay; it must have been used in a common household industry because several examples are known from LM I deposits. One from Vathypetro, found in place, has usually been regarded as a wine press (Marinatos 1952: 596 fig. 6; Platon 1974: pl. on p. 195). The production of olive oil is an alternative explanation (Forbes and Foxhall 1978). Also of uncertain use is the jar with neat holes in the sides in Figure 96C, from the same site. Containers like Figure 96B and D are more easily understood because they would have served the many needs for storage in a large household. Figure 96A might be a toy.

The curious vessels in Figure 96E and F are often called "fireboxes." Several varieties exist, with the simplest consisting of a hollow rounded capsule, perforated on the bottom and solid on top, with a flaring rim that spreads out from the upper part (Fig. 96E). Variations may add three small feet and a handle for lifting or a flat base, with the perforations moved to the sides (Fig. 96F). The class has been studied by Hara Georgiou (1973A; 1973B; 1973C). She has suggested that the most plausible use would be with something like aromatics, prepared in small quantities to be spread and warmed on the rim, suggesting a possible use in perfume making. Alterna-

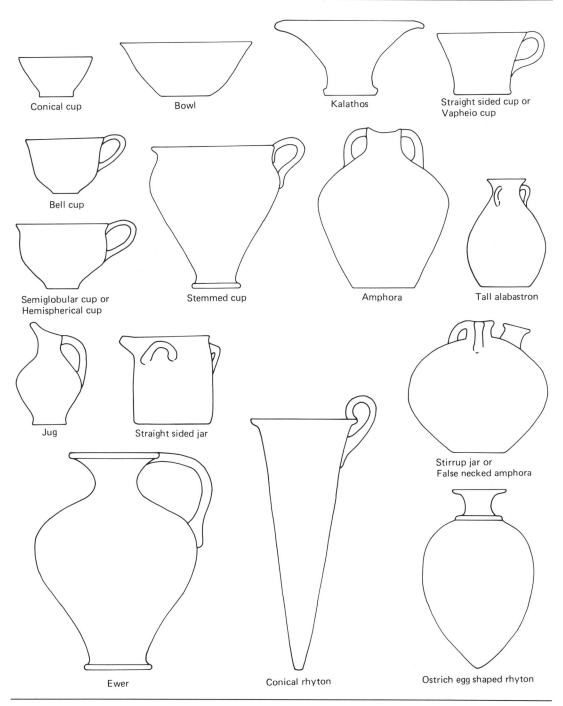

Conical cup

Bowl

Kalathos

Straight sided cup or Vapheio cup

Bell cup

Stemmed cup

Amphora

Tall alabastron

Semiglobular cup or Hemispherical cup

Jug

Straight sided jar

Stirrup jar or False necked amphora

Ewer

Conical rhyton

Ostrich egg shaped rhyton

93 · Names of LM I fine ware shapes.

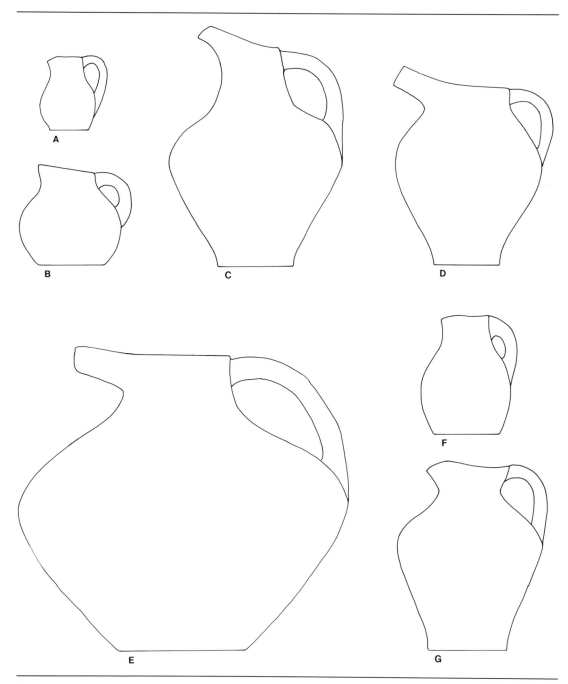

94 · Late Minoan I jug shapes, Scale 1:9.

95 · A large clay vat with a drain at the bottom, from Gournia, LM I, Ht. 36 cm.

tives are the burning of incense or aromatics or the melting of perfumed unguents.

Large clay containers continue to be made for commodities kept from one season to the next. The lipped jar in plate 14C is a standard type for MM III and LM I, and many examples exist. This is a provincial piece, found in the cemetery at Sphoungaras where it had been used for a burial.

Pithoi are still the largest vases. They

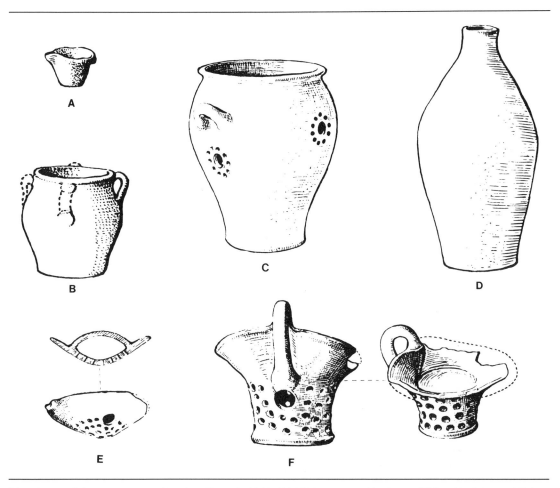

96 · Some of the coarse ware found at Gournia, LM I. (A) Miniature cup, Ht. 4 cm.; (B) Jar, Ht. 8.1 cm.; (C) Jar, Ht. 24.2 cm.; (D) Bottle, Ht. 27.7 cm; (E) Firebox, Ht. 4.4 cm.; (F) Firebox, Ht. 16.2 cm

are always handmade, continuing established traditions in technique as well as style. Shapes and ornaments are similar to those of MM III, making the date of many pieces uncertain. Examples, shown in Plate 16D and F, illustrate several varieties. Most of the pithoi have abstract designs in raised bands of clay, flattened and decorated with incisions. Some of the motifs are borrowed from the pot painters (see especially Pl. 16D).

Cooking vessels also follow Middle Minoan lines. As in MM III, the tripod cooking pot is the most common shape for heating liquids, and shallower cooking dishes and trays are used as well. Their coarse-textured fabric is normally red to reddish brown, with no decoration.

Lamps of several kinds provide light, and many are made of fired clay. Two varieties are shown in Figure 97. The stand lamp, with the bowl set on a high pedestal, has the advantage of raising the illumination to a higher level. The smaller variety is less effective but easier to make and move about. As in earlier times, a room might use any number of lamps to illumine it at the desired level.

LATE MINOAN IA

Late Minoan IA is the high point for the spiral, the rosette, the ripple motif, and the floral band. Although other ornaments are used as well, the selection of motifs in Figure 98 illustrates the popu-

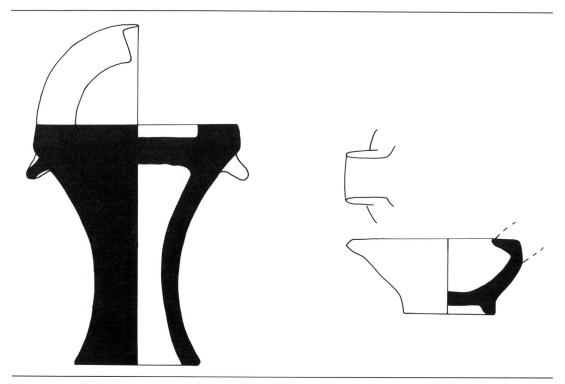

97 · Two LM I lamps from Gournia, Scale 1:3.

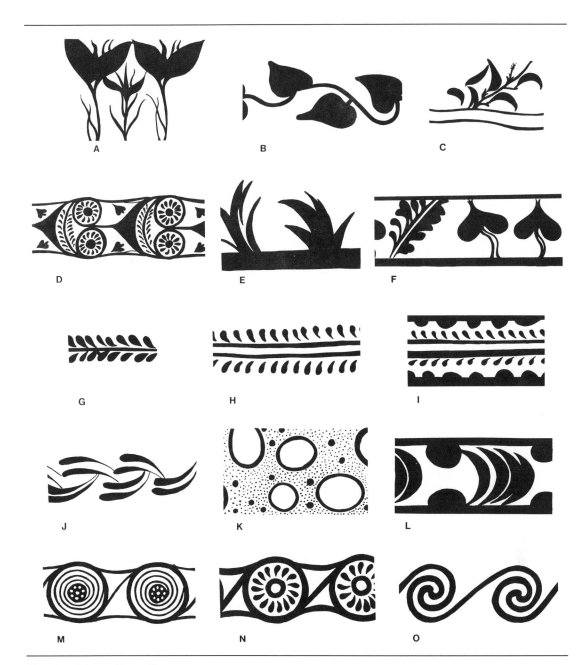

98 · Late Minoan IA motifs.

larity of these designs. All are used in horizontal friezes, with the individual elements more often repeated than alternated. Usually a vase has several types of ornament, capitalizing on the contrast between different motifs.

Foreign trade is already in progress. Contact with Cyprus is proved by an occasional Cypriote scrap in Crete (Popham 1963) as well as by several Minoan pieces in Cyprus, from Toumba tou Skourou (Vermeule and Wolsky 1978; Vermeule 1980) and Enkomi (Dikaios 1969-1971: I frontispiece no. 1-2 and 229-230; III pls. 58 nos. 26-27 and 86 nos. 1-2). These sherds may only be the tip of the iceberg, however, since the growing Minoan metals industry must have needed a steady supply of raw materials, especially copper. A Cretan influence on the Cypriote script seems highly likely, suggesting a rather deeper relationship than the exchange of an occasional pot.

The Cyclades continue to be important. Thera has more examples from LM IA than any other site, a circumstance that is perhaps due more to the destruction at the end of the period than to a lack of material from elsewhere (Marinatos 1968-1976). Other Cycladic settlements, listed below under the discussion of LM IB, were also already receiving Minoan pottery.

This is the main period for the Shaft Graves at Mycenae (Karo 1930-1933; Mylonas 1972-1973). Much Minoan influence is visible in the rich burial offerings of the Mycenaean rulers, but the evidence of trade is still too slight for us to decipher the exact nature of the artistic relationship (Shear 1967; Dickinson 1984; Hägg 1984). Few clay vases are present in the graves, indicating either disinterest in such commonplace materials or the fact that only a few actual Minoans reached the wealthy citadel.

Stylistically, LM IA develops very gradually. A conservative stage can be seen in MM III-LM I tombs at Poros (Lembesi 1967) and in several deposits from eastern Crete: some "pits" at Kato Zakros (Hogarth 1900-1901: 121ff.; Dawkins 1903: 248-251); a group of early LM I floors at Gournia (Hawes et al. 1908: Area D); some living surfaces at Palaikastro (Dawkins 1904-1905: 275-276 and 286ff.; Bosanquet and Dawkins 1923: 21ff.); and an uncertain context at Priniatikos Pyrgos (Betancourt 1978). Pottery from this phase is shown in Figure 99. The dark-on-light style is already being used for floral ornament, but the more conservative white paint is still common. Especially in the east, however, the older technique has picked up a new spirit of lightness and elegance. The motif of the leaf-like tendrils, for example, is a happy marriage between the foliate band and the running spiral (Fig. 99D), making an especially graceful pottery motif. Some of the floral designs, like the plants on the miniature jug in Figure 99C, had already appeared in white paint in MM III. They now switch to dark-on-light and increase in popularity at the expense of the more staid motifs of the earlier period. Tortoise-Shell Ripple Ware is present in quantity, especially on bowls and cups (Fig. 99A). As a whole, the early LM IA style is an interesting mixture of novelty and conservatism.

What is either a slightly later stage or a contemporary but more forward-looking style comes from a group of similar finds, a well on the hill of Gypsades at Knossos (Evans 1921-1935: II fig. 349; Popham 1967: pl. 76a-g), possibly some of the finds in a house near the acropolis at Knossos (Catling et al. 1979), and Room C 58 at Gournia (Hawes et al. 1908: pl. 7 nos. 25-32 and 34-41). The style from Knossos is rather sober—mostly reeds,

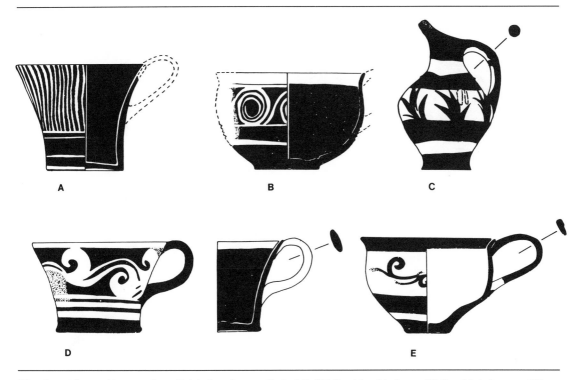

99 · Late Minoan IA vases from Priniatikos Pyrgos, Scale 1:3. (A) Straight sided cup; (B) Semiglobular cup; (C) Jug; (D) Straight sided cup; (E) Semiglobular cup.

spirals, tortoise-shell ripple, and foliate bands. Eastern Crete, on the other hand, is more flamboyant; its potters are more interested in plant life, and some of their designs are lush and complicated. Often the spirals evolve into complex variations (Pl. 17A and B). Light-on-dark patterns are now less common. The dark-on-light motifs are becoming more standardized, and some designs, like the spirals, foliate bands, and grass clumps, already comprise a set repertoire.

A group of vases from C 58 at Gournia is illustrated in Figure 100 and Plate 17C, D, and H. Rhyta of several types were stored in this room. Their shapes, more developed than in MM III, include the conical, globular, and ostrich-egg types (Pl. 17C and D and Fig. 100A-I). One rhyton is in the shape of a bull's head (Pl. 17H). It is extremely lifelike with excel-lent modeling, a dark painted eye, and touches of red paint on the hide. Jugs and other shapes are also found (Fig. 100J-L). Multiple bands of ornament are common, and designs usually fill their assigned spaces completely. They are often fairly complex. The painting is especially careful, much neater than in LM IB. White and red paint are used for accents, and rows of white dots or thin wavy lines are often painted on top of dark bands (see Fig. 100B).

The triple vessel in Figure 100K is a very unusual piece. A "trick vase," it consists of a cup with concave sides and two jars, with the three containers joined together. The cup has triangular holes in the sides and a false bottom a little above the real one, with a hole in the real bottom. A hollow ring at the base opens into the bottoms of the two jars and joins

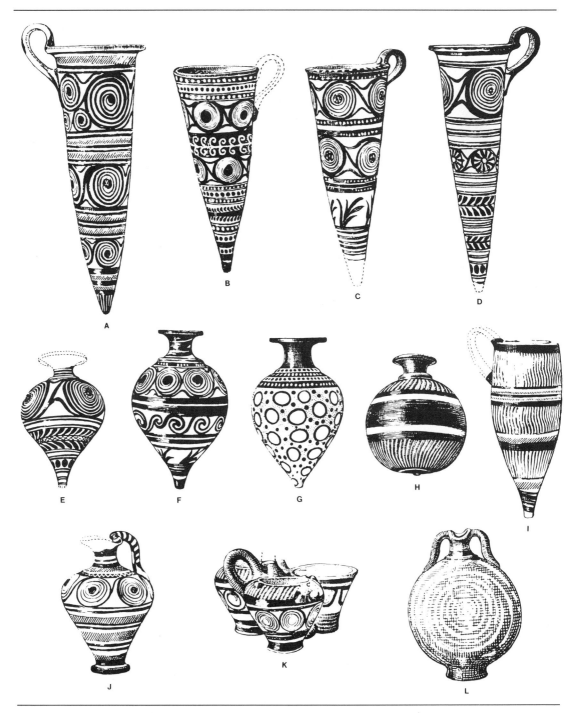

100 · Late Minoan 1A vases from Room C 58 at Gournia. (A) Conical rhyton, Ht. 36.5 cm.; (B) Conical rhyton, Ht. 27 cm.; (C) Conical rhyton, Ht. 31 cm.; (D) Conical rhyton, Ht. 32.5 cm.; (E) Ostrich-egg-shaped rhyton, Ht. 18.4 cm.; (F) Ostrich-egg-shaped rhyton, Ht. 22.4 cm.; (G) Ostrich-egg-shaped rhyton, Ht. 21.8 cm.; (H) Globular rhyton, Ht. 16.8 cm.; (I) Conical rhyton with convex sides, Ht. 25 cm.; (J) Jug, Ht. 19.6 cm.; Trick vase, Ht. of wall 9.2 cm.; (L) Flask, Ht. 19 cm.

them to the lower part of the cup, below the false bottom. Anything poured into the jars would stream out the botton of the cup, although it would look dry and empty to anyone who peeped inside.

Many of the elements in the pottery from Room C 58—rosettes, spirals, tortoise-shell ripple, foliate bands, flowers, dot bands, etc.—are like those found on the pottery from the best known LM IA context from the Aegean, the town of Akrotiri on the island of Thera. Akrotiri is by far the most useful site for most classes of LM I artifacts (Marinatos 1968-1976; Doumas 1975; 1976B; 1983). Hundreds of complete clay vases are present, all buried at one time by the deep ash accumulations from the Theran volcano. Except for a very few disputants (Luce 1976; 1978; Bolton 1976; Höckmann 1978), scholars agree in assigning the Theran pottery to LM IA (the best discussion is Niemeier 1980, following the lines laid down by Popham 1967). Its style is like that of the LM IA contexts from Crete, and it has none of the LM IB styles discussed below.

The vases in Plate 17E and F, found at Akrotiri, are typical of the Minoan imports at the site. The rosettes on both vases may be closely compared with those on the rhyton from Gournia in Plate 17D, and the shape of the jug in Plate 17F is also like one from Gournia (Pl. 17G).

As with so many LM IA pieces, the Theran vessels stack up a series of friezes, with white used as an accessory color on some zones. The pottery must lie very late in LM IA, at the eve of the introduction of LM IB.

LATE MINOAN IB

Late Minoan I may be divided into two phases. The second stage, however, has been difficult to characterize. It is usually recognized by the presence of the Marine Style, the Reed Painter and his associates and imitators, and other relatively rare products of palatial workshops, elaborate and artistic vessels that appear to be imports even at many sites in Crete. A realization of the more subtle changes that identify the later stages of the standard LM I style has only come recently, with restudy of material excavated some time ago (for example, Silverman 1978B; Niemeier 1979B; 1980) and with new evidence furnished by modern excavations, particularly at Knossos (Hood 1961-1962; 1962A; 1962B) Palaikastro (Sackett and Popham 1970: 215-232), Kythera (Coldstream and Huxley et al. 1973), and Thera (for negative evidence see Marinatos 1968-1976; Doumas 1983). Although problems still remain, the relative dating and the direction of the stylistic progression are well understood.

Large LM IB deposits come from all parts of Crete, from Knossos and the other palaces as well as from outlying areas. In addition, there are exports to the Aegean islands, the Greek mainland, the coast of Asia Minor, Egypt, and the Near East. Most of the good deposits come from the end of the period, buried in the violent destructions that brought it to a close.

Sites with LM IB destruction levels form a long list and cover the entire island. The most important pottery groups are from:

EASTERN CRETE

Gournia (Hawes et al. 1908)
Mokhlos (Seager 1909)
Palaikastro (Sackett and Popham 1970, with earlier bibliography)
Pseira (Seager 1910)
Pyrgos, Myrtou (Cadogan 1978)

CENTRAL CRETE

Aghia Triada (Pernier and Banti
1951: 532; Halbherr, Stefani, and
Banti 1977)

Arkhanes (Lembesi, Olivier, and Go-
dart 1974)

Amnissos (Marinatos 1932A; 1933;
Bequignon 1933: 292-295)

Khalara (Levi 1967-1968)

Knossos (Hood 1961-1962: 96-97;
1962A; 1962B; 1973; Warren
1981A)

Malia (the *deuxième époque, deuxième
phase*, Chapouthier and Charbon-
neaux 1928; Chapouthier and Joly
1936; Chapouthier and Demargne
1942; Demargne and Gallet de
Santerre 1953; Deshayes and Des-
sene 1959; Chapouthier, De-
margne, and Dessene 1962; Effen-
terre et al. 1963; Effenterre and
Effenterre 1969; Pelon 1970;
Amouretti 1970)

Nirou Khani (Xanthoudides 1922)

Phaistos (Pernier and Banti 1951;
Levi 1961-1962B: figs. 151-152)

Prasa (Platon 1951A)

Sklavokampos (Marinatos 1939-1941)

Tylissos (Hazzidakis 1921; 1934)

Vathypetro (Marinatos 1949; 1950;
1951; 1952; for the date see Nie-
meier 1980: 14)

WESTERN CRETE

Khamalevri (Hood, Warren, and Ca-
dogan 1964: pl. 13c)

Khania (Tzedakis 1966)

This period marks the high point of
Minoan foreign expansion. The vigorous
economic activity may be traced through
the greater percentage of Minoan ex-
ports in many materials, as well as
through local copies of Cretan products.
Minoan pottery is especially influential.

Its attractive styles set the pace for many
Aegean workshops, and the provincial
products were exported in turn, spread-
ing the styles even farther. The selection
of vases in Plate 81A-D comes from
Aghia Eirene on Keos, a Cycladic settle-
ment with an especially strong Minoan
presence (Cummer and Schofield 1984).
Dating from LM IB, they illustrate a
wide variety of attractive styles, indistin-
guishable from those found in Crete it-
self. The rhyton from Melos in Plate 18E
is less obviously Cretan. Although the
shape, the technology of the dark slip,
and even the retorted spirals are ulti-
mately inspired from Minoan originals,
the style departs enough from the Cretan
rhyta (compare Pl. 17C-E) to suggest it is
not a direct copy. Increased building ac-
tivity throughout the Aegean indicates
the beneficial results of this brisk trade;
most Minoanizing settlements enjoyed
their greatest prosperity during LM IB.

Minoan ceramic exports are well docu-
mented, and they come from a wide area
(Scholes 1956: 27-29). Mainland sites
with substantial quantities include Aghios
Stephanos in Lakonia where Minoan and
Minoanizing styles begin in Middle Hel-
ladic (Taylour 1972; Rutter and Rutter
1976; Jones and Rutter 1977). Messenia
and other areas also receive stimuli
(Hägg 1982). Aegean islands with many
imports include the towns at Kastri on
Kythera (Coldstream and Huxley et al.
1973; Coldstream 1978), Aghia Eirene on
Keos (Caskey 1962; 1964; 1966; 1971;
1972; 1979; Cummer and Schofield
1984), and Phylakopi on Melos (Atkinson
et al. 1904; Renfrew 1978). Among these
islands, the Western String may have en-
joyed some type of special trading rela-
tionship (Davis 1979; Schofield 1982A;
1982B). Farther east, material comes
from Karpathos (Melas 1981), Ialysos on
Rhodes (Monaco 1938; 1941; Furumark

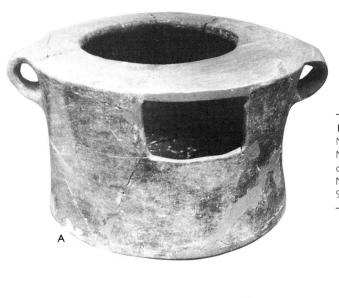

1 · Neolithic and Final Neolithic vessels. (A) Knossos, Middle Neolithic, Ht. 20 cm.; (B) Eileithyia Cave, Final Neolithic or Early Minoan I, Ht. 12 cm.; (C) Knossos, Middle Neolithic, Ht. 8.7 cm.; (D) Phourni Meramvellou, Final Neolithic, Ht. 19 cm. (E) Phaistos, Final Neolithic, Pres. ht. 9.8 cm.; (F) Knossos, Middle Neolithic, Length 21 cm.

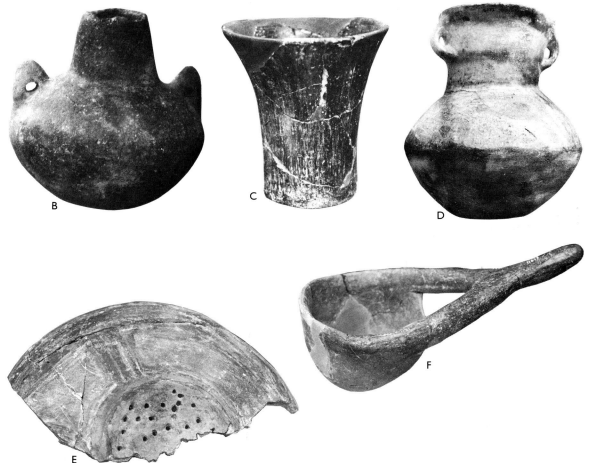

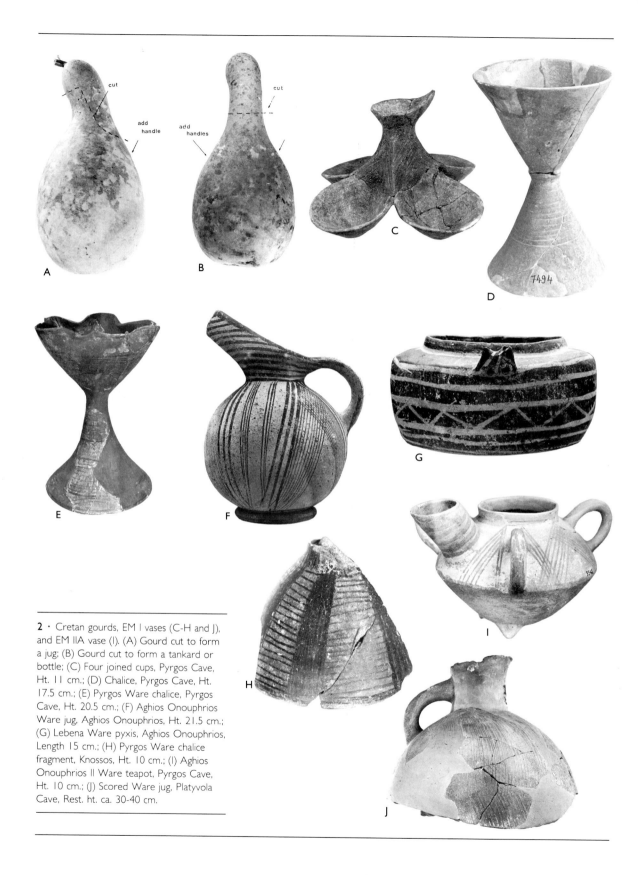

2 · Cretan gourds, EM I vases (C-H and J), and EM IIA vase (I). (A) Gourd cut to form a jug; (B) Gourd cut to form a tankard or bottle; (C) Four joined cups, Pyrgos Cave, Ht. 11 cm.; (D) Chalice, Pyrgos Cave, Ht. 17.5 cm.; (E) Pyrgos Ware chalice, Pyrgos Cave, Ht. 20.5 cm.; (F) Aghios Onouphrios Ware jug, Aghios Onouphrios, Ht. 21.5 cm.; (G) Lebena Ware pyxis, Aghios Onouphrios, Length 15 cm.; (H) Pyrgos Ware chalice fragment, Knossos, Ht. 10 cm.; (I) Aghios Onouphrios II Ware teapot, Pyrgos Cave, Ht. 10 cm.; (J) Scored Ware jug, Platyvola Cave, Rest. ht. ca. 30-40 cm.

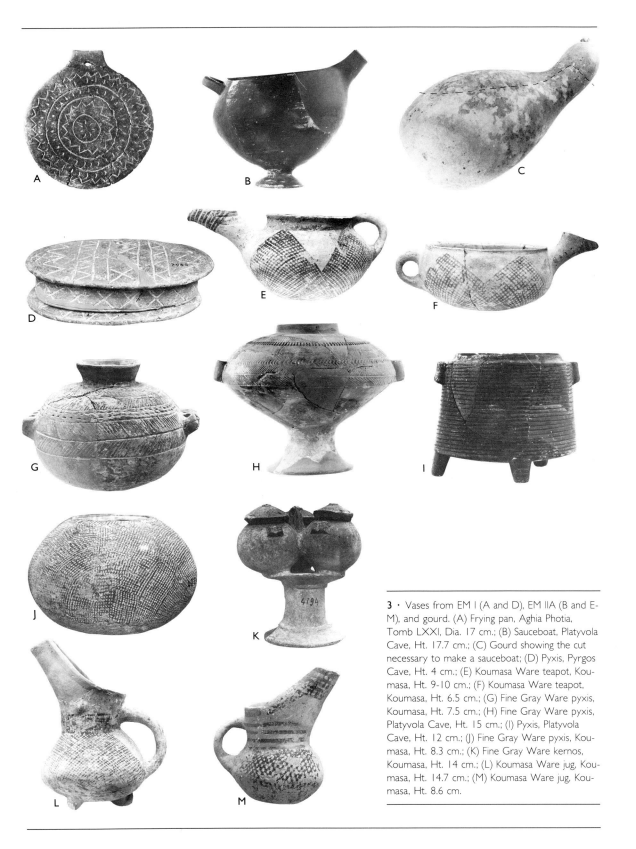

3 · Vases from EM I (A and D), EM IIA (B and E-M), and gourd. (A) Frying pan, Aghia Photia, Tomb LXXI, Dia. 17 cm.; (B) Sauceboat, Platyvola Cave, Ht. 17.7 cm.; (C) Gourd showing the cut necessary to make a sauceboat; (D) Pyxis, Pyrgos Cave, Ht. 4 cm.; (E) Koumasa Ware teapot, Koumasa, Ht. 9-10 cm.; (F) Koumasa Ware teapot, Koumasa, Ht. 6.5 cm.; (G) Fine Gray Ware pyxis, Koumasa, Ht. 7.5 cm.; (H) Fine Gray Ware pyxis, Platyvola Cave, Ht. 15 cm.; (I) Pyxis, Platyvola Cave, Ht. 12 cm.; (J) Fine Gray Ware pyxis, Koumasa, Ht. 8.3 cm.; (K) Fine Gray Ware kernos, Koumasa, Ht. 14 cm.; (L) Koumasa Ware jug, Koumasa, Ht. 14.7 cm.; (M) Koumasa Ware jug, Koumasa, Ht. 8.6 cm.

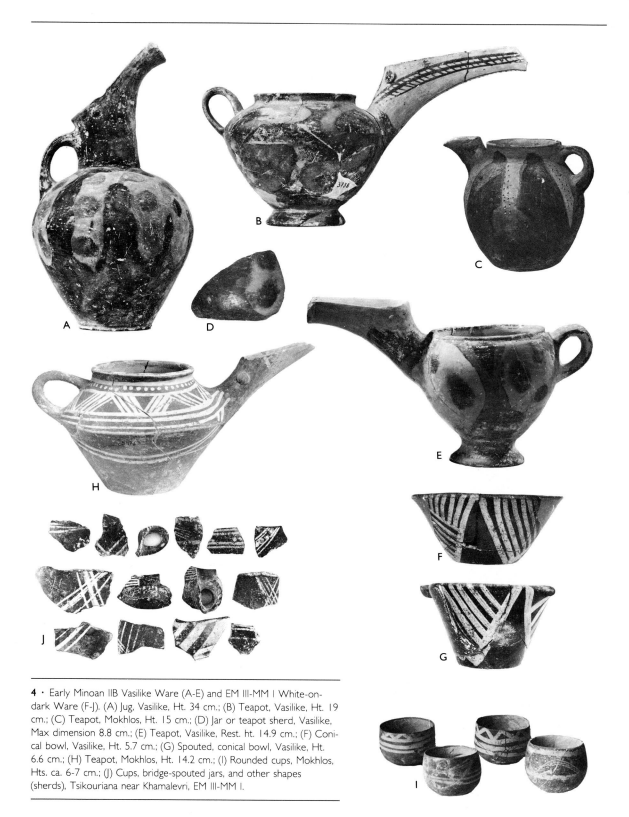

4 · Early Minoan IIB Vasilike Ware (A-E) and EM III-MM I White-on-dark Ware (F-J). (A) Jug, Vasilike, Ht. 34 cm.; (B) Teapot, Vasilike, Ht. 19 cm.; (C) Teapot, Mokhlos, Ht. 15 cm.; (D) Jar or teapot sherd, Vasilike, Max dimension 8.8 cm.; (E) Teapot, Vasilike, Rest. ht. 14.9 cm.; (F) Conical bowl, Vasilike, Ht. 5.7 cm.; (G) Spouted, conical bowl, Vasilike, Ht. 6.6 cm.; (H) Teapot, Mokhlos, Ht. 14.2 cm.; (I) Rounded cups, Mokhlos, Hts. ca. 6-7 cm.; (J) Cups, bridge-spouted jars, and other shapes (sherds), Tsikouriana near Khamalevri, EM III-MM I.

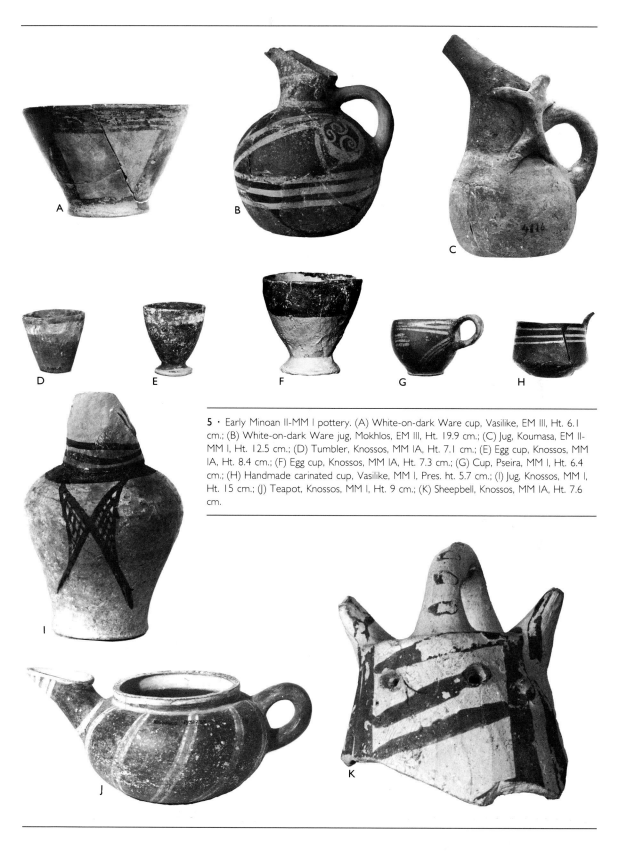

5 · Early Minoan II-MM I pottery. (A) White-on-dark Ware cup, Vasilike, EM III, Ht. 6.1 cm.; (B) White-on-dark Ware jug, Mokhlos, EM III, Ht. 19.9 cm.; (C) Jug, Koumasa, EM II-MM I, Ht. 12.5 cm.; (D) Tumbler, Knossos, MM IA, Ht. 7.1 cm.; (E) Egg cup, Knossos, MM IA, Ht. 8.4 cm.; (F) Egg cup, Knossos, MM IA, Ht. 7.3 cm.; (G) Cup, Pseira, MM I, Ht. 6.4 cm.; (H) Handmade carinated cup, Vasilike, MM I, Pres. ht. 5.7 cm.; (I) Jug, Knossos, MM I, Ht. 15 cm.; (J) Teapot, Knossos, MM I, Ht. 9 cm.; (K) Sheepbell, Knossos, MM IA, Ht. 7.6 cm.

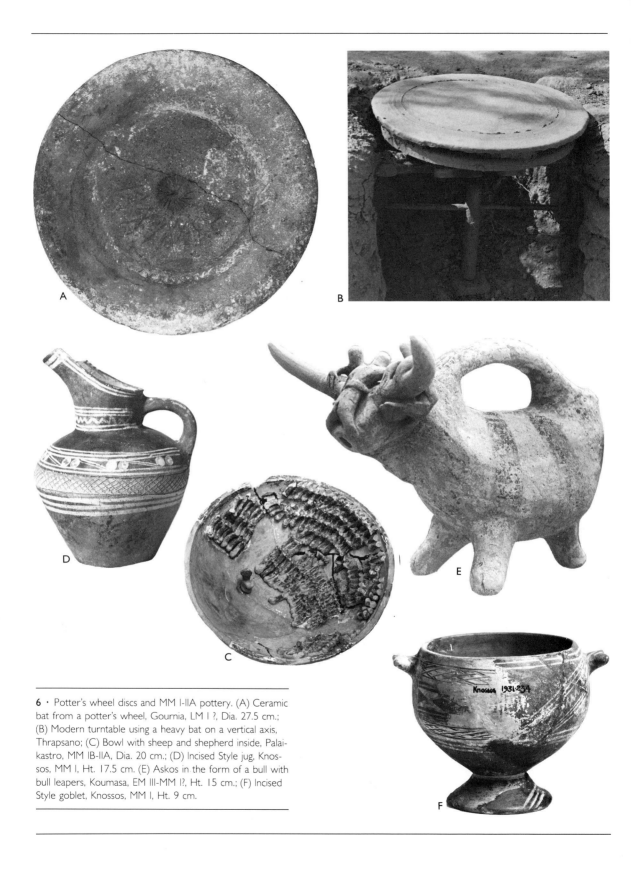

6 · Potter's wheel discs and MM I-IIA pottery. (A) Ceramic bat from a potter's wheel, Gournia, LM I ?, Dia. 27.5 cm.; (B) Modern turntable using a heavy bat on a vertical axis, Thrapsano; (C) Bowl with sheep and shepherd inside, Palaikastro, MM IB-IIA, Dia. 20 cm.; (D) Incised Style jug, Knossos, MM I, Ht. 17.5 cm. (E) Askos in the form of a bull with bull leapers, Koumasa, EM III-MM I?, Ht. 15 cm.; (F) Incised Style goblet, Knossos, MM I, Ht. 9 cm.

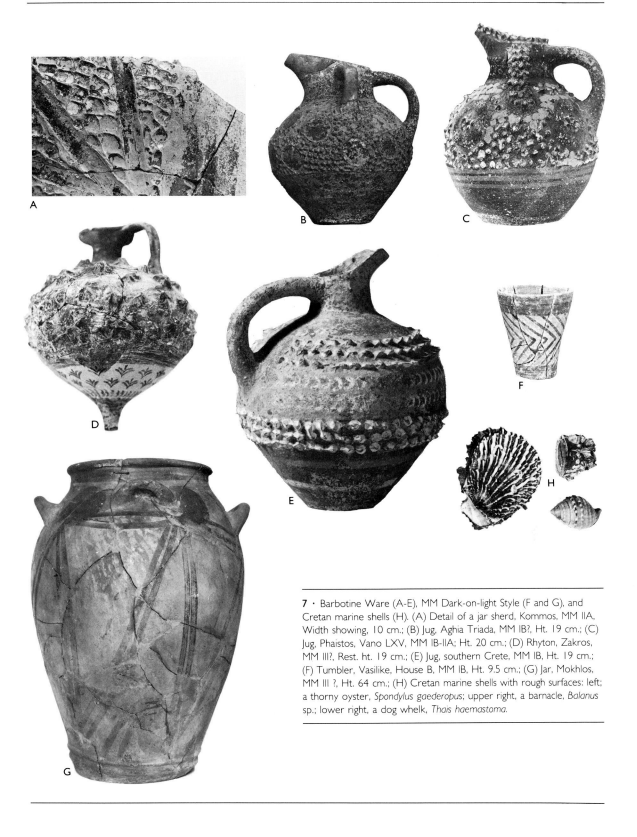

7 · Barbotine Ware (A-E), MM Dark-on-light Style (F and G), and Cretan marine shells (H). (A) Detail of a jar sherd, Kommos, MM IIA, Width showing, 10 cm.; (B) Jug, Aghia Triada, MM IB?, Ht. 19 cm.; (C) Jug, Phaistos, Vano LXV, MM IB-IIA; Ht. 20 cm.; (D) Rhyton, Zakros, MM III?, Rest. ht. 19 cm.; (E) Jug, southern Crete, MM IB, Ht. 19 cm.; (F) Tumbler, Vasilike, House B, MM IB, Ht. 9.5 cm.; (G) Jar, Mokhlos, MM III ?, Ht. 64 cm.; (H) Cretan marine shells with rough surfaces: left; a thorny oyster, *Spondylus gaederopus*; upper right, a barnacle, *Balanus* sp.; lower right, a dog whelk, *Thais haemastoma*.

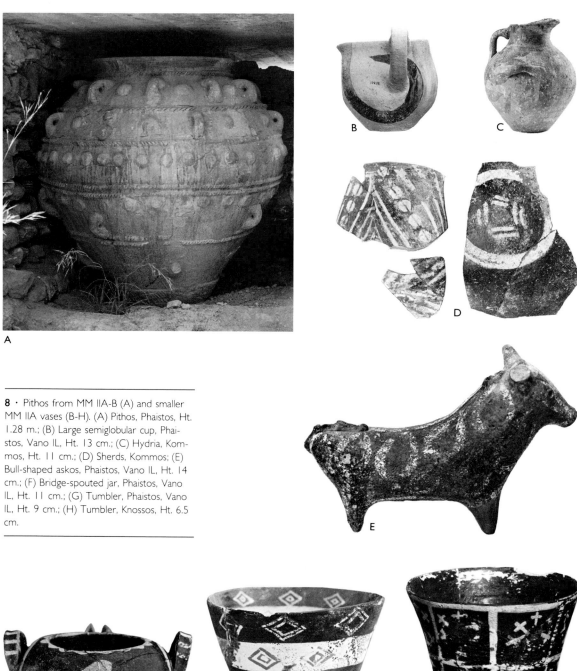

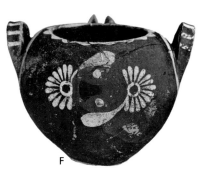

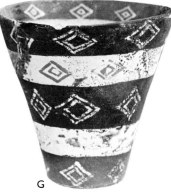

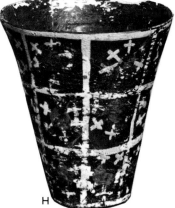

8 · Pithos from MM IIA-B (A) and smaller MM IIA vases (B-H). (A) Pithos, Phaistos, Ht. 1.28 m.; (B) Large semiglobular cup, Phaistos, Vano IL, Ht. 13 cm.; (C) Hydria, Kommos, Ht. 11 cm.; (D) Sherds, Kommos; (E) Bull-shaped askos, Phaistos, Vano IL, Ht. 14 cm.; (F) Bridge-spouted jar, Phaistos, Vano IL, Ht. 11 cm.; (G) Tumbler, Phaistos, Vano IL, Ht. 9 cm.; (H) Tumbler, Knossos, Ht. 6.5 cm.

A

B

C

D

E

F

G

H

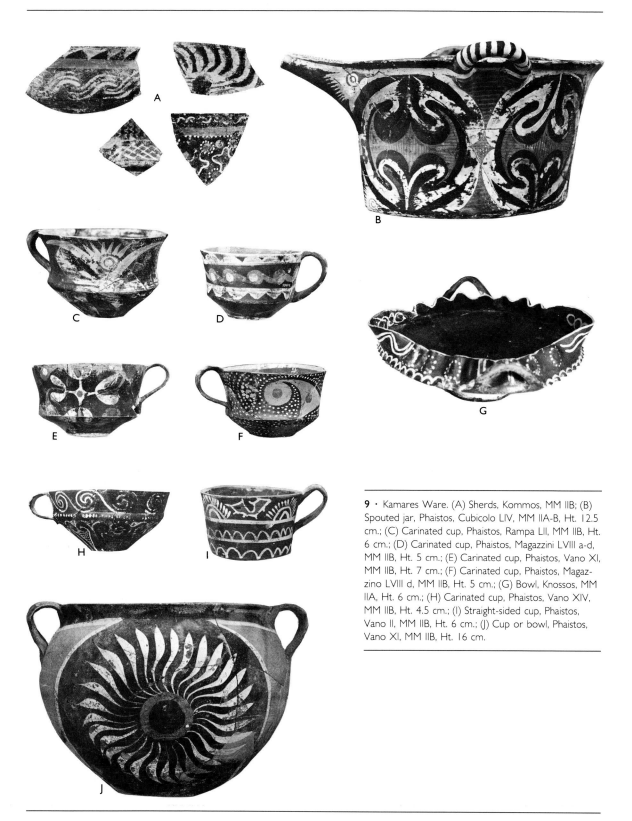

9 · Kamares Ware. (A) Sherds, Kommos, MM IIB; (B) Spouted jar, Phaistos, Cubicolo LIV, MM IIA-B, Ht. 12.5 cm.; (C) Carinated cup, Phaistos, Rampa LII, MM IIB, Ht. 6 cm.; (D) Carinated cup, Phaistos, Magazzini LVIII a-d, MM IIB, Ht. 5 cm.; (E) Carinated cup, Phaistos, Vano XI, MM IIB, Ht. 7 cm.; (F) Carinated cup, Phaistos, Magazzino LVIII d, MM IIB, Ht. 5 cm.; (G) Bowl, Knossos, MM IIA, Ht. 6 cm.; (H) Carinated cup, Phaistos, Vano XIV, MM IIB, Ht. 4.5 cm.; (I) Straight-sided cup, Phaistos, Vano II, MM IIB, Ht. 6 cm.; (J) Cup or bowl, Phaistos, Vano XI, MM IIB, Ht. 16 cm.

10 · Kamares Ware from Phaistos, MM IIB, (A) Straight-sided cup with shell impressions on the exterior, Vano XIX, Ht. 7.5 cm.; (B) Straight-sided cup, Vano XIII, Ht. 7 cm.; (C) Straight-sided cup, Vano XIII, Ht. 6.5 cm.; (D) Goblet with plastic ornament, Vano LV, Ht. 45.5 cm.; (E) Jug, Vano IV, Ht. 32 cm.

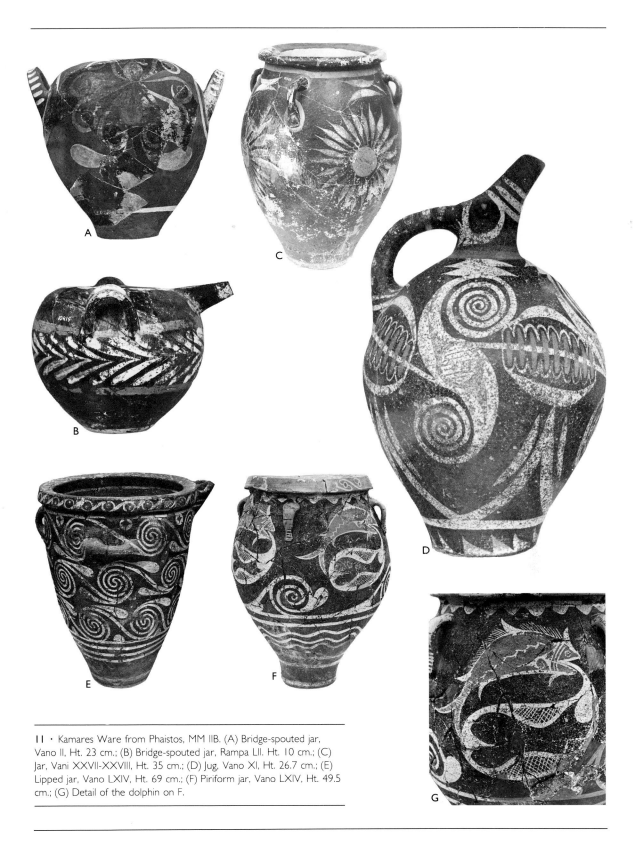

11 · Kamares Ware from Phaistos, MM IIB. (A) Bridge-spouted jar, Vano II, Ht. 23 cm.; (B) Bridge-spouted jar, Rampa LII. Ht. 10 cm.; (C) Jar, Vani XXVII-XXVIII, Ht. 35 cm.; (D) Jug, Vano XI, Ht. 26.7 cm.; (E) Lipped jar, Vano LXIV, Ht. 69 cm.; (F) Piriform jar, Vano LXIV, Ht. 49.5 cm.; (G) Detail of the dolphin on F.

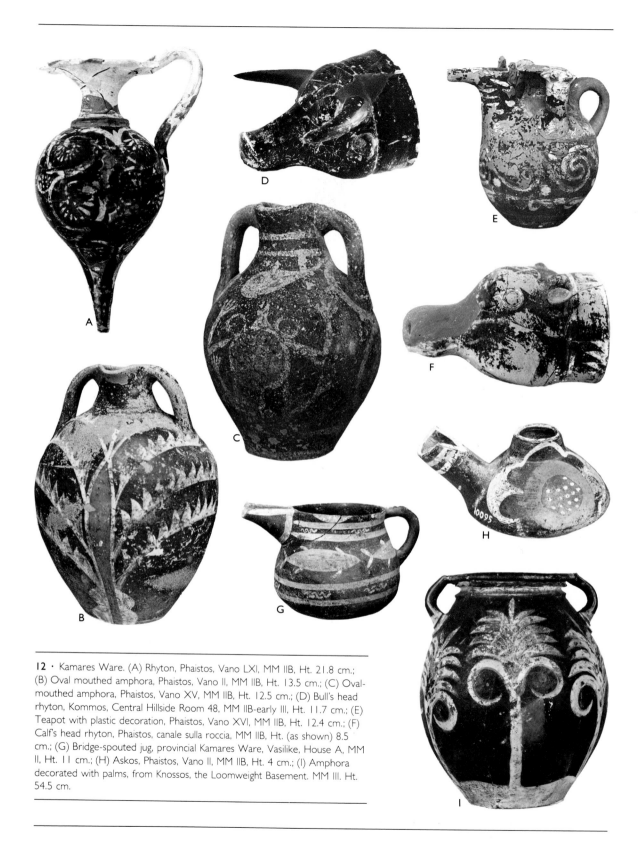

12 · Kamares Ware. (A) Rhyton, Phaistos, Vano LXI, MM IIB, Ht. 21.8 cm.; (B) Oval mouthed amphora, Phaistos, Vano II, MM IIB, Ht. 13.5 cm.; (C) Oval-mouthed amphora, Phaistos, Vano XV, MM IIB, Ht. 12.5 cm.; (D) Bull's head rhyton, Kommos, Central Hillside Room 48, MM IIB-early III, Ht. 11.7 cm.; (E) Teapot with plastic decoration, Phaistos, Vano XVI, MM IIB, Ht. 12.4 cm.; (F) Calf's head rhyton, Phaistos, canale sulla roccia, MM IIB, Ht. (as shown) 8.5 cm.; (G) Bridge-spouted jug, provincial Kamares Ware, Vasilike, House A, MM II, Ht. 11 cm.; (H) Askos, Phaistos, Vano II, MM IIB, Ht. 4 cm.; (I) Amphora decorated with palms, from Knossos, the Loomweight Basement. MM III. Ht. 54.5 cm.

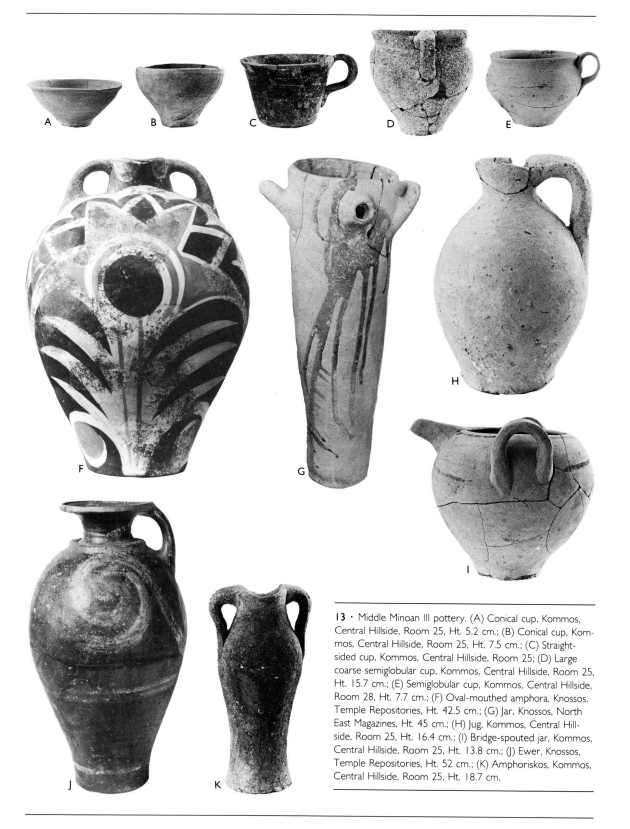

13 · Middle Minoan III pottery. (A) Conical cup, Kommos, Central Hillside, Room 25, Ht. 5.2 cm.; (B) Conical cup, Kommos, Central Hillside, Room 25, Ht. 7.5 cm.; (C) Straight-sided cup, Kommos, Central Hillside, Room 25; (D) Large coarse semiglobular cup, Kommos, Central Hillside, Room 25, Ht. 15.7 cm.; (E) Semiglobular cup, Kommos, Central Hillside, Room 28, Ht. 7.7 cm.; (F) Oval-mouthed amphora, Knossos, Temple Repositories, Ht. 42.5 cm.; (G) Jar, Knossos, North East Magazines, Ht. 45 cm.; (H) Jug, Kommos, Central Hillside, Room 25, Ht. 16.4 cm.; (I) Bridge-spouted jar, Kommos, Central Hillside, Room 25, Ht. 13.8 cm.; (J) Ewer, Knossos, Temple Repositories, Ht. 52 cm.; (K) Amphoriskos, Kommos, Central Hillside, Room 25, Ht. 18.7 cm.

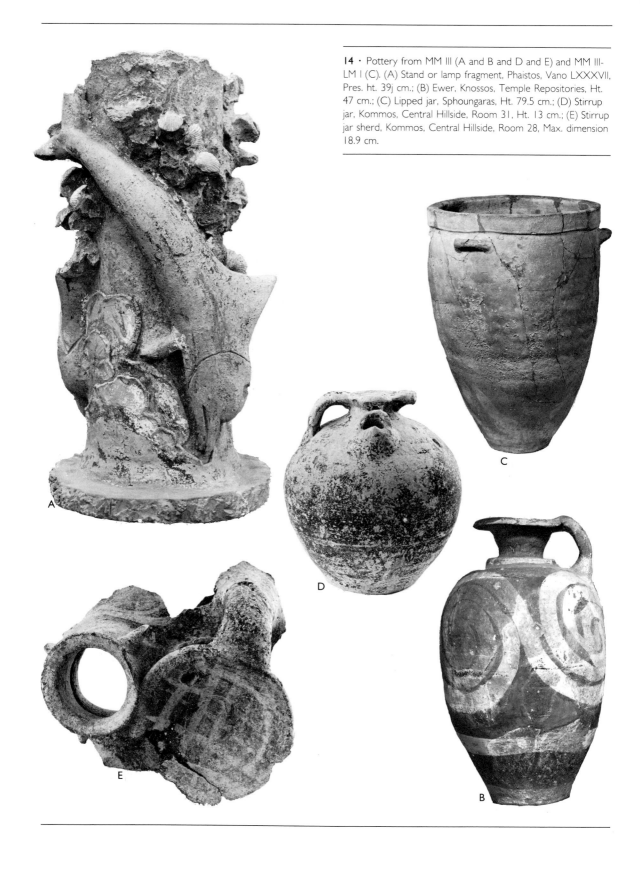

14 · Pottery from MM III (A and B and D and E) and MM III-LM I (C). (A) Stand or lamp fragment, Phaistos, Vano LXXXVII, Pres. ht. 39j cm.; (B) Ewer, Knossos, Temple Repositories, Ht. 47 cm.; (C) Lipped jar, Sphoungaras, Ht. 79.5 cm.; (D) Stirrup jar, Kommos, Central Hillside, Room 31, Ht. 13 cm.; (E) Stirrup jar sherd, Kommos, Central Hillside, Room 28, Max. dimension 18.9 cm.

A

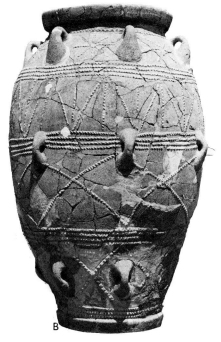

B

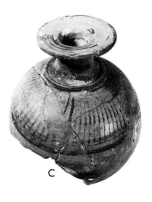

C

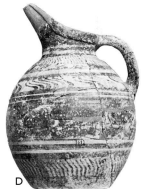

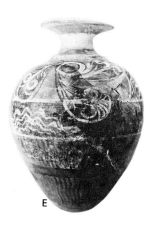

D

15 · Pottery from MM III-LM I (A-E) and kiln from Stylos (F). (A) Pithos, Knossos, Room of the Tall Pithos, MM III, Ht. 1.65 m.; (B) Pithos, Malia, Esplanade Nord, MM III, Ht. 1.74 m.; (C) Ostrich-egg-shaped rhyton, Ripple Ware, Gournia, LM IA, Rest. ht. ca. 20 cm.; (D) Jug, Ripple Ware, Gournia, LM I, Ht. 26 cm.; (E) Rhyton, Zakros, MM III-LM IA, Rest. ht. 19 cm.; (F) Potter's kiln from Stylos, LM III.

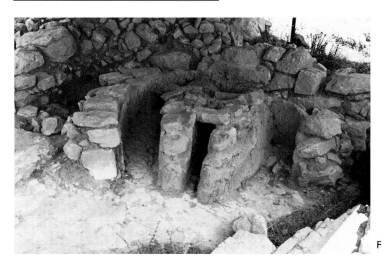

F

E

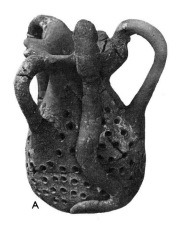

A

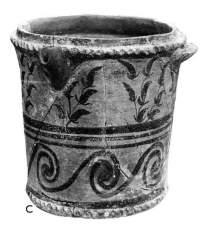

C

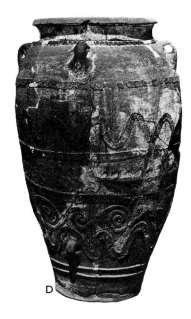

D

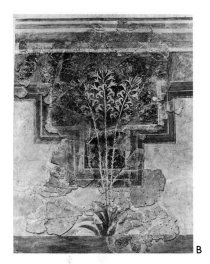

B

16 · Mural (B) and pottery from MM III-LM I. (A) Pierced tall alabastron with a snake on the side, Knossos, LM I, Ht. 11.2 cm.; (B) Mural from Amnissos, LM I; (C) Jar, Knossos, LM I, Ht. 38 cm.; (D) Pithos, Malia, Room 28, 2, LM I, Ht. 1.66 m.; (E) Pithos, Knossos, MM III-LM I, Ht. 1.15 m.; (F) General view of the West Magazines at Knossos with pithoi from several periods, mostly MM III-LM I; the undecorated example at the lower right is from LM III.

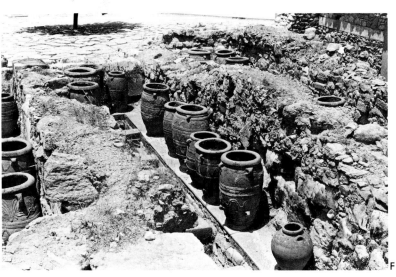

F

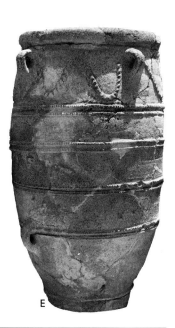

E

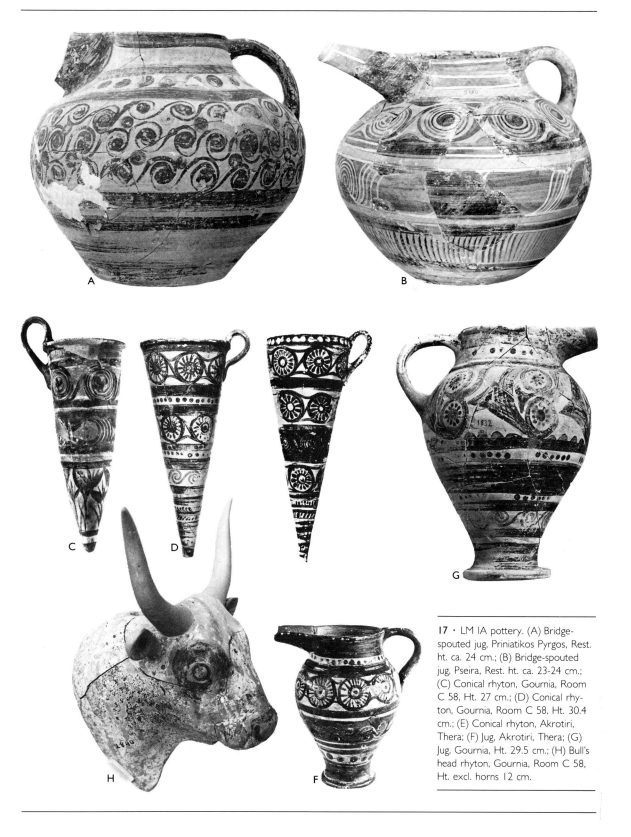

17 · LM IA pottery. (A) Bridge-spouted jug, Priniatikos Pyrgos, Rest. ht. ca. 24 cm.; (B) Bridge-spouted jug, Pseira, Rest. ht. ca. 23-24 cm.; (C) Conical rhyton, Gournia, Room C 58, Ht. 27 cm.; (D) Conical rhyton, Gournia, Room C 58, Ht. 30.4 cm.; (E) Conical rhyton, Akrotiri, Thera; (F) Jug, Akrotiri, Thera; (G) Jug, Gournia, Ht. 29.5 cm.; (H) Bull's head rhyton, Gournia, Room C 58, Ht. excl. horns 12 cm.

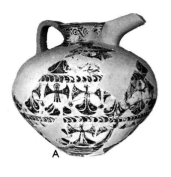

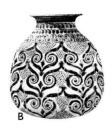

18 · Late Minoan IA-B vases. (A-D) LM IB Special Palatial Tradition, found at Aghia Eirene, Keos. (A) Jug, Ht. 32.3 cm.; (B) Tall alabastron, Pres. ht. 14.1 cm.; (C) Basket-shaped vase, ht. 13.8 cm.; (D) Cup rhyton, Ht. 11 cm.; (E) Cycladic rhyton found at Phylakopi, Melos, imitating the Minoan style, LM I, Ht. 27.5 cm.; (F) Jar, Gournia, LM IB Standard Tradition, Ht. 15 cm.; (G) Jug, Pseira, LM IB Standard Tradition, Ht. 16.9 cm.; (H) Jar, Pseira, LM IA or B, Ht. 80 cm.; (I) Stirrup jar, Gournia, passage between Rooms Ab and Ac, LM IA or B, Ht. 42 cm.

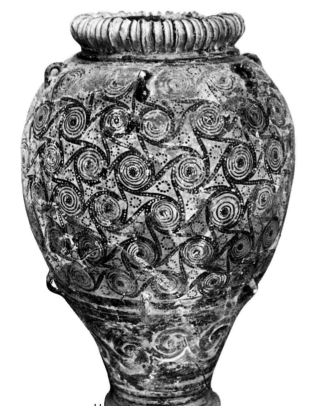

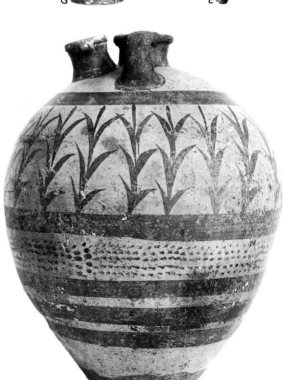

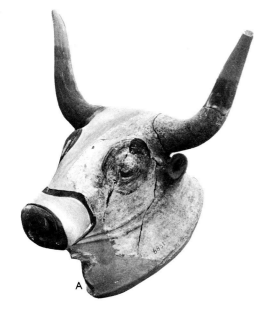

A

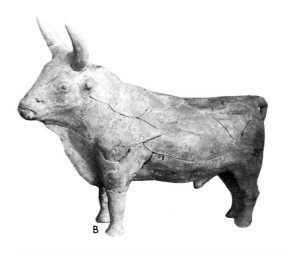

B

19 · Plastic vases and a large jar. (A) Bull's head rhyton, Mokhlos, LM IB, Rest. ht. ca. 32 cm.; (B) Bull-shaped askos, Pseira, LM IB, Length 25.5 cm.; (C) Bull-shaped askos, Pseira, LM IB, Length 26 cm.; (D) Jar, Pseira, LM IA or B(?), Ht. 76 cm.; (E) Rim sherd decorated with a griffin, Malia, LM IB (?), Rest, dia. ca. 15 cm.

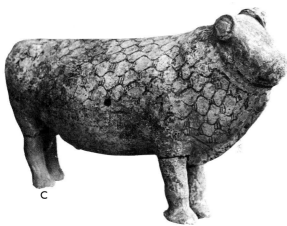

C

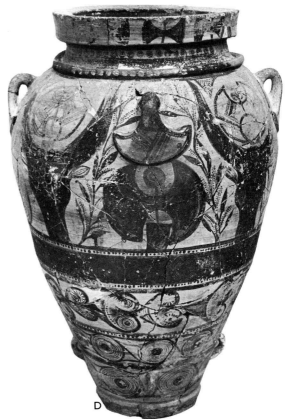

D

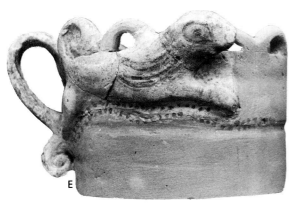

E

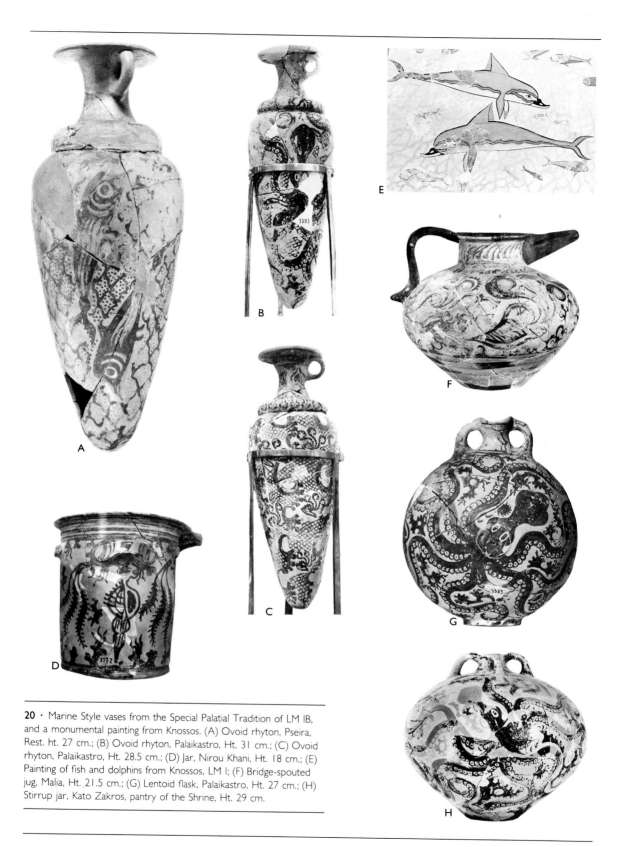

20 · Marine Style vases from the Special Palatial Tradition of LM IB, and a monumental painting from Knossos. (A) Ovoid rhyton, Pseira, Rest. ht. 27 cm.; (B) Ovoid rhyton, Palaikastro, Ht. 31 cm.; (C) Ovoid rhyton, Palaikastro, Ht. 28.5 cm.; (D) Jar, Nirou Khani, Ht. 18 cm.; (E) Painting of fish and dolphins from Knossos, LM I; (F) Bridge-spouted jug, Malia, Ht. 21.5 cm.; (G) Lentoid flask, Palaikastro, Ht. 27 cm.; (H) Stirrup jar, Kato Zakros, pantry of the Shrine, Ht. 29 cm.

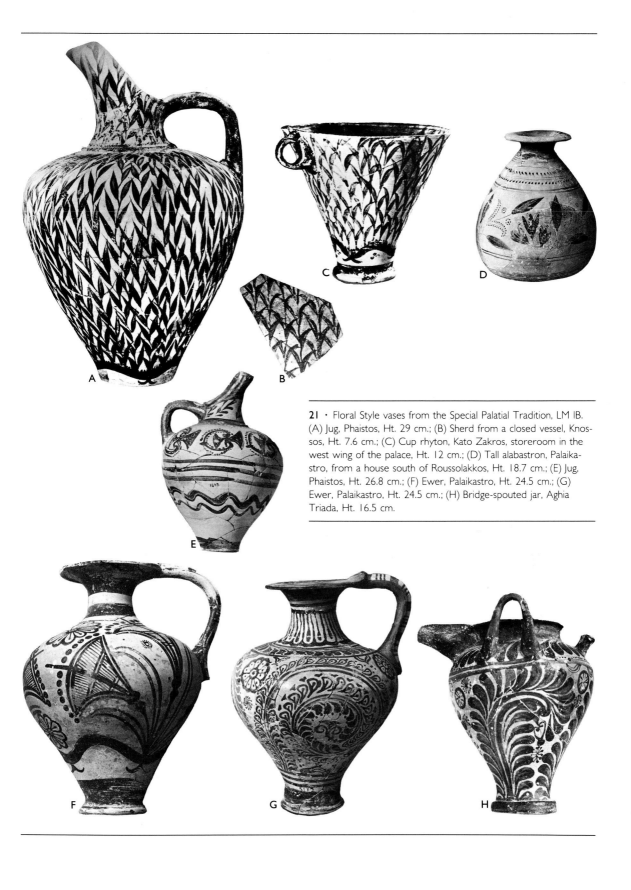

21 · Floral Style vases from the Special Palatial Tradition, LM IB. (A) Jug, Phaistos, Ht. 29 cm.; (B) Sherd from a closed vessel, Knossos, Ht. 7.6 cm.; (C) Cup rhyton, Kato Zakros, storeroom in the west wing of the palace, Ht. 12 cm.; (D) Tall alabastron, Palaikastro, from a house south of Roussolakkos, Ht. 18.7 cm.; (E) Jug, Phaistos, Ht. 26.8 cm.; (F) Ewer, Palaikastro, Ht. 24.5 cm.; (G) Ewer, Palaikastro, Ht. 24.5 cm.; (H) Bridge-spouted jar, Aghia Triada, Ht. 16.5 cm.

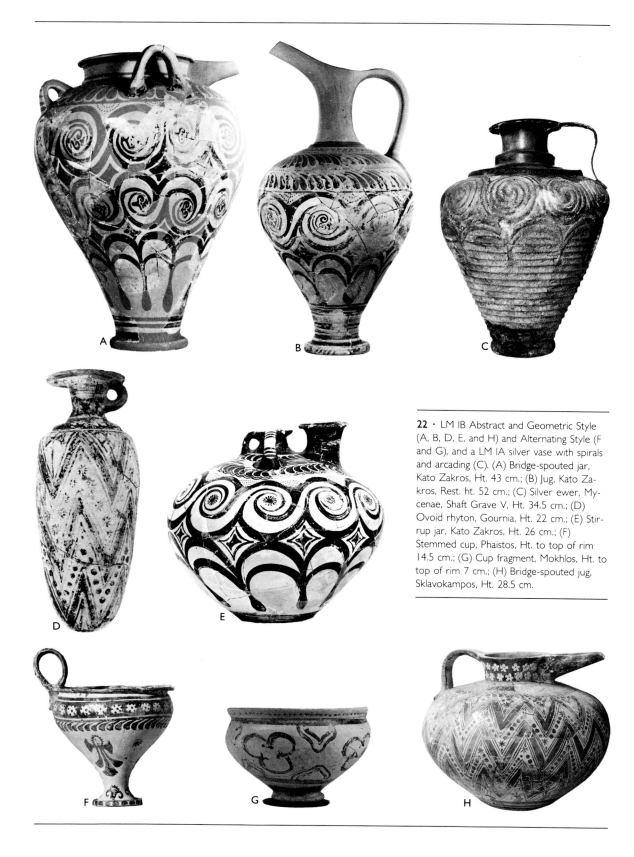

22 · LM IB Abstract and Geometric Style (A, B, D, E, and H) and Alternating Style (F and G), and a LM IA silver vase with spirals and arcading (C). (A) Bridge-spouted jar, Kato Zakros, Ht. 43 cm.; (B) Jug, Kato Zakros, Rest. ht. 52 cm.; (C) Silver ewer, Mycenae, Shaft Grave V, Ht. 34.5 cm.; (D) Ovoid rhyton, Gournia, Ht. 22 cm.; (E) Stirrup jar, Kato Zakros, Ht. 26 cm.; (F) Stemmed cup, Phaistos, Ht. to top of rim 14.5 cm.; (G) Cup fragment, Mokhlos, Ht. to top of rim 7 cm.; (H) Bridge-spouted jug, Sklavokampos, Ht. 28.5 cm.

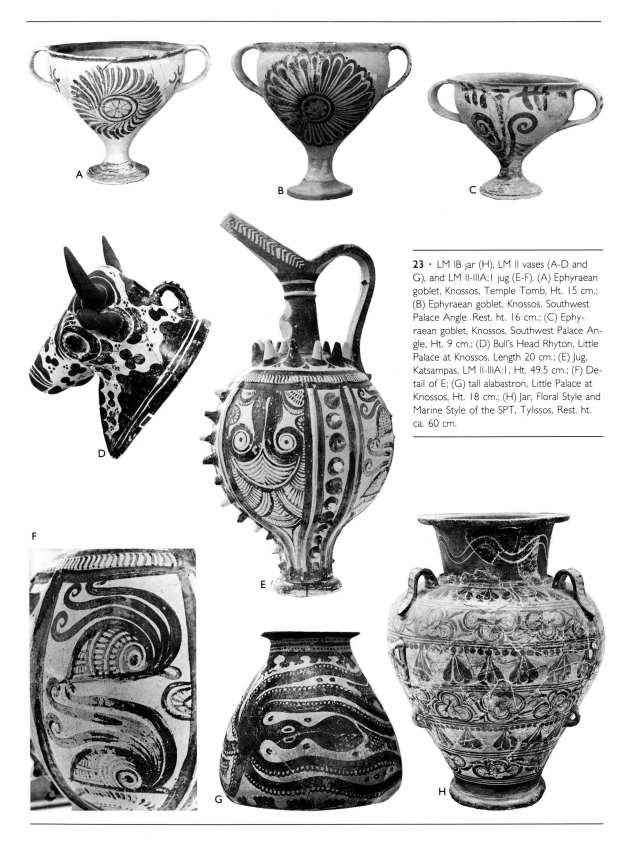

23 · LM IB jar (H), LM II vases (A-D and G), and LM II-IIIA:1 jug (E-F). (A) Ephyraean goblet, Knossos, Temple Tomb, Ht. 15 cm.; (B) Ephyraean goblet, Knossos, Southwest Palace Angle. Rest. ht. 16 cm.; (C) Ephyraean goblet, Knossos, Southwest Palace Angle, Ht. 9 cm.; (D) Bull's Head Rhyton, Little Palace at Knossos, Length 20 cm.; (E) Jug, Katsampas, LM II-IIIA:1, Ht. 49.5 cm.; (F) Detail of E; (G) tall alabastron, Little Palace at Knossos, Ht. 18 cm.; (H) Jar, Floral Style and Marine Style of the SPT, Tylissos, Rest. ht. ca. 60 cm.

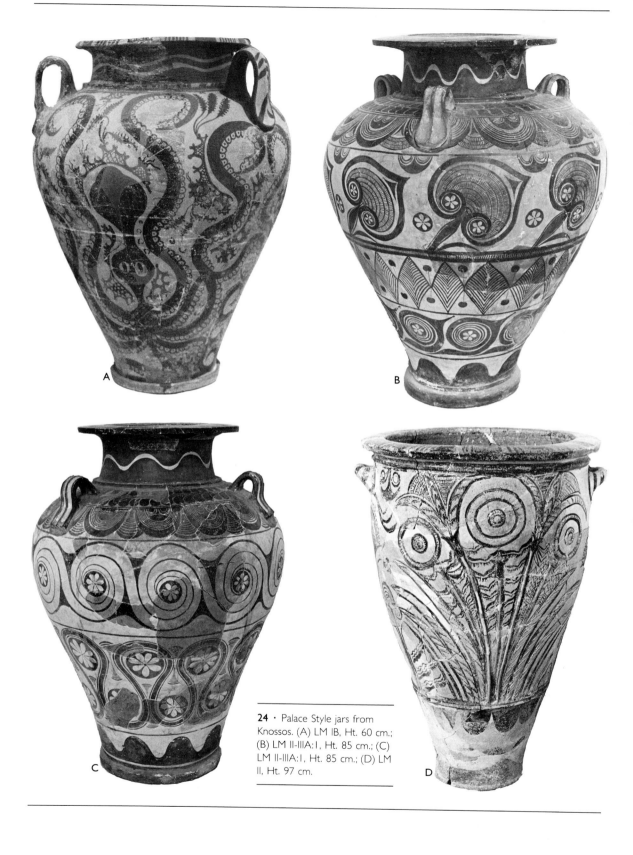

24 · Palace Style jars from Knossos. (A) LM IB, Ht. 60 cm.; (B) LM II-IIIA:1, Ht. 85 cm.; (C) LM II-IIIA:1, Ht. 85 cm.; (D) LM II, Ht. 97 cm.

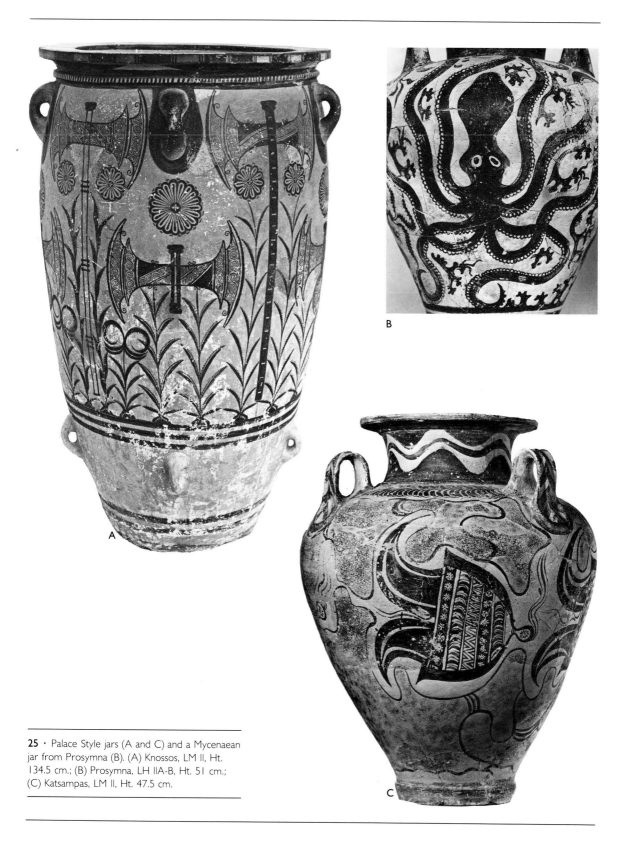

25 · Palace Style jars (A and C) and a Mycenaean
jar from Prosymna (B). (A) Knossos, LM II, Ht.
134.5 cm.; (B) Prosymna, LH IIA-B, Ht. 51 cm.;
(C) Katsampas, LM II, Ht. 47.5 cm.

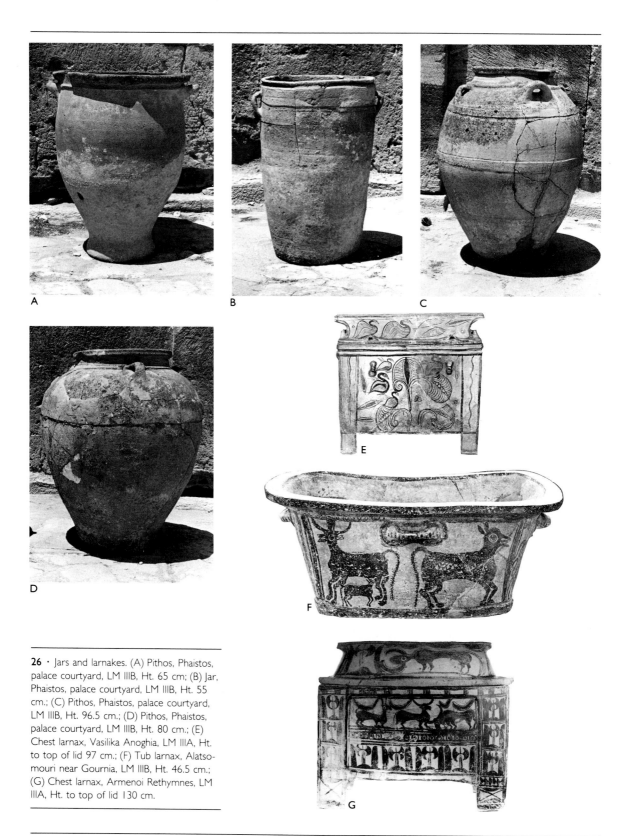

26 · Jars and larnakes. (A) Pithos, Phaistos, palace courtyard, LM IIIB, Ht. 65 cm; (B) Jar, Phaistos, palace courtyard, LM IIIB, Ht. 55 cm.; (C) Pithos, Phaistos, palace courtyard, LM IIIB, Ht. 96.5 cm.; (D) Pithos, Phaistos, palace courtyard, LM IIIB, Ht. 80 cm.; (E) Chest larnax, Vasilika Anoghia, LM IIIA, Ht. to top of lid 97 cm.; (F) Tub larnax, Alatsomouri near Gournia, LM IIIB, Ht. 46.5 cm.; (G) Chest larnax, Armenoi Rethymnes, LM IIIA, Ht. to top of lid 130 cm.

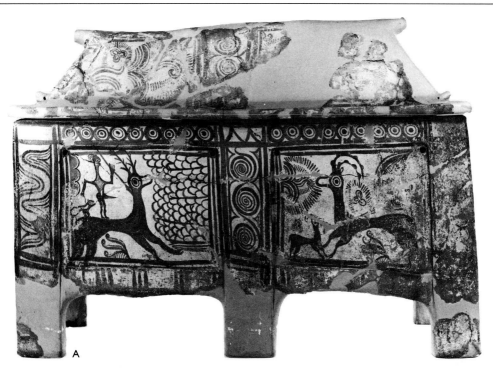

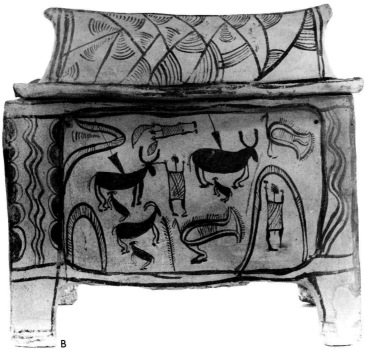

27 · Larnakes from Armenoi Rethymnes. (A) LM IIIA, Ht. to top of lid 103 cm.; (B) LM IIIA:2-IIIB, Ht. to top of lid 99 cm.

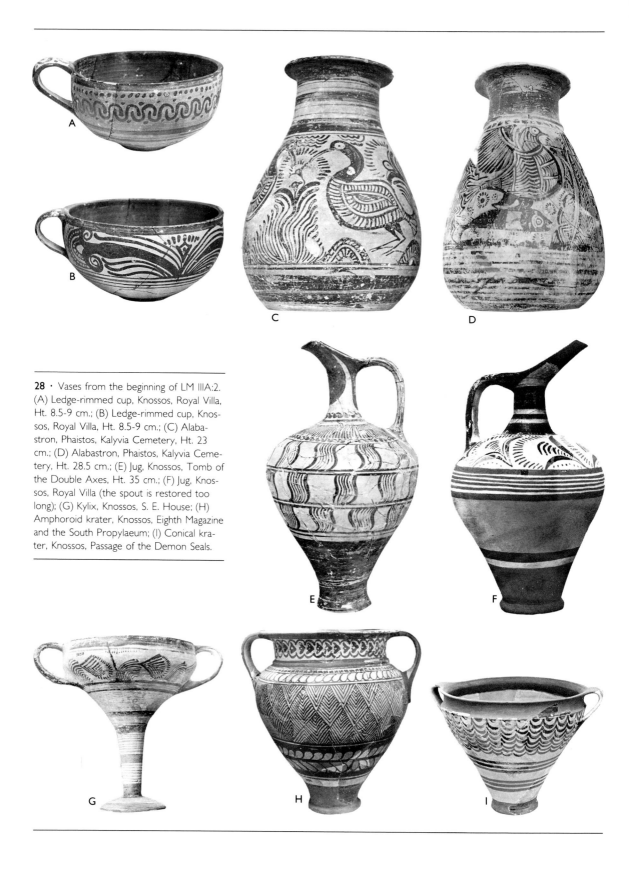

28 · Vases from the beginning of LM IIIA:2. (A) Ledge-rimmed cup, Knossos, Royal Villa, Ht. 8.5-9 cm.; (B) Ledge-rimmed cup, Knossos, Royal Villa, Ht. 8.5-9 cm.; (C) Alabastron, Phaistos, Kalyvia Cemetery, Ht. 23 cm.; (D) Alabastron, Phaistos, Kalyvia Cemetery, Ht. 28.5 cm.; (E) Jug, Knossos, Tomb of the Double Axes, Ht. 35 cm.; (F) Jug, Knossos, Royal Villa (the spout is restored too long); (G) Kylix, Knossos, S. E. House; (H) Amphoroid krater, Knossos, Eighth Magazine and the South Propylaeum; (I) Conical krater, Knossos, Passage of the Demon Seals.

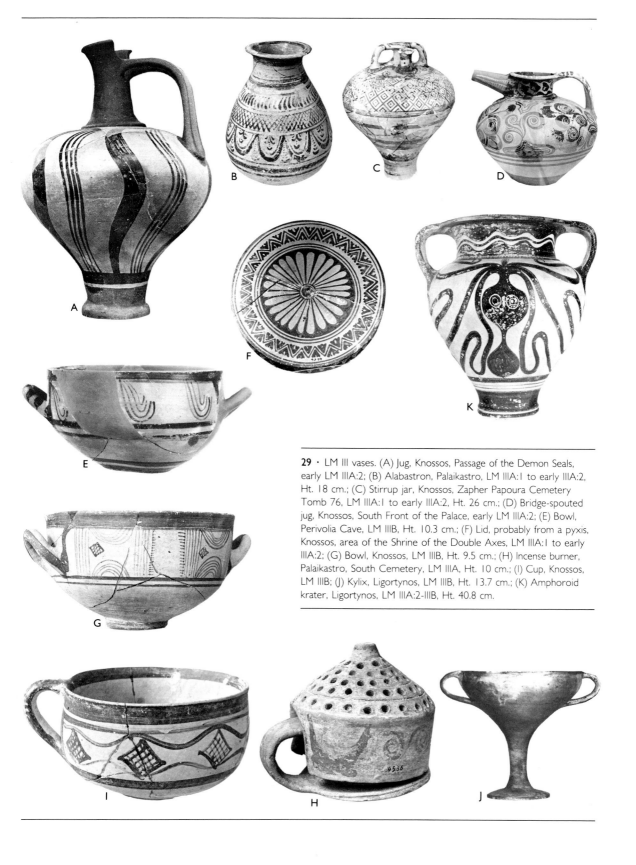

29 · LM III vases. (A) Jug, Knossos, Passage of the Demon Seals, early LM IIIA:2; (B) Alabastron, Palaikastro, LM IIIA:1 to early IIIA:2, Ht. 18 cm.; (C) Stirrup jar, Knossos, Zapher Papoura Cemetery Tomb 76, LM IIIA:1 to early IIIA:2, Ht. 26 cm.; (D) Bridge-spouted jug, Knossos, South Front of the Palace, early LM IIIA:2; (E) Bowl, Perivolia Cave, LM IIIB, Ht. 10.3 cm.; (F) Lid, probably from a pyxis, Knossos, area of the Shrine of the Double Axes, LM IIIA:1 to early IIIA:2; (G) Bowl, Knossos, LM IIIB, Ht. 9.5 cm.; (H) Incense burner, Palaikastro, South Cemetery, LM IIIA, Ht. 10 cm.; (I) Cup, Knossos, LM IIIB; (J) Kylix, Ligortynos, LM IIIB, Ht. 13.7 cm.; (K) Amphoroid krater, Ligortynos, LM IIIA:2-IIIB, Ht. 40.8 cm.

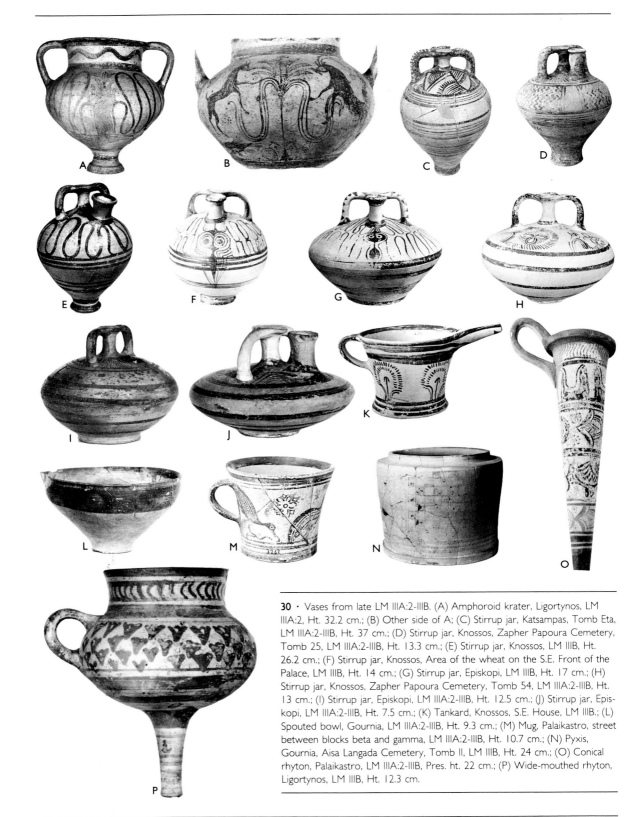

30 · Vases from late LM IIIA:2-IIIB. (A) Amphoroid krater, Ligortynos, LM IIIA:2, Ht. 32.2 cm.; (B) Other side of A; (C) Stirrup jar, Katsampas, Tomb Eta, LM IIIA:2-IIIB, Ht. 37 cm.; (D) Stirrup jar, Knossos, Zapher Papoura Cemetery, Tomb 25, LM IIIA:2-IIIB, Ht. 13.3 cm.; (E) Stirrup jar, Knossos, LM IIIB, Ht. 26.2 cm.; (F) Stirrup jar, Knossos, Area of the wheat on the S.E. Front of the Palace, LM IIIB, Ht. 14 cm.; (G) Stirrup jar, Episkopi, LM IIIB, Ht. 17 cm.; (H) Stirrup jar, Knossos, Zapher Papoura Cemetery, Tomb 54, LM IIIA:2-IIIB, Ht. 13 cm.; (I) Stirrup jar, Episkopi, LM IIIA:2-IIIB, Ht. 12.5 cm.; (J) Stirrup jar, Episkopi, LM IIIA:2-IIIB, Ht. 7.5 cm.; (K) Tankard, Knossos, S.E. House, LM IIIB.; (L) Spouted bowl, Gournia, LM IIIA:2-IIIB, Ht. 9.3 cm.; (M) Mug, Palaikastro, street between blocks beta and gamma, LM IIIA:2-IIIB, Ht. 10.7 cm.; (N) Pyxis, Gournia, Aisa Langada Cemetery, Tomb II, LM IIIB, Ht. 24 cm.; (O) Conical rhyton, Palaikastro, LM IIIA:2-IIIB, Pres. ht. 22 cm.; (P) Wide-mouthed rhyton, Ligortynos, LM IIIB, Ht. 12.3 cm.

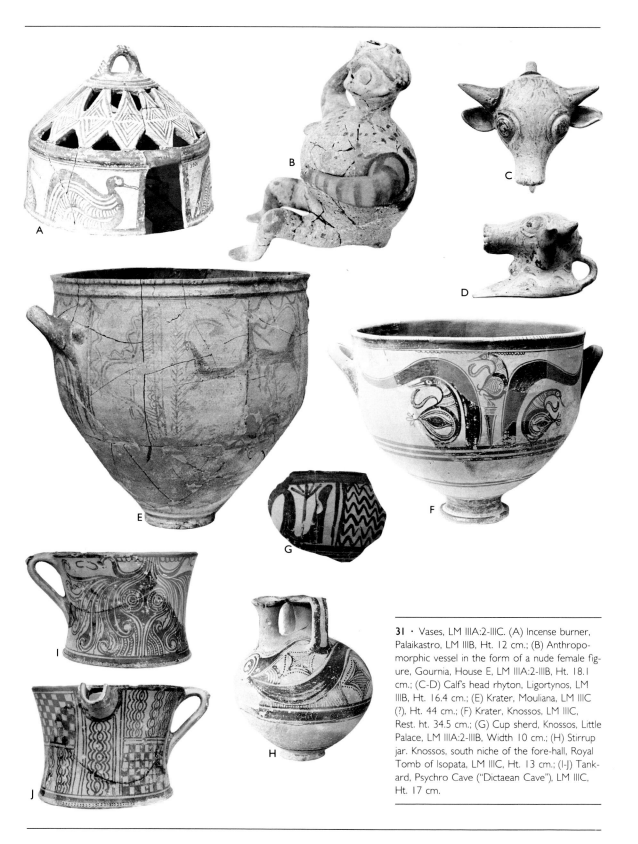

31 · Vases, LM IIIA:2-IIIC. (A) Incense burner, Palaikastro, LM IIIB, Ht. 12 cm.; (B) Anthropomorphic vessel in the form of a nude female figure, Gournia, House E, LM IIIA:2-IIIB, Ht. 18.1 cm.; (C-D) Calf's head rhyton, Ligortynos, LM IIIB, Ht. 16.4 cm.; (E) Krater, Mouliana, LM IIIC (?), Ht. 44 cm.; (F) Krater, Knossos, LM IIIC, Rest. ht. 34.5 cm.; (G) Cup sherd, Knossos, Little Palace, LM IIIA:2-IIIB, Width 10 cm.; (H) Stirrup jar. Knossos, south niche of the fore-hall, Royal Tomb of Isopata, LM IIIC, Ht. 13 cm.; (I-J) Tankard, Psychro Cave ("Dictaean Cave"), LM IIIC, Ht. 17 cm.

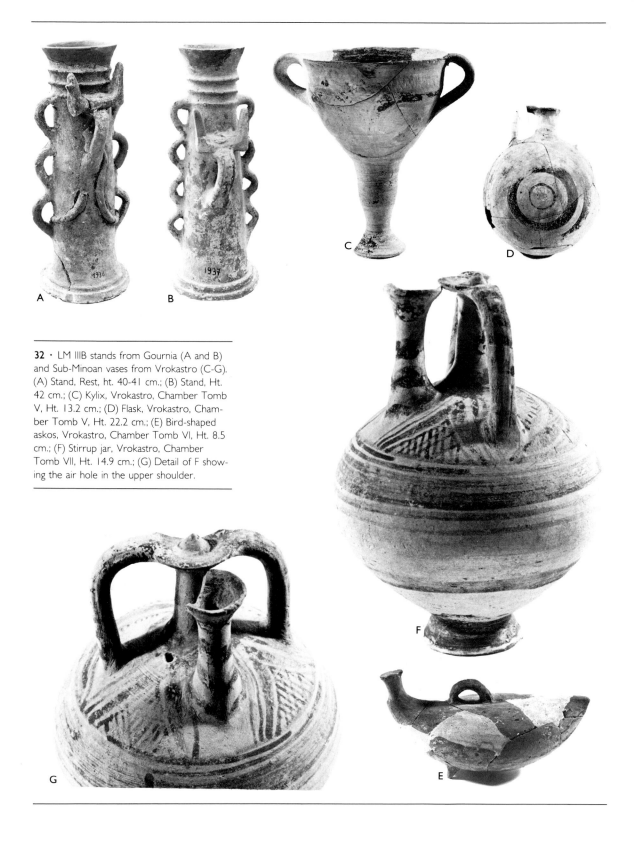

32 · LM IIIB stands from Gournia (A and B) and Sub-Minoan vases from Vrokastro (C-G). (A) Stand, Rest, ht. 40-41 cm.; (B) Stand, Ht. 42 cm.; (C) Kylix, Vrokastro, Chamber Tomb V, Ht. 13.2 cm.; (D) Flask, Vrokastro, Chamber Tomb V, Ht. 22.2 cm.; (E) Bird-shaped askos, Vrokastro, Chamber Tomb VI, Ht. 8.5 cm.; (F) Stirrup jar, Vrokastro, Chamber Tomb VII, Ht. 14.9 cm.; (G) Detail of F showing the air hole in the upper shoulder.

1950), Seraglio on Kos (Morricone 1972-1973), and Telos (Sampson 1980). Similar finds come from the Anatolian coast (Mee 1978), at Miletos (Weickert 1940; 1957; 1959-1960; Hommel 1959-1960; Schiering 1959-1960), Iasos (Levi 1972; Laviosa 1974), and Knidos (Iris Love, personal communication).

The finds on Crete itself paint a fairly homogeneous picture. With a few exceptions, sites are destroyed at the end of LM IB. Mycenaean influence follows immediately, and some Minoan specialists believe the native Cretan population was subjugated and perhaps largely exterminated, victims of the conquering Mycenaeans (a good discussion is Hood 1978A). An alternative, that the destructions are natural (perhaps from late tremors associated with the geological phenomena on Thera), is held by others (for discussion see Page 1970: 35-44; 1978; Sparks, Sigurdsson and Watkins 1978: 91; for the view against widespread tsunami and ash damage see Pichler and Schiering 1980).

Elsewhere, the evidence is less uniform. Phylakopi was destroyed at a time when it was receiving LM IB pottery (Renfrew 1978). Kythera may have been abandoned a little later than the LM IB destructions on Crete (Coldstream 1978: 398). At Aghia Eirene, the presence of Mycenaean Ephyraean goblets with highly stylized single ornaments (of the type usually called LH IIB) and of Marine Style vases of both Minoan and mainland fabric (Caskey 1972: 396) suggest either that the destruction takes place in LM II/LH IIB rather than at the end of LM IB or that LH IIB begins during LM IB (Cummer and Schofield 1984: 143-144). In all cases, the Minoan influence ends at or shortly after LM IB and is followed by abandonment or a sharp increase in the volume of Mycenaean pottery. The most

ready explanation is that the Minoan trading sphere has been broken, replaced by a new power from mainland Greece.

The nature and extent of the Minoan foreign relations has often been debated (see, for example, Starr 1954-1955, and against this, Buck 1962). Exported pottery furnishes the most evidence. Finds from Greece and the Aegean give abundant testimony for Minoan economic activity, but beyond these boundaries the evidence is less extensive. Sherds from Italy suggest only the slimmest Minoan presence (Taylour 1958; Buchholz 1980, with additional bibl.) Except for a handful of pieces from Lipari (Taylour 1958: 16-17), there is a little evidence for Minoan trade in this direction. A great amount of attention has focused on the eastern finds, but their total number is actually rather small; no single site has the quantity of material characterizing the Minoanizing settlements in the Aegean and on the Anatolian coast (for lists of Mycenaean and Minoan vases, with discussion, see Stubbings 1951; Hankey 1967; 1970-1971; Buchholz 1974; Cadogan 1979; Mee 1978).

As one moves east, the Minoan exports rapidly diminish. On Cyprus, cups and other shapes, some as early as LM IA, have been mentioned from Toumba tou Skourou and Enkomi (for other Aegean exports to Cyprus see Catling and Karageorghis 1960; 1979: 63). Vases from Egypt, including the alabastron from Sedment illustrated in Figure 90, have also been noted as has the sherd from Tell Ta'annek. Among the other LM IB vases from this part of the East is the Marseilles Ewer (Fig. 101), purchased in Egypt but said to have come from Palestine (for other Egyptian and Near Eastern finds see Helck 1979: 83-92; Merrillees and Evans 1980). Complementing the Egyptian finds are a handful of The-

ban tombs with paintings depicting Aegeans as foreigners bringing vases and other gifts to the Egyptian court (see especially Furumark 1950: 223-239; Vercoutter 1956; Strange 1980). The earliest

101 · A Minoan ewer decorated with argonauts purchased in Egypt but said to have come from Palestine, LM IB Marine Style, Ht. 25 cm.

examples, from the tomb of Senmut, date to the time of Hatshepsut, and the others are all from the reign of Thutmose III (Fig. 102). Vases in typical Aegean shapes are among the gifts presented. A discussion of the problems associated with the paintings is beyond the scope of this work, but their evidence helps fill out the picture suggested by the finds of actual vases; Aegeans were certainly not unknown in the East at the time of the early Eighteenth Dynasty.

Although the vigorous expansion of Minoan civilization is plainly visible, the mechanics of this expansion are still *terra incognita*. The possible position of Kythera as an intermediary with the Greek mainland or the roles of Cycladic seamen (Schachermeyr 1978) or Mycenaean traders (Iakovidis 1979) need more exploration. In the East, little more can be said except that Minoan pottery, probably at least partly carried by Aegeans, occasionally reached eastern markets.

The LM IB pottery can best be studied by dividing it into specific styles. The

102 · Wall painting from the tomb of Rekhmire, Thebes, Egypt, depicting men of Keftiu bringing a conical rhyton and other gifts, Reign of Thutmose III.

Standard Tradition, a selection of vases that follow traditional LM IA practices, may be contrasted with several dynamic groups centered at the palaces, especially Knossos.

THE STANDARD TRADITION

Most of the LM IB pottery is stylistically conservative, continuing along the lines laid down in LM IA. Since it is found at the palaces (including Knossos) as well as at less important sites, it cannot be termed "provincial," and it is here called the Standard Tradition. Only a few vases show an abrupt change from LM IA; in most cases the development is so subtle the style cannot be distinguished from that of the earlier pottery.

As a whole, the tradition is rather uneven (Figs. 103 and 104). Although some painters are still careful, others are hasty or even sloppy. Foliate bands, once ren-

103 · Motifs from the LM IB Standard Tradition.

104 · Vases from the LM IB Standard Tradition, Scale 1:3. (A-D and F-L) Pseira; (E) Mokhlos. (A) Straight-sided jar; (B) Squat oval-mouthed amphora; (C) Straight-sided cup; (D) Tall alabastron; (E) Tall alabastron; (F) Tall alabastron; (G) Rounded cup; (H) Conical cup; (I) Jug; (J) Bell cup; (K) Bowl; (L) Squat alabastron with one handle.

dered meticulously, now vary from neat designs to sketchy dashes, dots, or crescents with or without their central stems (Pl. 18F and G). Red and white are used more often, and much of the decoration, like zigzags or large waves, is designed for fast application.

The style has been studied most thoroughly from eastern Crete. Silverman (1978B) recognizes two main traditions, the "plain style" and the "polychrome style." They are fairly distinct, though they are joined by many stylistic considerations.

In the "plain style" a vase often has only one or two friezes of ornament, with the rest of the surface left plain or banded. White paint is rare, and red does not occur. It is most common on cups, little jars, jugs, and other small shapes (Pl. 18F, G, and I and Fig. 104). The simplicity departs more strongly from LM IA than the "polychrome style" does, and many vases are painted rather quickly. The continuity with LM IA, however, cannot be overemphasized, and it is strong enough to leave doubts on the dating of some pieces. The most common decorations are foliate bands and spirals, usually applied to the upper shoulders.

The "polychrome style" is named after the habit of adding white and red accessory ornament. Like the "plain style," it develops directly out of LM IA, and many of the late vases are similar to earlier ones. It is most common on large or important vases like fine jars. There are often several zones of ornament, a main frieze plus several subsidiaries. They can be separated by simple bands, rows of large dots, or dark bands with added white dots, floral bands, wavy lines, or other decoration. Red paint, usually earthy and fugitive, is used for accents or for filling in small open spaces. It may

either be painted on top of the black or on the plain buff clay.

Among the LM IB destructions are a few vases, principally large jars, which were probably survivals from LM IA. Two examples from Pseira are in Plates 18H and 19D. Spirals with solid centers (a LM IA variation) decorate the first vase. The other one uses bull's heads with double axes set within the horns, while spirals, ivy, and small axes help fill the field. The emblem of the axe between the horns of a bull occurs in metalwork (discussion in Mavriyannaki 1978) as well as on another jar from east Crete (Bosanquet and Dawkins 1923: pl. 12), suggesting a cult use. Bulls seem to have been important in Minoan religious symbolism, and their appearance in art has been the subject of much discussion (see, for example, Matz 1961-1962).

Plastic vases reach new heights of expression. The bull's head from Mokhlos in Plate 19A, like the more naturalistic head from Gournia (Pl. 17H), is a rhyton with a hole in the muzzle and another behind the horns. Comparing the two pieces clearly brings out the progression away from the naturalistic rendering of LM IA. In the later rhyton the eye is more patterned, the modeling has less feeling for muscle and sinew, and the overall look is more artificial. A movement toward abstraction has already begun, and it will increase in LM II.

More faithful to the natural form are a group of vases in the shape of standing bulls (Pl. 19B and C), a type with a long history in the Middle Bronze Age. The two LM I examples illustrated, from Pseira, have well-modeled features and holes for both filling and pouring. They are made in molds. Like normal askoi, they must be tipped to pour out the contents.

An especially elaborate sherd is shown in Plate 19E. The shape of the surviving handle suggests it is probably from a rhyton (for discussion see Effenterre 1980: 436 figs. 579-580). A griffin with all four legs off the ground in a "flying gallop" is attached to the rim above a painted foliate band. It recalls the scenes of leaping animals that were so popular in the murals at Knossos, Akrotiri, and elsewhere at the beginning of the Late Bronze Age (see, among others, Marinators 1973: color pls. 17 and 40).

THE SPECIAL PALATIAL TRADITION

Most of the LM IB deposits are joined stylistically by the presence of sherds or vases with extremely attractive, elaborate motifs (Fig. 105). These products are actually rather rare, though they have always commanded a large amount of attention. Mervyn Popham has called them "an artistic achievement which is perhaps the greatest in Cretan pottery" (1967: 339). Some of the best known examples come from places other than Knossos, but the majority of the style is still probably Knossian in origin (for the style at Knossos see Mountjoy 1974A). The fabric is usually very much like that of the Knossian ceramics, and it differs appreciably from the local east Cretan clay (where so many pieces have been found). One possible alternative is a traveling workshop based at the main Cretan palace but traveling occasionally to outlying areas in preference to shipping large and fragile clay vases (Betancourt 1977B: 39). Examples of the Special Palatial Tradition are also found on the Greek mainland, in local clay, and it seems likely that personnel from the Knossian workshop(s) traveled at some point to helladic Greece

where they played a role in the styles of LH II.

The tradition may be separated into four subdivisions on the basis of iconography: the Marine Style; the Floral Style; the Abstract and Geometric Style; and the Alternating Style. This division, while very useful, is actually quite artificial. Motifs from more than one style sometimes occur on the same vase, proving conclusively that the four styles cannot indicate four workshops. The Alternating Style is itself a mixture. There are several studies of specific aspects of the tradition, and the subject as a whole has been examined by Pernier and Banti (1951: 530-545).

The vase shapes are a worthy subject in their own right. They are extremely creative, and many are used nowhere else. In most cases their origins may be traced to the ceramics of LM IA, but other sources, chiefly metalwork, are known as well. The forms are taut, refined, and sophisticated: they differ from LM IA as the Parthenon differs from an Archaic temple.

Several new features may be isolated. The concepts of the development are especially visible in a shape like the ovoid rhyton, one of the most specialized of the new shapes (Fig. 106 and Pl. 20A-C). The design is evidently an elongated and transformed version of the alabastron and ostrich-egg rhyta of earlier times. A heavy molding at the juncture of neck and shoulder in the LM IB variety could be inspired from metalwork, or it may be simply an exaggeration of the small moldings present on some of the earlier vases. Combined with the taller body, it makes an elegant presentation. Other shapes are also new. The straight-sided jar is a little more taut (Pl. 20D). The stirrup jar is low and round (Pl. 20H). Ewers, among the most graceful of the special shapes,

105 · Motifs from the LM IB Special Palatial Tradition.

106 · The development of the ovoid rhyton shape, MM III to LM IB, Scale 1:3. The profile of the mouth is already present in alabastron shaped rhyta from MM III, and a small ridge at the junction between neck and shoulder has been added by LM IA. The LM IB shape used in the Special Palatial Tradition is on the right.

occur in several variations; seldom are any two exactly alike. They often have a strainer built into the mouth (Pl. 21F and G). While metal vessels must play a role in their design (compare the silver example from Mycenae in Pl. 22C), earlier clay jugs are also influential. Jugs are particularly creative (Pls. 21H and 22B); they can exaggerate one or more features, and an exact prototype cannot usually be found.

Since the vases are so unique, they are easily recognizable as members of the tradition. Like the presence of more than one ornamental style on the same vase, they serve to unite the Special Palatial Tradition as a whole; Marine, Floral, and Abstract Styles occur on the same range

of shapes, suggesting a closely knit group. Since the Alternating Style shapes are sometimes a little more developed, they may be slightly separated in time or space from the first development of the tradition. By the end of LM IB, however, they all occur together, both in Crete and elsewhere within the Aegean.

Like the lily vase from Knossos (Fig. 92), much of the Special Palatial Tradition can probably be regarded as an anecdotal borrowing from monumental art. The coral of Plate 20C can be seen in the shoreline on a mural from the West House at Thera (Marinatos 1968-1976: VI color pl. 7). On the same wall painting cycle are the tiny bifurcated lines below the sinuous water line of Plates 21A,

107 · Ovoid rhyton from Palaikastro, LM IB Marine Style, Pres. ht. ca. 24 cm.

108 · Conical rhyton decorated with the Crocus and Festoons, from Palaikastro. LM IB Floral Style, Restored ht. ca. 37 cm.

C, and F, the reeds from the neck of Plate 21E, the papyrus of Plate 21F, the palms of Figure 105, the crocus and festoons of Figure 108, and the star of Figure 107 (Marinatos 1968-1976: VI color pls. 8 and 9; for additional discussion see Morgan 1983).

By LM I Minoan painting had apparently developed an extensive fashion of seascapes and landscapes with animal and human figures, a tradition that only survives in a very few examples. The Theran paintings are members of this group. Murals offered great scope for the imagination, but artists who worked on small fields like seals or vases could never achieve the same monumentality, so they chose anecdotes instead—a small rock, a pleasing design, or an interesting detail of plant or animal life. Among the vases, the Special Palatial Tradition is the closest style to the muralist tradition; its repertoire gives us a pleasant glimpse of many of the details from the lost landscapes and seascapes. Although the Theran paintings give us our best view of the muralist side of the tradition, they are stylistically somewhat removed from the vases of LM IB; a less lyrical and more

formal style, probably from Crete itself, is a more likely candidate.

The Marine Style

Designs taken from the sea are peculiarly well adapted to the Minoan way of painting (Fig. 107 and Pl. 20). Like all Minoan art, the LM IB style is essentially a two-dimensional system. Naturalistic elements must be redesigned as flat images before they can be used, and the ornament is then applied as if on the outer skin of the vessel. Three-dimensional illusionism plays no role. The impact of the painting comes from the shapes and their arrangement and from the design's relation to the vessel itself. The style emphasizes informal (non symmetrical) balance, interlocking curves, and opposed diagonal movements.

Contour, especially curvilinear contour, is very important. Sea elements work well in this kind of system because they often have irregular or sinuous outlines and interesting shapes. Since they are also fairly simple, allowing a ready translation into two-dimensional images, they can make an attractive ornament.

The role of wall paintings in this style has often been emphasized. One need only compare the dolphin scene from Knossos (Pl. 20E) with its ceramic counterpart (Pl. 20A) to see this influence at work. Similarities include the net pattern used as the background, the general treatment of dolphins with their down-pointing flippers and incorrectly painted tails (turned to face the viewer as in fish), and the positioning of the animals as isolated, flattened elements with little overlapping. This relationship, however, is only part of the story. Marine ornament appears on many different Minoan art objects, and it is more accurate to think of a general style surfacing in several media, including clay reliefs (Pl. 14A), stone vases (Evans 1921-1935: II figs. 307-308), and faience (Foster 1979: pl. 13) as well as pottery and monumental paintings. The painted vases are actually rather late comers to the scene since similar designs occur on other objects from somewhat earlier (for example, the clay relief in Pl. 14A, plastered stands from Thera, Marinatos 1968-1976: IV pl. 82, V color pl. C, or a clay sealing from Knossos, Evans 1921-1935: II fig. 306).

Many examples of the Marine Style pottery have been found in the Aegean islands and on the Greek mainland as well as on Crete. They have been studied in a series of articles by P.-A. Mountjoy (1972; 1974A; 1974B; 1977A; 1977B; Mountjoy, Jones, and Cherry 1978), and she and her colleagues have used optical emission spectroscopy to show that an essential difference exists between the analyzed Cretan sherds and sherds from the mainland, Melos, and Aigina (Mountjoy, Jones, and Cherry 1978). All of the vases share the same decorative elements: argonauts; triton shells; octopuses; seaweed; and other motifs. They also have the same general compositional and syntactical arrangements. Minor differences in the composition, brushwork, and details of the iconography set some groups off from others, and some of the stiffer mainland pieces can be rather easily distinguished from the main Cretan group on the basis of their "dryer" style.

A selection from Crete is illustrated in Plate 20A-D and F-H and Figures 101 and 107. Their crowded compositions, with selected large elements floating in a field surrounded by smaller filling ornaments, are typical of a large percentage of the Cretan vases. The group shares many traits, and selected smaller sets can be picked out by using this or that char-

acteristic (that is, an unusual vase shape, a use of a particular filling ornament, or a specific way of handling a certain motif). This has led to the identification of a few small groups that might represent the work of specific artists, but the style as a whole shares so many mannerisms that the groups can be arranged in more than one way (Betancourt 1972; 1977C; or Mountjoy 1977B). Either the painters were all trained in a single workshop tradition, or they were familiar with one another's work through some other mechanism (for the suggestion of one major workshop, called the Polyp Workshop, see Betancourt 1972; 1977B).

One of the most successful artists from LM IB is a painter who has been called the Marine Style Master. His work includes a lentoid flask from Palaikastro (Pl. 20G, the definitive piece for the hand) and the stirrup jar from Zakros in Plate 20H. Both vases are decorated with facing octopuses, with the animals swimming diagonally. Small bits of rockwork and other filling ornaments crowd into the spaces between the tentacles. The vases are joined by their *horror vacui* (a desire to fill every available space with ornament), by a similar brushwork and iconography, and by their visual impact. Their artist was truly a master, typifying the best qualities of Minoan vase painting at its height (Betancourt 1977B).

The other vases have variations of similar nautical themes. The rhyton in Plate 20C, the central piece for the Polyp Painter group (Betancourt 1972), shows a crowded composition composed of argonauts and successive vertical coral-fringed shorelines. The rhyton in Plate 20A has many of the same details of coral, but the dolphins give it a very different feeling. It has a twin, found stored with it in the same room at Pseira. The jar from Nirou Khani (Plate 20D) and the jug from

Malia (Plate 20F) give additional examples of the style. As in most cases, they have a central motif with several subsidiary ones, arranged in a crowded composition that creates an overall tapestry of design.

The Floral Style

Floral designs, both traditional and new, make an important contribution to LM IB pottery. Sometimes they are elaborated into new patterns or combined in new ways, but they always retain their vital energy. Even when used in symmetrical compositions, arrested motion is just beneath the surface.

An Olive Spray Painter has been identified by Popham from among pottery found at Knossos and elsewhere (1967: 341). An example of his work, an alabastron from Palaikastro, is illustrated in Plate 21D. The painting is delicate and meticulous, totally different from the crowded style of much contemporary work. Empty space helps set off the diagonally placed olive sprays and crocus blossoms of the main frieze. The ornament occupies a precisely ordered zone on the body, with a minutely painted foliate band on the upper shoulder completing the scheme.

A group of vases painted with reeds has been discussed by Popham (1967: 342) and Betancourt (1976A). Many of the pieces seem to be the work of one hand, the Reed Painter whose style is illustrated in Plate 21A and B. The leaves of his plants, always painted with two strokes, make an interlocking pattern of light and dark. A cup from Kato Zakros, near the style of the Reed Painter, has a very similar iconography (Pl. 21C). The plants grow from a sinuous line that may represent the waterline, with curved lines

and small floating bits below the surface.

Crocus and festoons, one of the more abstract of the floral motifs, is used on a large group of LM IB vases found in Crete and several other parts of the Aegean. The example in Figure 108 is one of a pair of similar rhyta discovered at Palaikastro. Four bands of the motif decorate the body, each one composed of hanging flowers with three petals alternating with festoons of dotted semicircles, all suspended from horizontal bands of dots. The origins of the design may be traced to garlands of flowers (perhaps crocuses) known from the gaily decorated ships in a mural from Akrotiri on Thera and from paintings of ikria from the same house (Marinatos 1968-1976: VI color pl. 9 and pl. 57; for the motif see Betancourt 1982A).

Ivy is used in several variations. Some-

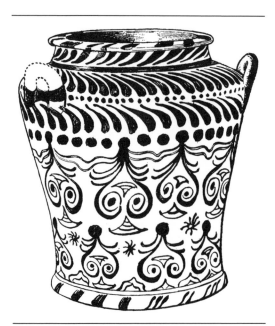

times, as on a jar from Pseira (Fig. 109) or a jug from Palaikastro (Pl. 21E), it is so schematized it is barely recognizable. It occurs here as isolated elements, embellished with additional details until the original character is almost lost. Imagination is necessary to trace the leaves back to more lifelike paintings like those in Figure 108. This abstract vocabulary, however, is only one aspect of the Floral Style; many vases use a more organic repertoire.

The vessels in Plate 21F and H show the exuberance of the Floral Style at its best. A ewer from Palaikastro (Pl. 21F) is decorated with papyrus, with the plants growing out of a wavy line like the one on the reed vases. The energy of the composition is so great, and the spreading movement of the plants is so compelling, one must look twice to see the ordered rationality of the symmetrical arrangement. Another ewer (Pl. 21G) is from the same site. In this case the main ornament, called a foliate scroll, is a composite of the madonna lily, the foliate band, and the spiral. Like the first ewer, it uses flowers and other small details as accessory designs. Plate 21H is a bridge-spouted jar. Foliate bands of a different type spring up from the base and crowd up as if they were still growing. A band of similarly painted petals on the shoulder may be copied from metalwork (compare Evans 1921-1935: II figs. 402-404). In many ways, these floral vases are a high-water mark in Minoan painting; it will be a long time before such enthusiasm is seen in art again.

The Abstract and Geometric Style

The Special Palatial Tradition is a very creative group. Religious symbols, geometric patterns, imitations of stonework,

109 · A jar from Pseira, LM IB Floral Style, Ht. 14.5 cm.

and other designs all appear occasionally. Sometimes they do not fit easily into any category, and many vases use several different decorations.

The three vases from Kato Zakros in Plate 22A, B, and E have spirals and arcading as their main motif. The interlocking opposed spirals, set above the arcading, make an attractive design. Like so many motifs, spirals and arcading are also known from metalwork (compare Pl. 22C).

A bridge-spouted jug from Sklavokampos has elaborate zigzags over most of the body (Pl. 22H). Perhaps the design imitates the veins in alabaster, as a more naturalistic version also survives (Pernier and Banti 1951: 533 fig. 293 left). This is an important vase because it helps prove the connections between different styles in the Special Palatial Tradition. The coral at the bottom is from the Marine Style (compare Pl. 20D), the half foliate bands on the upper shoulder occur on vases with spirals and arcading (Pl. 22A and B), and the reserved rosettes on the neck may be compared with a stemmed cup from Phaistos in the Alternating Style (Pl. 22F). A very similar iconography, except for the coral, is on the rhyton from Gournia in Plate 22D. As these vases indicate, we are not dealing with a series of disparate facets but with a single organism, a multivariate tradition with many interrelated parts.

The Alternating Style

The Alternating Style has been mainly defined from Minoan exports discovered on the island of Kythera (Coldstream and Huxley et al. 1973: 296 and 302-303). Its ornament, often derived from motifs of the other styles of the Special Palatial Tradition, consists of isolated elements in strict alternation on an open field (see Pl. 22F and G). Motifs include the ogival canopy, the sea anemone, irregular rockwork, trefoil rockwork, figure-eight shields, double axes, and other elements. Several shapes are used, with a favorite being the semiglobular cup with an offset rim.

The vase in Plate 22G is typical of the tradition. Its open space focuses attention on the elements in a very strident way, and the alternation of widely spaced, telelocative motifs creates a more systematic compositional scheme than is usual in the other styles. The total effect is stiff and formal, looking forward to the styles of LM II.

Opinions differ on the chronology of the Alternating Style. At Kythera it is definitely later than the first appearance of Marine Style sherds (Coldstream 1978: 398), and its formalism and open compositions also suggest a late floruit because these characteristics continue into the next period. It had already appeared by the time of the destructions in eastern Crete, however, because a few examples come from these sites (such as Pl. 22G). The recent excavations at Knossos have also found examples within the LM IB destruction levels (Warren 1981A).

The center of the production is not really known. Knossos, which was not completely destroyed in LM IB, has more pieces than are found farther east. Kastri, on Kythera, has an especially large *corpus*, all imported. It is possible that some examples of the style were made in the west of Crete because vases come from Khania, in a fabric the excavators consider local (for discussion see Coldstream 1978: 398).

An example of a religious symbol is shown in Plate 22F. The vase, a stemmed cup with a high swinging handle, comes from Phaistos. It has several different or-

naments: reserved rosettes and half of a foliate band at the upper body; a small papyrus plant above a dotted band at the base; and double axes tied with sacred knots on the body, painted in alternation with the sea anemone. The axe with the knotted sash, a motif whose meaning is not fully understood, seems to be grounded in Minoan religious symbolism.

Like the other Special Palatial styles, the Alternating Style spreads to Greece and the Aegean islands at the end of LM I (for a distribution map see Coldstream 1978: 399). The mainland and Cycladic examples follow the Cretan style, but their fabrics do not seem to be Minoan. As is to be expected, the Alternating Style mirrors its times; the last examples are Mycenaean.

12 · LATE MINOAN II

In the words of Arne Furumark, LM II heralds "a new artistic spirit, aiming at the ornate and the grandiose" (1941: I 166-167). Although the style develops directly out of LM IB, it has a decorative and abstract aspect not shared by its predecessor. Most of the LM II motifs are greatly stylized, and many vases either repeat individual elements in horizontal friezes or use bilateral symmetry. With a lesser spirit such a tradition might be dull and repetitious, but this is far from the case with LM II. Especially in the Palace Style jars, giant clay vessels with large areas available for painting, the tradition reaches the level of monumental art.

Relatively few sites have the style. At Knossos, it has been recognized from the borders of the palace (Evans 1921-1935: IV 297ff.), from the Unexplored Mansion (Popham and Sackett 1973; Popham 1973: 55-59; 1974), from houses behind the Stratigraphical Museum (Warren 1981A), and from several other places (for a list of the find spots reported by Evans see Vermeule 1963: 196 note 3). A number of tombs in the region, particularly the Temple Tomb (Evans 1921-1935: IV fig. 196), the Royal Tomb at Isopata (Evans 1905: 526ff.), the Warrior Graves (Hood and de Jong 1952; Hood 1956A; Hutchinson 1956A), and some of the tombs at Katsampas (Alexiou 1967) and Mavro Spelio (Forsdyke 1928) add important additional material. Although it was once thought that LM II was confined to the vicinity of Knossos, this was

certainly not the case. Exports reach as far as Rhodes. Other sites are listed by Popham (1980), but only two have large enough deposits to help establish the style:

Kommos (Watrous 1978; 1981)
Malia, House *Epsilon* (Pelon 1970: phase IIIB, regarded by the excavation as LM IB)

Largely because of the limited quantity of material available for study, the style is still not fully understood. If LM II is regarded as the first stage of the LM III development, it could either be thought of as a chronological phase (Popham 1975; Watrous 1981) or as a limited tradition that is largely contemporary with LM IB (Banti 1941-1943: 12; Levi 1959: 250ff.; 1967-1968: 124-132; Vermeule 1963; 1964: 144-146) or LM IIIA:1 (Niemeier 1979A). There are many similarities between LM II and the styles called LM IB and LM IIIA:1, and those who do not accept the style as a chronological period note the absence of the pottery from most Cretan sites, suggesting that it is unlikely so many settlements would have been deserted for several years. The alternative, that there is a provincial LM II we have so far failed to isolate very well, has also been suggested (Silverman 1978A: 84). Those who defend the style as a period emphasize the clear stratigraphy at some sites, and they note that several features are associated exclusively with LM II.

Stratigraphically good deposits come

from Knossos (Popham 1973: 55-59; 1974) and Kommos (Shaw 1977: 231-232; 1978: 120-125; Watrous 1978; 1981). In both cases the strata were found under LM IIIA:1 levels, with several characteristics that do not occur in LM IB. New shapes include the Ephyraean goblet, the conical bowl with horizontal handles below the rim, the krater, and the squat alabastron. Since none of these shapes occur in any significant numbers in LM IB, LM II must be regarded as a separate style. For the close of the period, Kommos provides a good illustration of the difference between LM II and LM IIIA:1. The ledge-rimmed cup accounts for more than 20 percent of the identifiable fine ware sherds in the LM IIIA:1 deposit found overlying the LM II dump at this site (Watrous 1981), whereas it is practically absent from the dump itself. This difference, surely an indication of the passage of a gap of time, suggests that LM II must represent a chronological period, at least at this south Cretan town.

The style, like the chronology, can best be defined from Knossos and Kommos.

It would seem to be a combination of the old with the new, evolving directly out of LM IB with a special debt to the Alternating Style. Several of the LM IB tendencies progress dramatically: simplification and general abstraction; fragmentation or stylization of the elements; formalism of both motifs and compositions; an emphasis on selected parts of the vase, especially the upper shoulder; and a use of open space as a contrast for the painting.

Many new motifs begin in this period. A large number of them fall into two categories, unity motifs and repeat motifs. The repeat motifs, used as bands of decoration, are often more abstract than in LM I (Fig. 110). Most of them, like the fragmented version of the leaf-like tendrils called the foliate scroll (Fig. 110C), begin in LM IB but become more popular in LM II. The unity motifs represent a fresh concept in decoration (Fig. 111). They are often derived from the accessory patterns used as filling ornaments in LM IB (compare, for example, the flowers in Pl. 21F with Fig. 111A), but while

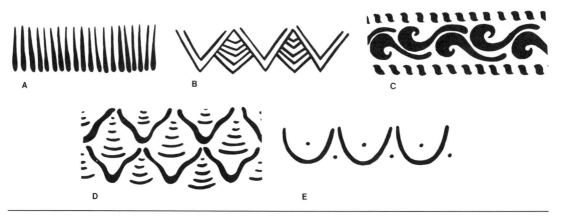

110 · Repeat motifs from LM II.

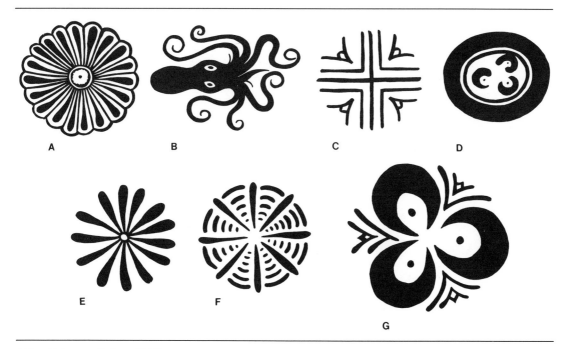

111 · Unity motifs from LM II.

the LM I designs formed parts of larger compositions, the LM II ones are full ornaments. Abstract elements like the iris cross (Fig. 111C) are especially popular, and the more naturalistic designs (flowers and the like) are farther from nature. On some vases the painters now cheerfully omit formerly essential details like the suckers on octopus and nautilus tentacles (Fig. 111B). Designed to highlight the two faces of kylikes and other vases, the new unity motifs set the period off completely from LM IB.

The ornament is more restricted than in LM I, and it often covers less of the vase. Bowls and cups usually have a frieze of ornament on the upper body, with the lower part set off by bands and left plain. Jugs and small jars are usually decorated on the upper shoulder, while Palace Style jars more often have an all-over scheme.

The shapes combine traditional and new designs (Fig. 112). Old forms, like

jugs, cups, rhyta, and tall alabastra, are inherited from LM IB, but they have now developed slightly. New designs, like the Ephyraean goblet and the squat alabastron, are not of Cretan origin; they are usually ascribed to Mycenaean influence.

A selection of vases from Kommos can be seen in Figure 113. Undecorated conical cups with straight or convex walls are the most common shapes; as in LM I, they have no handles (A-C). Painted cups, on the other hand, usually have vertical handles (E, F, G and H) or (rarely) a horizontal handle shaped like a wishbone (D). Most of the cup rims are larger and more everted than in LM I. The ornament, nearly always derived from earlier Minoan motifs, is now more schematic. Leaves (H), foliate bands (E), and even argonauts (D) are simplified and sketchy, almost caricatures of their more naturalistic antecedents. The Ephyraean kylix (I), the conical bowl with two

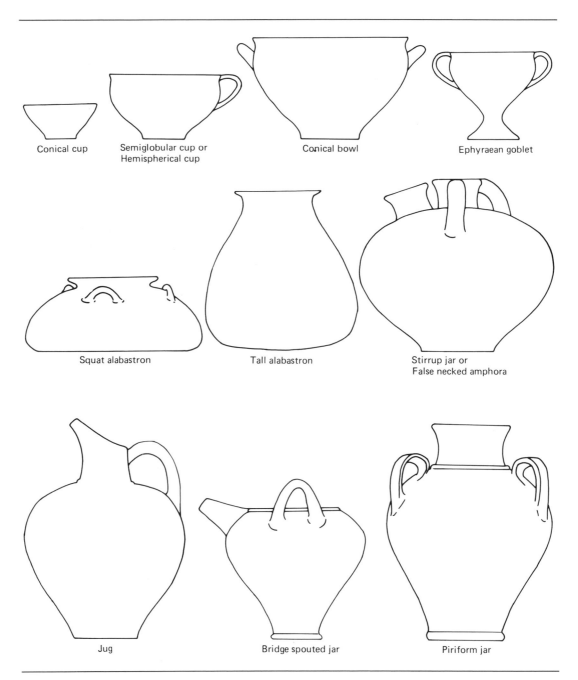

Conical cup

Semiglobular cup or
Hemispherical cup

Conical bowl

Ephyraean goblet

Squat alabastron

Tall alabastron

Stirrup jar or
False necked amphora

Jug

Bridge spouted jar

Piriform jar

112 · Names of LM II fine ware shapes.

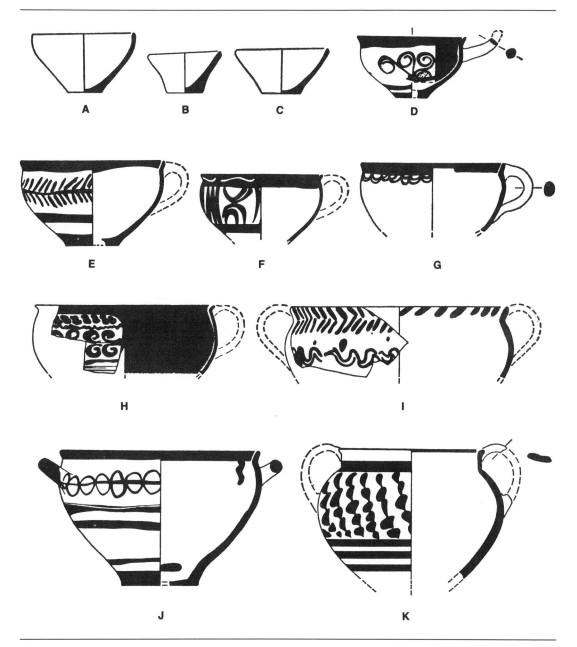

113 · Vases from Kommos, LM II Dump, Scale 1:3. (A-C) Conical cups; (D-H) Semiglobular cups; (I) Kylix; (J) Bowl; (K) Krater.

handles (J), and the krater (K) are not LM I shapes, and Mycenaean sources probably helped fix their designs. Like the cups, their decoration is often limited to the shoulder.

The most easily recognizable of the new shapes is the type of kylix called an Ephyraean goblet (Pl. 23A-C). It occurs in the west and in central Crete, but not at the eastern sites. The unusual shape, with two small vertical handles, an offset rim, and a short–stemmed base that flows smoothly out of the rounded body, makes it easy to distinguish from the taller kylikes of LM III. Most examples are unpainted or have one large motif on each side. Once in a while a frieze of several elements is used, but even then, large areas are left plain, making the ornament a spot of pattern set against the clean lines of the goblet itself. Occasionally a piece has an overall coat of dark paint, a conservative custom inherited from the Middle Bronze Age. The shape becomes very common in LM II, and it gradually develops into the LM IIIA type at the end of the phase.

Knossos and Katsampas provide samples of several other fine ware shapes. Knossian cups of the LM IB types—both conventional and with a contracted base—continue to be made (Popham 1973: fig. 26). As at Kommos, they are joined by larger examples with an everted rim, a coil handle, and often a spout, as well as by conical bowls (Popham 1973: figs 21 and 24). Closed shapes are less frequent. They include squat alabastra, jugs, bridge-spouted vases, stirrup jars, and large jars decorated in the Palace Style (discussion below). Less common shapes include the conical rhyton, the ewer, the pyxis, and the tall alabastron.

A good example of this last shape is decorated with a facing octopus (Pl. 23G). Found in a LM II deposit at Knossos, it is more schematic than its LM IB ancestors. The octopus has drawn out tentacles and small dumpy bits of coral, set in a field with a few dots.

The bull's head rhyta from the period illustrate the direction of the development very well. A comparison between a Late Minoan II bull from the Little Palace at Knossos (Pl. 23D) and the LM I examples (Pls. 17H and 19A) shows the progressive stylization. By LM II the painting has become a decorative pattern, and the shape takes no notice of the subtle animal musculature that was so much a part of the LM IA style. The vases have slowly changed through the process of long repetition, and in so doing they have departed farther from the natural form of the animal.

The high-spouted jug from Katsampas in Plate 23 E and F is unusual in both form and decoration. Its large size, almost half a meter high, may mean it was intended for display, and it is probably a ritual libation vessel. Nonutilitarian features like the projecting knobs on the shoulder and body give it a highly unique appearance. The ornament is divided into panels by the knobs; it consists of argonauts and intricate floral motifs, with simpler designs on the neck and spout. The date, from LM II to LM IIIA:1, is not completely secure.

Fine display pieces like this jug are balanced by the other side of the coin, the coarse, plain vases used for household chores. As in earlier times, pots, trays, and dishes are all used for cooking (Betancourt 1980). Sherds from cooking pots from the LM II dump at Kommos show that the standard tripod vessel of LM III has already appeared by this period (Fig. 114). The shape, substantially different from that of MM-LM I, has a large everted rim with no spout and a more globular shape than the earlier vessels

114 · Profiles of the rims of cooking pots, Kommos, LM II Dump, Scale 1:3. For a complete LM cooking pot of this type see Figure 116.

(see below, Fig. 116, for a more complete example). It has been called the Type A tripod cooking pot (Betancourt 1980). More conservative pieces, called Type B cooking pots, are found in the same deposit, indicating that Kommian LM II is a transitional phase as far as this shape is concerned. Since the new type has parallels from the mainland (Furumark 1941: form 320), it may be a sign of Mycenaean contacts.

Mycenaean influence is also visible in many other aspects of the LM II pottery. Prototypes for the Ephyraean goblets occur on the Greek mainland from well back in Middle Helladic times (Furumark 1941: 56-59; Wace 1956), contradicting Evans' theory of a local Minoan derivation from cups with contracted bases (1921-1935: IV 363-371). Conical bowls also have Middle Helladic predecessors (Furumark 1941: I 47), and, in its final form, the squat alabastron is a Mycenaean shape as well (Furumark 1941: I 40-41). Mainland features can be seen in several aspects of the ornament: the preference for decorating only the shoulder; the use of open space; a love of abstraction; the concept of the unity motif; and many of the individual patterns.

Other Mycenaean influences underscore the new directions of Minoan life in general. Crete now embraces several new architectural features—some would place the Throne Room at Knossos with the murals of heraldic griffins in this period. New stone vases (like squat alabastra), new types of weapons, and several other elements now appear in Crete for the first time (for brief summaries see Vermeule 1964: 145-154; Alexiou N.D.: 58-61; Popham 1976). The most important changes, however, concern the tombs. The two most characteristic Minoan burial habits are pithos burials and communal tombs with sometimes hundreds of individuals in one chamber. In LM II, both are mostly replaced by chamber tombs intended for only a few persons. Equally important, the evidence for burial ritual changes dramatically— traditional Minoan burial sites are often associated with small courts or open spaces containing caches and strews of pottery and other offerings, a practice that is seldom encountered after LM I. The burial gifts of LM II assume a new emphasis, with more swords, daggers, and fine ornaments. With mainland architecture and the burial offerings of proud warriors, the LM II tombs betray a previously unknown militaristic presence; many scholars believe that the speakers of Mycenaean Linear B entered Crete at this time.

THE PALACE STYLE JARS

The name Palace Style is often applied to a group of monumental jars manufactured between the end of LM IB and the beginning of LM IIIA:2. By extension, the term can also be used for a few similarly decorated smaller vessels from the same or closely related workshops. Although most of the Palace Style vases come from Knossos and its environs, a few have been found elsewhere, for ex-

ample at Kommos (Shaw 1978: 125). The class has been discussed by several writers, especially Evans (1921-1935: IV 297ff.), Furumark (1941: I 166-169), Popham (1970A: 71-73), and Niemeier (forthcoming).

The most common shape is sometimes called a "Palace Style amphora" (Pls. 23H and 24A-C), an unfortunate misnomer because amphoras should have two opposed handles, not three or more. A better name is piriform jar. Several subvarieties exist, but all have a flat or outturned rim above a short neck set on a piriform body. The base is pronounced, and a heavy basal ring is common. The usual type has three vertical ribbed handles on the shoulder, a contrast with the nine-handled jars of LM IB (for the development see Evans 1921-1935: II 421-428).

A second shape has a more open mouth, gently rounded sides, and a contracted base (Pl. 24D). Two small horizontal handles may be placed below the flat, outturned rim. Like the first type, it is descended from earlier Cretan pottery. Ancestors may be traced to the Middle Minoan period (Levi 1961-1962B: 455 fig. 20), and there are many MM III and LM I examples (see Pl. 14C and the series from Pakheia Ammos, Seager 1916, or Sphoungaras, Hall 1912: figs. 34-36).

A third shape, shown in Plate 25A, has vertical, slightly convex sides, a larger base than the other jars, and tiny handles. A utilitarian shape designed for ease in scooping or dipping out the contents, it is copied from a type of coarse–ware pithos (for such pithoi at Knossos see Evans 1921-1935: IV 637-642).

Palace Style jars express the qualities of LM II pottery in a very striking way. Since the shapes are large, the area for decoration is more spacious than on most Minoan vases, allowing a fuller development of the new ideas. Almost all of the surviving examples are well designed and carefully painted. Their elegant ornament is woven into an overall tapestry of attractive decoration in which the elements are increasingly stylized; we are a further step removed from the natural world, running quickly toward the standardization and repetition of LM III.

Many of the favorite LM II motifs are borrowed from the final stage of LM IB, especially the Alternating Style. They include the papyrus and lily (Pl. 24D), the ivy (Pl. 24B), the rosette (Pl. 24C), and other floral ornaments (Pl. 25A). The designs are often abstracted or joined together with new elements in a contradiction of nature. Among the marine motifs are the octopus and the dolphin (Evans 1921-1935: IV figs. 239, 240, and 242). Other pictorial elements, like the double axe (Pl. 25A) and even a zoned helmet (Pl. 25C), are used occasionally. Abstract ornaments are common: chevrons (Pl. 24B); undulating bands (Pl. 24B-C); spirals (Pl. 24B); and the triglyph and half-rosette (Evans 1905: fig. 144; 1921-1935: IV figs. 291-292). Necks are often decorated with one or two reserved undulating lines. Stippling, perhaps an imitation of the texture of alabaster (Schiering 1960: 26-27), is sometimes used around the principal design (Pl. 25C). It could also represent sand. So many of the motifs have a long history that even mature Palace Style jars like the one in Plate 24C are mostly composed of traditional elements: for the foliate band on the shoulder see Plate 17B; for rosettes see Plate 21G; for spirals see Plate 22B. The LM II potters added new vase shapes, more abstraction and formalism, and a feeling for the grandiose, but their roots were in the Minoan ceramic tradition.

To enrich this tradition, the style seems to have turned to other art. Some of the

repeat bands look very much like the re-poussé used for metalwork (for discussion see Evans 1921-1935: IV 302). Wall paintings were already monumental in scope, with a style well suited to the grandiose scale of the jars; it should come as no surprise that they exerted renewed influence. The plants on the large jar with double axes in Plate 25A belong to the same genre as the floral decoration in the Griffin Mural in the Throne Room at Knossos (Evans 1921-1935: IV color pl. 32 and figs. 884 and 889). Stippling, as in Plate 25C, also finds a parallel in the murals (Evans 1921-1935: II 501 fig. 305).

Several problems hinder our understanding of the chronology of these great jars. Most of the known examples come from a limited number of contexts at Knossos. Several are from rooms buried in the palace's destruction, dated to the beginning of LM IIIA:2 (Popham 1967: 343), but these deposits contain vases from several periods. Evidently storage jars, left in place for many years, were not as subject to breakage and replacement as more portable containers. Thus they accumulated over a span of time, and many early pieces were still in use when the palace burned. The basic work in arranging the jars into a stylistic sequence to span the period from LM IB to LM IIIA had been done by Popham (1970A: 71-73), though work still remains for the future.

The earliest jars should be those most related to the style of LM I. A few, like the vase from Tylissos in Plate 23H, are still completely within the LM IB tradition. This piece has the nine handles of LM IB, and its decorative elements all belong to the earlier tradition. Already, however, there is a predilection for bands, with rows of motifs repeated around the body.

The jar in Plate 24A, found near the southwest corner of the palace at Knossos, has a shorter neck and only three handles. It also surely dates to LM IB because a similar vessel, almost a twin, comes from a secure LM IB context in a basement room north of the Royal Road (Hood 1961-1962: pl. 2 no. 1). Many other examples are known from sherds. The decoration, large frontal octopuses, owes much to the traditional Marine Style: the tentacles have suckers with central dots; coral and other accessory ornaments float in the field; seaweed grows in clumps of three; and tentacles sometimes overlap. Because of these similarities in the iconography it has been suggested we are probably looking at a product of the same workshop that produced the vases by the Marine Style Master (Betancourt 1977B: 42). Perhaps because of the scale, however, essential differences look forward rather than back: the bodies are vertical, with symmetrically arranged tentacles; both the animals and the filling ornaments are attenuated and enlarged; and the overall feeling is grandiose and somewhat stilted. The jar, already with three instead of nine handles, is well on its way toward the new style.

The formality of the later palace style is well expressed by the two jars in Plate 24B and C. Both come from Knossos where they were surely made in the same workshop, probably by the same hand. The mood is carried both by the main motifs and by the ambience of the accessory friezes. The jar in Plate 24B, with an elaborate band of "sacral ivy" on the shoulder and several subsidiary friezes, is elegant yet cold. The combination of floral pictorialism with precise formal abstraction is equally apparent on its companion, a vase with bands of rosettes joined to spirals and meanders. Both jars have a fully developed zonal composition.

There are also vases with the type of

syntax called unity composition by Furumark (1941: I 168-169). The class may be illustrated by Plates 24D and 25A. In contrast with the zonal compositions, the unity motifs cover all or most of the field. Both facial and circumcurrent varieties occur. In the facial type (Pl. 24D), large motifs are presented over most of the vessel, giving it a two-sided or three-sided aspect. In the circumcurrent class, a series of plants or other elements parade around the vase (Pl. 25A). An important difference in the syntax that sets this style off very clearly from that of LM IB is the lessening of the torsional effects. Diagonal motion is still common (see the ivy in Pl. 24B), but it is zigzag movement rather than the twisting torsion of earlier compositions. With bilateral symmetry or vertical circumcurrent motifs, this aspect is necessarily limited.

Of the many Palace Style jars known, perhaps the most unusual shows a series of helmets set within stippling (Pl. 25C). Found at Katsampas, it is one of the finest vases in the style (Alexiou 1967: 51; Vermeule 1967: 89; Borchhardt 1972: 48-49). Each helmet has a knob at the crown, cheek plates, and a series of horizontal zones on the headpiece. Although the zones could be rows of protective plates or boar's tusks, their ornament—rosettes and other motifs—is not an obvious reflection of a helmet's structure,

and they may simply be decorative. This type of helmet does not go back to LM I, and its antecedents are not clear.

As with LM I, the LM II style occurs on the Greek mainland as well as at sites in Crete. Vases like the piriform jar in Plate 25B illustrate the mainland tradition at its best, a style for fine jars of monumental size and aristocratic mien. On this Mycenaean example, the frontally facing octopus readily betrays its debt to Knossian jars like the one in Plate 24A, but the mainland version—a bit dry and lacking the Minoan energy—suggests an art that is now copying other art instead of creating fresh concepts.

Scholars have puzzled for a long time about the mechanisms that spread the style. The complete picture will surely never be known, but one can be sure that the exodus involved people, not just trade goods or a spreading of superficial elements. The mainland vases show too close a familiarity with the details of Cretan shapes and ornaments (including the systems of syntax) for any explanation that does not involve the travel or permanent emigration of potters trained in the Minoan style. This need not, however, have been anything novel or new; close pottery contacts had existed between Crete and other parts of the Aegean since the end of the Middle Bronze Age (Jones and Rutter 1977).

13 · LATE MINOAN III

THE THIRD LATE MINOAN PERIOD is a time of increased production and expanded commercial enterprise. Mycenaean pottery reaches both the Near East and the West in increasing quantities, vivid testimony to the thriving Aegean economy. Crete, well within the Mycenaean sphere, has a good share in this profitable trade.

The period can be divided into three phases, A, B, and C. Late Minoan IIIA follows many of the artistic lines laid down in LM II, but standardization, affecting both the shapes and the ornaments, advances steadily. The period to the end of LM IIIB is long and stable, allowing for a considerable development. It is economically successful, and Crete supports a sizeable population. Problems, surely political as well as economic, plague the Aegean at the end of LM IIIB (for the author's views see Betancourt 1976B). The LM IIIC period sees a change in settlement patterns. Many people move inland to less exposed sites, and the pottery experiences increased tendencies toward abstraction. Trade is disrupted for a time, and less pottery is made. After a short revival, the style slowly merges into the Iron Age tradition.

Among the many directions that can be detected in LM III pottery, one of the most dynamic is a concern for religion. This aspect of Minoan culture had surely always been an important part of everyday life, but its visible manifestations now seem more strikingly specialized. Since the direction represented a new opportunity, some of the forms quickly adapted:

stands sprouted snakes, horns of consecration, and other paraphernalia; larnakes became more elaborate; hollow figures of persons and animals saw wider use; incense burners of new design were invented; and the old painted symbols received new life. The funeral and cult vessels took their place alongside a growing repertoire of commercial and domestic pottery, resulting in a lively and flourishing industry. The pottery was more varied than ever, with plenty of room for individual expression.

The broken tablet in Figure 115 is a good example of the new performance expected from LM III potters. Found at Knossos, it lists at least 1800 stirrup jars (with perhaps more broken away). The jars are presumably being stored for their contents, most likely olive oil (Ventris and Chadwick 1973: 328). Whether the liquid on this particular tablet was

115 · Broken Linear B tablet from Knossos listing stirrup jars. Each circle signifies one hundred.

collected for export, for disbursement, for taxes, or for some other purpose, it obviously represents an enormous output that needed clay containers, and the potters were expected to keep pace. To accomplish this aim, they needed to increase production greatly, and this could best be done by standardizing the shapes and ornaments. It is success, not failure, that is most responsible for the repetitive nature of many of the Late Bronze Age products. Standardization made mass production possible, so that the surplus for trade could be as large as possible. As a result, Cretan pottery is found on many overseas shores.

Pottery furnishes the most important evidence for the reconstruction of Late Bronze Age trade, and Crete evidently had many active centers (for a useful list of LM III imports and exports see Kanta 1980: chap. 6). The most common Minoan object found overseas is the stirrup jar, either inscribed in Linear B or decorated with an octopus trail or some other pattern. Occasionally other vases, including cups, jugs, pyxides, and many other shapes, are found as well. All cannot have been traded for their contents. Foreign imports, especially Mycenaean wares, balance the picture. The distribution suggests that the closest contacts are within the Aegean itself; trade westward increases, and relations with the east seem to have been continuous but less extensive than within the Aegean itself. Cyprus offers a particularly strong case for inter-island exchange (Catling and Karageorghis 1960; Karageorghis 1968; Masson 1961-1962; Dikaios 1961-1962; 1969-1971; Åström 1972: 403-408; Hankey 1979; Karageorghis 1979; Popham 1979). Overseas localities with many Minoan vases—places like Rhodes, Olympia, or Thebes—might have had some special roles in the exchange network.

Within Crete itself, many towns were in especially close touch with the Mycenaeans. Khania and other sites in the west have a rich series of imported Mycenaean vases, suggesting special ties with Helladic areas. Knossos has Mycenaean contacts in the same period, and an occasional vase comes from elsewhere. Kommos, in the south, brings in many foreign imports during LM IIIA. More indirect, but equally persuasive, is the evidence for Mycenaean influence on the shapes and motifs. Particularly in LM IIIB, Minoan pottery is never out of touch with the mainland. Foreign contacts continue in LM IIIC. An increase in trade with the Dodecanese is suggested by similar Close Style stirrup jars found in the two islands (discussed more fully below). Cyprus also shows increased Minoan activity at this time. Even Sub-Minoan has signs of Mycenaean influence.

Whereas fine wares are the most useful items in reconstructing the pottery industry, the coarser vases are important as well. Their development, less dynamic than the fine painted styles, results in conservative shapes that often change slowly if at all.

Cooking vessels continue along established lines. The most complete study is by Betancourt (1980). A new tripod cooking pot, globular in shape with two handles and a turned out rim, had already appeared in LM II. It now becomes the norm. By LM IIIB and C, it has supplanted the earlier types. The pot's rim develops considerably, beginning as a slightly turned out lip and gradually assuming the strongly everted shape shown in Figure 116. The legs normally have round cross sections. Shallow cooking trays with similar tripod legs and cooking dishes without legs are still found.

Most storage jars and pithoi are smaller and less ornate than before. Four

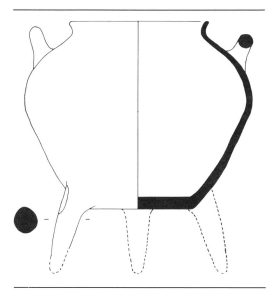

116 · The typical LM II-III cooking pot, with a rounded profile, an everted rim, and two handles (the Type A tripod cooking pot), Kommos, from the Household Shrine, LM IIIB, Scale 1:6.

found as fine decorated pieces (Kanta 1980: 271-272). The brazier, a common vase in both tombs and houses, continues the traditions of MM III-LM I. The shape still has a flat base or a tall foot, an open conical bowl with a spreading rim, and one handle. It is well suited for incense or for small fires needed indoors (Fig. 117).

Most of the known Cretan larnakes date form LM III. They are of two types, the chest larnax and the tub larnax. The most complete study is by Bogdan Rutkowski (1966). Chest larnakes (Pl. 26E) are rectangular boxes with short legs and high, gabled lids, with small handles for lifting (for discussion see also Richter 1966: 10-11). The tub class (Pl. 26F) is oval in shape, with a pronounced rim at the open mouth (Cook 1959). Although the original uses are domestic, by LM III the funerary customs have made larnax burials commonplace.

examples from Phaistos are shown in Plate 26A-D, and Knossian jars are generally comparable (Evans 1921-1935: II fig. 433). The Phaistian jars, discussed by Alexiou (1968: 106), may be dated to LM IIIB. They illustrate some of the main types from the period: a wide-mouthed variety with a heavy flat rim, two horizontal handles, and a pronounced base (Pl. 26A); a nearly cylindrical form with small vertical handles (Pl. 26B); and a type with a rounded body and a maximum diameter above the midpoint (Pl. 26C and D). None of the examples have unnecessary decoration, and they are strictly utilitarian in concept.

Miscellaneous coarse wares fill various needs. Sometimes they simply duplicate the fine wares, but occasionally vessel types are only made in coarse clay. Amphoras, for example, are almost never

117 · Brazier from Kommos, LM III, Scale 1:3.

Both types go back to the Middle Bronze Age. The Middle Minoan examples, however, are rather generalized, without the specialization of the Late Bronze Age. Both rounded and rectangular Middle Minoan larnakes have lids, usually flat or gently rounded. One may assume the Late Minoan types are at least partly indebted to normal household furniture—wooden chests for storage and

tubs for bathing. Similar larnakes of both types have been found in settlements, and it seems likely some of the clay boxes were used in life before being deposited in a tomb (discussion in Rutkowski 1966; 1968).

A good example of the chest larnax comes from Vasilika Anoghia and dates to LM IIIA (Pl. 26E). Its shape, a rectangular box with four tiny feet and a gabled lid, is standard. The pictorial decoration of birds and fishes is interesting and lively, though it seems a bit disjointed. A tub-shaped sarcophagus from Alatsomouri, a burial site near Gournia, is also typical (Pl. 26F). Its decoration may be ascribed to an east Cretan workshop that featured a painter of considerable skill (for another work by his hand see Kanta 1980: 156-158 and fig. 63). The illustrated side shows a herd of three cattle, with a cow and her calf on the left. A date of LM IIIA:2 to IIIB is indicated by the stylized octopus trail found on the ends and back.

Some of the most splendidly painted of the Minoan larnakes come from a cemetery at Armenoi Rethymnes (Tzedakis 1971B). Three examples are illustrated in Plates 26G and 27A and B. Two of them are painted in a polychrome technique using red, blue, and black. The first illustrates a herd of cattle and a series of double axes set within horns of consecration (Pl. 26G); the other has panels showing a man hunting a deer and an agrimi with its young (Pl. 27A). Accessory details like flowers and argonauts link the chests to the vase-painting tradition. The two larnakes are probably by the same artist, a man whose work can be dated to LM IIIA. The third larnax is perhaps slightly later (Pl. 27B). It depicts a hunt with two animals who have been hit by spears amid a group of hunters. One of the men has fallen, while another holds a

double axe above his head. The drawing is simple, and it is not as spontaneous as the polychrome scenes. Together, the chests suggest a vigorous narrative style with real wit and flair. Although the style is indebted to the vase tradition, it is far more elaborate.

Any interpretation of these scenes is difficult and fraught with problems. The context, on chests intended for the dead, invites speculation on the relation, if any, to cult or to belief in a life after death. Are these scenes of joyous activities in the next life? Are they favorite pastimes of the deceased, or stylized ritual hunts associated with a particular act such as the induction into manhood? Whatever they meant to the Minoans, the repetition of set pieces (agrimis, cattle, fish, birds, horns of consecration, and the rest) and the inclusion of symbols from the Aegean religion suggest their iconography is far from casual.

The pictorial larnakes have an importance for art history that goes beyond our ability to identify specific scenes. A case has been made for a dynamic but mostly lost landscape and seascape tradition in MM III-LM I, with figures and animals set within nature. Most of the earlier reflections of this style in pottery are cursory anecdotes, small vignettes borrowed from details of the larger scenes. In this period, however, the larnakes give us a better glimpse of the history of Minoan landscapes in LM III. They show some fundamental changes: human action is emphasized at the expense of the landscape features; many of the interesting little details that were admired and copied by the pot painters are eliminated; and, instead, we see very stylized animals and human figures, stationary or in action, with a proliferation of religious symbolism. The landscape tradition is still alive, but like so much LM III

art it is less dependant on observations of the natural world.

LATE MINOAN IIIA:1 TO IIIA:2 (EARLY)

At Knossos, Kommos, and a few other sites, the earliest stages of LM III seem to develop smoothly from LM II with no break in style. A different situation, however, prevails in the eastern towns. Knossian LM II has not been found here, but LM IIIA vases are recognizable from Palaikastro, Gournia, and several other places; either new activity, a new population, or a more Knossian-centered pottery has brought this part of Crete into the mainstream of the industry. Although local and regional workshops and mannerisms can be recognized, the more even style of the LM III pottery underlines the closer contacts that must have existed during this period. Late Minoan IIIA has been examined by many scholars; among the most important contributions are studies by Evans (1921-1935), Furumark (1941), Popham (1970A), Schachermeyr (1979B), and Kanta (1980). The stylistic development generally mirrors the progression of Late Helladic styles, and the chronology of southern Greece is the model against which the Minoan sequence is measured (E. French 1963; 1964; 1965).

By far the most significant deposits come from Knossos. The palace was completely destroyed at the beginning of LM IIIA:2, and many sherds and vases were buried in the resulting debris. Although this event does not occur at the precise division between LM IIIA and B, it marks a major turning point in the history of Crete. A study by Popham (1970A) is the most thorough presentation of the palatial evidence, and the Knossian sequence is confirmed by de-posits from its environs (Forsdyke 1928; Hutchinson 1956A; Hood and de Jong 1958-1959; Popham 1969A: 31; 1973: 59; 1974B).

Other pottery groups are listed by Popham (1980) and Kanta (1980). Only the most important are given here:

EASTERN CRETE

Episkopi (Kanta 1980: 146-160)
Milatos (Orsi 1899; Kanta 1980: 125-128)
Myrsini (Kanta 1980: 163-169)
Palaikastro (Bosanquet and Dawkins 1923: 74-114, with the clear exposition of the material in Kanta 1980: 189-193)

CENTRAL CRETE

Aghia Triada (Kanta 1980: 102-104)
Amnissos (Kanta 1980: 41)
Arkhanes (Sakellarakis 1965; 1966; 1970; 1972A; 1972B)
Episkopi (Platon 1952A; 1952C; Kanta 1980: 58-68)
Kamilari (Levi 1961-1962A)
Katsampas (Alexiou 1967)
Khalara (Levi 1967-1968: 138-146)
Khondros Viannou (Platon 1957; 1959A; Kanta 1980: 114-117)
Kommos (Shaw 1978: pl. 36a-b)
Phaistos and vicinity, especially the Kalyvia cemetery (Savignoni 1904; Kanta 1980: 99 and 101-102)
Stamnioi (Platon 1952A: 624-628; Kanta 1980: 54-56)

WESTERN CRETE

Armenoi (Tzedakis 1971B)
Khania (Tzedakis 1969A; 1973; 1977; Kanta 1980: 217-228)
Rethymnon (Platon 1947)
Stavromenos (Alexiou 1960B: 272; Kanta 1980: 211-212)

Although the vessels and their patterns are now becoming more standardized, the Minoan romance with nature is still very much alive. A fashion for animals, birds, and exotic plant life creates a small series of marvelously luxuriant vases, their crowded natural settings teeming with pattern and motion. More staid designs are turned out in larger numbers, and many vases, even fine ones, are plain and undecorated (Fig. 118).

The beginning of the period may be defined by the appearance of the ledge-rimmed cup (Pl. 28A and B). This one-handled shape, with a small outturned rim, is substantially different from the usual cups of LM IB and LM II. It is common enough to form a good diagnostic trait, and it is easily recognizable even in small sherds. A new kylix, with a taller stem than in LM II, also gradually appears (Pl. 28G). Other shapes that begin or increase in popularity include the krater (Pl. 28H and I), the globular flask, and the shallow, ring-footed cup. Among the favorite patterns are festoons, the foliate scroll, the iris zigzag, and several other continuous repeat motifs, especially those with zigzag motion. The practice of applying the main ornament on the upper shoulder is now widespread. Bands and empty spaces usually fill the lower body, and necks or handles have their own designs. The total number of motifs begins to decline during the period, and fewer elements are in use by the end of the phase.

Many changes have already taken place by the time of the destruction of Knossos early in LM IIIA:2. One-handled cups without the ledge rim have begun to replace the ledge-rimmed variety. The decorated kylix is less popular than before, and the stem is taller. A new shape, the one handled goblet or champagne cup (see Fig. 118A), appears now and may

perhaps be used to mark the beginning of LM IIIA:2. Decoration is less inventive, and some of the plants and the other more naturalistic designs are no longer used. The ornamental repertoire, already quite abstract, will soon settle down into a more stable series of specific emblems, applied in a repetitive and stereotyped way.

Much of the LM IIIA ornament is easily recognized by its predilection for continuous, smoothly flowing abstract designs. Most of the motifs are decorative friezes with one element repeated enough times to fill the assigned space (Fig. 119). Some of the patterns are new to pottery, and Popham has suggested they may have been borrowed from textiles (1967: 245). Often a small filler is placed in the interstice between the main motifs, or alternate elements are reversed in position to make the pattern flow more smoothly. Lines are regularly joined to make the design continuous. Unity motifs, as in Plate 28B, are employed more sparingly than in LM II. Overall designs are common on larger shapes, but even on the big vases a series of bands is much more popular (see Pl. 28H and I). Although scenes incorporating animals and other elements are not really common, they are some of the most attractive of the LM IIIA designs.

Birds of several kinds become popular in this period. Only a few immediate antecedents exist (i.e. Hood and de Jong 1952: fig. 10 upper left and fig. 11; Popham 1973: fig. 28), and one wonders if perishable art, perhaps embroideries or paintings on wooden boxes and other objects, had a hand in their development. Ultimately, they must go back to scenes of animals set with aquatic landscapes because fish and river plants like the papyrus are common accessory details; an origin in "Nilotic" scenes like those on the

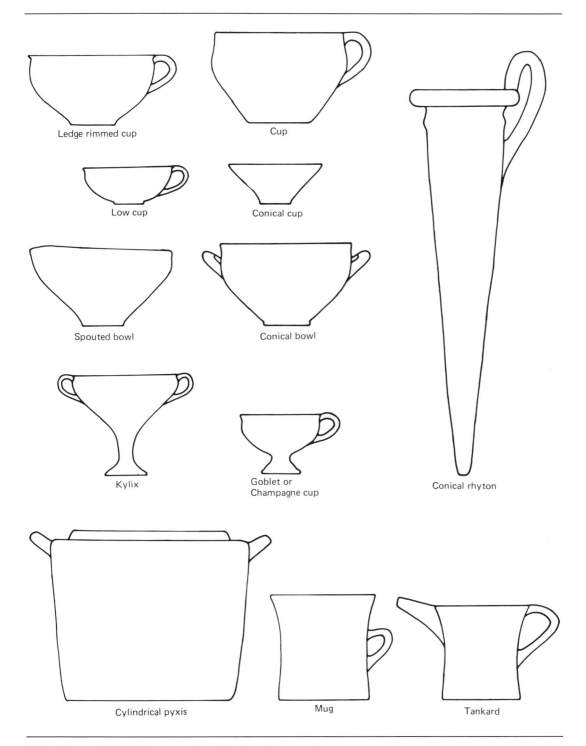

Ledge rimmed cup

Cup

Low cup

Conical cup

Spouted bowl

Conical bowl

Kylix

Goblet or
Champagne cup

Conical rhyton

Cylindrical pyxis

Mug

Tankard

118 · Names of LM III fine ware shapes (*continued next page*).

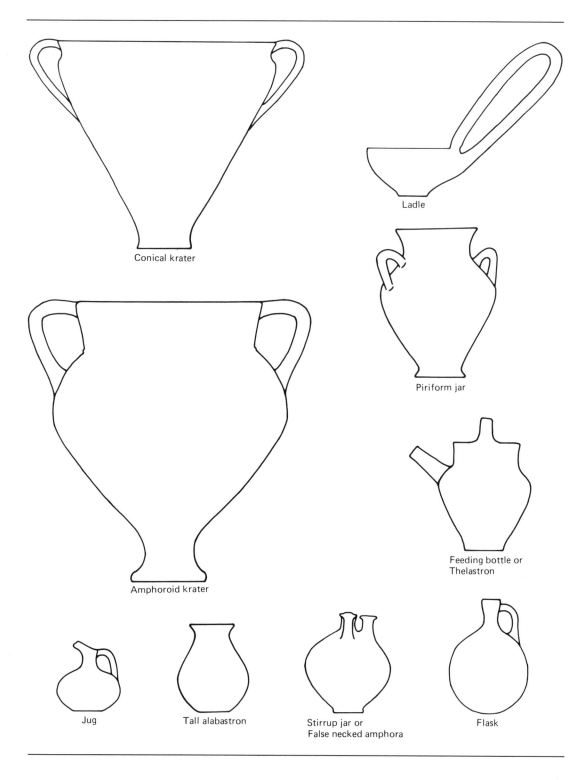

Conical krater

Ladle

Piriform jar

Amphoroid krater

Feeding bottle or Thelastron

Jug

Tall alabastron

Stirrup jar or
False necked amphora

Flask

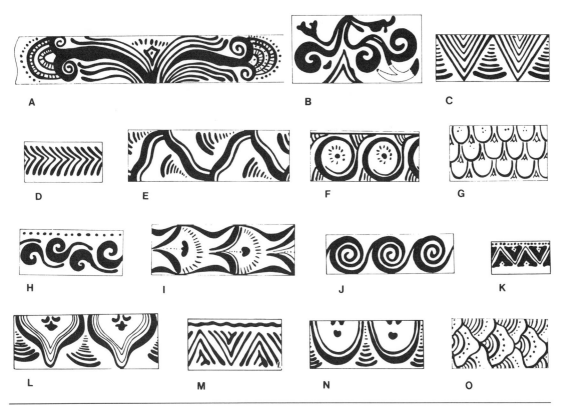

wall painting from the West House at Akrotiri shown in Figure 120A (Marinatos 1968-1976: VI color pl. 8) and on an inlaid dagger from Mycenae (Marinatos 1973: color pl. 49 above) seems a likely source.

The elaborate pyxis in Figure 120B and C preserves much of the unity of earlier pictures. It has been placed in the first part of LM IIIA on stylistic grounds, though it comes from a mixed context, a tomb with several burials at Alatsomouri near Pakheia Ammos and Gournia (Hawes et al. 1908: pl. 10 no. 40; Silverman 1974: 18). The shape, with straight sides, no handles, and a small ridge for the lid, is typical of LM IIIA (for other examples see Kanta 1980: 282). Papyrus and other plants grow from the upper

and lower borders, framing a plump bird who flies vigorously toward the right. Sprouting vegetation suggests the real world, but the decorative composition denies this aspect. As is to be expected for the period, the style is crowded, completely linear, and strongly two-dimensional—there is no overlapping of forms or details.

Two stylistically more advanced scenes come from the Kalyvia cemetery near Phaistos (Pl. 28C and D). They are both alabastra, dated to early LM IIIA:2 by comparison with a similarly decorated vase from the palace at Knossos (Popham 1970A: 77, pl. 18c, and fig. 5 no. 2). On the first piece two long-beaked water birds flank a growing plant derived from the papyrus (Pl. 28C). The heraldic

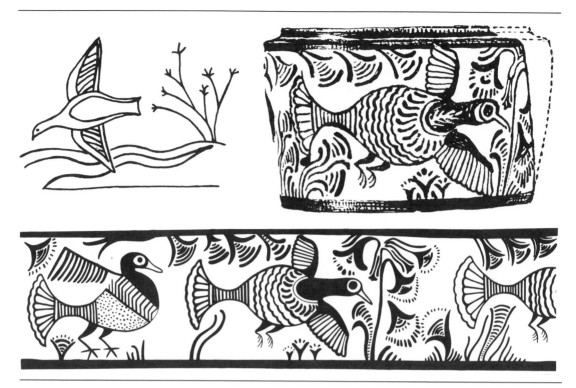

120 · Birds in "Nilotic landscapes" from the Aegean. (*top left*) Mural from Room 5 of the West House at Akrotiri, Thera, LM IA; (*top right and bottom*) Pyxis from a tomb at Alatsomouri near Pakheia Ammos, LM IIIA:1, Ht. 11 cm.

scheme recalls LM II designs but is equally characteristic of LM III. The second vase, with the painting in panels, shows a different species of bird struggling to fly with a gigantic fish. The crowded, closely patterned animals are stiffer than their cousins on the pyxis from Alatsomouri, and the designs seem more removed from the Nilotic scenes of earlier years.

This gradual loss of pictorial unity is one of the most important characteristics of LM III as a whole. Late Minoan I landscapes, as in Figure 120A, are organic and rational, fully grounded in the natural world. Their coherence contrasts with the artificial, decorative quality of Plate 28C and D or the general dissolution of pictorial space on the Vasilika Ano-

ghia sarcophagus (Pl. 26E). The painted larnax is clearly a part of the same bird-painting tradition, but its curious intermingling of fish and birds denies the whole concept of natural landscape. Unlike the larnakes from near Rethymnon, the animals and plants are no longer anecdotes in a narrative scene, and they neither suggest a specific event nor establish a coordinated setting of action on a natural stage.

This direction in the development is often ascribed to influence from the Greek mainland, an aspect of LM III that may also be seen in some of the new vase shapes. The new designs—both details on old forms and entirely new shapes—join the general repertoire inherited from LM II. As always, the main

121 · The development of the kylix shape from LM IIIA:1 to LM IIIB.

group shows complete continuity from the preceding phase.

Most of the open vessels are derived from LM II. The ledge-rimmed cup (Pl. 28A and B), with a well-rounded body and a thin ribbon handle, is simply a later version of the cups shown in Figure 113. A few examples are plain, but most have painted ornament, usually a repeat motif or a unity motif on the upper shoulder with bands and an open space on the lower body. Interiors are always painted. Except for the loss of the ledge rim, there is little change in early LM IIIA:2

Low cups with a more open mouth also exist (Fig. 118A). They vary in shape from conical to rounded, but they cannot be regarded as shallow versions of the usual type because their interiors are plain or banded, and their bases are depressed or have a small ring. Mycenaean influence may be traced in the shape. Other cups with Mycenaean counterparts include a bell-shaped form with slightly concave sides (Popham 1970A: fig. 8 nos.

4-5; compare Furumark 1941: FS 230) and a mug with one handle (Popham 1970A: pl. 10a; compare FS 225).

Among other open shapes are bowls, basins, kraters, and two types of stemmed cups. The undecorated conical cup, long a hallmark of Minoan pottery, declines somewhat in popularity; it may have been replaced by the two stemmed cups, the kylix and the goblet. These shapes have been discussed in detail by Popham (1969A). The kylix, which begins with the LM II Ephyraean goblet, gradually becomes taller and more aristocratic until it reaches the tall-stemmed variety of LM IIIA:2 and LM IIIB (Fig. 121). The development can be traced with undecorated examples (Popham 1969A; 1970: 74-75 and 78-79), but the painted kylix is extremely rare in LM IIIA:1; examples like Plate 28G, from the South East House at Knossos, only provide a glimpse of the shape at the end of LM IIIA. The low-stemmed goblet, which probably begins at about the start of LM IIIA:2, has one handle, a short stem, and a disc foot

(Fig. 118). Most examples are unpainted, though a rare type has a solid coat of dark-firing slip.

Kraters are not common, but their large size and careful style make them some of the premier vases of LM III. They begin in LM II (see the incomplete example from Kommos in Fig. 113) but are more common later (for discussion see Karageorghis 1965: 220-224). Two types were in use at Knossos when the palace was destroyed, a conical and an amphoroid shape. The conical krater looks like a very large, deep conical cup with an offset rim and vertical handles (Pl. 28I). Its wide mouth would allow the contents to be dipped out easily, and one supposes the use, as in Classical times, was for mixing wine with water. The amphoroid krater, an especially attractive shape, is used as well (Pl. 28H). Both types have Mycenaean versions (see Popham 1970A: 76), and metallic kraters may also have helped fix their design.

There are two fine ware bowls. The deep bowl, a Late Minoan II shape, has a conical body with two horizontal handles, a rounded shoulder, and a slightly turned out rim. A shallower version, always undecorated, is also found (Popham 1970: pl. 32h).

Most closed shaped are traditional. Jugs have a contracted base and a piriform body, set off from the neck with a small raised ridge (Pl. 13E and F). Spouts are narrow and raised. At Knossos the handles develop slightly; they are thin in LM II and IIIA:1 but become more oval in section in LM IIIA:2 (Popham 1970A: 70). Ewers are shaped like the jugs but have round mouths (Pl. 29A). The bridge-spouted jug in Plate 29D seems to be one of the last painted examples of this standard Minoan shape (see also Bosanquet and Dawkins 1923: fig. 62); the form is not known from LM IIIB.

The stirrup jar, with its peculiar handle system with the main opening blocked and another added on the side, now becomes more common (discussion in Benson 1961; Popham 1970A: 73-74; Kanta 1980: 244-255). The design continues to be unexplained. One suggestion is that it is intended for bathing. The fingers would be slipped inside the bridged-handle arrangement and the jar would be tilted forward to pour a small quantity of oil onto the palm (Cook 1981). The suggestion is weakened by the chronology of the small jars that could have been used in this way, since most of the early ones are large containers intended for storage or transport. An alternative suggestion is that the handles are designed to assist in pouring out thin oil (Leonard 1981: 92). The LM IIIA jars are usually only slightly ornamented. When they are given fine designs, which is not very often, they are painted on the upper body and shoulder, a larger field than is used by their Mycenaean contemporaries (Pl. 29C).

Many other closed shapes are known. Piriform jars and squat alabastra are popular as grave gifts. Palace Style jars also continue into this period. Other shapes include the amphora, the tall alabastron (Pl. 28C-D and 29B), the flask (see the detailed discussion by Tzedakis 1971A), the side-spouted jar or thelastron (Fig. 113 and Kanta 1980: 281), the pyxis (Fig. 120), the askos, and the rhyton (Fig. 118 and Popham 1970A: 78). The lid in Plate 29F, decorated with a rosette surrounded by the iris zigzag, is probably from a pyxis.

A specialized shape, the incense burner, is first known from LM IIIA; its origins are unknown (For discussion see Georgiou 1973A; 1979). The shape consists of two separate pieces, a cup and a cover (Pl. 29H). The cup normally has a

flat base and vertical sides, with a single handle for lifting. Its matching cover, with a cut out portion to accommodate the cup's handle, is made with a cylindrical lower part and a higher, pierced top. The normal context is tombs and shrines.

LATE MINOAN IIIA:2 (LATE) TO LATE MINOAN IIIB

Technically, LM IIIB is the high point of Minoan potting and pyrotechnology. Most vases are expertly thrown and well fired, with a pale-colored fabric that is hard and durable. An occasional problem with an irregular wall or an overfired body is not due so much to lack of knowledge as to hasty execution or carelessness.

Although observations on the development can be made for individual sites, there is as yet no universally accepted criterion for dividing the end of LM IIIA from the beginning of LM IIIB for the island as a whole. On the other hand, the direction of the stylistic progression is well understood. A few shapes—notably the decorated kylix and the bowl with two handles—increase in popularity. The motifs also change, moving toward greater abstraction and stylization. As time goes on, they tend to separate into their component parts, resulting in bands of isolated elements that contrast with the smooth and continuous flow of the LM IIIA friezes. This development follows the mainland styles, and, as in the preceding period, LM IIIA:2 to IIIB is largely dependent on the definitions set up for Late Helladic pottery in the Argolid (Ålin 1962; E. French 1963; 1966; 1967; 1969A; 1977; Wardle 1969; 1973). Crete, however, maintains its essentially independent character (for the historical implications of the relationship see Hooker 1969).

Late Minoan IIIB deposits come from several parts of the Knossian palace (Popham 1964) and its vicinity (Evans 1902-1903: 142; Forsdyke 1928; Hood, Huxley, and Sandars 1958-1959; Hood and de Jong 1958-1959; Smee 1966; Popham 1970C). Their significance has become one of the most hotly contested points in Minoan archaeology: battle lines are drawn between Evans' view of a slight occupation after the main destruction in early LM IIIA:2 (Boardman 1963; Popham 1966: 95) and a suggestion that LM IIIB is the main period at Knossos (Palmer 1963; 1965; 1969A; 1969B; 1971; Hallager 1977; Niemeier 1982A; 1982B). The principal arguments center around the date of deposition for the archives written in Linear B script. Knossian clay tablets list commodities in such large quantities that they must reflect a major palatial economy, so their date should be the high point of Cretan power. Although the dispute is crucial to any analysis of Minoan history, it does not really affect the pottery. The ceramic sequence is firmly fixed, in spite of disagreement about which vases were actually found with the tablets.

Other contexts have been discussed by Kanta (1980). Their distribution, like that of LM IIIA:1 to early IIIA:2, indicates a large population that covers the entire island. The most important sites besides Knossos include:

Eastern Crete

Episkopi (Kanta 1980: 148-160)
Gournia (Hawes et al. 1908: pl. 10)
Myrsine (Kanta 1980: 170-171)
Pakheia Ammos (Hawes et al. 1908: pl. 10; Alexiou 1954B)
Palaikastro (Kanta 1980: 189-193, with many references)

CENTRAL CRETE

Aghia Triada (Kanta 1980: 102-104)
Amnissos (Kanta 1980: 38-43)
Episkopi (Kanta 1980: 58-68)
Gazi (Marinatos 1937: figs. 6-7; Alexiou 1972)
Gournes (Hazzidakis 1918: 63-87)
Katsampas (Kanta 1980: 28)
Khondros Viannou (Platon 1957; 1959; Kanta 1980: 114-117)
Kommos (Shaw 1977: pls. 52b and d and 53e; 1978: pl. 34e-f)
Ligortynos (Pottier 1907; Savignoni 1904: 656-659; Mavriyannaki 1974; Kanta 1980: 83-84)
Liliano Cave (Kanta 1971)
Malia (Effenterre and Effenterre 1963: pl. 37 nos. 8511 and 8554 and pl. 39; 1969: pls. 58-59)
Nirou Khani (Kanta 1980: 43-45)
Stamnioi (Platon 1952A: 624-628; Kanta 1980: 56-58)

WESTERN CRETE

Armenoi (Tzedakis 1971B; Kanta 1980: 213-214)
Khania (Tzedakis 1969A; 1973; 1977; Kanta 1980: 217-228)
Maroulas (Mavriyannaki 1973)
Perivolia Cave (Tzedakis 1967: 506; 1968: 417-418; 1969A: 400-405)
Stylos (Davaras 1973; Kanta 1980: 235)

These groups indicate a thriving pottery industry. Individual workshops can be recognized from several regions: Khania (Tzedakis 1969A), Knossos, Episkopi, Palaikastro, and a few other places (discussion in Kanta 1980: 288-290). They have local variations within a general style that exists across the whole island; LM IIIB has often been called a *koine*. It follows the lead of the Greek mainland wherever it can, with shapes, decorations, and even occasionally with the distinctly Mycenaean habit of covering a vase with tin to effect a metallic look (for the mainland see Immerwahr 1966; Pantelidhou 1971; for Crete see Kanta 1980: 315 and 327).

The most common fine ware shapes are the bowl, the cup, and the kylix. All are made in both plain and decorated versions. The bowl, developing from the conical bowls of LM II-IIIA, changes somewhat by LM IIIB (Pl. 29E and G). Its rim is now straight or nearly straight, its handles are set lower on the body, and its form is more rounded. The usual decoration is a frieze on the upper body. Interiors are sometimes painted and sometimes left plain except for bands near the rim and perhaps some concentric circles on the bottom, but unlike the situation at Mycenae, there is no chronological significance to the painted interior. A ring base is occasionally added, and several examples with a stemmed base, a Mycenaean detail (FS 305), have been found at Khania (Kanta 1980: 258). Cups with one handle are often shaped like the bowls, though they tend to be a little smaller (Pl. 29I). They sometimes have a slightly everted rim or a ring base. The typical kylix, plain or nicely painted, has a tall cylindrical stem and a ring foot, with a slightly rounded body (Pl. 29J and Fig. 121). Handles are either conventional or curved high above the rim.

Kraters are among the finest vases of the period. Their scale is large enough to encourage special efforts, and the spacious painting fields allow more developed designs than on smaller vessels. Wide-mouthed shapes suggest a use as serving bowls; dippers with long handles, which sometimes occur in the same deposits (Popham 1964: pl. 2b), may have been used as ladles. An amphoroid shape that develops from the earlier types is

shown in Plates 29K and 30A and B. The example with a conical base (Pl. 29K) presents an octopus, a rather anemic version of the fierce creature of LM IB, now with only six spindly tentacles devoid of all their suckers. Its companion in Plate 30A and B comes from the same tomb at Ligortynos but is decorated far more elegantly. On the front are a pair of goats who confront each other at a stylized tree while an octopus trail and a floral element fill up the back. Although the goats and tree motif is rare within the Aegean, it has an incredibly long history in the Near East where it is often associated with the "tree of life" (discussion in Danthine 1937). In Crete the artist has substituted local agrimis for the original animals, and one wonders how much (if any) of the original religious symbolism is still present.

Other open vessels include the goblet, the mug, the tankard, and several rare cup and bowl designs. The goblet is shaped like the LM IIIA:2 pieces but often has a lower foot; it is seldom decorated. The mug and its spouted version called a tankard, on the other hand, are normally painted with fine designs (Pl. 30K and M). Among the less common shapes are several types of spouted cups and bowls (Pl. 30L).

As in earlier periods jars, jugs, and other closed shapes round out the ceramic inventory. Mostly they are undecorated, though an occasional piece is fine and painted. With some shapes, the development is considerably advanced. Conical rhyta are much slimmer than in LM I (Pl. 30O), and they have a heavy rounded rim. A more open-mouthed rhyton has also developed (Pl. 30P). The thelastron, a side-spouted jar with a long mainland ancestry (Fig. 118), would give a steady stream of liquid (as in modern Greek oil jars). Pyxides continue to be popular; the example in Plate 30N comes from a tomb near Gournia. Pithoi, jars, and amphoras are used for storage. Animal-shaped rhyta are much more stylized than before. The example in Plate 31C and D, a calf or bull with short pointed horns, may be sharply contrasted with the earlier and more lifelike heads. Found at Ligortynos, it has large bulging eyes and an artificial shape. Openings are in the back of the head and the muzzle.

Stirrup jars are incredibly diverse (Pl. 30C-J). They range from big coarse shapes with a large capacity to miniatures that would hold only a few ounces. Shapes are plump and rounded, tall and piriform, or low and squat. Most of the larger jars are plain or have simple motifs like the octopus trail (Pl. 30E), while the smaller ones are painted on the body or upper shoulder. They are often hard to date, ranging at least from LM IIIA:2-IIIB.

One group of large stirrup jars has inscriptions in the Linear B script. Exported to several sites on the Greek mainland, they have been found at Mycenae, Tiryns, Eleusis, Orkhomenos, and Thebes, as well as in Crete (Raison 1968; Sacconi 1974; Godart and Olivier 1975: 37-53; Hallager 1975; Haskell 1981). The examples in Figure 122 come from Thebes. Their inscriptions, in the same dark slip used for the sparse decoration, say *a-nu-to*, probably a personal name, and *wa*, an abbreviation for some longer word or phrase (*wa-na-ka-te-ro*, royal, is tempting but unproved). As with these examples, the inscriptions are always brief. One group from Thebes has sets of three words: a personal name; a place name as a noun or derived adjective; and a second personal name, in the genitive. Since the signs are always painted on before firing, they probably concern the jars' places of manufacture rather than

122 · Coarse stirrup jars from Thebes, inscribed with Linear B script (above) *a-nu-to*, Ht. 42 cm.; (below) *wa* Ht. 39 cm.

their ultimate destinations. Some of the place names have been identified as Cretan towns because they occur on the Knossos tablets. Perhaps, as suggested by John Chadwick, the inscriptions acted "as a kind of label or trade-mark guaranteeing the origin of the liquid" (1976: 18).

A few incised inscriptions are also known, especially from the Mesara. They are usually isolated signs. Some are not readily identifiable, conforming to some abbreviation or pot-mark system we have no way of understanding.

A selection of samples taken from the inscribed Theban jars was analyzed by optical emission spectroscopy in the 1960s in an attempt to ascertain the place of manufacture (Catling and Millett 1965; 1969). For some of the jars, eastern Crete seemed to have the best match for the percentages of certain elements, but there were problems with this attribution, and the conclusions were challenged by several writers on various grounds (Hart 1965; Godart 1971; Palmer 1971; 1972; 1973; McArthur 1974; Wilson 1976). A reexamination of the samples and a comparison with newly available comparanda from western Crete provided a different conclusion, that the jars may have been made in the vicinity of Khania (Catling and Jones 1977; Catling et al. 1980). This correlation seems more in keeping with the archaeological and linguistic evidence because inscribed jars are found here, and place names on the vessels (such as *wa-to* and *o-du-re-we*) have occasionally been located in western Crete.

All of these shapes—cups and bowls, kraters, stirrup jars and the rest—are associated with traditional household activities. They deal with cooking, serving, storage, transport, and commerce. Another concern, however, shows a dramatic flowering in LM IIIA:2 to IIIB.

The specialized cult vessel, long a part of Minoan ceramic tradition, develops new ideas, and several types exist: effigy figures; vessels for incense or aromatics; elaborate stands; and other special shapes.

An example of a human figure is shown in Plate 31B. The vase is a hollow container with a small cup-like opening in the top of the head. Found in a IIIA:2 to IIIB house at Gournia, it is shaped like a nude woman wearing two necklaces. The body is bulbous, and the features are not very lifelike. An elaborate gesture using both arms suggests ritual. The vase is unique, and whatever act or ceremony required its use was perhaps uncommon because vessels of this complexity are extremely rare.

Other cult vessels take various forms. Incense burners like the example in Plate 31A have been mostly found in tombs and shrines. Rhyta and animal-shaped vases may also have figured in rituals. Special groups, like a hoard of double vases found in the palace at Knossos, could also have had a religious purpose (Popham 1964: 6-7). Tomb furniture, especially the painted larnakes, takes dramatic steps forward in LM III, and vases like the krater with the agrimis and the tree and the bull's head rhyton from Ligortynos (Pls. 30B and 31D) may also be placed within the same religious preoccupation. Scenes with religious symbols, like the rhyton in Plate 30O and the sherd in Plate 31G, increase in numbers.

Yet the most striking examples of the new concern for religion are the stands that are a regular feature in shrines. Aside from the religious sculptures, now also often made of clay, they are the most elaborate pieces of temple furniture from the end of the Late Minoan period (Cadogan 1973; Gesell 1976; Betancourt et al. 1983). Often called "snake tubes"

from the multiple handles that grace their sides, they were evidently used to support cups or other vessels (an example from Kommos was found with a matching cup still in place, Shaw 1977: pl. 54c-d). Two stands from Gournia show the shape at its best (Pl. 32A and B). Made of coarse red clay, they are decorated with three-dimensional models of the "horns of consecration," a motif usually thought to represent the horns of a bull. An additional symbol, a pair of snakes, is added to one piece. The stands were often used in groups, and their exotic shapes must have helped contribute to the mystic feeling of the Bronze Age shrines.

The ornament of late LM IIIA:2 and LM IIIB already uses many of the concepts that will distinguish the art of the early first millennium B.C. Designs are carefully ordered abstract or nonobjective motifs. They are often used in repetitive sequences, building up an overall effect from carefully arranged small parts. The tectonic syntax, which emphasizes the upper shoulder, is directly related to the compositions of later times. Evidently the painting theory of the Protogeometric to Geometric tradition was already being developed, and much of the aesthetic success of the later styles is dependent on this long period of experiment and refinement.

Much has been made of the "Mycenaean" character of LM IIIB painting as opposed to the "Minoan" character of MM I-LM IB. This analysis is a little too simplistic because it overlooks both the essential fact that LM IB was already well on its way toward the LM III styles and the point that the "Mycenaean" vases of LH I are as Minoan as they are Middle Helladic. The seeds of all the "Mycenaean" characteristics—abstraction, tectonic syntax, a use of bands, an emphasis

on the upper shoulder, and most other LM IIIB features—can all be found within earlier Minoan art. It is more accurate to note that after the beginning of MM III Aegean pottery becomes a communal affair. The third stage of the Late Bronze Age is jointly Minoan, Mycenaean, Cycladic, and perhaps a few other things. It has developed in a continuous unbroken line from the earlier styles, incorporating contributions from many

quarters along the way. The Helladic contribution, which includes much that is tectonic and rational, had been absorbed long before LM IIIB. A similar picture, suggesting the merging of populations, is indicated by many types of more objective evidence: the combination of Minoan and Mycenaean names on the Linear B tablets with no concern for status; the widespread appearance of non-Greek loan words; and the mixed physical char-

123 · Motifs from LM IIIA:2-IIIB.

acteristics of the skeletal material. Late Minoan IIIB pottery is neither Minoan nor Mycenaean; it is Aegean.

Patterns from the Cretan version of this Aegean style are shown in Figure 123. It differs considerably from the mainland style. Among the typical motifs are quirks (F), zigzags (D), concentric arcs (B-C), flowers (I), spirals (G), and chevrons (H). Elements are sometimes set against an open field with enough space around them to suggest a sequence of isolated parts. Above all, the motifs are procrustean; they are forced into a standardized repertoire, conforming to set types to be repeated over and over. They are also simpler than in LM IIIA, with few nonessential details.

Other ornaments are shown in the plates. The shoulder decorations from the stirrup jars form a subset of their own (Pl. 30C, and H-J). Most of the jars share a limited number of motifs repeated in various combinations, though a few are nicer. Except for the octopus (Pl. 30F and G) and the figural scenes (Pl. 30A and B), overall patterns are not common.

The octopus motif is one of the most characteristic of all Cretan ornaments. It develops from the Marine Style representations of LM IB and LM II-IIIA, but it now assumes a much more formal and symmetrical aspect (for discussion see Furumark 1941: motif 21; Pinsent 1978). In the simplest versions, as in Plate 30E, the head and body are omitted entirely and only a single tentacle meanders around the vase. More elaborate examples, like the stirrup jar from Episkopi in Plate 30G, present a carefully painted abstraction with waves and waves of tentacles. In other cases the animal is more sketchy (Pl. 29K), and the tentacles are simpler as well. The motif is especially popular on stirrup jars, both those used at home and those exported around the Aegean.

By the end of LM IIIB, some of the paintings have begun to lose their tightness and clarity. Irregular wavy lines like those on the neck of the amphoroid krater in Figure 124 herald the more informal nature of the next period. This krater, found at Palaikastro, is a good example of the tendency to disorganization that progresses steadily during the later part of LM IIIB. It has several vertical panels filled with carelessly drawn ornament, described by R. M. Dawkins as the "degenerate remains of the patterns of a better period all jumbled together, no one part of the design bearing any relation to the others" (1902-1903: 318). The tendency is by no means universal, but it looks forward to the stylistic changes that will occur at the end of the Bronze Age.

LATE MINOAN IIIC

As with all ceramic phases, LM IIIC begins gradually; the change is a process, not an event. The beginning of the pe-

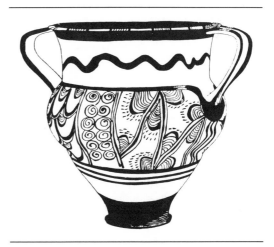

124 · Amphoroid krater from Palaikastro, LM IIIB, Ht. 39 cm.

riod coincides roughly with a series of destructions on the Greek mainland, political upheavals that brought the "Mycenaean empire" to a close and ushered in the early Iron Age. The resulting changes in the Cretan pottery are partly inspired from abroad; others appear to be local, a new provincial flowering that was not possible during IIIB. The best pieces, taut and finely painted, come from the early and middle parts of the period; by the close of IIIC a laxness has set in, a waning of aesthetic vigor. Sub-Minoan is a poor shadow of former greatness, and the new precision of Protogeometric will have to wait for stimuli from Athens and other quarters.

Historically, LM IIIC is a pivotal period. Evidence for a breakdown in central authority exists from throughout the Aegean (Betancourt 1976B). Many Cretan sites are abandoned or suffer recessions, and new foundations are usually away from the more exposed seacoast. Sometimes, as at Karphi, these "refuge sites" are windswept heights with a hostile climate, suggesting a real motivation to inhabit their relative safety.

Most archaeologists use the nomenclature in Table 6 for the final periods of Minoan history. Late Minoan IIIC was once called LM IIIB:2 (Furumark 1944: 262), but a term that corresponds more closely with the mainland Late Helladic IIIC is now generally preferred. Unlike the mainland styles, the Cretan periods cannot yet be subdivided; they are still known only generally, and their chronology follows that of the mainland.

The stylistic development of Cretan pottery at the end of the Bronze Age has been discussed by many scholars. Among them, one may cite in particular the works of Levi (1927-1929: 625-643), Furumark (1941; 1944), Desborough (1964: 166-195; 1972A: 112-114), Popham (1965), Schachermeyr (1979A; 1979B), and Kanta (1980).

At the beginning of LM IIIC, the pottery has many ties with the preceding period. A good central Cretan group from this phase, with material from Knossos, Phaistos, and Aghia Triada, has been published by Popham (1965; 1970C: 202). Although it is firmly grounded in IIIB, the mature phase of the period develops along lines that are more independent. Useful pottery groups from the mature part of IIIC include the following (for others see Kanta 1980):

EASTERN CRETE

Aghios Theodoros near Vasilike
 (Seager 1906: 129-132 and pl. 30)
Karphi (Desborough 1972: 120-129,
 with references)
Kastri near Palaikastro (Sackett, Popham, and Warren 1965: 278-299)
Kavousi (Boyd 1901; Levi 1927-
 1929: 562-567 and 582-592)
Milatos (Evans 1906: 93-103; Xanthoudides 1920-1921; Kanta 1980:
 125-128)
Mouliana (Xanthoudides 1904:
 Tomb B; Desborough 1964: 177-
 178)
Myrsine (Kanta 1980: 171-172)
Psykhro Cave (the "Dictaean Cave")

Table 6 · Chronology at the end of the Bronze Age.

	CRETE	GREEK MAINLAND
ca. 1200	LM IIIB	LH IIIB
ca. 1100	LM IIIC	LH IIIC
ca. 1000	Sub-Minoan	Sub-Mycenaean

(Hogarth 1899-1900)
Vrokastro (Hall 1914: 91-93; Levi
 1927-1929: fig. 614)

CENTRAL CRETE

Amnissos (Kanta 1980: 41-42)
Erganos (Halbherr 1901: 262-281;
 Kanta 1980: 75-76)
Katsampas (Kanta 1980: 27-29)
Knossos (Popham 1970C)
Knossos, Gypsades Cemetery (Hood,
 Huxley and Sandars 1958-1959)
Phaistos (Pernier 1902: figs. 45-47
 and pl. 8 no. 4; Savignoni 1904:
 cols. 627-651)

WESTERN CRETE

Atsipades (Petroulakis 1915)

At the beginning of the period, the potting and firing are still good, and the fabric is hard and durable. Some vases have a matte surface, while others are more glossy. The most common fine ware shape is the bowl, a significant change from LM IIIB when bowls were less common. Other fine ware shapes include the kylix, cup, shallow bowl, stirrup jar, tankard, ladle, and krater. Mycenaean influence can be detected in several areas, including the shapes of the bowls and some of the painted ornament, especially the antithetic spiral and panel motifs. An elaborate decorative system with many fine lines, called the Close Style, has already developed by the beginning of the period. It is complemented by a Plain Style in which isolated elements decorate an empty field.

As the period develops, the repertoire of shapes changes slightly. Conical bowls become even more popular at the expense of the cups and kylikes. By the end of the period, the kylix develops a bulge on the stem and an offset rim (Fig. 125).

Bases on bowls are now very small, giving the lower part of the shape a contracted look. The potting is poorer, and the firing is not always as fine as before. One can perhaps detect a looser attitude, as if expert technique is no longer the desired achievement it once was.

Motifs also develop significantly; a selection is shown in Figure 126. Compositions are either bilateral or in series, giving the vases a formal look. Many compositions are facial, emphasizing the two sides of the vessel in a very rigid way. Since the antithetic spiral does not appear in LM IIIB, it makes a good "type fossil" for the new phase. The repeat designs are often small, with a lot of open field around them. Common are diamonds, spirals, quirks, and other simple elements. They all continue along their road toward increased stylization, and most have completely lost sight of their origins in the natural world. By the end of the period they are often careless, painted with unsteady lines and indifferent spacings.

This is not to say that fine examples do not still exist. Highly skilled vases are still made, and the best painting is well executed and carefully detailed. Some of the best examples are pictorial, an aspect of Minoan painting that continues to the end of the Bronze Age. It may be regarded as the counterpart to the other styles, some of which are so simple they do not lend much ornament to their vessels. The pictorial designs are sometimes sketchy presentations with little or no context, though others combine animals and human figures in vigorous action, creating an effect that verges on the narrative. The style is two-dimensional and rigorously simplified, but it is usually sufficient to carry the message.

A fine example of the style is the krater in Plate 31F. It comes from Knossos,

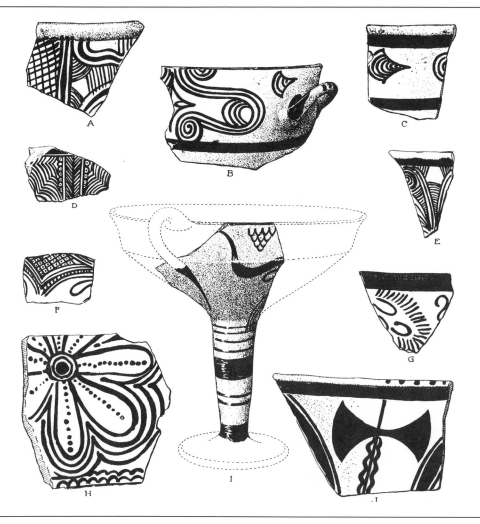

125 · LM IIIC sherds from Vrokastro, Scale 1:2.

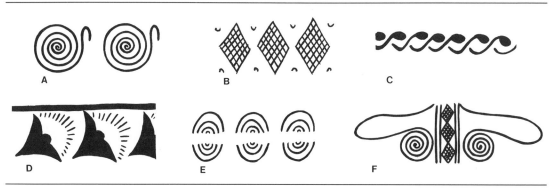

126 · Motifs from early LM IIIC.

from a stage at the very beginning of IIIC. The shape, a new development from the LM IIIB kraters, has almost straight sides and a tall foot. A bilateral composition is composed of birds and tri-curved streamers; it makes an attractive emblem for the elegant bowl.

The krater in Plate 31E is far more lively. Its date is uncertain, LM IIIC or perhaps a little later. The panel arrangement is typical of this general period, and the painting seems to be derived from the pictorial style of IIIB-C. Found at Mouliana, it held the remains of a cremation burial. On one side a man hunts agrimis in an exterior landscape suggested by a spindly tree; he brandishes a spear and advances menacingly while the animals scatter in all directions. On the back is a man on horseback (Fig. 127). The vase is naively painted, but it is still convincing in regard to the action, a fine example of the pictorial style at its best.

THE PLAIN STYLE

A style with a few linear designs placed on an open field is particularly characteristic of the period. Most of its motifs develop from the LM IIIB repertoire, but they are often more cursory. Some of the vases are still well painted, but others are hastily executed, especially toward the end of the period. A minimum amount of painting is used, creating a sober and formal style.

Two examples of the Plain Style from a tomb at Aghios Theodoros near Vasilike are shown in Figures 128 and 129. One is a kalathos, a basket-shaped vase, with high handles and a pronounced rim. Its main ornament is a meandering octopus trail. The other vase, a lens-shaped flask, is decorated with concentric circles. Since the tomb also held a stirrup jar decorated in the Close Style, it conveniently illustrates the contemporary nature of the two main IIIC styles.

THE CLOSE STYLE

The Close Style is perhaps the most distinctive painting tradition from the

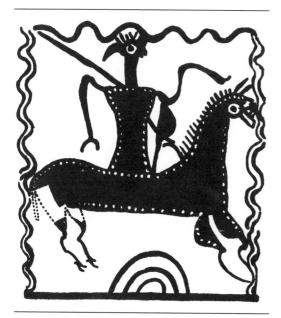

127 · Decoration on a krater from Mouliana showing a man on horseback, LM IIIC(?).

128 · A kalathos from a tomb at Aghios Theodoros near Vasilike, LM IIIC, Ht. 14.6 cm.

end of the Cretan Bronze Age. It uses crowded compositions with many patterns and elements, with a *horror vacui* that closes off most of the available space. The style is found in many parts of the Aegean, and a few examples have been excavated from Cyprus and the Near East. Good discussions of the Minoan versions include studies by Furumark (1944: 222-229), Desborough (1964: 175-177), and Kanta (1980: 304-307).

129 · A flask from the same tomb as the kalathos in Figure 128, Scale 2:3.

The Cretan style is known for its use of heavy, solid elements. Sometimes they are "fringed and combined with a forest of fine lines and closely hatched subordi-

nate figures" (Pendlebury 1939: 252). This "fringed style" seems to be peculiar to Crete, allowing Minoan exports and imitations to be readily identified.

In the Helladic sequence the Close Style begins somewhat later than the start of LH IIIC. As defined by Elizabeth French (1969A; 1969B) and by Wardle (1973), the final phase of LH IIIB is first followed in the Argolid by a period in which deep bowls with solid painted interiors and deep semiglobular cups appear (for a good deposit see Döhl 1973). The Close Style, however, does not appear until later (perhaps considerably later, for which see Rutter 1977). Since the Cretan ceramic chronology is completely dependent on the mainland sequence, it is possible that a Minoan phase has not yet been recognized. On the other hand, if the Close Style begins on Crete, Minoan examples could be early.

The Cretan motifs are borrowed from the general pool of LM IIIB-C. Figural elements are especially prominent: shells, octopuses, birds, animals, and flowers. Hatching is common, and small designs of several types help fill the fields.

The painting is careful, making the style much more attractive than most other IIIC handwork. Formal syntax—especially bilateral composition—contributes to the controlled effect. Often the vases use a miniaturist technique, and the tiny lines and details suggest fine needlework.

A good example of the style is the remarkable tankard in Plate 31I and J. The piece stands 17 cm. high, making it too monumental for a simple drinking cup; its find spot in the Psykhro Cave suggests an offering made for display. Each side has a simple decoration. The spout side is painted with four panels arranged antithetically with a vertical motif below the

spout. Its geometric composition shows off the Close Style at its best. It is the other side, however, which was probably intended as the front. Here is an octopus with fierce vissage, its fourteen tentacles framing a massive head. Smaller motifs close in the space at the edges, filling most of the interstices with small details.

Tankards, however, are rare; a far more important shape is the stirrup jar, a vase with a wide distribution in Crete and abroad. The most common type is decorated with octopuses. Examples from tombs may have held perfumed oil, so that decorations were recognized as a "label" denoting the contents. Certainly the repetition of a few basic types suggests a well-known and recognizable product.

Two typical stirrup jars are illustrated in Figure 130 and Plate 31H. The piece in Plate 31H comes from the Royal Tomb at Isopata, near Knossos. Its schematic animal, combining wide solid areas with closely spaced thin lines, is characteristic of the style. A "fringe" is visible at the top of the decoration, framing the highest tentacles. More fine lines are used on the other jar, found in a tomb at Tourloti.

Within the strictures of their own laws, the octopus stirrup jars are fine and attractive vases. The animals depart from earlier Minoan octopuses in several specific ways, by changing or omitting parts of the design and adding embellishments that are new (for discussion see Pinsent 1978). The result is a series of complex spiraliform ornaments with flowing lines set against small geometric details (Fig. 131). The designs are abstract rather than organic, with the original shape of the animal suggesting a decorative system that then exists on its own.

130 · A stirrup jar from a tomb at Tourloti, LM IIIC, Ht. 10.5 cm.

Especially in the Dodecanese, the presence of Cretan style stirrup jars indicates a new overseas connection (for a list of examples see Kanta 1980: 303-304). Some of the jars are certainly actual exports, suggesting that trade remained an important aspect of island life. Although the Aegean was already beset with troubles, commerce could still find a way.

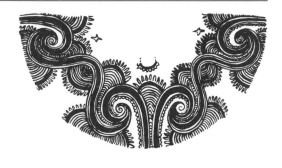

131 · Decorations on LM IIIC vases from Mouliana.

14 · SUB-MINOAN AND THE END OF THE BRONZE AGE STYLES

IRON OBJECTS, arched fibulas, cremation burials, and other accouterments of the early Iron Age are already in Crete by LM IIIC. They come in somewhat gradually, but by the end of the phase they are well established. Whether or not they represent Dorians at this early period is another matter. Although the Dorian Greeks had certainly reached southeastern Europe by sometime in the early Iron Age, the date of their arrival is still uncertain. Trade and cultural contact are valid alternatives for the picture in Crete in LM IIIC/SM, especially since the local pottery shows complete continuity with earlier periods.

The times must have been quite unsafe. Coastal settlements were not yet resettled, and refugees from the Aegean's troubled cities probably passed by often. Some of the Iron Age customs were surely brought in by strangers, and a few Cretans may themselves have moved to Cyprus or elsewhere.

In terms of pottery, Sub-Minoan immediately follows LM IIIC. The new style has the island to itself for a while, but it must soon fight a rearguard action against the encroachment of Attic Protogeometric and other foreign fashions. Although it is related to Sub-Mycenaean through a common ancestry as well as through cross-fertilization, it has many independent features. Most motifs and vase shapes may be traced to LM IIIC.

Decorations are simpler and more abstract, and the "fringed style" all but disappears. General studies are by Furumark (1944: 229-230), Desborough (1952: 233-271; 1964: 166-195; 1972A: 57-63 and 120-129), Snodgrass (1971: 40-43), and Seiradaki (1960).

The Sub-Minoan dating is not completely secure, but it has generally been placed in the eleventh century B.C. No interior division into phases has been possible (contrast Attic Sub-Mycenaean, as in Styrenius 1967). Early Protogeometric should begin about the beginning of the tenth century B.C. (Coldstream 1972: 65-66). Protogeometric influences were stronger at Knossos and other central Cretan sites than elsewhere, and outlying towns kept local traditions alive when more sophisticated folk had already moved on to the next style. Sub-Minoan and Protogeometric may have coexisted for a century or even longer.

The best site for the end of LM IIIC and for Sub-Minoan is Karphi (Pendlebury, Pendlebury, and Money-Coutts 1937-1938B; Seiradaki 1960; Desborough 1972A: 120-129). Set on a high and inhospitable hill, it was probably only inhabited for a few generations before life became safe enough to come down to lower ground, perhaps to Papoura (Watrous 1980: 282). Other settlements and cemeteries with good Sub-Minoan pottery groups include:

Dreros (Effenterre 1948: chap. 3,
Tomb 1; Desborough 1952: 260-
262)
Kavousi Cemetery (Boyd 1901)
Knossos and its vicinity
Aghios Ioannes (Boardman 1969:
144-145; Hood and Coldstream
1968: 209-212)
Gypsades Cemetery (Hood, Huxley,
and Sandars 1958-1959)
Kephala (Cadogan 1967)
Spring Chamber of the Caravanserai
(Evans 1921-1935: II, 123-139)
Teke (Brock 1957: Tomb *Pi*)
Kourtes (Halbherr 1901: pl. 8; Mariani
1901)
Kritsa (Platon 1951B: 444-445)
Phaistos (Rocchetti 1969-1970)
Vrokastro (Hall 1914: fig. 89)

Whereas Crete was certainly thrown
back on its own resources at this time, it
would be a mistake to assume complete
isolation. Contact was maintained with
other parts of the Aegean sphere, and
new ties with Cyprus are particularly in-
teresting (for discussion see Karageorghis
1968; Desborough 1972A: 60-63 and
118-119; 1973: 82; for a possible import
from Karphi at Enkomi see Dikaios 1969-
1971: 316-317 and pl. 95, no. 26). Both
islands produced similar stirrup jars,
duck vases, small jugs, and a few minor
shapes. Although the impetus to make
clay vessels for trade was apparently less-
ened, influences still traveled, probably
on a regular basis.

The technical expertise of the Sub-Mi-
noan pottery is not very high. Except for
an occasional exception like some high-
fired products from Karphi, the fabric is
relatively soft. Often the paint does not
adhere well, and many vases are badly
flaked. Although the potter's wheel con-
tinues to be used, the expert throwing
skill of IIIB is now long past.

The shapes from this period are well
represented in the IIIC/SM material
from Karphi (Fig. 132). Kylikes now reg-
ularly have a bulge in the stem, and their
rims are often offset (Fig. 133 and Pl.
32C). Their cups are more conical than
before, a feature suggesting mainland in-
fluence. The bowl, the most common fine
ware shape, occurs in several varieties; it
has a tiny base and two horizontal han-
dles, betraying an ancestry in the conical
bowls of IIIB and C. Larger counter-
parts, used as kraters, are also made reg-
ularly. Other open shapes include cups,
kalathoi, tankards, and dippers.

All the closed shapes of IIIC are still in
evidence. New developments for the stir-
rup jar include a knob on top of the disc
and an air hole in the upper shoulder
(see Pl. 32G). The Sub-Minoan pyxides
are also a little different; examples from
Karphi have horizontal handles that be-
gin at the base and extend all the way up
the wall to rise above the rim (Fig.
132H). Amphoras, jars, flasks, and small
pithoi continue earlier traditions. An un-
usual shape is the duck vase, a special
form of askos found in several parts of
the Aegean (Pl. 32E). The Cretan variety,
which also occurs in Cyprus, consists of
an elongated body with small feet and a
spout instead of a head. It has been stud-
ied in detail by Desborough (1972B).

Motifs, shown in Figure 134, are mostly
very simple. Rectilinear designs are
now more common than curvilinear ones,
and many vases have only a little orna-
ment. Often much of a vase is painted
solid. Hatched triangles are the most
common motif on the shoulders of stir-
rup jars, replacing the rich assortment of
motifs in this position in earlier styles.

The kylix in Figure 133 and Plate 32C
shows what is left of the "fringed style."
It comes from a good context, a rectan-
gular stone tomb at Vrokastro that held

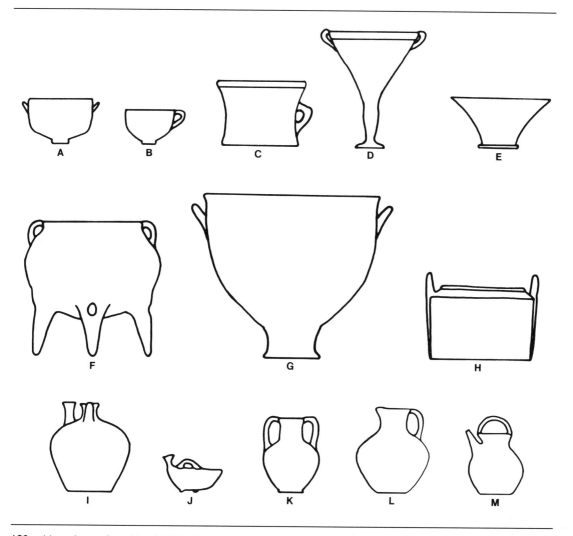

132 · Vase shapes from Karphi, LM IIIC to Sub-Minoan, Scale 1:8. (A) Bowl; (B) Cup; (C) Mug; (D) Kylix; (E) Conical cup or bowl; (F) Tripod cooking pot; (G) Krater; (H) Pyxis; (I) Stirrup jar; (J) Bird-shaped askos (or askoid rhyton); (K) Amphora; (L) Jug; (M) Thelastron.

only Sub-Minoan vases (Hall 1914: 149-151). The shape, with a cup that flows smoothly from the fattened stem, is smaller than most earlier kylikes. Decoration consists of antithetic tricurved streamers with accessory details. A little fringe survives at the top, but the motif is only a pale version of the complex earlier streamer designs (compare the krater in Pl. 31F). Crosshatching at the center completes the composition.

Other vases from the same site are shown in Plate 32D-G. The flask is a shape with a wide distribution both in the Aegean and in the east. As in earlier times, concentric circles are a common decoration. The stirrup jar is also typical of the type; its shoulder decoration of crosshatched triangles is particularly characteristic of the period.

A perfect example of the persistence of the Minoan notions is to be found in the

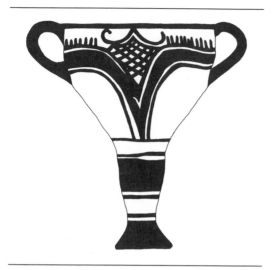

133 · Kylix from Chamber Tomb V at Vrokastro, Sub-Minoan, Ht. 13.5 cm.

Bronze Age spirit, but it still could have been made well after the end of IIIC. Several Iron Age vases were found near the krater, and the tomb also held vases from LM IIIC. The point is that Sub-Minoan ideas persisted for an uncertain length of time; in the absence of corroborative evidence from a whole context, it is difficult to date some of the specific pieces.

By the Iron Age, the old Cretan principles reach a low ebb. At the height of Minoan art in MM II-LM IB, ceramic decoration had been a happy combination of nonobjective design and abstract natural forms borrowed from the plant and animal kingdom. Organic shapes were simplified and reduced to two-dimensional designs, then placed singly or in groups to create rhythmic, flowing ornament on the "skin" of a ceramic vessel. Shapes were expertly potted and well fired. Their decoration took cognizance of the form, using torsion, flowing or interrupted movement, and many types of aesthetic balances set in complex syntactical arrangements. Potters and painters were skilled in a demanding and sophisticated art. Almost all of these principles were gone by the first millennium B.C.

scholarship surrounding the bell krater from Mouliana (Pl. 31E), discussed above. It has been dated everywhere from LM IIIC to Geometric (Xanthoudides 1904: cols. 32-35; Pendlebury 1939: 309; Desborough 1964: 177; Kanta 1980: 175). The shape is clearly derived from LM IIIC, and the figures are set within an antithetic scheme, indicating a

134 · Sub-Minoan motifs.

It is not so much the handwork skill that was now missing—the best vases were still beautifully painted—but the commitment to the old ideas. Gradually, beginning already in MM III/LM I, Minoan pottery began to change. By LM III it was losing its organic quality and becoming increasingly standardized and repetitive. More and more, the vases were made along the lines of mass production, stereotyped shapes with a limited repertoire of design elements and an uninspired syntax. The few early Iron Age monuments that rise above the others take their excellence from a refreshingly interesting motif or a careful attention to detail and craftsmanship, not from the blend of a sophisticated shape and pleasing patterns set in a complex syntax. Organic qualities in the ornament were gradually lessened until the time of the Protogeometric to Geometric tradition, a style that was distinctly un-Minoan. Precise geometric designs, drawn with ruler and compass, were totally alien to the Minoan concept of ceramic decoration: the old Bronze Age styles were now completely submerged.

REFERENCES CITED

Alexiou, S. N.D. Μινωικὸς Πολιτισμός. Herakleion.

——. 1951. "Πρωτομινωικαὶ ταφαὶ παρὰ τὸ Κανλὶ-Καστέλλι Ἡρακλείου." *KrChron* 5: 275-294.

——. 1953. " Ἀνασκαφαὶ ἐν Κατσαμπᾷ." *Praktika*: 299-308.

——. 1954A. "Ἀνασκαφαὶ ἐν Κατσαμπᾷ." *Praktika*: 369-376.

——. 1954B. "Ὑστερομινωικὸς τάφος Παχυάμμου." *KrChron* 8: 399-412.

——. 1958A. "Ein frühminoisches Grab bei Lebena auf Kreta." *AA*: 1-10.

——. 1958B. "Ἡ μινωϊκὴ θεὰ μεθ᾽ ὑψωμένων χειρῶν." *KrChron* 12: 179-299.

——. 1959. "Χρονικά." *KrChron* 13: 370-371.

——. 1960. "New Light on Minoan Dating. Early Minoan Tombs at Lebena." *ILN* (Aug. 6): 225-227.

——. 1961-1962. "Οἱ πρωτομινωικοὶ τάφοι τῆς Λεβῆνος." *KrChron* 15-16, pt. 1: 88-91.

——. 1964A. "Κρήτη. Περιφέρεια Χανίων." *Deltion* 19: Khronika, 446-447.

——. 1964B. "Μικραὶ σκαφικαὶ ἔρευναι—Περισυλλογὴ ἀρχαιοτήτων." *Deltion* 19: Khronika, 440-441.

——. 1965. " Ἀρχαιότητες καὶ μνημεῖα κεντρικῆς καὶ ἀνατολ. Κρήτης." *Deltion* 20: Khronika, 549-557.

——. 1967. Ὑστερομινωικοὶ τάφοι λιμένος Κνωσσοῦ (Κατσαμπά). Athens.

——. 1968. "Περὶ τὸ πρόβλημα τῆς ὑστερᾶς χρήσεως τοῦ χώρου τῶν μινωϊκῶν ἀνακτόρων." In *Πεπραγμένα τοῦ Β΄ Διεθνοῦς Κρητολογικοῦ Συνεδρίου*, pp. 105-114. Athens.

——. 1969. "Μικραὶ ἀνασκαφαὶ καὶ περισυλλογὴ ἀρχαίων εἰς Κρήτην." *Praktika*: 238-240.

——. 1970. "Μικραὶ ἀνασκαφαὶ καὶ περισυλλογὴ ἀρχαίων εἰς Κρήτην." *Praktika*: 252-255.

——. 1972. "Λάρνακες καὶ ἀγγεῖα ἐκ τάφου παρὰ τὸ Γάζι Ἡρακλείου." *ArchEph*: 86-98.

Ålin, P. 1962. *Das Ende der mykenischen Fundstätten auf dem griechischen Festland*. Lund.

Amouretti, M.-C. 1970. *Fouilles exécutées à Mallia. Le centre politique* II. *La crypte hypostyle*. Études crétoises 18. Paris.

Andreou, S. 1978. "Pottery Groups of the Old Palace Period in Crete." Dissertation, University of Cincinnati.

Åström, P. 1957. "The Middle Cypriote Bronze Age." In Åström, ed. *The Swedish Cyprus Expedition*, vol. IV, pt. 1(b). Lund.

——. 1961-1962. "Remarks on Middle Minoan Chronology." *KrChron* 15-16, part 2: 137-150.

——. 1968. "New Evidence for Middle Minoan Chronology." In *Πεπραγμένα τοῦ Β΄ Διεθνοῦς Κρητολογικοῦ Συνεδρίου*. Athens.

——. 1972. "The Late Cypriote Bronze Age Architecture and Pottery." In Åström, ed. *The Swedish Cyprus Expedition*, vol. IV, pt. 1(c). Lund.

Atkinson, T. D. et al. 1904. *Excavations at Phylakopi in Melos*. London.

Banti, L. 1930-1931. "La grande tomba a tholos de Haghia Triada." *ASAtene* 13-14: 155-251.

———. 1939-1940. "Cronologia e ceramica del palazzo minoico di Festòs." *ASAtene*, n.s., 1-2: 9-39.

———. 1941-1943. "I culti minoici e greci di Haghia Triada (Creta)." *ASAtene*, n.s., 3-5: 9-74.

Barber, R.L.N. 1978. "The Cyclades in the Middle Bronze Age." In Doumas, ed. 1978-1980: 367-379.

———. 1981. "The Late Cycladic Period: a Review." *BSA* 76: 1-21.

Barber, R.L.N., and J. A. MacGillivray. 1980. "The Early Cycladic Period: Matters of Definition and Terminology." *AJA* 84: 141-157.

Bass, G. F. 1972. "The earliest seafarers in the Mediterranean and the Near East." In G. F. Bass, ed. *A History of Seafaring Based on Underwater Archaeology*, pp. 11-36. London and New York.

Benson, J. 1961. "Coarse ware stirrup jars of the Aegean." *Berytus* 14: 37-52.

Béquignon, Y. 1933. "Chronique des Fouilles." *BCH* 57: 236-312.

Bernabò-Brea, L. 1964-1976. *Poliochni. Città preistorica nell'Isola di Lemnos*, vols. I-II. Rome.

Best, J.G.P., and M. W. de Vries, eds. 1981. *Interaction and Acculturation in the Mediterranean*. Amsterdam.

Betancourt, P. P. 1973. "The Polyp Workshop; A Stylistic Group from LM IB." *AJA* 77: 333-334.

———. 1975. "Some New Attributions to Minoan Ceramic Workshops." In *Abstracts of Papers Delivered in Art History Sessions. 63rd Annual Meeting, College Art Association of America*. Washington, D.C.

———. 1976A. "Economic Implications of the Reed Painter's Vases." *Temple University Aegean Symposium* 1: 15-17.

———. 1976B. "The end of the Greek Bronze Age." *Antiquity* 50: 40-47.

———. 1977A. "Some Chronological Problems in the Middle Minoan Dark-on-light Pottery of Eastern Crete." *AJA* 81: 341-353.

———. 1977B. "Marine-Life Pottery from the Aegean." *Archaeology* 30: 38-43.

———. 1977C. "Further Observations on the Marine Style." *AJA* 81: 561.

———. 1978. "A Middle Minoan Pottery Deposit." In Shaw, Betancourt, and Watrous 1978: Appendix A, 155-164.

———. 1978-1980. "LM IA Pottery from Priniatikos Pyrgos." in Doumas, ed. 1978-1980: I 381-387.

———. 1980. *Cooking Vessels from Minoan Kommos. A Preliminary Report*. Los Angeles.

———. 1982A. "The Crocus and Festoons Motif: Evidence for Traveling Vase-Painters?" *Temple University Aegean Symposium* 7: 34-37.

———. 1982B. "Preliminary Results from the East Cretan White-on-dark Ware Project." In J. S. Olin and A. D. Franklin, eds. *Archaeological Ceramics*, pp. 183-187. Washington, D.C.

———. 1983. *Objects Excavated from Vasilike, Pseira, Sphoungaras, Priniatikos Pyrgos, and Other Sites. The Cretan Collection in the University Museum University of Pennsylvania*, vol. I. Philadelphia.

———, ed. 1984A. *East Cretan White-on-dark Ware*. Philadelphia.

———. 1984B. "The Middle Minoan Pottery of Southern Crete." In Hägg and Marinatos, eds. 1984: 89-92.

Betancourt, P. P., M. G. Ciaccio, B. Crowell, J. M. Donohoe, and R. C. Green. 1984. "Ceramic Stands." *Expedition* 26 no. 1: 32-37.

Betancourt, P. P., T. K. Gaisser, E. Koss, R. F. Lyon, F. R. Matson, S. Montgomery, G. H. Myer, and C. P. Swann, 1979. *Vasilike Ware. An Early Bronze Age Pottery Style in Crete*. Göteborg.

Betancourt, P. P., and G. A. Weinstein. 1976. "Carbon-14 and the Beginning of the Late Bronze Age in the Aegean." *AJA* 80: 329-348.

Bisson de la Roque, F. 1950. *Trésor de Tôd.* Cairo.

Bisson de la Roque, F., G. Contenau, and F. Chapouthier. 1953. *Le Trésor de Tôd.* Cairo.

Blackman, D. J., and K. Branigan. 1978. "Moni Odigitrias Area." *Deltion* 27: Khronika, 630-631.

———. 1982. "The Excavation of an Early Minoan Tholos Tomb at Ayia Kyriaki, Ayiofarango, Southern Crete." *BSA* 77: 1-57.

Blackman, D., and K. Branigan et al. 1977. "An Archaeological Survey of the Lower Catchment of the Ayiofarango Valley." *BSA* 72: 13-84.

Blegen, C. 1937. *Prosymna,* vol. II. Cambridge, England.

Blegen, C. W. et al.,1950. *Troy,* vol. I. Princeton.

Blinkenberg, C., and K. F. Johansen. N.D. *CVA Copenhagen, National Museum* 1 (*Denmark* 1). Paris.

Boardman, J. 1960. "Protogeometric graves at Agios Ioannes near Knossos." *BSA* 55: 128-148.

———. 1963. "The Date of the Knossos Tablets." In Palmer and Boardman 1963.

Bolton, K. 1976. "Addendum to Luce." *AJA* 80: 17-18.

Bonacasa, N. 1967-1968. "Patrikiès—Una stazione medio-minoica fra Haghia Triada e Festòs." *ASAtene,* n.s., 29-30: 7-54.

Borchhardt, J. 1972. *Homerische Helme.* Mainz am Rhein.

Bosanquet, R. C., and R. M. Dawkins. 1923. *The Unpublished Objects from the Palaikastro Excavations 1902-1906. BSA* Supp. 1. London.

Bossert, E.-M. 1960. "Die gestempelten Verzierungen auf frühbronzezeitlichen Gefässen der Ägäis." *JdI* 75: 1-16.

Boyd, H. A. 1901. "Excavations at Kavousi, Crete, in 1900." *AJA* 5: 125-157.

Boyd, H. A. 1904-1905. "Gournia. Report of the American Exploration Society's Excavations at Gournia, Crete, 1904." *University of Pennsylvania Transactions of the Department of Archaeology, Free Museum of Science and Art* 1: 177-188.

Branigan, K. 1968. "The Mesara Tholoi and Middle Minoan Chronology." *SMEA* 5: 12-30.

———. 1969. "The genesis of the Household Goddess." *SMEA* 8: 28-38.

———. 1970. *The Foundations of Palatial Crete.* London, New York, and Washington, D.C.

———. 1971. "Cycladic Figurines and their Derivatives in Crete." *BSA* 66: 57-78.

———. 1973. "Radio-Carbon and the absolute chronology of the Aegean Bronze Age." *KrChron* 25: 352-374.

———. 1974. *Aegean Metalwork of the Early and Middle Bronze Age.* Oxford.

———. 1975. "The Tombs of Mesara: New Tombs and New Evidence." *BICS* 22: 200-203.

———. 1981. "Minoan colonialism." *BSA* 76: 23-33.

Brock, J. K. 1957. *Fortetsa. Early Greek Tombs Near Knossos.* Cambridge, England.

Buchholz, H.-G. 1974. "Ägäische Funde und Kultureinflüsse in den Randgebieten des Mittelmeers. Forschungsbericht über Ausgrabungen und Neufunde 1960-1970." *AA*: 325-462.

Buchholz, H.-G. 1980. "The Problem of Minoan Relations with the West at the Beginning of the Late Bronze Age." *Temple University Aegean Symposium* 5: 45-60.

Buck, R. J. 1962. "The Minoan Thalasso-

cracy Re-examined." *Historia* 11: 129-137

———. 1964. "Middle Helladic Matt-painted Pottery." *Hesperia* 33: 231-308.

Cadogan, G. 1967. "Late Minoan III C Pottery from the Kephala Tholos near Knossos." *BSA* 62: 257-265.

———. 1973. "Clay Tubes in Minoan Religion." In Πεπραγμένα τοῦ Γ' Διεθνοῦς Κρητολογικοῦ Συνεδρίου. Athens.

———. 1978. "Pyrgos, Crete, 1970-7." *Archaeological Reports for 1977-78*: 70-84.

———. 1979. "Cyprus and Crete c. 2000-1400 B.C." In *Acts of the International Archaeological Symposium: "The Relations Between Cyprus and Crete, ca. 2000-500 B.C.,"* pp. 63-68. Nicosia.

Caskey, J. L. 1954. "Excavations at Lerna, 1952-1953." *Hesperia* 23: 3-30.

———. 1956. "Excavations at Lerna, 1955." *Hesperia* 25: 147-173.

———. 1957. "Excavations at Lerna: 1956." *Hesperia* 26: 142-162.

———. 1960. "The Early Helladic Period in the Argolid." *Hesperia* 29: 285-303.

———. 1962. "Excavations in Keos, 1960-61." *Hesperia* 31: 263-283.

———. 1964. "Excavations in Keos, 1963," *Hesperia* 33: 314-335.

———. 1966. "Excavations in Keos, 1964-65." *Hesperia* 35: 363-376.

———. 1971. "Investigations in Keos. Part I." *Hesperia* 40: 358-396.

———. 1972. "Investigations in Keos. Part II: A Conspectus of the Pottery." *Hesperia* 41: 357-401.

———. 1979. "Ayia Irini, Keos: The Successive Periods of Occupation." *AJA* 83: 412.

Casson, S., ed. 1927. *Essays in Aegean Archaeology Presented to Sir Arthur Evans in honour of his 75th birthday.* Oxford.

Catling, E. A., H. W. Catling, and D. Smyth. 1979. "Knossos 1975: Middle Minoan III and Late Minoan I Houses by the Acropolis." *BSA* 74: 1-80.

Catling, H. W., J. F. Cherry, R. E. Jones, and J. T. Killen. 1980. "The Linear B Inscribed Stirrup Jars and West Crete." *BSA* 75: 49-113.

Catling, H. W., and R. E. Jones. 1977. "A reinvestigation of the provenance of the inscribed stirrup jars found at Thebes." *Archaeometry* 19: 137-146.

Catling, H. W., and V. Karageorghis. 1960. "Minoika in Cyprus." *BSA* 55: 109-127.

Catling, H. W., and A. Millett. 1965. "A Study of the Inscribed Stirrup-Jars from Thebes." *Archaeometry* 8: 3-85.

———. 1969. "Theban Stirrup-Jars: Questions and Answers." *Archaeometry* 11: 3-20.

Chadwick, J. 1976. *The Mycenaean World.* Cambridge, England, London, New York, and Melbourne.

Chapouthier, F., and J. Charbonneaux. 1928. *Fouilles exécutées à Mallia. Premier rapport (1922-1924).* Études crétoises 1. Paris.

Chapouthier, F., and P. Demargne. 1942. *Fouilles exécutées à Mallia. Troisième rapport. Exploration du palais . . . (1927, 1928, 1931, 1932).* Études crétoises 6. Paris.

Chapouthier, F., P. Demargne, and A. Dessene. 1962. *Fouilles exécutées à Mallia. Quatrième rapport. Exploration du palais. (1929-1935 et 1946-1960).* Études crétoises 12. Paris.

Chapouthier, F., and R. Joly. 1936. *Fouilles exécutées à Mallia. Deuxième rapport. Exploration du palais (1925-1926).* Études crétoises 4. Paris.

Christopoulos, G. A., et al., eds. 1974. *History of the Hellenic World. Prehistory and Protohistory.* University Park, Pennsylvania.

Coldstream, J. N. 1972. "Knossos 1951-

61: Protogeometric and Geometric Pottery from the Town." *BSA* 67: 63-98.

———. 1974. "Kythera: the change from Early Helladic to Early Minoan." In Crossland and Birchall, eds. 1974: 33-36.

———. 1978-1980. "Kythera and the Southern Peloponnese in the LM I Period." In Doumas, ed. 1978-1980: I 389-401.

Coldstream, J. N., G. L. Huxley, et al. 1973. *Kythera. Excavations and Studies Conducted by the University of Pennsylvania Museum and the British School at Athens.* Park Ridge, New Jersey.

Coleman, J. E. 1977. "Early Cycladic Clay Vessels." In Thimme, ed. 1977: 109-117.

Coles, J., ed. 1971. *Contributions to Prehistory offered to Graham Clark. Proceedings of the Prehistoric Society* 37, pt. 2. London.

Cook, J. M. 1959. "Bath-tubs in ancient Greece." *Greece and Rome* 6: 34-41.

Cook, J. M., and J. Boardman. 1954. "Archaeology in Greece, 1953." *JHS* 74: 166-169.

Cook, K. 1981. "The Purpose of the Stirrup Vase." *BSA* 76: 167.

Crossland, R. A., and A. Birchall, eds. 1974. *Bronze Age Migrations in the Aegean.* Park Ridge, New Jersey.

Cummer, W. W., and E. Schofield. 1984. *Keos*, vol. III. *Ayia Irini: House A.* Mainz on Rhine.

Danthine, H. 1937. *Le Palmier-Dattier et les arbres sacrés.* Paris.

Daux, G. 1958. "Chronique des Fouilles." *BCH* 82: 644-830.

———. 1959. "Chronique des fouilles en 1958. Lébèna." *BCH* 83: 742-745.

———. 1960. "Chronique des fouilles en 1959. Lébèn." *BCH* 84: 844-846.

Davaras, C. 1971. " Ἀρχαιότητες καὶ μνημεῖα ἀνατολικῆς Κρήτης." *Deltion* 27: Khronika, 645-654.

———. 1973. "Μινωικὴ κεραμεικὴ κάμινος εἰς Στύλον Χανίων." *ArchEph*: 75-80.

———. 1976. *Guide to Cretan Antiquities.* Park Ridge, New Jersey.

———. 1980. "A Minoan Pottery Kiln at Palaikastro." *BSA* 75: 115-126.

———. N.D. *Μουσεῖον Ἁγίου Νικολάου.* Athens.

Davis, E. N. 1979. "The Silver Kantharos from Gournia." *Temple University Aegean Symposium* 4: 34-45.

Davis, J. L. "Minos and Dexithea: Crete and the Cyclades in the Later Bronze Age." In Davis and Cherry, eds. 1979: 143-157.

Davis, J. L., and J. F. Cherry, eds. 1979. *Papers in Cycladic Prehistory.* Los Angeles.

Dawkins, R. M. 1902-1903. "Excavations at Palaikastro II." *BSA* 9: 274-341.

———. 1903. "Pottery from Zakro." *JHS* 23: 248-260.

———. 1903-1904. "Excavations at Palaikastro III." *BSA* 10: 192-226.

———. 1904-1905. "Excavations at Palaikastro IV." *BSA* 11: 258-292.

Deger-Jalkotzy, S. 1977. *Fremde Zuwanderer im spätmykenischen Griechenland: zu einer Gruppe handgemachter Keramik aus den Myk. III C Siedlungsschichten von Aigeira.* Vienna.

Demargne, P. 1945. *Fouilles exécutées à Mallia. Exploration des nécropoles (1921-1933).* Études crétoises 7. Paris.

Demargne, P., and H. Gallet de Santerre. 1953. *Fouilles exécutées à Mallia. Exploration des maisons et quartiers d'habitation (1921-1948), premier fascicule.* Études crétoises 9. Paris.

Desborough, V.R.d'A. 1952. *Protogeometric Pottery.* Oxford.

———. 1964. *The Last Mycenaeans and their Successors.* Oxford.

———. 1972A. *The Greek Dark Ages.* New York.

Desborough, V.R.d'A. 1972B. "Bird Vases." *KrChron* 24: 245-277.

———. 1973. "Mycenaeans in Cyprus in the 11th Century B.C." In *Acts of the International Archaeological Symposium: "The Mycenaeans in the Eastern Mediterranean,"* pp. 79-87. Nicosia.

Deshayes, J. 1962. "A propos du Minoen Ancien." *BCH* 86: 543-568.

Deshayes, J., and A. Dessene. 1959. *Fouilles exécutées à Mallia. Exploration des maisons et quartiers d'habitation (1948-1954), deuxième fascicule.* Études crétoises 11. Paris.

Detournay, B., J.-C. Poursat, and F. Vandenabeele. 1980. *Fouilles exécutées à Mallia. Le Quartier Mu* II. Paris.

Dickinson, O.T.P.K. 1984. "Cretan Contacts with the Mainland during the Period of the Shaft Graves." In Hägg and Marinatos, eds. 1984: 115-118.

Dikaios, P. 1961-1962. "Αἱ σχέσεις τῆς Κύπρου καὶ Κρήτης." *KrChron* 15-16, pt. 1: 151-155.

———. 1969-1971. *Enkomi.* Mainz am Rhein.

Döhl, H. 1973. "Iria. Die Ergebnisse der Ausgrabungen 1939." In *Tiryns,* VI: 127-194. Mainz am Rhein.

Doumas, C. 1975 "Ἀνασκαφὴ Θήρας." *Praktika*: 212-229.

———. 1976A. "Προϊστορικοὶ Κυκλαδίτες στὴν Κρήτη." *AAA* 9: 69-80.

———. 1976B. " Ἀνασκαφὴ Θήρας." *Praktika*: 309-329.

———. 1977. *Early Bronze Age Burial Habits in the Cyclades.* Göteborg.

———. ed. 1978-1980. *Thera and the Aegean World.* London.

———. 1982. "The Minoan thalassocracy and the Cyclades." *AA*: 5-14.

———. 1983. *Thera.* London.

Easton, D. F. 1976. "Towards a Chronology for the Anatolian Early Bronze Age." *AnatSt* 26: 145-173.

Edel, E. 1975. "Der Funde eines Kamaresgefässes in einem Grabe der Qubbet el Hawa bei Assuan." In *Actes du XXXIXe Congrès International des Orientalistes. Egyptologie,* vol. I: 38-40. Paris.

Edgar, C. C. 1896-1897. "Prehistoric Tombs at Pelos." *BSA* 3: 35-51.

Effenterre, H. van. 1980. *Le Palais de Mallia et la cité minoenne.* Rome.

Effenterre, H. van and M. van Effenterre. 1969. *Fouilles exécutées à Mallia. Le Centre politique I. L'Agora (1960-1966).* Études crétoises 17. Paris.

Effenterre, H. van and M. van Effenterre et al. 1963. *Fouilles exécutées à Mallia . . . Étude du site (1956-1957) . . . et exploration des nécropoles (1915-1928).* Études crétoises 13. Paris.

Ehrich, R. W., ed. 1965. *Chronologies in Old World Archaeology.* Chicago and London.

Engelbach, R. 1923. *Harageh.* London.

Evans, A. J. 1895. *Cretan Pictographs and Prae-Phoenician Script.* London.

———. 1902-1903. "The Palace of Knossos." *BSA* 9: 1-153.

———. 1903-1904. "The Palace of Knossos." *BSA* 10: 1-62.

———. 1905. "The Prehistoric Tombs of Knossos." *Archaeologia* 59: 391-562. Also published as a separate monograph, London, 1906.

———. 1921-35. *The Palace of Minos at Knossos.* London.

Evans, J. D. 1964. "Excavations in the Neolithic settlement at Knossos, 1957-60." *BSA* 59: 132-240.

———. 1968. "Knossos Neolithic, Part II, Summary and Conclusions." *BSA* 63: 267-276.

———. 1971. "Neolithic Knossos: the growth of a settlement." In Coles, ed. 1971: 81-117.

———. 1972. "The Early Minoan Occupation of Knossos." *Anatolian Studies* 22: 115-128.

Fairbanks, A. 1928. *Museum of Fine Arts,*

Boston. Catalogue of Greek and Roman Vases, Preceding Athenian Black-figured Ware. Cambridge, Mass.

Farnsworth, M., and I. Simmons. 1963. "Coloring Agents for Greek Glazes." *AJA* 67: 389-396.

Faure, P. 1964. *Fonctions des cavernes crétoises.* Paris.

———. 1965. "Recherches sur le peuplement des montagnes de Crète: sites, cavernes et cultes." *BCH* 89: 27-63.

———. 1969A. "Antiques cavernes de refuge dans la Crète de l'Ouest." *AAA* 2: 213-216.

———. 1969B. "Sur trois sortes de sanctuaires crétoises." *BCH* 93: 174-213.

Fiandra, E. 1975. "Skutelia MM à Festòs," *Πεπραγμένα τοῦ Γ´ Διεθνοῦς Κρητολογικοῦ Συνεδρίου* I. 84-91, Athens.

Fischer, F. 1967. "Ägäische Politurmusterware." *IstMitt* 17: 22-33.

Forbes, H. A. and L. Foxhall. 1978. "The Queen of All Trees." *Expedition* 21, no. 1: 37-47.

Forsdyke, E. J. 1925. *Catalogue of the Greek and Etruscan Vases in the British Museum,* vol. I, pt. 1, *Prehistoric Aegean Pottery.* London.

———. 1928. "The Mavro Spelio Cemetery at Knossos." *BSA* 28: 243-296.

Foster, K. P. 1978. "The Mount Holyoke Collection of Minoan Pottery." *Temple University Aegean Symposium* 3: 1-30.

———. 1979. *Aegean Faience of the Bronze Age.* New Haven and London.

———. 1982. *Minoan Ceramic Relief.* Göteborg.

Frankfort, H. 1927. *Studies in Early Pottery of the Near East,* vol. II. London.

French, D. H. 1961. "Late Chalcolithic Pottery in North-West Turkey and the Aegean." *AnatSt* 11: 99-141.

———. 1964. "Prehistoric pottery from Macedonia and Thrace." *PZ* 42: 30-48.

French, E. 1963. "Pottery groups from Mycenae: a summary." *BSA* 58: 44-52.

———. 1964. "Late Helladic IIIA:1 Pottery from Mycenae." *BSA* 59: 241-259.

———. 1965. "Late Helladic IIIA 2 Pottery from Mycenae." *BSA* 60: 159-202.

———. 1966. "A Group of Late Helladic IIIB 1 Pottery from Mycenae." *BSA* 61: 216-238.

———. 1967. "Pottery from Late Helladic IIIB 1 Destruction Contexts at Mycenae." *BSA* 62: 149-194.

———. 1969A. "A Group of Late Helladic IIIB:2 Pottery from within the Citadel at Mycenae." *BSA* 64: 71-93.

———. 1969B. "The First Phase of LH IIIC." *AA* 84: 133-136.

———. 1977. "Mycenaean Problems 1400-1200 B.C.." *BICS* 24: 136-138.

Frödin, O., and A. W. Persson. 1938. *Asine. Results of the Swedish Excavations, 1922-1930.* Stockholm.

Furness, A. 1953. "The Neolithic Pottery of Knossos." *BSA* 48: 94-134.

———. 1956. "Some early pottery of Samos, Kalimnos and Chios." *Proceedings of the Prehistoric Society* 22: 173-212.

Furumark, A. 1939. *Studies in Aegean Decorative Art. Antecedents and Sources of the Mycenaean Ceramic Decoration.* Dissertation, Uppsala.

———. 1941. *The Mycenaean Pottery.* Stockholm.

———. 1944. "The Mycenaean III c Pottery and its relation to Cypriote Fabrics." *OpArch* 3: 194-265.

———. 1950. "The Settlement at Ialysos and Aegean History c. 1550-1400 B.C." *OpArch* 6: 150-271.

Garstang, J. 1913. "Note on a vase of Minoan fabric from Abydos (Egypt)." *AnnLiv* 5: 107-111.

Georgiou, H. S. 1973A. "Minoan 'Fireboxes' from Gournia." *Expedition* 15, no. 4: 7-14.

———. 1973B. "Aromatics in Antiquity and in Minoan Crete. A Review and

Reassessment." *KrChron* 25: 441ff.

———. 1973C. "A Study of the Form and Function of a Select Group of Minoan Utilitarian Ceramics." Dissertation, Bryn Mawr College.

———. 1979. "Late Minoan Incense Burners." *AJA* 83: 427-435.

Georgiou, H., and Y. Tzedakis. 1976. *Excavations at Kastelli, Chania, Greece*. Los Angeles.

Gerard, M. 1967. "La Grotte d'Eileithya à Amnissos." *SMEA* 3: 31-32.

Gesell, G. C. 1976. "The Minoan Snake Tube: A Survey and Catalogue." *AJA* 80: 247-259.

Godart, L. 1971. "Les tablettes de la série Co de Cnossos." *Acta Mycenaea* 2 (*Minos* 12): 418-424.

Godart, L., and J.-T. Olivier. 1975. "Nouveaux Textes en Linéaire B de Tirynthe." In *Tiryns. Forschungen und Berichte*, vol. VIII: 37-53. Mainz.

Goldman, H. 1931. *Excavations at Eutresis in Boeotia*. Cambridge, Mass.

———. 1956. *Excavations at Gözlü Kule, Tarsus*, vol. II. Princeton.

Grace, V. R. 1940. "A Cypriote Tomb and Minoan Evidence for its Date." *AJA* 44: 10-52.

Groenewegen-Frankfort, H. A. 1951. *Arrest and Movement. An Essay on Space and Time in the representational Art of the ancient Near East*. London.

Hägg, R. 1982: "On the nature of the Minoan influence in Early Mycenaean Messenia." *Opuscula Atheniensia* 14: 27-37.

———. 1984. "Degrees and Character of the Minoan Influence on the Mainland." In Hägg and Marinatos, eds. 1984: 119-121.

Hägg, R., and N. Marinatos, eds. 1981. *Sanctuaries and Cults in the Aegean Bronze Age*. Stockholm.

———. 1984. *The Minoan Thalassocracy. Myth and Reality*. Stockholm.

Halbherr, F. 1901. "Three Cretan Necropoleis." *AJA* 5: 259-293.

Halbherr, F., E. Stefani, and L. Banti. 1977. "Haghia Triada nel Periodo Tardo Palaziale." *ASAtene*, n.s., 39.

Hall, E. H. 1904-1905. "Early Painted Pottery from Gournia." *University of Pennsylvania Transactions of the Department of Archaeology, Free Museum of Science and Art* 1: 191-205.

———. 1906-1907. "The Decorative Art of Crete in the Bronze Age." *University of Pennsylvania Transactions of the Department of Archaeology, Free Museum of Science and Art* 2: 5-50.

———. 1908. "Early Minoan III Ware from the North Trench." In Hawes et al. 1908: Appendix E, p. 57.

———. 1912. *Excavations in Eastern Crete. Sphoungaras*. Philadelphia.

———. 1914. *Excavations in Eastern Crete. Vrokastro*. Philadelphia.

Hallager, E. 1975. "Linear A and Linear B Inscriptions from the Excavations at Kastelli, Khania 1964-1972." *OpusAth* 11: 53-76.

———. 1977. *The Mycenaean palace at Knossos: evidence for final destruction in the IIIb period*. Stockholm.

Hankey, V. 1967. "Mycenaean Pottery in the Middle East: Notes on Finds since 1951." *BSA* 62: 107-147.

———. 1970-1971. "Mycenaean trade with the south-eastern Mediterranean." *Mélanges Univ. Saint-Joseph* 46: 11-30.

———. 1973A. "The Aegean deposit at el Amarna." In *Acts of the International Archaeological Symposium: "The Mycenaeans in the Eastern Mediterranean,"* Nicosia.

———. 1973B. "Late Minoan Finds in the South-eastern Mediterranean," In Πεπραγμένα τοῦ Γ´ Διεθνοῦς Κρητολογικοῦ Συνεδρίου, I: 104-110. Athens.

———. 1979. "Crete, Cyprus and the

South-eastern Mediterranean, 1400-1200 B.C." In *Acts of the International Archaeological Symposium: "The Relations between Cyprus and Crete, ca. 2000-500 B.C.,"* pp. 144-157. Nicosia.

Hankey, V., and O. Tufnell. 1973. "The Tomb of Maket and its Mycenaean Import." *BSA* 68: 103-111.

Hankey, V., and P. Warren. 1974. "The Absolute Chronology of the Aegean Late Bronze Age." *BICS* 21: 142-160.

Haskell, H. H. 1981. "Coarse-ware stirrup-jars at Mycenae." *BSA* 76: 225-237.

Hart, G. R. 1965. "The grouping of place names in the Knossos tablets." *Mnemosyne* ser. 4, 18 (1): 1-28.

Hawes, H. B., B. E. Williams, R. B. Seager, and E. H. Hall. 1908. *Gournia, Vasiliki and other Prehistoric Sites on the Isthmus of Hierapetra, Crete.* Philadelphia.

Hayes, W. C. 1970. "Chronology I. Egypt to the end of the Twentieth Dynasty." In *Cambridge Ancient History*, rev. ed., vol. I: 173-193.

Hazzidakis, J. 1912-1913. "An Early Minoan Sacred Cave at Arkalokhori in Crete." *BSA* 19: 35-47.

———. 1918. "Μινωϊκοὶ τάφοι ἐν Κρήτῃ." *Deltion* 4: 45-87.

———. 1921. *Étude de préhistoire crétoise. Tylissos à l'époque minoenne.* Paris.

———. 1934. *Les villas minoennes de Tylissos. Études crétoises*, 3. Paris.

Heidenreich, R. 1935-1936. "Vorgeschichtliches in der Stadt Samos. Die Funde." *AthMitt* 60-61: 125-183.

Helck, W. 1979. *Die Beziehungen Ägyptens und Vorderasiens zur Ägäis bis ins 7. Jahrhundert v. Chr.* Darmstadt.

Hennessy, J. B. 1967. *The Foreign Relations of Palestine during the Early Bronze Age.* London.

Höckmann, O. 1978. "Theran Floral Style in Relation to that of Crete." In Doumas, ed. 1978-1980: 605-616.

Hofmann, U. 1962. "The Chemical Basis of Ancient Greek Vase Painting." *Angewandte Chemie. International Edition* 1: 341-414.

Hogarth, D. G. 1899-1900. "The Dictaean cave." *BSA* 6: 94-116.

———. 1900-1901. "Excavations at Zakro, Crete." *BSA* 7: 121-149.

Hommel, P. 1959-1960. "Die Ausgrabung beim Athena-Tempel in Milet 1957. II. Der Anschnitt östlich des Athenatempels." *IstMitt* 9-10: 31-62.

Hood, M.S.F. 1956A. "Another Warrior-Grave at Ayios Ioannis near Knossos." *BSA* 51: 81-93.

———. 1956B. "A Tholos Tomb on the Kephala." *BSA* 51: 74-99.

———. 1958. "Archaeology in Greece, 1957." *Archaeological Reports for 1957*: 3-25.

———. 1961-1962. "Stratigraphic Excavations at Knossos, 1957-61." *KrChron* 15-16, pt. 1: 92-98.

———. 1962A. "Sir Arthur Evans vindicated: A remarkable discovery of Late Minoan I B vases from beside the Royal Road at Knossos." *ILN* Feb. 17: 259-263.

———. 1962B. "Archaeology in Greece, 1961-62." *Archaeological Reports 1961-62*: 25-29.

———. 1965. "Minoan Sites in the Far West of Crete." *BSA* 60: 99-113.

———. 1966. "The Early and Middle Minoan Periods at Knossos." *BICS* 13: 110-111.

———. 1971A. *The Minoans.* New York and Washington.

———. 1971B. "An Early Helladic III import at Knossos and Anatolian connections." In Marcel et al. 1971: 427-436.

———. 1973. "The Destruction of Crete c. 1450 B.C." *BICS* 20: 151-153.

———. 1978A. "Traces of the Eruption

outside Thera." In Doumas, ed. 1978-1980: 681-690.

———. 1978B. *The Arts in Prehistoric Greece.* Harmondsworth.

———. 1981. *Prehistoric Emporio and Ayio Gala.* London.

Hood, S., and N. Coldstream, 1968. "A Late Minoan tomb at Ayios Ioannis near Knossos." *BSA* 63: 205-218.

Hood, S., and P. de Jong, 1952. "Late Minoan Warrior-Graves from Ayios Ioannis and the New Hospital Site at Knossos." *BSA* 47: 243-277.

———. 1958-1959. "A Late Minoan 'kitchen' at Makritikhos (Knossos) (Knossos Survey 90)." *BSA* 53-54: 182-193.

Hood, S., G. Huxley, and N. Sandars. 1958-1959. "A Minoan cemetery on Upper Gypsades." *BSA* 53-54: 194-261.

Hood, S., P. Warren, and G. Cadogan. 1964. "Travels in Crete, 1962." *BSA* 59: 50-99.

Hooker, J. T. 1969. "Homer and Late Minoan Crete." *JHS* 89: 60-71.

Hornung, E. 1964. *Untersuchungen zur Chronologie und Geschichte des neuen Reiches.* Wiesbaden.

Hutchinson, R. W. 1956A. "A Late Minoan Tomb at Knossos." *BSA* 51: 68-73.

———. 1956B. "A Tholos Tomb on the Kephala." *BSA* 51: 74-80.

———. 1962. *Prehistoric Crete.* Harmondsworth, Baltimore, and Mitcham.

Iakovidis, Sp. 1979. "Thera and Mycenaean Greece." *AJA* 83: 101-102.

Immerwahr, S. 1966. "The Use of Tin on Mycenaean Vases." *Hesperia* 35: 381-396.

Immerwahr, S. A. 1971. *The Athenian Agora,* vol. XIII, *The Neolithic and Bronze Ages.* Princeton.

Jantzen, U. 1951. "Die Kumaro-Höhle." In Matz 1951: 1-12.

Johnston, R. H. 1974. "The Biblical Potter." *The Biblical Archaeologist* 37: 86-106.

Jones, R. E. 1978. "Composition and Provenance Studies of Cycladic Pottery with Particular Reference to Thera." In Doumas, ed. 1978-1980: 471-482.

Jones, R. E., and J. B. Rutter. 1977. "Resident Minoan potters on the Greek mainland? Pottery composition analyses from Ayios Stephanos." *Archaeometry* 19: 211-219.

Kaiser, B. 1976. *Untersuchungen zum minoischen Relief.* Bonn.

Kanta, A. 1971. "Τὸ Σπήλαιο τοῦ Λιλιανοῦ." *KrChron* 23: 425-439.

———. 1980. *The Late Minoan III Period in Crete. A Survey of Sites, Pottery and their Distribution.* Göteborg.

Kantor, H. J. 1947. "The Aegean and the Orient in the Second Millennium B.C." *AJA* 51: 1-103.

———. 1965. "The Relative Chronology of Egypt and Its Foreign Correlations before the Late Bronze Age." In Ehrich, ed. 1965: 1-46.

Karageorghis, V. 1965. *Nouveaux documents pour l'étude du Bronze Récent à Chypre.* Paris.

———. 1968. "Αἱ σχέσεις μεταξὺ Κύπρου καὶ Κρήτης κατὰ τὸν IIον αἰῶνα π. Χ." In *Πεπραγμένα τοῦ β΄ Διεθνοῦς Κρητολογικοῦ Συνεδρίου.* Athens.

———. 1979. "Some Reflections on the Relations between Cyprus and Crete during the Late Minoan IIIB Period." In *Acts of the International Archaeological Symposium: "The Relations between Cyprus and Crete, ca. 2000-500 B.C.,"* pp. 199-203. Nicosia.

Karo, G. 1930-1933. *Die Schachtgräber von Mykenai.* Munich.

Kelso, J. L. 1948. *The Ceramic Vocabulary of the old Testament.* New Haven.

Kemp, B. J., and R. S. Merrillees. 1980. *Minoan Pottery in Second Millennium*

Egypt. Mainz am Rhein.

Kenna, V.E.G. 1968. "Ancient Crete and the Use of the Cylinder Seal." *AJA* 72: 321-336.

Kenyon, K. M. 1970. *Archaeology in the Holy Land*. New York and Washington, D.C.

Klein, J., J. C. Lerman, P. E. Damon, and E. K. Ralph. 1982. "Calibration of Radiocarbon Dates." *Radiocarbon* 24: 103-150.

Koehl, R. B. 1981. "The Functions of Aegean Bronze Age Rhyta." In Hägg and Marinatos, eds. 1981: 179-188.

Lacy, A.D. 1967. *Greek Pottery in the Bronze Age*. London.

Lamb, W. 1932. "Schliemann's prehistoric sites in the Troad." *Praehistorische Zeitschrift* 23: 111-131.

Lapp, P. W. 1967. "The 1966 Excavations at Tell Ta'annek." *BASOR* 185: 2-38.

Laviosa, C. 1972-1973. "L'abitato prepalaziale di Haghia Triada." *ASAtene*, n.s., 34-35: 503-513.

———. 1974. "Iasos, 1973." *AnatSt* 24: 33-35.

Lawrence, W. G. 1972. *Ceramic Science for the Potter*. Radnor, Pennsylvania.

Lembesi, A. 1967. "Ἀνασκαφὴ τάφου εἰς Πόρον Ἡρακλείου." *Praktika*: 195-209.

Lembesi, A., J. P. Olivier, and L. Godart. 1974. "Πινακίδες Γραμμικῆς Α ἐξ Ἀρχανῶν." *ArchEph*: 113-167.

Leonard, A. 1981. "Considerations of Morphological Variation in the Mycenaean Pottery From the Southeastern Mediterranean." *BASOR* 241: 87-101.

Levi, D. 1927-1929. "Arkades. Una Città cretese all'alba della civiltà ellenica." *ASAtene* 10-12.

———. 1951. "Attività della Scuola Archeologica italiana di Atene nell' anno 1950." *Bolletino d'Arte* 36: 335-358.

———. 1957-1958. "L'archivo di cretule a Festòs." *ASAtene*, n.s., 19-20: 7-192.

———. 1960. "Per una nuova classificazione della civiltà minoica." *La Parola del Passato* 15: 81-121.

———. 1961-1962. "La tomba a tholos di Kamilari presso a Festòs." *ASAtene*, n.s., 23-24: 7-148.

———. 1961-1962B. "Gli scavi a Festòs negli anni 1958-60." *ASAtene*, n.s., 23-24: 377-504.

———. 1964. *The Recent Excavations at Phaistos*. Lund.

———. 1965. "Le varietà della primitiva ceramica cretese." In *Studi in onore de Luisa Banti*, pp. 223-239. Rome.

———. 1965-1966. "La Conclusione degli scavi a Festòs." *ASAtene*, n.s., 27-28: 313-399.

———. 1967-1968. "L'abitato di Festòs in località Chálara." *ASAtene*, n.s., 29-30: 55-166.

———. 1969-1970. "Iasos. Le campagne di scavo 1969-70." *ASAtene*, n.s., 31-32: 461-532.

———. 1976. *Festòs e la civiltà minoica*, vol. I. Rome.

Lloyd, S., and J. Mellaart, 1962. *Beycesultan*, vol. I. London.

Lucas, A. 1962. *Ancient Egyptian Materials and Industries*. London.

Luce, J. V. 1976. "Thera and the Devastation of Minoan Crete." *AJA* 80: 9-16.

———. 1978. "The Chronology of the LM I Destruction Horizons on Thera and Crete." In Doumas, ed. 1978-1980: 785-790.

McArthur, J., and J. McArthur. 1974. "The Theban Stirrup-Jars and East Crete: Further Considerations." *Minos* 15: 68-80.

MacGillivray, J. A. 1984. "Cycladic Jars from Middle Minoan III Contexts at Knossos." In Hägg and Marinatos, eds. 1984: 153-157.

Mackenzie, D. 1903. "The Pottery of Knossos." *JHS* 23: 157-205.

———. 1906. "The Middle Minoan Pot-

tery of Knossos." *JHS* 26: 243-267.

Mackeprang, M. B. 1938. "Late Mycenaean Vases." *AJA* 42: 537-559.

Marcel, G., et al. 1971. *Mélanges de préhistoire, d'archéocivilisation et d'éthnologie offerts à André Varagnac.* Paris.

Mariani, L. 1901. "The Vases of Erganos and Courtes." *AJA* 5: 302-314.

Marinatos, S. 1929A. "Τὸ Σπέος Εἰλειθυίης." *Praktika*: 95-104.

———. 1929B. "Πρωτομινωϊκὸς θολωτὸς τάφος παρὰ τὸ χωρίον Κράσι Πεδιάδος." *Deltion* 12: 102-141.

———. 1930. "Ἀνασκαφαὶ ἐν Κρήτῃ 1930." *Praktika:* 91-99.

———. 1931. "Δύο πρώϊμοι μινωϊκοὶ τάφοι ἐκ Βοροῦ Μεσαρᾶς." *Deltion* 13: 137-170.

———. 1932A. "Ἀνασκαφὴ Ἀμνισοῦ Κρήτης." *Praktika*: 76-94.

———. 1932B. "Archäologische Funde. Kreta." *AA*: cols. 174-179.

———. 1933. "Funde und Forschungen auf Kreta." *AA*: cols. 287-295.

———. 1937. "Αἱ Μινωϊκαὶ Θεαὶ τοῦ Γάζι." *ArchEph*: 278-291.

———. 1939-1941. "Τὸ Μινωϊκὸν μέγαρον Σκλαβοκάμπου." *ArchEph*: 69-96.

———. 1949. "Ἀνασκαφαὶ Βαθυπέτρου Ἀρχανῶν (Κρήτη)." *Praktika*: 100-109.

———. 1950. "Τὸ μέγαρον Βαθυπέτρου." *Praktika*: 242-257.

———. 1951. "Ἀνασκαφὴ μεγάρου Βαθυπέτρου Κρήτης." *Praktika*: 258-272.

———. 1952. "Ἀνασκαφαὶ ἐν Βαθυπέτρῳ Κρήτης." *Praktika*: 592-610.

———. 1955. "Ἀνασκαφαὶ ἐν Λυκάστῳ καὶ Βαθυπέτρῳ Κρήτης." *Praktika*: 306-310.

———. 1968-1976. *Excavations at Thera*, vols. I-VIII. Athens.

———. 1973. *Kreta, Thera und das mykenische Hellas.* Munich.

Masson, O. 1961-1962. "Remarques sur les rapports entre la Crète et Chypre à la fin de l'Age de Bronze." *KrChron* 15-16, pt. 1: 156-161.

Matz, F. 1928. *Die frühkretischen Siegel.* Berlin and Leipzig.

———. 1951. *Forschungen auf Kreta 1942.* Berlin.

———. 1961-1962. "Minoischer Stiergott?" *KrChron* 15-16, pt. 1: 215-223.

Mavriyannaki, C. 1973. "Vasi inconsueti del Tardo Minoico da Rethymno e rapporti con la ceramica Cipriota." *Report of the Department of Antiquities. Cyprus*: 83-90.

———. 1974. "Εὑρήματα τῆς ΥΜ ΙΙΙ περιόδου ἐκ Λιγορτύνου Μονοφατσίου εἰς τὸ Μουσεῖον τοῦ Λούβρου." *ArchEph*: 45-56.

———. 1978. "Double Axe-Tool with Engraved Bucranium from the District of Amari (Nome of Rethymno)." *AAA* 11: 198-208.

Mee, C. 1978. "Aegean Trade and Settlement in Anatolia in the Second Millennium B.C." *AnatSt* 28: 121-156.

Melas, E. M. 1981. "Νέα στοιχεῖα γιὰ τὴ μινωϊκὴ ἀποίκηση τῆς Καρπάθου." *Καρπαθιακαὶ Μελέται* 2: 99-161.

Mellaart, J. 1966. *The Chalcolithic and Early Bronze Ages in the Near East and Anatolia.* Beirut.

Mellink, M. 1965. "Anatolian Chronology." In Ehrich, ed. 1965: 101-131.

Merrillees, R. S. 1968. *The Cypriote Bronze Age Pottery found in Egypt.* Lund.

———. 1972. "Aegean Bronze Age Relations with Egypt." *AJA* 76: 281-294.

Merrillees, R. S., and J. Evans. 1980. "An essay in provenance: the Late Minoan IB pottery from Egypt." *Berytus* 28: 1-45.

Milojčić, V. 1961. *Samos I. Die prähistorische Siedlung unter dem Heraion. Grabung 1953 und 1955.* Bonn.

Monaco, G. 1938. "Scoperta nella zona micenea di Ialiso (Campagna di scavo 1936)." *Memorie pubblicate a cura*

dell'Istituto Storico-archeologico F.E.R.T. e della R. Deputazione di Storia Patria per Rodi 3: 57-68.

―――. 1941. "Scavi nella zona micenea di Jaliso (1935-1936)." Clara Rhodos 10: 41-178.

Morgan, L. 1983. "Morphology, Syntax, and the issue of Chronology." Workshop on Prehistoric Cycladic Chronology, London, June 10, 11, and 13, 1983 (unpublished).

Morricone, L. 1972-1973. "Coo―Scavi e scoperte nel 'Seraglio' e in località minori (1935-1943)." ASAtene, n.s., 34-35: 139-396.

Mortzos, C. E. 1972. "Πάρτιρα. Μία πρώϊμος Μινωϊκὴ κεραμεικὴ ὁμάς." Ἐπετηρὶς Ἐπιστημονικῶν Ἐρευνῶν 3: 386-419.

Mosso, A. 1908. "Ceramica neolitica di Phaestos e vasi dell'epoca minoica primitiva." MonAnt 19: cols. 141-218.

Mountjoy, P.-A. 1972. "A Late Minoan IB Marine Style Stirrup-jar." BSA 67: 125-128.

―――. 1974A. "A Note on the LM IB Marine Style at Knossos." BSA 69: 173-175.

―――. 1974B. "A Later Development of the Late Minoan IB Marine Style." BSA 69: 177-180.

―――. 1977A. "A Late Minoan IB Marine Style Rhyton from Pseira." AAA 9: 83-86.

―――. 1977B. "Attributions in the LM IB Marine Style." AJA 81: 557-560.

Mountjoy, P.-A., R. E. Jones, and J. F. Cherry. 1978. "Provenance Studies of the LM IB/LH IIA Marine Style." BSA 73: 143-171.

Muhly, J. D. 1976. "The Ox-hide Ingots and the Development of Copper Metallurgy in the Late Bronze Age." Temple University Aegean Symposium 1: 10-14.

―――. 1980. "Metals and Metallurgy in Crete and the Aegean at the Beginning

of the Late Bronze Age." Temple University Aegean Symposium 5: 25-36.

Mylonas, G. 1972-1973. Ὁ ταφικὸς κύκλος Β' τῶν Μυκηνῶν. Athens.

Niemeier, W.-D. 1979A. "Towards a New Definition of Late Minoan II." AJA 83: 212-214.

―――. 1979B. "The Master of the Gournia Octopus Stirrup Jar and a Late Minoan I Pottery Workshop at Gournia Exporting to Thera." Temple University Aegean Symposium 4: 18-26.

―――. 1980. "Die Katastrophe von Thera und die Spatminoische Chronologie." JdI 95: 1-76.

―――. 1982A. "Mycenaean Knossos and the Age of Linear B." SMEA 23: 219-287.

―――. 1982B. "Das mykenische Knossos und das Alter von Linear B." Beiträge zur ägäischen Bronzezeit (Kleine Schriften aus dem Borgeschichtlichen Seminar Marburg 11): 29-126.

Noble, J. V. 1965. The Techniques of Painted Attic Pottery. New York.

Noll, W. 1977. "Techniken antiker Töpfer und Vasenmaler." Antike Welt 8, no. 2: 21-36.

―――. 1982. "Mineralogie und Technik der Keramiken Altkretas." Neues Jahrbuch für Mineralogie. Abhandlunden 143, no. 2: 150-199.

Olsen, F. L. 1973. The Kiln Book. Bassett, California.

Orlandos, A. K. 1972. "Κρήτη." Ergon: 111-118.

Orsi, P. 1889. "Urne funebri cretesi." MonAnt 1: cols. 201-230.

Osten, H. H. von der. 1937. The Alishar Hüyük, vol. I. Chicago.

Page, D. L. 1970. The Santorini Volcano and the destruction of Minoan Crete. London.

―――. 1978. "On the Relation between the Thera Eruption and the Desolation of Eastern Crete c. 1450 B.C." In Dou-

mas, ed. 1978-1980: 691-698.

Palmer, L. R. 1963. "The Find Places of the Knossos Tablets." In Palmer and Boardman 1963.

———. 1965. *Mycenaeans and Minoans.* Oxford.

———. 1969A. *The Penultimate Palace of Knossos.* Rome.

———. 1969B. *A New Guide to the Palace of Knossos.* London.

———. 1971. "Mycenaean Inscribed Vases I." *Kadmos* 10: 70-86.

———. 1972. "Mycenaean Inscribed Vases II. The Mainland Finds." *Kadmos* 11: 27-46.

———. 1973. "Mycenaean Inscribed Vases III." *Kadmos* 12: 60-75.

Palmer, L. R., and J. Boardman. 1963. *On the Knossos Tablets.* Oxford.

Pantelidhou, M. 1971. " Ἐπικασσιτερωμένα ἀγγεῖα ἐξ Ἀθηνῶν." *AAA* 4: 433-438.

Paribeni, R. 1913. "Scavi nella Necropoli preellenica de Festo . . . Siva." *Ausonia* 8: 14-31.

Pelagatti, P. 1961-1962. "Osservazioni sui ceramisti del I palazzo di Festòs." *KrChron* 15-16, pt. 1: 99-111.

Pelon, O. 1970. *Fouilles exécutées à Mallia. Exploration des maisons et quartiers d'habitation (1963-1966), troisième fascicule.* Études crétoises 16. Paris.

Pendlebury, H. W., and J.D.S. Pendlebury. 1928-1930. "Two Protopalatial Houses at Knossos." *BSA* 30: 53-73.

Pendlebury, H. W., J.D.S. Pendlebury, and M. B. Money-Coutts. 1935-1936. "Excavations in the Plain of Lasithi. I. The Cave of Trapeza." *BSA* 36: 5-131.

———. 1937-1938A. "Excavations in the Plain of Lasithi. II." *BSA* 38: 1-56.

———. 1937-1938B. "Excavations in the Plain of Lasithi. III. Karphi: A City of Refuge of the Early Iron Age in Crete." *BSA* 38: 57-145.

Pendlebury, J.D.S. 1930. *Aegyptiaca.* Cambridge, England.

———. 1939. *The Archaeology of Crete.* London.

Pernier, L. 1902. "Ricerche e scavi sulle acropoli di Phaestos." *MonAnt* 12: cols. 7-132.

———. 1904. "Scavi della Missione Italiana a Phaestos (1902-1903)." *MonAnt* 14: cols. 313-492.

———. 1935. *Il Palazzo minoico di Festòs,* vol. I. Rome.

Pernier, L., and L. Banti. 1951. *Il Palazzo minoico di Festòs,* vol. II. Rome.

Petroulakis, E. 1915. "Κρητικῆς Ἀτσιπάδας τάφοι." *ArchEph:* 48-50.

Pichler, H., and W. Schiering. 1980. "Der spätbronzezeitliche Ausbruch des Thera-Vulkans und seine Auswirkungen auf Kreta." *AA:* 1-37.

Pini, I. 1968. *Beiträge zur minoischen Gräberkunde.* Wiesbaden.

Pinsent, J. 1978. "The iconography of octopuses: a first typology." *BICS* 25: 172-173.

Pirie, P., and G. Edwards. 1983. "Going potty; pick of the terracotta pots." *Woman's Journal,* June: 142-144.

Platon, N. 1947. " Ἡ ἀρχαιολογικὴ κίνησις ἐν Κρήτῃ κατὰ τὰ ἔτη 1941-1947." *KrChron* 1: 631-640.

———. 1950. "Χρονικά." *KrChron* 4: 529-535.

———. 1951A. " Ἀνασκαφὴ Μινωϊκῶν οἰκιῶν εἰς Πρασᾶ Ἡρακλείου." *Praktika:* 246-257.

———. 1951B. "Χρονικά." *KrChron* 5: 438-449.

———. 1952A. " Ἀνασκαφὴ ΥΜ III τάφων Ἐπισκοπῆς καὶ Σταμνιῶν Ἡρακλείου." *Praktika:* 310-362.

———. 1952B. " Ἀνασκαφαὶ περιοχῆς Σητείας." *Praktika:* 630-648.

———. 1952C. " Ἀνασκαφὴ λαξευτῶν τάφων εἰς τὴν περιοχὴν Ἐπισκοπῆς καὶ Σταμνιῶν Πεδιάδος Ἡρακλείου, *Praktika:* 619-630.

————. 1956. "Ἀνασκαφὴ μινωϊκῆς ἀγροι-
κίας εἰς Ζοῦ Σητείας." *Praktika*: 232-
240.

————. 1957. "Ἀνασκαφὴ Χόνδρου
Βιάννου." *Praktika*: 136-147.

————. 1959A. "Ἀνασκαφὴ Μινωϊκοῦ
συνοικισμοῦ εἰς Κεφάλι Χονδροῦ."
Praktika: 197-206.

————. 1959B. "Χρονικά." *KrChron* 13:
359-393.

————. 1961. "Chronologie de la Crète et
des Cyclades à l'Age du Bronze." In
*Bericht über den V. Internationalen Kon-
gress für Vor- und Frühgeschichte, Ham-
burg, 1958*, pp. 671-676. Berlin.

————. 1969. *CMS II. Iraklion Archäolo-
gisches Museum*, pt. 1, *Die Siegel der Vor-
palastzeit*. Berlin.

————. 1971. *Zakros. The Discovery of a
Lost Palace of Ancient Crete*. New York.

————. 1974. "The New-palace Minoan
period." In Christopoulos et al., eds.
1974: 174-219.

————. 1979. "L'exportation du cuivre de
l'île de Chypre en Crète et les installa-
tions métallurgiques de la Crète mi-
noenne." In *Acts of the International Ar-
chaeological Symposium: "The Relations
between Cyprus and Crete, ca. 2000-500
B.C.,"* pp. 101-110. Nicosia.

Popham, M. R. 1963. "Two Cypriot
sherds from Crete." *BSA* 58: 89-93.

————. 1964. *The Last Days of the Palace at
Knossos. Complete Vases of the Late Mi-
noan IIIB Period*. Lund.

————. 1965. "Some Late Minoan III
Pottery from Crete." *BSA* 60: 316-342.

————. 1967. "Late Minoan Pottery, A
Summary." *BSA* 62: 337-351.

————. 1969A. "The Late Minoan goblet
and kylix." *BSA* 64: 299-304.

————. 1969B. "Knossos." *Archaeological
Reports for 1968-69*: 31-33.

————. 1970A. *The Destruction of the Pal-
ace at Knossos. Pottery of the Late Minoan
IIIA Period*. Göteborg.

————. 1970B. "Late Minoan Chronol-
ogy." *AJA* 74: 226-228.

————. 1970C. "Late Minoan IIIB Pot-
tery from Knossos." *BSA* 65: 195-202.

————. 1973. "The Unexplored Mansion
at Knossos: a preliminary report on the
excavations from 1967 to 1972. Part I.
The Minoan building and its occupa-
tion." *Archaeological Reports for 1972-73*:
50-61.

————. 1974A. "Knossos: The Unex-
plored Mansion." *Archaeological Reports
for 1973-74*: 35.

————. 1974B. "Sellopoulo Tombs 3 and
4, two Late Minoan graves near Knos-
sos." *BSA* 69: 195-257.

————. 1975. "Late Minoan II Crete: A
Note." *AJA* 79: 372-274.

————. 1976. "Mycenaean-Minoan rela-
tions between 1450 and 1400 B.C."
BICS 23: 119-121.

————. 1979. "Connections between
Crete and Cyprus between 1300-1100
B.C." In *Acts of the International Archaeo-
logical Symposium: "The Relations between
Cyprus and Crete, ca. 2000-500 B.C.,"*
pp. 178-191. Nicosia.

————. 1980. "Cretan sites occupied be-
tween c. 1450 and 1400 B.C." *BSA* 75:
163-167.

Popham, M., and H. Sackett. 1973. "Ex-
cavation in the Unexplored Mansion."
Deltion 28: Khronika, 576-578.

Pottier, E. 1907. "Documents céramiques
du Musée du Louvre." *BCH* 31: 115-
138.

Poursat, J.-C. 1972. "Mallia." *BCH* 96:
957-961.

————. 1973. "Mallia." *BCH* 97: 580-583.

————. 1975. "Fouilles récentes à Mallia
(Crète): l'art palatial minoen à l'époque
de Camarès." *Gazette des Beaux-Arts* 86:
89-98.

————. 1980A. "Reliefs d'appliqué
moulés." In Detournay, Poursat, and
Vandenabeele 1980: 116-132.

Poursat, J.-C. 1980B. "Vannerie." In Detournay, Poursat, and Vandenabeele 1980: chap. 3.

Raison, J. 1968. *Les Vases à Inscriptions Peintes de l'Âge Mycénien et Leur Contexte Archéologique*. Rome.

Ralph, E. K., H. N. Michael, and M. C. Han. 1973. "Radiocarbon Dates and Reality." *MASCA Newsletter* 9: 1-20.

Ralph, E. K., and R. Stuckenrath, Jr. 1962. "University of Pennsylvania Radiocarbon Dates V." *Radiocarbon* 4: 144-159.

Renfrew, C. 1964. "Crete and the Cyclades before Rhadamanthus." *KrChron* 18: 107-141.

———. 1969. "The Development and Chronology of the Early Cycladic Figurines." *AJA* 73: 1-32.

———. 1971. "Sitagroi, radiocarbon and the prehistory of south-east Europe." *Antiquity* 45: 275-282.

———. 1972. *The Emergence of Civilisation.* London.

———. 1978-1980. "Phylakopi and the Late Bronze I Period in the Cyclades." In Doumas, ed. 1978-1980: I 403-421.

Rhodes, D. 1964. *Kilns.* Philadelphia.

Rice, P. M. 1976. "Rethinking the Ware Concept." *American Antiquity* 41: 538-543.

Richter, G.M.A. 1953. *Handbook of the Greek Collection. Metropolitan Museum of Art.* New York.

———. 1966. *The Furniture of the Greeks, Etruscans and Romans.* London.

Rocchetti, L. 1969-1970. "Depositi Sub-Micenei e Protogeometrici nei dintorni di Festòs." *ASAtene*, n.s., 31-32: 41-70.

Rosa, V., la. 1977. "La ripresa dei lavori ad Haghia Triada: relazione preliminare sui saggi del 1977." *ASAtene*, n.s., 39: Appendice, 297-342.

Rutkowski, B. 1966. *Larnaksy Egejskie.* Warsaw.

———. 1968. "The origin of the Minoan coffin." *BSA* 63: 219-227.

Rutter, J. 1977. "Late Helladic IIIC Pottery and some Historical Implications." In *Symposium on the Dark Ages in Greece,* pp. 1-20. New York.

Rutter, J. B., and S. H. Rutter. 1976. *The transition to Mycenaean: a stratified Middle Helladic II to Late Helladic IIA pottery sequence from Ayios Stephanos in Lakonia.* Los Angeles.

Rutter, J. B., and C. W. Zerner. 1984. "Early Hellado-Minoan Contacts." In Hägg and Marinatos, eds. 1984: 75-83.

Sacconi, A. 1974. *Corpus delle Iscrizione Vascolari in Lineare B.* Rome.

Sackett, L. H., and M. Popham. 1970. "Excavations at Palaikastro VII." *BSA* 65: 203-242.

Sackett, L. H., M. R. Popham, and P. M. Warren. 1965. "Excavations at Palaikastro, VI." *BSA* 60: 248-314.

Sakellarakis, J. A. 1965. " Ἀνασκαφὴ Ἀρχανῶν." *Praktika*: 174-184.

———. 1966. " Ἀρχάναι." *Deltion* 21: Khronika, 411-419.

———. 1970. "Das Kuppelgrab A von Archanes und das kretisch-mykenische Tieropferritual." *PZ* 45: 135-219.

———. 1972A. " Ἀρχάνες." In Orlandos 1972: 111-118.

———. 1972B. " Ἀνασκαφὴ Ἀρχανῶν." *Praktika*: 310-362.

———. 1972C. "Μυκηναϊκὸς ταφικὸς περίβολος εἰς Κρήτην." *AAA* 5: 399-419.

———. 1973. "Neolithic Greece." In Theocharis 1973: 131-146.

Sakellarakis, I., and E. Sakellarakis. 1976. " Ἀνασκαφὴ Ἀρχανῶν." *Praktika*: 342-399.

Sakellarakis, Y., and E. Sapouna-Sakellaki. 1981. "Drama of Death in a Minoan Temple." *National Geographic* 159, no. 2: 205-222.

Sampson, A. 1980. "Μινωϊκὰ ἀπὸ τὴν Τῆλο." *AAA* 13: 68-73.

Savignoni, L. 1904. "Scavi e scoperte nella necropoli di Phaestos." *MonAnt* 14: cols. 501-666.

Schachermeyr, F. 1955. *Die ältesten Kulturen Griechenlands*. Stuttgart.

———.1962. "Forschungsbericht über die Ausgrabungen und Neufunde zur Ägaische Frühzeit 1957-1960." *AA*: cols. 105-382.

———. 1964. *Die minoische Kultur des alten Kreta*. Stuttgart.

———. 1978. "Akrotiri—first maritime republic?" In Doumas, ed. 1978-1980: 423-428.

———. 1979A. "The Pleonastic Pottery Style of Cretan Middle IIIC and its Cypriote Relations." In *Acts of the International Archaeological Symposium "The Relations between Cyprus and Crete, ca. 2000-500 B.C.,"* pp. 204-214. Nicosia.

———. 1979B. *Die ägäische Frühzeit*. Vienna.

Schaeffer, C. F.-A. 1932. "Fouilles de Minet-el-Beida et de Ras Shamra." *Syria* 13: 1-27.

———. 1937. "Les fouilles de Ras Shamra-Ugarit. Huitième campagne (Printemps 1936)." *Syria* 18: 125-154.

———. 1938. "Les fouilles de Ras Shamra-Ugarit. Neuvième campagne (Printemps 1937)." *Syria* 19: 193-255.

———. 1939. *Ugaritica*, vol. I. Paris.

———. 1948. *Stratigraphie comparée et chronologie de l'Asie Occidentale (IIIe et IIe millénaires)*. London.

Schiering, W. 1959-1960. "Die Ausgrabung beim Athena-Tempel in Milet 1957. I. Südabschnitt." *IstMitt* 9-10: 4-30.

———. 1960. "Steine und Malerei in der minoische Kunst." *JdI* 75: 17-36.

———. 1981. "Prinzipien der Bildgestaltung mittelminoischer Siegel." *Studien zur minoischen und helladischen Glyptik*, CMS suppl 1: 189-206.

Schiering, W., with W. Muller and W. D.

Niemeier. 1982. "Landbegehungen in Rethymnon und Umgebung." *AA*: 15-54.

Schofield, E. 1982A. "Plus and Minus Thera: Trade in the Western Aegean in Late Cycladic I-II." *Temple University Aegean Symposium* 7: 9-14.

———. 1982B. "The Western Cyclades and Crete: a 'Special Relationship.' " *Oxford Journal of Archaeology* 1, fasc. 1.

Scholes, K. 1956. "The Cyclades in the Later Bronze Age: a Synopsis." *BSA* 51: 9-40.

Seager, R. B. 1904-1905. "Excavations at Vasiliki, 1904." *University of Pennsylvania Transactions of the Department of Archaeology, Free Museum of Science and Art* 1: 207-221.

———. 1906-1907. "Report of Excavations at Vasiliki, Crete, in 1906." *University of Pennsylvania Transactions of the Department of Archaeology, Free Museum of Science and Art* 2: 111-132.

———. 1908. "Excavations at Vasiliki." In Hawes et al. 1908: 49-50 and pl. 12.

———. 1909. "Excavations on the Island of Mochlos, Crete, in 1908." *AJA* 13: 273-303.

———. 1910. *Excavations on the Island of Pseira, Crete*. Philadelphia.

———. 1912. *Explorations in the Island of Mochlos*. Boston and New York.

———. 1916. *The Cemetery of Pachyammos, Crete*. Philadelphia.

Seiradaki, M. 1960. "Pottery from Karphi." *BSA* 55: 1-37.

Shaw, J. W. 1977. "Excavations at Kommos (Crete) During 1976." *Hesperia* 46: 199-240.

———. 1978. "Excavations at Kommos (Crete) during 1977." In Shaw, Betancourt, and Watrous 1978: 111-154.

———. 1979. "Excavations at Kommos (Crete) during 1978." *Hesperia* 48: 145-173.

———. 1980. "Excavations at Kommos

(Crete) during 1979." *Hesperia* 49: 207-250.

———. 1981. "Excavations at Kommos (Crete) During 1980." *Hesperia* 50: 211-251.

———. 1984. "Excavations at Kommos (Crete) during 1982-1983." *Hesperia* 53: 251-287.

Shaw, J. W., P. P. Betancourt, and L. V. Watrous. 1978. "Excavations at Kommos (Crete) during 1977." *Hesperia* 47: 111-170.

Shear, T. L. Jr. 1967. "Minoan Influence on the Mainland: Variations of Opinion since 1900." In *A Land Called Crete. A Symposium in Memory of Harriet Boyd Hawes*, pp. 47-65. Northhampton, Mass.

Silverman, J. 1974. "A Lost Notebook from the Excavations at Gournia, Crete." *Expedition* 17, no. 1: 11-20.

———. 1978A. "The Gournia Collection in the University Museum: A Study in East Cretan Pottery." Dissertation, University of Pennsylvania.

———. 1978B. "The LM IB Painted Pottery of Eastern Crete." *Temple University Aegean Symposium* 3: 31-35.

Smee, M. H. 1966. "A Late Minoan tomb at Palaikastro." *BSA* 61: 157-162.

Snodgrass, A. M. 1971. *The Dark Age of Greece*. Edinburgh.

Sparks, R.S.J., H. Sigurdsson, and N. D. Watkins. 1978. "The Thera eruption and Late Minoan-IB destruction on Crete." *Nature* 271: 91.

Sperling, J. W. 1976. "Kum Tepe in the Troad: Trial Excavation, 1934." *Hesperia* 45: 305-364.

Starr, C. G. 1954-1955. "The Myth of the Minoan Thalassocracy." *Historia* 3: 282-291.

Stewart, J. R. 1963. "The Tomb of the Seafarer at Karmi in Cyprus." *OpusAth* 4: 199-206.

Stos-Fertner, Z., R.E.M. Hedges, and R.D.G. Evely. 1979. "The application of the XRF-XRD method to the analysis of the pigments of Minoan painted pottery." *Archaeometry* 21: 187-194.

Strange, J. 1980. *Caphtor/Keftiu: a new investigation*. Leiden.

Strøm, I. 1981. "Middle Minoan Crete: A Re-consideration of Some of its External Relations." In Best and de Vries, eds. 1981: 105-123.

Strong, D. E. 1966. *Greek and Roman Gold and Silver Plate*. Ithaca, New York.

Stubbings, F. H. 1951. *Mycenaean pottery from the Levant*. Cambridge, England.

———. 1970. "Chronology III. The Aegean Bronze Age." In *Cambridge Ancient History*, rev. ed., I: 239-247.

Stucynski, S. L. 1982. "Cycladic Imports in Crete: A Brief Survey." *Temple University Aegean Symposium* 7: 50-59.

Styrenius, C.-G. 1967. *Submycenaean Studies*. Lund.

Styrenius, C.-G., and J. Tzedakis. 1970. "Chania: A new Minoan centre." *AAA* 3: 100-108.

Switsur, V. R. 1972. "Radiocarbon Dates." In Warren 1972A: Appendix 15, 344-345.

Taramelli, A. 1897. "The Prehistoric Grotto at Miamù." *AJA* 1: 287-312.

Taylour, Lord W. 1958. *Mycenaean Pottery in Italy and Adjacent Areas*. Cambridge, England.

———. 1972. "Excavations at Ayios Stephanos." *BSA* 67: 205-263.

Theocharis, D. R. 1973. *Neolithic Greece*. Athens.

Thimme, J., ed. 1977. *Art and Culture of the Cyclades in the Third Millennium B.C.* Chicago and London.

Tufnell, O., C. H. Inge, and L. Harding. 1940. *Lachich*, vol. II. London, New York, and Toronto.

Tzedakis, I. G. 1965. "Ἀρχαιότητες καὶ μνημεῖα δυτικῆς Κρήτης." *Deltion* 20: Khronika, 568-570.

————. 1966. "Ἀρχαιότητες καὶ μνημεῖα δυτικῆς Κρήτης." *Deltion* 21: Khronika, 425-429.

————. "Ἀρχαιότητες καὶ μνημεῖα δυτικῆς Κρήτης." *Deltion* 22: Khronika, 495-506.

————. 1968. "Ἀρχαιότητες καὶ μνημεῖα δυτικῆς Κρήτης." *Deltion* 23: Khronika, 413-420.

————. 1969A. "L'atelier de céramique postpalatiale à Kydonia." *BCH* 93: 396-418.

————. 1969B. "Ἀρχαιότητες καὶ Μνημεῖα Δυτικῆς Κρήτης." *Deltion* 24: 428-436.

————. 1971A. "Minoan Globular Flasks." *BSA* 66: 363-368.

————. 1971B. "Λάρνακες Ὑστερομινωϊκοῦ νεκροταφείου Ἀρμένων Ρεθύμνης." *AAA* 4: 216-222.

————. 1973. "The Late Minoan III Settlement of Kydonia." *BICS* 20: 154-156.

————. 1977. "Καστέλλι Χανίων." *Ergon*: 199-204.

Vagnetti, L. 1972-1973. "L'insediamento neolittico di Festòs." *ASAtene*, n.s., 34-35: 7-138.

Vagnetti, L., and P. Belli. 1978. "Characters and Problems of the Final Neolithic in Crete." *SMEA* 19: 125-163.

Ventris, M., and J. Chadwick. 1973. *Documents in Mycenaean Greek*. Cambridge.

Vercoutter, J. 1956. *L'Égypte et le monde égéen préhellénique*. Cairo.

Vermeule, E. 1963. "The Fall of Knossos and the Palace Style." *AJA* 67: 195-199.

————. 1964. *Greece in the Bronze Age*. Chicago and London.

————. 1967. "The Decline and End of Minoan and Mycenaean Culture." In *A Land Called Crete. A Symposium in Memory of Harriet Boyd Hawes*, 81-98. Northampton, Mass.

————. 1975. *The Art of the Shaft Graves of Mycenae*. Norman, Oklahoma.

————. 1980. "Minoan Relations with Cyprus: The Late Minoan I Pottery from Toumba tou Skourou, Morphou." *Temple University Aegean Symposium* 5: 22-24.

Vermeule, E., and F. Wolsky. 1978. "New Aegean Relations with Cyprus: The Minoan and Mycenaean Pottery from Toumba tou Skourou, Morphou." *Proceedings of the American Philosophical Society* 122: 294-317.

Wace, A.J.B. 1956. "Ephyraean Ware." *BSA* 51: 123-127.

Wace, A.J.B., and M. S. Thompson. 1913. *Prehistoric Thessaly*. Cambridge, England.

Walberg, G. 1976. *Kamares. A Study of the Character of Palatial Middle Minoan Pottery*. Uppsala.

————. 1978. *The Kamares Style. Overall Effects*. Uppsala.

————. 1981. "The Identification of Middle Minoan Painters and Workshops." *AJA* 85: 73-75.

————. 1983. *Provincial Middle Minoan Pottery*. Mainz am Rhein.

Ward, W. A. 1971. *Egypt and the East Mediterranean World 2200-1900 B.C.* Beirut.

————. 1981. "The Scarabs from Tholos B at Platanos." *AJA* 85: 70-73.

Wardle, K. A. 1969. "A Group of Late Helladic IIIB 1 Pottery from within the Citadel at Mycenae." *BSA* 64: 261-297.

————. 1973. "A Group of Late Helladic IIIB 2 Pottery from within the Citadel at Mycenae." *BSA* 68: 297-342.

Warren, P. M. 1965. "The first Minoan stone vases and Early Minoan chronology." *KrChron* 19: 7-43.

————. 1969A. "The origins of the Minoans." *BICS* 16: 156-157.

————. 1969B. *Minoan Stone Vases*. London.

————. 1969C. "An Early Bronze Age

Potter's Workshop in Crete." *Antiquity* 43: 224-227.

———. 1972A. *Myrtos. An Early Bronze Age Settlement in Crete.* London.

———. 1972B. "Knossos and the Greek Mainland in the Third Millennium B.C." *AAA* 5: 392-398.

———. 1974. "Crete, 3000-1400 B.C.: immigration and the archaeological evidence." In Crossland and Birchall, eds. 1974: 41-47.

———. 1976. "Radiocarbon Dating and Calibration and the Absolute Chronology of Late Neolithic and Early Minoan Crete." *SMEA* 17: 205-219.

———. 1979. "Knossos." *Archaeological Reports for 1978-79*: 36-37.

———. 1980. "Problems of Chronology in Crete and the Aegean in the Third and Earlier Second Millennium B.C." *AJA* 84: 487-499.

———. 1981A. "Knossos: Stratigraphical Museum excavations, 1978-1980. Part I." *Archaeological Reports for 1980-81*: 73-93.

———. 1981B. "Knossos and its Foreign relations in the Early Bronze Age." In *Πεπραγμένα τοῦ Δ' Διεθνοῦς Κρητολογικοῦ Συνεδρίου.* Athens.

Warren, P., and J. Tzedhakis. 1972. "Debla: A New Early Minoan Settlement." *AAA* 5: 66-72.

———. 1974. "Debla. An Early Minoan settlement in western Crete." *BSA* 69: 299-342.

Watrous, L. V. 1978. "A Late Minoan I-II Deposit." In Shaw, Betancourt, and Watrous. 1978: Appendix B, 165-170.

———. 1980. "J.D.S. Pendlebury's Excavations in the Plain of Lasithi. The Iron Age Sites." *BSA* 75: 269-283.

———. 1981. "The Relationship of Late Minoan II to Late Minoan III A1." *AJA* 85: 75-77.

Weickert, C. 1940. "Grabungen in Milet 1938." In *Bericht über den VI internatio-*

nalen Kongress für Archäologie: 325-332.

———. 1957. "Die Ausgrabung beim Athena-Tempel in Milet 1955." *IstMitt* 7: 102-132.

———. 1959-1960. "Die Ausgrabung beim Athena-Tempel in Milet 1957. III. Westabschnitt." *IstMitt* 9-10: 63-66.

Weinberg, S.S. 1965. "The Relative Chronology of the Aegean in the Stone and Early Bronze Ages." In Ehrich, ed. 1965: 285-320.

Wiener, M. H. 1984. "Crete and the Cyclades in LM I: The Tale of the Conical Cups." In Hägg and Marinatos, eds. 1984: 17-25.

Wilson, A. L. 1976. "The provenance of the inscribed stirrup-jars found at Thebes." *Archaeometry* 18: 51-58.

Woolley, Sir L. 1955. *Alalakh.* Oxford.

Xanthoudides, St. 1904. " Ἐκ Κρήτης." *ArchEph*: 1-56.

———. 1918A. "Μέγας πρωτομινωϊκὸς τάφος Πύργου." *Deltion* 4: 136-170.

———. 1918B. "Πρωτομινωϊκοὶ Τάφοι Μεσσαρᾶς. Μαραθοκέφαλον. Ἰδαῖον ἄνδρον. Δρῆρος." *Deltion* 4: Parartema, 15-32.

———. 1920-1921. " Ἀρχαιολογικὴ περιφέρεια." *Deltion* 6: 154-157.

———. 1922. "Νίρου Μινωϊκὸν μέγαρον." *ArchEph*: 1-25.

———. 1924. *The Vaulted Tombs of Mesará.* London.

———. 1927. "Some Minoan Potter's-wheel Discs." In Casson, ed. 1927: 111-128.

Yadin, Y., et al. 1960. *Hazor*, vol. II. Jerusalem.

Yule, P. 1977-1978. "Platanos, Tholos B in Kreta: Bemerkungen zu den Siegeln." *Marburger Winckelmann-Programm*: 3-5.

Zerner, C. 1978. *The Beginning of the Middle Helladic Period at Lerna.* Dissertation, University of Cincinnati.

Zervos, C. 1956. *L'Art de la Crète néoli-*

thique et minoenne. Paris.

Zois, A. A. 1965. "Φαιστιακά." *ArchEph*: 27-109.

———. 1968A. *Der Kamares-Stil. Werden und Wesen.* Dissertation, Eberhard-Karls-Universität zu Tübingen.

———. 1968B. "῾Υπάρχει ΠΜ ΙΙΙ ἐποχή;" In *Πεπραγμένα τοῦ Β' Διεθνοῦς Κρητολογικοῦ Συνεδρίου.* Athens.

———. 1968C. " ῎Ερευνα περὶ τῆς μινωϊκῆς κεραμεικῆς." ᾿Επετηρὶς ᾿Επιστημονικῶν ᾿Ερευνῶν 1967-1968: 703-731.

———. 1969. Προβλήματα χρονολογίας τῆς μινωϊκῆς κεραμεικῆς. Γοῦρνες. Τύλισος. Μάλια.

———. 1972. "Νεολιθικὴ Κρήτη." ᾿Επετηρὶς ᾿Επιστημονικῶν Ερευνῶν 3: 442-466.

———. 1973. *Κρήτη. ᾿Εποχή τοῦ Λίθου. ᾿Αρχαῖες ῾Ελληνικὲς Πόλεις.* Athens.

———. 1976. *Βασιλική*, vol. I. Athens.

INDEX

LIBRARY OF CONGRESS CATALOGING
IN PUBLICATION DATA

Betancourt, Philip P., 1936-
The history of Minoan pottery.

Bibliography: p. Includes index.
1. Pottery, Minoan. 2. Pottery—Expertising.
3. Pottery dating. 4. Crete—Antiquities.
5. Greece—Antiquities. I. Title.
DF221.C8B564 1985 738.3′0939′18 84-22305
ISBN 0-691-03579-2 (alk. paper)
ISBN 0-691-10168-X (pbk.)

PHILIP P. BETANCOURT is Professor of Art History,
Temple University, and Visiting Lecturer in Classi-
cal Archaeology, University of Pennsylvania. He is
the author of *The Aeolic Style in Architecture* (Prince-
ton, 1977).